MEDIEVAL BRITAIN FROM THE AIR

MEDIEVAL BRITAIN FROM THE AIR

Colin Platt

George Philip

British Library Cataloguing in Publication Data
Platt, Colin
 Medieval Britain from the air
 1. Great Britain—History—Pictorial works
 I. Title
 942.02 DA195

ISBN 0 540 01077 4

© Colin Platt 1984
Published by George Philip, 12–14 Long Acre, London
WC2E 9LP

Filmset by Tameside Filmsetting Limited,
Ashton-under-Lyne, Lancashire
and printed by BAS Printers Limited,
Over Wallop, Hampshire.

Photographic Acknowledgements
Aerofilms Limited: 2, 3, 4, 5, 7, 8, 10, 12, 13, 14, 15, 16, 17, 18, 20, 24, 25, 26, 27, 29, 30, 31, 32, 34, 37, 38, 40, 41, 42, 47, 48, 49, 54, 55, 56, 57, 58, 59, 60, 61, 62, 63, 65, 67, 68, 69, 71, 72, 73, 74, 75, 76, 77, 80, 81, 82, 83, 84, 85, 86, 88, 89, 90, 91, 92, 93, 94, 96, 97, 98, 99, 100; Committee for Aerial Photography, University of Cambridge: 1, 6, 9, 11, 22, 23, 33, 35, 50, 51, 52, 66, 70, 78, 87, 95; Ministry of Defence (Crown Copyright Reserved) 19, 21, 36, 53, 79; The Royal Commission on the Ancient and Historical Monuments of Scotland: 28, 39, 43, 44, 45, 46, 64

The plan of Framlingham Castle (26) has been based, with permission, on the official Crown copyright plan prepared by the Department of the Environment and published by HMSO.

Special thanks are due to John Dunbar and Lisbeth Thoms for help in locating the Scottish material in this book.

Publisher's Note The date at the end of each caption is the date the photograph was taken.

To my son, Theo – good companion

Contents

List of Illustrations

Preface

There is nothing novel, let it be said, in the use of aerial photography for the study and interpretation of major medieval buildings or for the unravelling of historical landscapes. Valuable books have been published on the subject, and I have made frequent reference to them in my own. Nevertheless the method employed, even in the latest of these works, has usually been that of the descriptive catalogue, extracting the most important lessons from the individual photographs in the book, but of less value in placing them in context. My book, in contrast, takes the photograph as one of a hundred stepping-stones in the unfolding of a narrative history. My theme is the social history of medieval Britain, from the Norman Conquest to its fading out under the Tudors, told primarily in terms of its architecture. Inevitably this method, too, has imposed its own discipline, and I have been able to say comparatively little about some of those themes – rural settlement and mining or transport are among the more obvious examples – treated to such good effect in the earlier studies. These are omissions I regret, but they worry me less in that others have made them up before me.

In my book, unlike its predecessors, whereas the captions to the photographs have been developed at fair length, they do not try to say everything about their subjects. What I have striven to achieve is a total picture, built up through a succession of distinct images, but better understood as a whole than in its parts. I am not alone in viewing History as a seamless web, and offer this book as a contribution to that philosophy.

Colin Platt

1 Improvisation and Policy: the Anglo-Norman Settlement

Most landscapes, as a rule, will retain a sluggish record of the peoples and events that cross and touch them. Yet the Norman impact on Anglo-Saxon England was both immediate and, in practice, irreversible. Why this should have been so goes back beyond the events of the Conquest itself to the recent past of the Norman dukes and of their pious but restive aristocracy. Relatively unsophisticated in administrative routines, about which they had a lot to learn from the Anglo-Saxons, the Normans had nevertheless perfected, through the experience of half a century of almost continuous local crisis, two instruments of control perfectly suited to a society of conquest. One of these was the private castle, known since the days of the wicked Fulk Nerra (d. 1040) as the best means of encroaching upon new territory. The other was a reformed and a purified Church, usually monastic and almost always still dependent on the favours of its lay patrons, which might be held in the left hand of the Conqueror and his associates, as the sword was grasped in the right.

Characteristically, the use made by the Normans of each of these instruments was energetic but essentially flexible. Duke William and his companions-at-arms, gathered together from different territories in the common adventure of the Conquest, were natural improvisers, owing much of their success to this ability. They had arrived under the papal banner, supported by the blessing of a reforming Church injured by Harold's violation of his recent oath of fealty to the Norman duke. And this debt, as we shall see, they would repay. More

immediately, while aware of the advantages of digging themselves in, they had not come to England with doctrinaire preconceptions of the castle and its plan, knowing it already in a dozen different forms. At Pevensey, on the Sussex coast, the Conqueror had taken shelter in a Roman fort, as the first step in the consolidation of his landing. In the mid-1070s, he was still making use of existing Iron Age and Late Saxon defensive rings in the refortification of Old Sarum (Fig. 1), in Wiltshire, to coincide with the transfer of Bishop Osmund's see there from Sherborne.[1] Among the earliest verifiable remains of the Conqueror's defensive strategy in his new kingdom, these earthworks at Old Sarum show the Normans in the first flurry of their Settlement, improvising on such defences as they found already in existence to bring castle, cathedral and borough together in a unit they could hope to hold secure. At the centre of the enclosure, William's castle ringwork, later refortified in stone, took the highest land about which a formidable ditch and rampart could be constructed. Beyond (but still within the circuit of the Iron Age defences) was Bishop Osmund's cathedral. All around were the garden plots and tenements of the new borough. A unit of settlement as compact as this, taking its shape from whatever preceded it on the same site, was characteristic of the pressures of these early years, when nobody knew the face of

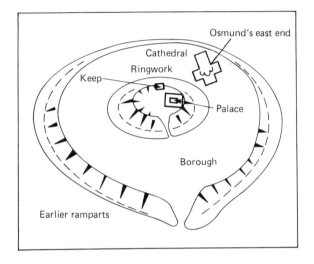

1 Old Sarum, Wiltshire

Duke William's Norman forces, in the first uncertain years of their conquest and settlement of England, were as likely to re-use existing defences as to build entirely new castles of their own. At Old Sarum, a Norman ringwork defends the highest ground at the centre of a great Iron Age and Late Saxon fortified enclosure, already large enough to accommodate the town to which Bishop Osmund transferred his see from Sherborne in the later 1070s. Osmund's comparatively small cathedral terminated in the triple apse which can still be seen at foundation level towards the centre of the building, under the later crossing. It was his successor at Salisbury, Roger the Justiciar, who rebuilt the cathedral church in a much grander manner, giving it a great new presbytery, transepts to north and south, and a carefully squared-off west end (showing towards the top of the photograph). Roger of Salisbury was a noted builder, responsible for other great works at Sherborne and elsewhere. It was he, very probably, who first replaced the timber defences of the castle at Old Sarum with a stone curtain wall and a formidable east gate. Roger's palace, to the right of this gate, surrounded a small central court as at Sherborne Castle. It was protected by a strong tower-keep on the stone circuit to the west, the whole dominating the small borough which spread through the outer bailey below. No trace of this borough remains above ground. It decayed when the cathedral was re-sited at Salisbury (Fig. 37) and when the castle itself became disused. (1965)

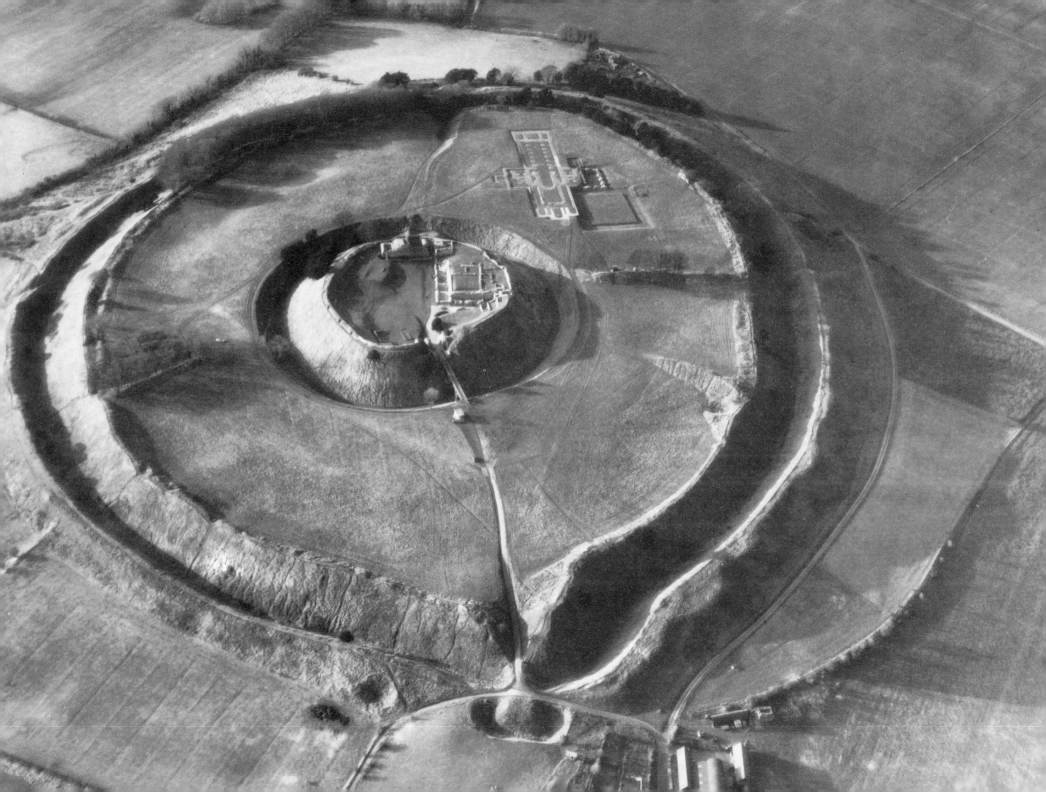

the future. 'While the king lives', wrote Archbishop Lanfranc at just this time, 'we have peace of a kind, but after his death we expect to have neither peace nor any other benefit.'[2] Yet such precautions would come to seem too cumbersome in those later decades to which Lanfranc had trembled to look ahead. In the 1220s, under the energetic and visionary leadership of Bishop Richard Poore (1217–28), both the borough and the cathedral of Salisbury (Fig. 37) were to be re-established on a new valley site, only lightly protected by the River Avon. The former castle at Old Sarum, while long retaining an administrative role, was otherwise an increasing anachronism.

William, at Pevensey, had re-used a Roman circuit wall, patched but still recognizably of the fourth century. At Old Sarum, he had taken advantage of a well-preserved Iron Age earthwork. Elsewhere, he and his castle-building companions would similarly benefit from the Roman defences at Cardiff, Rochester, or Carisbrooke (Fig. 96), as from whatever earthworks they might find – Anglo-Saxon or prehistoric – at Oxford or Dover, Thetford or Castle Neroche. Such expedients suggest a flexibility of approach in these early years which was certainly not as true of the later generations which produced, among others, William de Mandeville's Pleshey (Fig. 7), where the mound of the motte and the lines of its baileys have achieved their full maturity of form. For the moment, military engineering was more instinctive. Alan the Red, although a kinsman of the Conqueror, was himself a Breton, and it might well be that it was Alan's own experience at home in Brittany that persuaded him to build his castle at Richmond (Fig. 2) on a very different plan from those of his Norman companions. Richmond, in North Yorkshire, is a formidable kite-shaped fortress, strongly placed high on a promontory overlooking the Swale, and protected by a steep cliff on that quarter. Count Alan needed an enclosure that would be large enough, should an emergency require it, to shelter his entire entourage. He had chosen his site not for any overall strategic significance (of which it had none) but purely as an estate-centre, a retreat in times of trouble, a strong-point designed to overawe.

2 Richmond Castle, North Yorkshire
It was the promontory fortresses of Alan the Red's Brittany homeland that probably suggested the unusual plan of Richmond Castle. This great kite-shaped fortress, its longest flank protected by an almost vertical drop to the Swale, was one of the first major stone castles of the Anglo-Norman Settlement. Built in the 1070s, it had to be laid out on a sufficient scale to accommodate Count Alan and the small army he required to keep order on his estates. Before the end of the same century, Richmond had been equipped with a fine first-floor hall (bottom left) at its most secure south-eastern angle. On the north-east, at the apex of the triangle, Alan's already massive gate tower was rebuilt in the late twelfth century as a lofty tower-keep, the gate itself being re-sited to adjoin it. Just beyond this gate, a market and borough developed in an association characteristic of the Settlement. Richmond's great sloping market-place was to be 'colonized' quite early by permanent buildings that included a church. Yet it remains a feature of the town today, and although no longer dependent on the neighbouring fortress for its protection, continues to serve its original purpose. (1961)

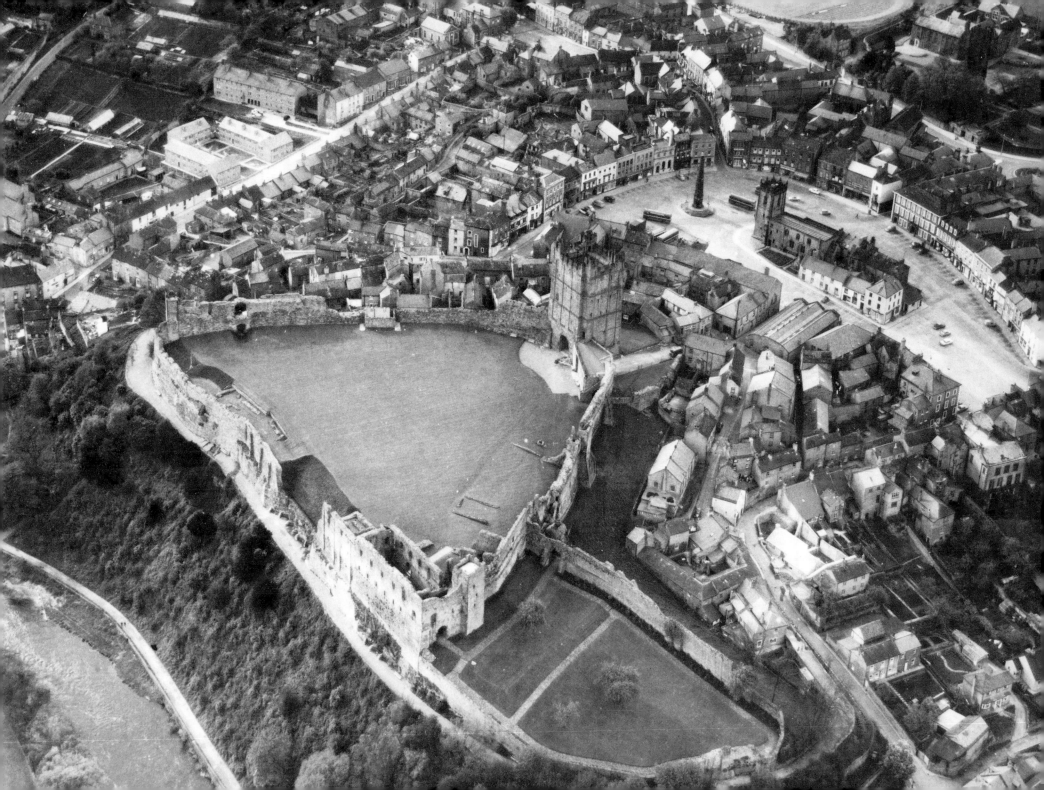

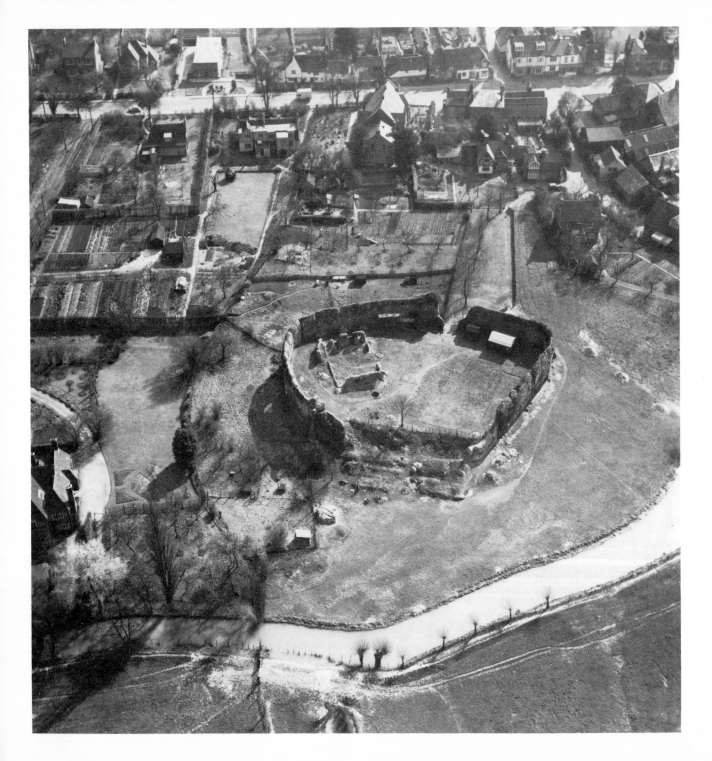

3 Eynsford Castle, Kent

Improvisations in castle building characterized a period of continuing disorder. At Eynsford, the stone fortifications are likely to have been a response to Bishop Odo's rebellion of 1088, and they took the form of a strong curtain wall in place of the more familiar but less durable palisaded banks and ditches of the ringwork. William de Eynsford, son of Ralph and builder of the castle, was already in the second generation of Norman settlement. His own son, William de Eynsford II, lived through another period of civil war, during the struggle between Stephen and Matilda. And it was probably this William who built the large rectangular structure, part residence and part keep, which occupies the eastern half of the enclosure, replacing his father's timber watch-tower. At the same time, William II raised the surrounding curtain wall to its present height, leaving us at Eynsford with a rare and precious example of contemporary stone castle-building, simple but effective, at a social level well below that of the magnate. (1951)

As we see it now, Richmond's great keep is a late-twelfth-century rebuilding. Yet it re-uses the plan of Alan the Red's original gate tower, of which it preserves the inner entrance, and there is no denying the impressive scale of the first castle.[3] Essentially, what Count Alan had done was to recreate in stone the ringwork principle, individual in plan as the site dictated, but similar in conception to Old Sarum. The primary need, in the North as in Wessex, was for a simple defensible space.

There can be no more straightforward demonstration of the continuing urgency of the times than the archbishop of Canterbury's castle at Eynsford (Fig. 3). Some of Archbishop Lanfranc's worst fears had been realized soon after the death of his patron, William I, in September 1087. Within a few months, Lanfranc's Kentish manors were to be plundered by the troops of Odo of Bayeux, leader of the faction that favoured Duke Robert of Normandy as king of England, in place of his younger brother, William II. The rebellion was defeated. Bishop Odo was captured and expelled. Nevertheless, the threat remained, and Lanfranc and his loyal vassal, William de Eynsford, were adopting no more than a reasonable precaution in fortifying this strategically situated estate. Contemporaneously Bishop Gundulf, architect of the Conqueror's White Tower and among the most noted fortress-builders of his day, was re-siting his own castle at Rochester which had been one of the centres of Odo's rebellion. And both at Eynsford and at Rochester, the defensive strategy adopted was the same, a strong stone curtain wall entirely enclosing the irregular oval of the bailey. Eynsford's curtain wall was later to be raised and strengthened. Within it, the rectangular stone hall, more fully excavated and displayed since this photograph was taken, is similarly an improvement of the mid-twelfth century, replacing an earlier timber watch-tower.[4] But the changes are insignificant, and what they cannot hide is the still experimental quality of contemporary castle-building, even in the generation once removed from the Conquest. An orthodoxy had yet to be established. Bishop Gundulf built one way for the king in London and at Colchester; at home in

Rochester with fewer resources to support the work, he built another way entirely for himself. His associates improvised on what they had.

Sometimes, indeed, systematic fortification seems not to have been envisaged at all in the earliest years. Castle Acre (Fig. 4) today is one of our greater surviving earthwork fortresses, apparently quite orthodox in form. There is a tall motte (with something of the character of a ringwork also) on the north edge of the site, with a steeply-banked oval bailey immediately to the south and with another great enclosure, ramparted and gated, to shelter the little market-town that grew up between castle and church. On the face of it, Castle Acre might appear the typical site of the Settlement period, bringing church, borough and fortress together very much in the manner of Old Sarum. Yet excavations on the castle mound in recent years have come up with some major surprises. Below the turf of the motte at Castle Acre, shown undisturbed in the photograph, were the remains of a substantial two-storeyed structure, being the first Norman building on the site. The visible defences all post-date this building which, if protected at all, can only have had a low surrounding bank and palisade.[5] William de Warenne, whose hall this was, is known to have been an experienced soldier. Among the Conqueror's more trusted companions, he had fought alongside William on a number of campaigns, had been present at Hastings, and was himself the builder of at least two other castles, one at Reigate, another at Lewes. This first Norman

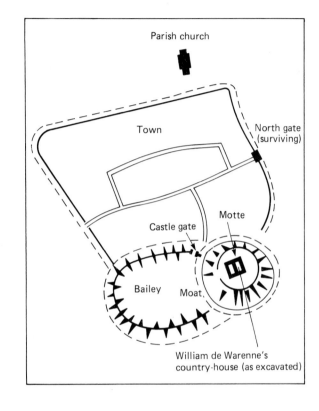

4 Castle Acre, Norfolk

On a far grander scale than Eynsford, Castle Acre was the Norfolk estate centre of the Warenne earls of Surrey, themselves among the greatest magnates of Anglo-Norman England. What remains at Castle Acre now is a tall motte (bottom right), dipping in the middle like a ringwork, with a steeply ramparted bailey, or lower ward, cut off from the mound by its encircling moat on the south (left). To the west, another large fortified enclosure is defined by trees along the line of its ditch. Gated to north and south, it held the little market-town, the parish church lying just beyond the ditch and rampart to the west (top). These huge fortifications precisely fitted the rank and great wealth of the Warennes. But they were not the first Norman use of the site. Under the turf of the castle mound, excavations in the 1970s have uncovered the remains of a substantial stone-built 'country-house', being the original hall of William de Warenne, companion-at-arms of the Conqueror. Although adapted and more strongly fortified within a short space of time, William's first country-house was only lightly defended by bank and palisade, just as if it had been a thegn's hall. Plainly the Normans, as military engineers, were only slowly developing an orthodoxy. (1971)

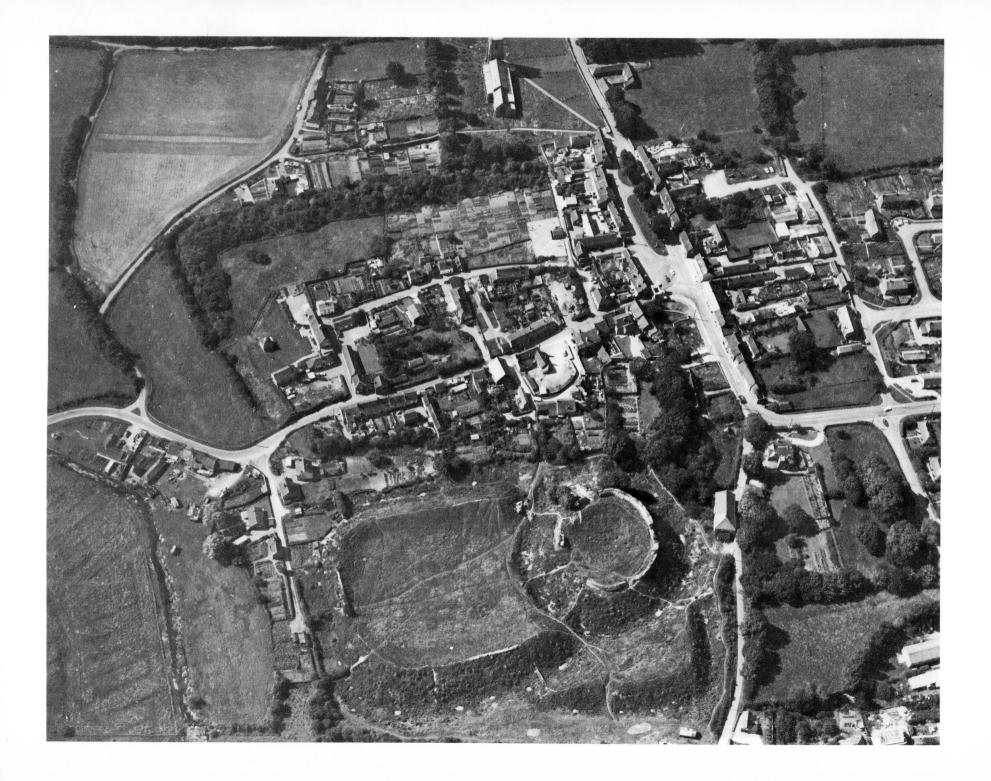

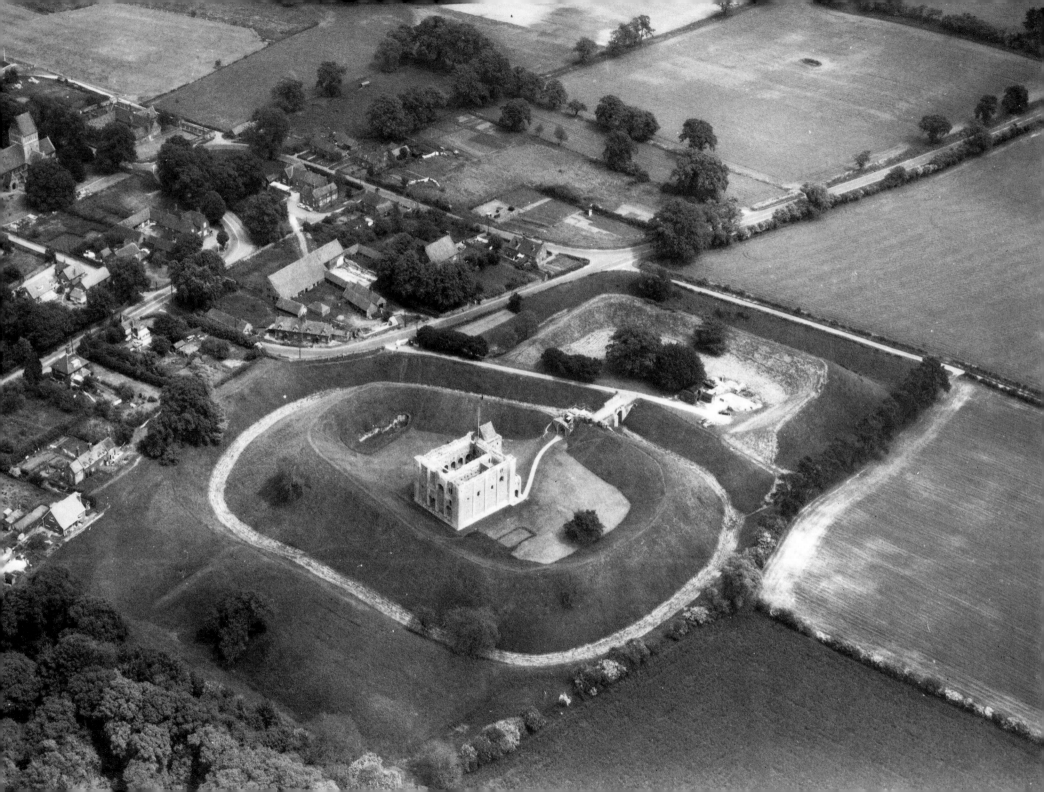

5 Castle Rising, Norfolk
Castle Acre's conventional motte-and-bailey
plan dates to the first half of the twelfth
century. And this is the period too of the
major works at Castle Rising, another Norfolk
fortress, begun by William d'Aubigny in the
1130s. To achieve his purpose, William
d'Aubigny (or 'de Albini') had to remove the
parish church to a new site north (top left of
photograph) of his proposed castle, where it
was to be rebuilt on an exceptionally grand
scale. The remains of the former church,
concealed by the castle bank, have recently
been fully excavated and consolidated (visible
on left of keep). He then built a palatial hall-
keep on an east-west axis, with lavish first-
floor apartments for himself and his countess,
widow of Henry I, approached by an
elaborate forebuilding (on the east side,
hidden by the angle of the photograph). Later
in the same century, Castle Rising's ditches
were re-cut and its ramparts raised, almost
hiding the keep that lay within. But by this
time also residential keeps of the Castle Rising
kind had begun to look a little old-fashioned,
as the defensive emphasis shifted from keep to
curtain wall and to other more sophisticated
fortifications. (1967)

earl of Surrey knew very well how to put up a castle. However, at Castle Acre he had chosen not to do so.

Before the end of the century, to be sure, Castle Acre would be better protected. And further improvements through the first half of the twelfth century were to make it the fortress we see now. Yet Castle Acre's earliest flowering as an undefended country palace might serve us still as a useful warning against assuming too readily that the first generations of Norman settlers in England were necessarily the most active in castle-building. Certainly, many of our more impressive surviving castle remains – and perhaps the majority of the minor earthworks – belong rather to those troubled years of King Stephen in the mid-twelfth century, commonly described as the Anarchy. Few are more memorable than Castle Rising (Fig. 5). As with Castle Acre, also in Norfolk, it has only been comparatively recently that the sequence of building at this great baronial fortress has come to be better understood. It is now thought, in particular, that whereas the ramparts round the stone keep at Castle Rising were undoubtedly enlarged and strengthened in the later twelfth century, almost concealing the building within, they had been given their present line in the 1130s – not earlier, as was previously supposed – when William d'Aubigny re-located an existing church and settlement to build himself a castle in their place. Fragments of the displaced church can still be seen half-concealed in the rampart on the left. In the middle, William d'Aubigny's castle-palace is a magnificent domestic building, appropriate to the escalating rank and ambitions of a fortunate young nobleman who had recently obtained the hand of the late king's widow, Alice the Queen, and who was busy collecting earldoms by the basketful.[6]

The subsequent heightening of the great rampart round the keep at Castle Rising has made it look absurdly out of place. Like Henry II's even larger and more sophisticated keep at Dover, built half a century later in the 1180s, William d'Aubigny's stone tower was to lose defensive purpose as anything but a refuge or a place of last resort just as soon as its outer protective circuits were completed. Yet

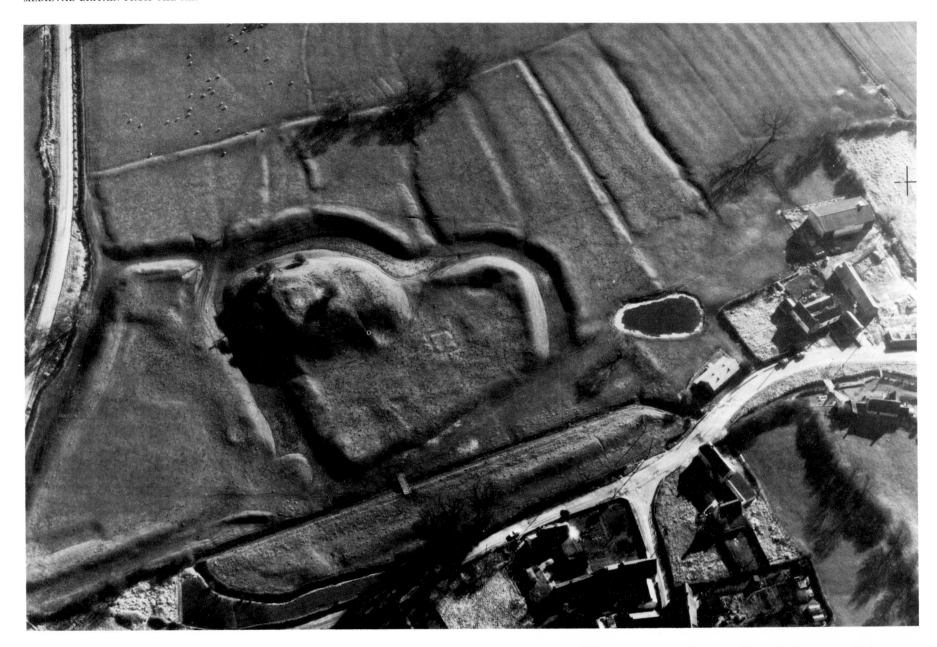

Castle Rising's residential tower-keep had always been palace first and fortress second. And it is as an example less of military technique than of the quality of accommodation coming to be required by a great lord that we would surely do best now to view it. In the keep at Castle Rising, above capacious stores and magazines, the earl's personal quarters were laid out generously at first-floor level, approached by a grand stair in a richly ornamented forebuilding and entered by way of a handsome vestibule. The lord's hall and his chamber were the two main apartments, and each was equipped with a pair of garderobes, or lavatories, fashioned in the thickness of the wall. In addition, there was a kitchen west of the hall, next to a service room, with a chapel at the east end of the great chamber and with another small apartment over this chapel, probably intended for the priest.

William d'Aubigny's hall-keep was not the most elaborate of its class. Already at Norwich, in the previous generation, Henry I's engineers had made better use of an encircling passage, constructed in the thickness of the walls, to allow easy movement to the defenders; in the next reign, following Stephen, the internal arrangements of Henry II's great keep at Dover would be especially complex and successful.[7] Nevertheless, the meticulous planning of the intermeshed apartments at Castle Rising, some constituents of which (including the spine wall) are visible in the air photograph of the site, is already one indication of the growing tendency among castle-builders of the period to apply geometric principles to their work. Another is the regular layout of the great ramparts at the same fortress. A third is the ever more obvious standardization of the motte-and-bailey plan, frequently emphasized by later refortifications.

Earthwork castles on the motte-and-bailey principle had not taken long to establish themselves as the characteristic defence works of the Anglo-Norman Settlement. Yet through its first decades they were to assume, as we have seen, a very wide variety of forms. Yielden (Fig. 6), in Bedfordshire, has not been dated securely. However, its origins are certainly not too distant from the Conquest, and

6 Yielden, Bedfordshire
Although undated, the earthworks at Yielden belong probably to an early phase of motte-and-bailey construction and are certainly of more than one period. At the centre is the castle mound of the Trailly family, tenants of the bishop of Coutances to whom the estate was granted soon after the Conquest. It is adjoined by an inner bailey of the same period, cut by the line of a dried-out fishpond post-dating the castle's disuse. A wide moat separates the motte from a second-phase bailey, more geometrical in plan, to the north (left). It was probably during this phase that Yielden was walled in stone, although little more than traces of these defences have been found in miscellaneous excavations on the site. The well-marked field boundaries to the east (top) and south of the castle are also likely to be medieval. (1969)

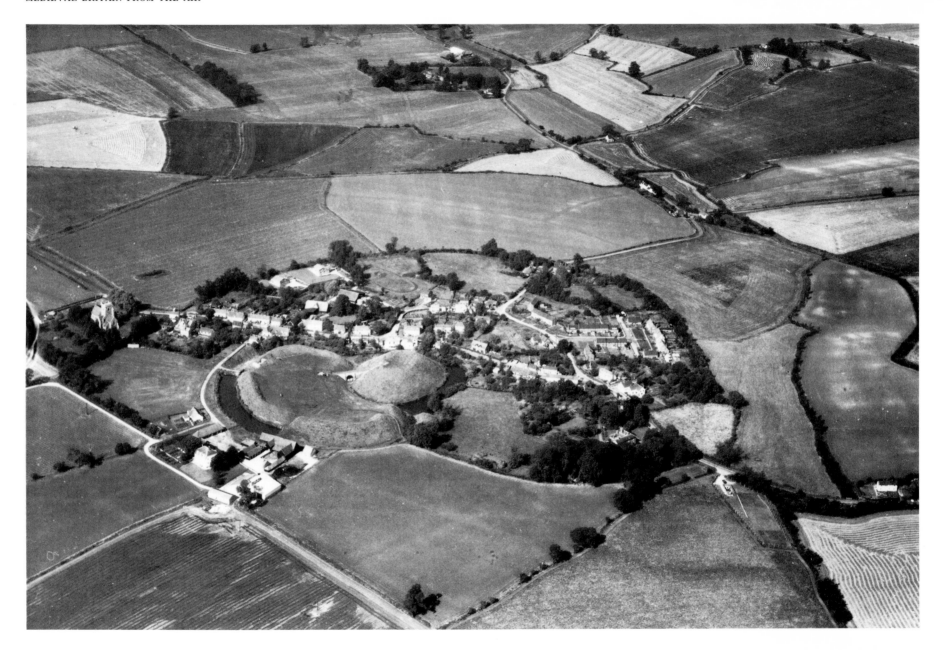

the fluid line of the surviving earthworks suggests a date within the first half of the twelfth century.[8] Pleshey (Fig. 7), in contrast, lavishly refortified in the 1170s, stands at the very end of the tradition. William de Mandeville, third earl of Essex, was the builder of Pleshey as we now see it. He was an experienced soldier and, unlike his brother, the turbulent Geoffrey de Mandeville, a dependable supporter of the Crown. Licensed by the king and completed at reasonable leisure, Pleshey's re-cut earthworks have all the elements of the textbook motte and bailey: the sharply-profiled upturned basin of a mound, the deep encircling ditches, the by now traditional kidney-shaped bailey. Other castles of the period, among them Pickering and Berkhamsted, were to preserve their earthworks by similar re-cutting and re-use. But the plan of Pleshey is given further emphasis by the larger sweep of the borough it protected. Many such boroughs, in subsequent generations, would outgrow their defences, losing the line of their ramparts in later sprawl. Pleshey, however, was less successful. Although preserving its market function throughout the rest of the Middle Ages, it seems not to have flourished to any marked degree and was probably never fully built-up.[9]

In due course we shall return to those new town 'plantations' of which Pleshey is a good, if unlucky, example. Like the castles of the twelfth century, they would come to adopt an increasingly standardized form. However, Pleshey has its interest too as an unusually well-preserved specimen of that almost necessary association of fortress with annexed sheltered settlement which was proving its worth through the post-Conquest decades. Such associations are obvious at Old Sarum (Fig. 1), at Richmond (Fig. 2), and at Castle Acre (Fig. 4). Another fine example, though the borough's remote origins are less certain, is the development of Ludlow (Fig. 8), initially eastwards along the line of the natural ridge away from the castle gate, and then southwards, stage by stage, towards the river.[10]

Ludlow's former market-place has been very largely built-over, 'colonized' by separate islands of permanent shops. And in other ways too the town's later prosperity, first in the cloth industry, then in border administration, and finally as

7 Pleshey, Essex
The clean-cut lines and geometrical precision of William de Mandeville's motte and bailey at Pleshey mark it out as a refortification of the late twelfth century, by which time earthwork castle plans had become fully developed. Broad water-filled ditches surround the motte and the kidney-shaped bailey (now traditional in the genre) by which it is partly enfolded. Beyond the castle to the north (top) is the larger half-circle of a small market-town, the defences of which clearly take their line from those of the almost centrally-placed motte. On the west (far left), the church is a Victorian rebuilding of a fourteenth-century collegiate church established on that site, beyond Pleshey's defences, when these were no longer maintained. The bridge joining motte and bailey is brick and of about 1400, replacing what would have been a succession of earlier timber links. (1966)

a social focus for the gentry of the region, has overlain and concealed its earliest elements. Should we wish to see those elements in the raw, we would do better to turn instead to a rural site like Kilpeck (Fig. 9), in Hereford and Worcester, where castle and priory, parish church and village (now deserted), cluster together on an individual island of settlement, under threat from the disorders of the Welsh March. If we remember Kilpeck today, it is usually for its truly remarkable village church, exceptionally rich in high-quality stone carving of the mid-twelfth-century Herefordshire School, and one of the most perfect of its kind. The roof of this church, with its little western belfry, shows clearly in the photograph, immediately below the earthworks of the castle. Between church and motte, a kidney-shaped bailey is still readily identifiable on the ground, and there are other enclosures (to the north, west, and south) which may also have been a part of the defences. Below the church again, and most obvious to the right of the prominent central road, are the house-plots and crofts of a deserted settlement. The priory site lies close at hand, just off the photograph to the south-east.

Nothing at Kilpeck is on a very large scale. Kilpeck Priory was no more than a dependency, or 'cell', of the rich Benedictine community at Gloucester; it would be suppressed, to be absorbed in the general run of the abbey's estates, as early as 1428. Similarly the castle, although equipped with a polygonal shell-keep in more permanent stone later in the twelfth century, seems never to have developed beyond its original motte-and-bailey plan. Nevertheless, the communities of castle and priory, at the height of their prosperity during the second quarter of the twelfth century, could support the construction of a parish church which, though small in size, was to be of quite exceptional elaboration and expense. Kilpeck's parish church, like its castle and its priory, obviously played its part in the reconciliation and mature settlement of the region. It replaced an existing Anglo-Saxon building already of great antiquity, and is thought to have been the work of Hugh de Kilpeck, grandson of the Conqueror's kinsman, William fitz Norman, to whom the estate had been granted in the first division of the spoils of the March.[11]

8 Ludlow, Shropshire
The great castle at Ludlow, one of the most impressive in England, has many remarkable features, including an early gate tower subsequently rebuilt, as at Richmond (Fig. 2), as a keep. But of equal interest is the effect of such a fortress on the plan development of the market-town it adjoined. Ludlow's medieval market-place, though built-over since, still recognizably stretches from the castle gate eastwards to where it stopped just south of the church (top left). In later centuries, this church was to be rebuilt in the grandest manner by the borough's wealthy Palmers Gild, with the assistance of the other gilds in the community. However, it replaces an earlier building which, with the castle and the market, made up the three essential elements of Norman settlement. Starting along the ridge (left), the town spread southwards in the direction of the River Teme (top right), which still bounds it on the south and on the west. Ludlow remained through the Middle Ages, and has continued to be to this day, a prosperous and enterprising community, enjoying one of its principal periods of popularity as a resort of county society in the eighteenth century, for the buildings of which it is now chiefly known. (1955)

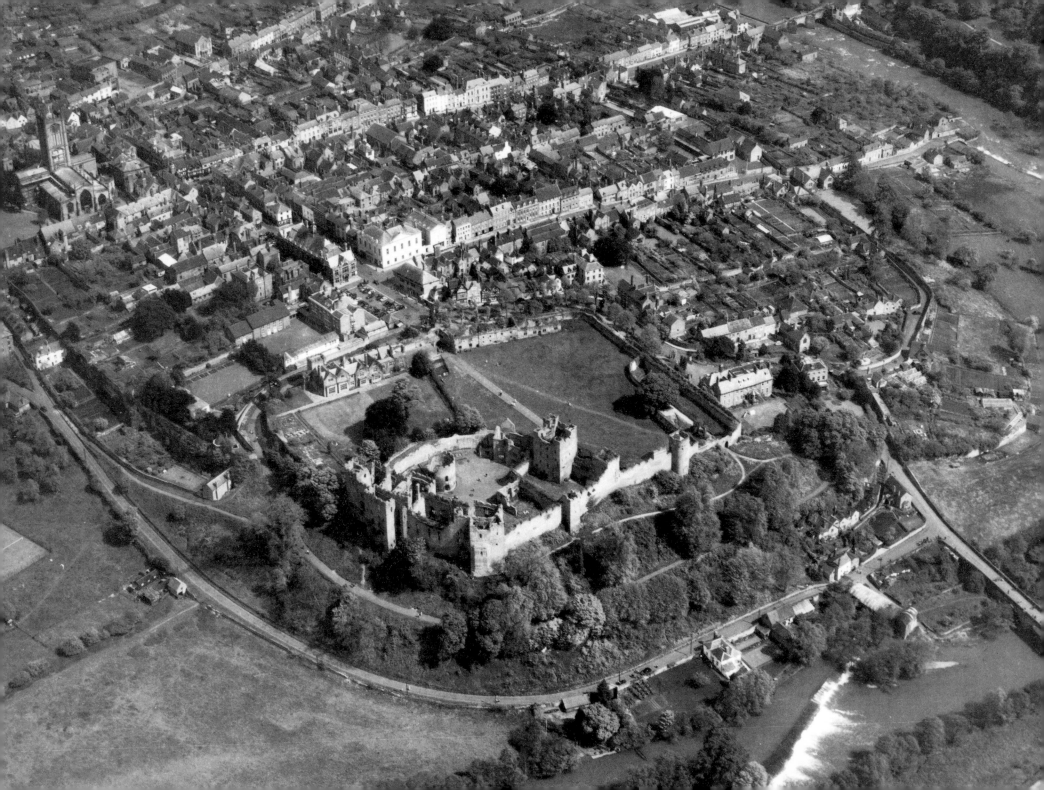

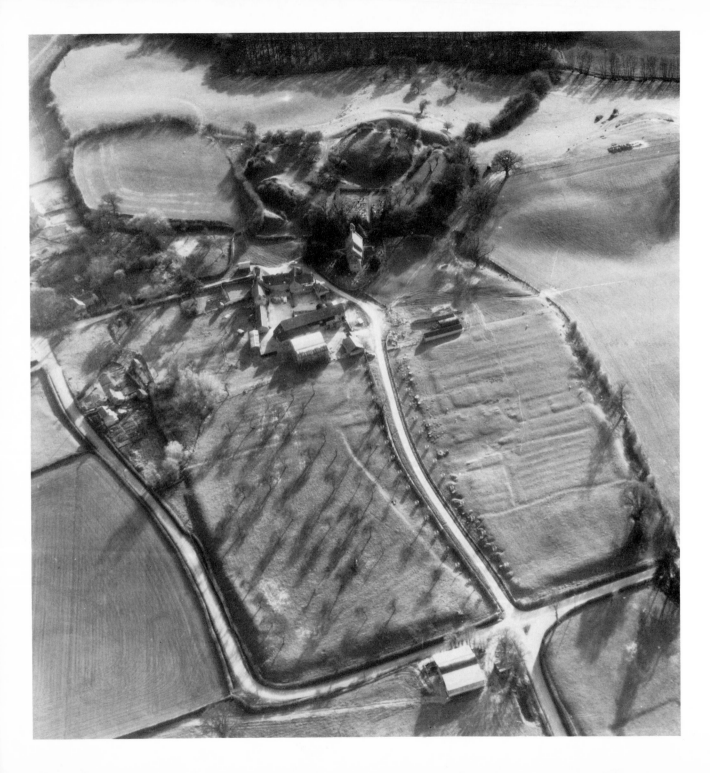

9 Kilpeck, Hereford and Worcester

At remote Kilpeck, the characteristic units of the Anglo-Norman Settlement cluster together untroubled by later development. On the west (top) is the motte-and-bailey castle of William fitz Norman and his heirs, with the parish church just below it, thought to have been rebuilt by William's grandson, Hugh de Kilpeck, before 1150. East of the church, within rudimentary earthwork defences, are the remains of a village, cut through by a modern road and re-settled by the farmhouse (c.1600) and other buildings of the present Kilpeck Court. Away to the south-east, but off the photograph, is the site of Kilpeck Priory, formerly a dependency of Gloucester Abbey by which it was colonized in 1134. Soldiers, monks, parish clergy, and villagers – all had their interests at Kilpeck, to which in turn each would contribute. Kilpeck's parish church, famous for its fine stone carvings, is of exceptionally high quality for a rural location of this kind. It could not have been so without the patronage of castellan and prior. (1965)

10 Clare, Suffolk

Richard fitz Gilbert's castle at Clare is one of the great earthwork fortresses of the immediate post-Conquest generation, equipped with a tall motte (centre right) and a large adjoining bailey, only part of which is visible on the photograph (on right of motte). Like the much smaller Kilpeck, Clare brings together the principal elements of the Settlement. A little market-town grew up to the north of the fortress, its parish church (rebuilt with great pomp in the fifteenth century) closing off one end of the market-square (top). South of the castle (bottom), the Austin friary dates only to 1248. But the friars had been preceded at Clare by Benedictine monks from the famous reforming house at Le Bec-Hellouin (Normandy), invited in 1090 to take over the buildings and endowments of an existing collegiate church, bringing the comforts of religion to the garrison. In the next reign, with the Norman regime firmly established, the monks were resettled on a more spacious site down the road to the west at Stoke-by-Clare. It was this move that left the field open at Clare to the Austin friars, the first of their order to settle in England and a pioneer of the great Mendicant mission to the towns. (1970)

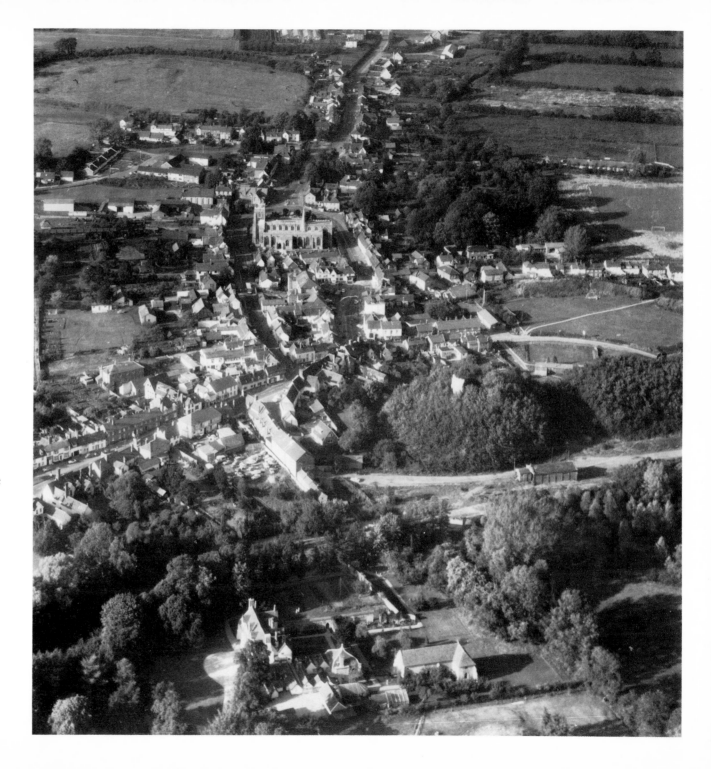

Another companion of the Conqueror, Richard fitz Gilbert, would establish an estate centre at Clare (Fig. 10), in Suffolk, which again brought together these three elements. Richard was a very great man, founder of a house especially prominent through the following two centuries under its Clare earls of Hertford and Gloucester. He built himself an exceptionally tall motte which still offers a fine prospect over the little market-town at its base. To the north of the castle, closed off by the parish church broadside-on, a wide market-square has been colonized by later shops and other buildings. To the south-west (at the bottom left of the picture), the substantial surviving remains of a former Austin friary, recently resettled, are themselves no earlier than the mid-thirteenth century. However, Norman Benedictines from Le Bec-Hellouin had already come to Clare as far back as 1090 at the invitation of Gilbert, Richard's son. They had been established initially at a former collegiate church within the castle bailey, bringing the comforts of a religion familiar to the lord's household. Only later (1124) were they to remove to Stoke-by-Clare and to a less cramped location.

It is in individuals like Richard de Clare (or fitz Gilbert, son of Gilbert de Brionne) that the pieces of the Conquest story come together. Richard was a close confidant of Duke William, appointed co-justiciar of England with William de Warenne when the new king returned to Normandy shortly following his coronation, and a prominent supporter of the duke-king in his freshly conquered territories during the first rebellion of the earls in 1075. Before the Conqueror's death in 1087, Richard's loyalty had been rewarded with the gift of many lordships. He had two great castles, at Tonbridge and at Clare. Both as a soldier in war and as a councillor in peace, he had made himself indispensable to the king. In addition though, like so many of his kind, he was content to acknowledge another responsibility in the support and endowment of the Church.

Already for some decades before 1066 – so much so that it had become a part of Richard's inheritance – the Church in Normandy had been experiencing renewal, characterized especially by the foundation of new monasteries. Herluin,

one of the knights of Richard's father, Count Gilbert, had himself founded the most prestigious of these communities at Le Bec-Hellouin, to which Lanfranc and Anselm, both to be archbishops of Canterbury, would later add the lustre of their names. By the time that Richard fitz Gilbert came to England, his family's associations with the monks of Bec had developed so inseparably that it was natural for him – as it had been for his father and would be for his son – to share his own good fortune with the abbey. It was Richard who gave Bec its important estate at Tooting (Tooting Bec), in Surrey, making the monks also a still more substantial gift from his wife's Huntingdonshire lands (now in Cambridgeshire) to refound the community at St Neots. Then Gilbert, Richard's son, brought the monks of Bec to Clare itself, while it was a cousin, William son of Baldwin, who gave the abbey its lands at Cowick, in Devonshire, later to be developed as a dependent priory of the house and subsequently made over to Tavistock.[12]

St Neots, Clare, and Cowick were each to be endowed on a sufficient scale to maintain a full conventual routine. At each, a complete set of common buildings included church and cloister, chapter-house, refectory and dormitory. But Tooting, like the bulk of the Bec estates in England, never supported a community of its own. It functioned as an estate centre where the prior and his companions were less concerned with a life of religion than with maximizing their profits on the land. Had this not been the case, the financial advantage to the home community in Normandy would have been much less. And it is entirely understandable that both patrons and monks, in this initial phase of the Norman Settlement, should have looked on such possessions as a boost to the endowment of the Normandy houses, not as a means of exporting their reform.[13] In practice, loyalty to a family's favourite monastery in France remained for some decades uppermost in the minds of the invaders, from Duke William himself (supporting his own recent foundations at Caen) to Richard fitz Gilbert (the patron of Bec), and then down the line to those lesser men who could still find a surplus to reward the prayers of those who had speeded and upheld their great enterprise.

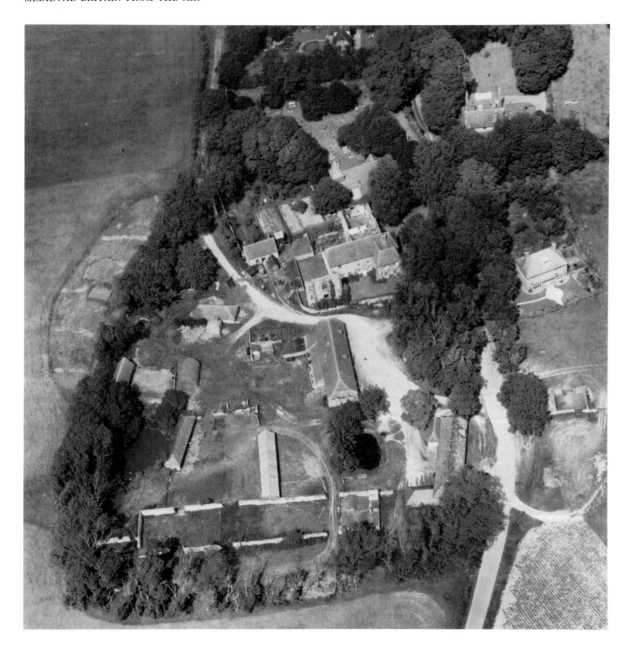

11 Wilmington Priory, East Sussex

The manor of Wilmington, granted to Grestain Abbey by Robert of Mortain, became an important overseas estate-centre and dependency of the Benedictines of that house: a typical 'alien priory'. In point of fact, establishments of this kind, of which Stoke-by-Clare was another, only rarely achieved independent priory status. Their communities were small, very often no more than the 'prior' and his companion, and they had no need for the claustral buildings of the more fully developed house of religion. Certainly, there is little sign at Wilmington of a cloister of the conventional pattern. What survives instead is a manor-house, located immediately to the south of the parish church (partly hidden in the trees) which the monks tended and regarded as their own. As rebuilt extensively in the fourteenth century, Grestain's manor-house was to be equipped with a fine west hall, the south facade of which shows clearly on the photograph. But times were already difficult, and they became much worse as the Anglo-French wars cut

Parish church

Manor-house

14th-century hall

Wilmington off from its mother-house. In 1414, along with the other alien houses, the association was broken for good in the formal suppression of Henry V's reign. Wilmington, granted to the dean and chapter of Chichester the previous year, was confirmed to the cathedral in perpetuity. (1948)

Inevitably these earliest debt repayments have themselves left little mark on our landscape. Very quickly, the so-called 'alien' priories and their annexed estates ran into difficulty. Communications across the Channel had never been easy. They became much worse when John, in 1204, allowed himself and the English interest to be driven from northern France; and were made nearly impossible by the revival of hostilities in 1294, soon quickening into the Hundred Years War. Well before the formal suppression of the alien priories in 1414, these estates had become poverty-stricken and run down, repeatedly the victim of Anglo-French rivalries which had cost the Norman houses the bulk of their overseas revenues. Yet they had always been weak and catastrophe-prone. And we should see them now for what they were – the unhappy by-products of a post-Conquest euphoria, never fully thought out by either donor or beneficiary, and barely distinguishable from the surrounding lay estates out of which they had usually been carved.

One of the more important of these establishments, surviving better than most, was the alien priory at Wilmington (Fig. 11), in East Sussex, a dependency of the Norman Benedictines of Grestain. At home in Normandy, Grestain had risen quickly under the patronage of Herluin, vicomte of Conteville, and of Robert, count of Mortain, his son. Then Robert, as a wealthy Norman landowner and half-brother of the duke, had taken a prominent part in the Conquest of England. And for this he was richly rewarded. In East Sussex, it was Robert who held Pevensey Castle, with Wilmington among the supporting lands detachable for the endowment of his monks whose own English estates, before very long, had come to include properties in five or more counties. Characteristically, the community at Grestain made no effort to reorganize these lands as the founding endowments of new English priories, preferring the role of farmer and rentier over that of a pioneer of reform. Wilmington itself became a major centre for the administration of Grestain's interests in the locality. But to have elevated it to a priory, with a full community of its own to support, would have cost the mother-house dear in lost

revenues. Nor is there anything to suggest, in the buildings that survive there, that such a project, if considered, was ever realized. Wilmington's accommodation is manorial, not monastic. Most prominent in the photograph is the grand south facade of a fourteenth-century hall. It stood at the west end of an earlier domestic range to which was attached another north-south wing (roofless now), almost linking these buildings with the parish church. There may indeed, at an establishment of this scale, have been some concessions to the life of religion at Wilmington. At the adjoining parish church, the chancel is unusually spacious, while the present south aisle could quite possibly conceal some claustral arrangements on that quarter. However, there is little real evidence, whether in the buildings or the records, of Benedictine monks living at Wilmington according to the full requirements of their Rule. The prior and his associates were farmers first, monks second. Their rhythm was not that of the liturgical year but of the unvarying rotation of the seasons.[14]

Plainly, the alien priories would be no place to look for evidence of a monastic revival. Yet this is not to say that the Normans, once arrived in England, were indifferent to the moral and political advantages of their home-based reform, even if they could find little room for it on their estates. Both at the larger Anglo-Saxon monastic houses and at the cathedrals with which these were sometimes identified, the Normans met problems to which their characteristic response was new building. Paul of Caen, a nephew of Archbishop Lanfranc, was to be the first post-Conquest building abbot of the great house at St Albans (Fig. 12), which he ruled from 1077 to 1093. He belonged himself to the reforming party in Normandy and, like his uncle, had clear misgivings about the quality of the Church he had entered, being accustomed to dismiss his predecessors in office as 'rudes et idiotas', unworthy of the rank they had held. Already Lanfranc before him, on his appointment to Canterbury in the summer of 1070, had found his own cathedral 'reduced almost to nothing by fire and ruin'. He had cleared the site of its surviving buildings, laying out new ones 'which greatly excelled them in

12 St Albans Abbey, Hertfordshire
Like other Norman prelates, Paul of Caen's first instinct on becoming abbot of St Albans in 1077 was to rid himself of the work of his predecessors. As we see it now, this former abbey church has been extended in several stages, reaching its full length only in the early fourteenth century, when the Lady Chapel was added on the east (top). But the crossing and monumental transepts are of Paul of Caen's time, and they tell us a lot about the scale and ambition of his rebuilding of the church, accomplished within a decade even while other works were in progress on the transformation of the monks' quarters round the cloister. Later abbots continued Paul of Caen's building tradition, although not always with as much dedication and success. Thomas de la Mare's fortress-like gatehouse (bottom centre) is a characteristic addition of the later fourteenth century – round about the period of the Peasants' Revolt (1381) – when the monks felt themselves, with good reason, to be under threat. On the church itself, the Victorian west front hides the luckless work of Abbot John de Cella (d.1214), too elaborate and expensive in its original design ever to rise far above its lowest courses. Abbot John had other great works to his credit in the now vanished claustral buildings to the south, but it was on the west front that he 'began to weary and to be alarmed'. (1971)

beauty and size', making himself a church 'more noble' than the one that had gone before.[15] Paul of Caen again took his model from his uncle. With Lanfranc's help and at least as impatient as the archbishop had been with the cluttered memorials of the past, he swept the site at St Albans clear. Heedlessly ignoring the tombs of past abbots, he laid out his great church on the scale we see now, completing the best part of it within a decade.[16]

Three lessons stand out in works of this kind, and they each tell us something about the Settlement. First was the contempt that the Norman reformers felt for traditional Anglo-Saxon beliefs. Second was their great energy in driving on buildings, St Albans rising in ten years or so, Canterbury reputedly in seven. Third was the staggering scale of these early building enterprises, very obvious still in the ambitious cruciform church of Abbot Paul's St Albans, though Lanfranc's new cathedral on the ashes of its predecessor was soon to be replaced in its turn. A spirit like this, arrogant and insensitive though it might seem to us now, was exactly what was needed to establish a Norman presence in Anglo-Saxon England at least as essential to the Church in its various manifestations as to the Conqueror's soldier-settlers and lay landowners. A great deal would hang on firm leadership. Archbishop Lanfranc, as we know from his letters, was a sensitive man, frequently on the point of despair. In spite of this, his 'acts, his buildings, his alms and his labours', we are told, 'were very many'. And it was the same memorialist who recorded of him too – not without a hint of admiration – that he had caused a rebellious monk to be 'tied naked in front of the great door of St Augustine's, and there to be flogged in view of all the people' before his expulsion from Canterbury. 'Thus did Lanfranc enforce obedience, and so long as he lived he broke down the opposition of the rest by dread of his name.'[17]

One problem, clearly, was the rebellious monk; another the merely sleepy and inert. Under Lanfranc, reorganization of the Church had included the rationalization of episcopal sees, too long neglected by the Anglo-Saxons. Among these was the move from North Elmham to Thetford in 1071, later resolved in a

13 Norwich Cathedral, Norfolk
After Paul of Caen's St Albans, Herbert Losinga's scarcely less ambitious Norwich was a cathedral priory of the next generation, established on its new site in the last years of the eleventh century when the see was transferred there from what had already proved a merely temporary resting-place at Thetford. Herbert Losinga, like Paul of Caen, had been a Norman monk, and he came to his task with a characteristic contempt of Anglo-Saxon institutions and with a driving ambition to do better. In the event, Bishop Herbert's ambitions exceeded his means. He was unable to raise money from the local landowners on the scale required to finish his task, and left the cathedral to his successors to complete. But as at St Albans again, the scale of the original enterprise – staggering even by the standards of today – is made clear in the subsequently untampered-with first four bays of the nave (which was as far as Bishop Herbert could take his church) and of course in the great crossing and transepts. With the exception of the projecting eastern chapel, which is a much later addition, the choir and presbytery of Norwich and the entire length of its nave stretch to the dimensions laid down by its first builder. (1951)

final shift to Norwich. There were plenty of things wrong with the Norman bishop of Thetford, Herbert Losinga, who made this last move in the 1090s. He was known to have bought his preferment at a very high price, being guilty of simony at just that time when such purchases of office within the Church had been identified as a major abuse. He was as ambitious and as unscrupulous as any of his generation or his race. But what Herbert Losinga never lacked was that energy and drive which would give shape to his new cathedral at Norwich (Fig. 13) well before his death, and which would cause him to view with open contempt the monks whose charge it became. 'Behold', he told them, 'the servants of the king and my own are really earnest in the works allotted to them, gather stones, carry them to the spot when gathered, and fill with them the fields and ways and houses and courts, and you meanwhile are asleep with folded hands, numbed as it were, and frostbitten by a winter of negligence, shuffling and failing in your duty through a paltry love of ease.'[18]

The bishop, as was his way, had grown over-ambitious. His cathedral proved too large for the resources of his see, failing to draw in the support of the local nobility who had other interests of their own to promote. Bishop Losinga, moreover, had had to pay highly for the site, described soon afterwards as 'a large part of the town of Norwich', over which he had 'torn down houses and levelled the ground for a great space' before building his 'most beautiful church'.[19] Nevertheless, there that same 'beautiful church' remains to this day. It preserves the dream of a great ecclesiastical entrepreneur who, though he did not live to see his cathedral completed, had already taken it as far as the fourth bay of the nave, after which he might leave it with a good heart to his successor.

Bishop Losinga had once been a monk himself, a member of the Benedictine community at Fécamp, in Normandy, an early centre of the Norman reform. It had been his idea, whether or not he lived to regret it, to bring monks to serve God at his cathedral. Certainly, at this level in the Church if not yet in the localities, the principles of the reform were taking hold. On the site of Hastings, the Conqueror's

Battle Abbey had been the fulfilment of a vow: a reward to the saints, like the alien houses, without missionary purpose of its own. But the Conqueror, before the end of his reign, was to make a personal approach to the abbot of Cluny to recruit what he recognized to be a better class of monk.[20] And there were others, both in the Church and outside it among the ranks of the greater baronage, who increasingly felt the drive to reform.

An early missionary effort of the Norman monastic church, showing the way the wind was beginning to blow, was the exploration of the North in 1073–4 by Aldwin, prior of Winchcombe (Gloucestershire), and by his two companions, Reinfrid and Aelfwig, both monks of the neighbouring community at Evesham. It was to these that land was given at Tynemouth (Fig. 67) in 1075, being one element in an influential programme of monastic refoundations which would include the recovery of ancient houses at Jarrow and Monkwearmouth, and which would culminate in 1083 in the establishment of Benedictines on the natural promontory at Durham and in the endowment of a great cathedral priory. Aldwin himself was the first prior of Durham. His monks, recruited locally, kept a flavour of Anglo-Saxon monasticism alive under the protection of their patron, St Cuthbert. Elsewhere, a more natural impulse of the Norman baronage was to look overseas, as the Conqueror had done, for monks of a different background and persuasion, less likely to be in conflict with their own.

Accordingly, Tynemouth's early difficulties were to lead almost immediately to a refoundation by Robert de Mowbray, first effective Norman earl of Northumberland (1081–95), on this occasion recruiting from among the Benedictines of St Albans, long since Normanized by their abbot, Paul of Caen.[21] In the South, when the desire to found his own monastic community came upon William de Warenne, his thoughts turned naturally to the Burgundian house at Cluny, still the exemplar of contemporary monasticism. Already Hugh of Cluny, when similarly approached by the Conqueror, had shown himself unwilling to release monks of his community for such a purpose. He had to be persuaded by a

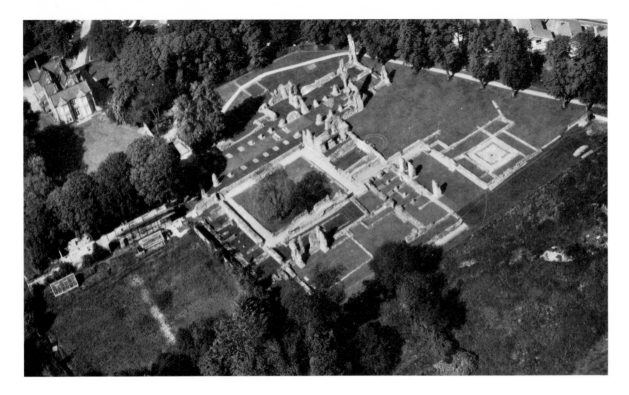

14 Thetford Priory, Norfolk

The cathedral's move to Norwich left Thetford vacant, and initially it was to the old cathedral church that Roger Bigod brought his Cluniac monks in 1103–4. They found the site cramped and, deserving better, almost immediately began building in a new location south of the river, laying out the fine priory we see now. As one of the most respected orders, still identified with the purest ideals of the continental monastic reform, the Cluniacs found support among magnate patrons, eager to obtain the best that money could buy and ready to find the funds for spacious buildings. On this Norfolk site, early in the twelfth century, the priory already follows a standard monastic plan, much of it modelled (though on a much smaller scale) on the great mother-house at Cluny herself. The main apartment east of the cloister (right centre) is the chapter-house, its original apse (Cluny inspired) marked out on the grass just beyond. South of it, at first-floor level, was the monks' dormitory, with their reredorter (row of

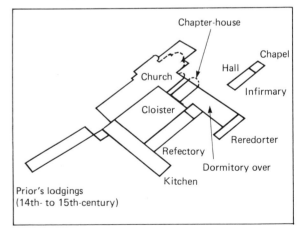

rich endowment and by special conditions, including the personal guarantee of the king. However, once the Cluniac monks had secured a base of their own in England at Lewes Priory, the objections of their abbot lost force. Even so, the first major thrust of Cluniac expansion in England would come not from Cluny herself but from La Charité-sur-Loire. Wenlock Priory (Fig. 77), in Shropshire, was one of La Charité's daughters, refounded by Roger of Montgomery on this ancient religious site in 1080–1, scarcely later than the Warenne house at Lewes. And the next important Cluniac community for which Abbot Hugh agreed to provide monks of his own was Montacute, in Somerset, founded by William of Mortain over twenty years later than Lewes. Before the mid-twelfth century, Cluniac monks had settled at least fourteen major houses in England, with that number

privies) over the main drain at the extreme south end. The infirmary hall, later developed with a cloister of its own, lay east of the dormitory. To the west, occupying the south claustral range, was the refectory, with a kitchen to the south-west, and stores closing off the cloister on that quarter. The prior's lodgings, at first in the west range, were subsequently extended in a long spur to the north-west, giving him the generous quarters that, in the later Middle Ages, were considered appropriate to his rank. (1963)

again of less substantial communities and priory cells. Since the early Christian settlement and the first arrival of monks, there had been no infusion of new blood to compare with them.[22]

Cluny, as was well recognized at the time, represented what was best in contemporary monasticism. And certainly it was the quality of life at Cluny that is said to have attracted William de Warenne, for a short while resident in the community. But this is not to say that either Cluny or her daughters were particularly well suited to the missionary role now thrust upon them. Cluniac influence had been strong in the original Norman reform. But like that reform, it came to England at the bidding of the conquerors, not through any self-generated impulse to expand. In practice, Cluniacs settled in England where their magnate patrons told them to do so. The earls of Surrey, William de Warenne and William II de Warenne, his son and heir, wanted Cluniacs next to their fortresses at Lewes (East Sussex) and Castle Acre (Norfolk). It was William, count of Mortain, son of the Robert who had been such a generous supporter of Grestain Abbey at Wilmington and elsewhere, who brought the Cluniacs to Montacute, giving them church and borough, manor and demesnes, and even the site of his own castle on the hill. Roger of Montgomery, also the founder of Shrewsbury Abbey which he colonized from the Norman house of Séez, welcomed the Cluniacs to Wenlock, a few miles to the south. Roger Bigod, another major figure in the conquest of England, attracted them to Thetford, vacated by Herbert Losinga in 1094 on the re-location of his cathedral church at Norwich.

Thetford Priory (Fig. 14), as we find it now, has nothing to do with Bishop Losinga's abandoned cathedral. Very soon, the Cluniacs of Thetford were to find the original cathedral site too cramped for their purposes, moving instead to a more spacious location where they could lay out a church of greater dignity. In due course, that new church itself would be much altered and extended, obscuring the characteristically Cluniac arrangements of its east end. Nevertheless, we know that what Thetford shared with other contemporary

Cluniac churches like those at Lewes and at Castle Acre was a multi-apsed plan –
visible now only in the traced-out apse of its chapter-house – which was an
architectural compliment at every one of these communities to Cluny, mother of
them all. When Roger Bigod and Thetford's prior laid out the first stones on the
new site on 1 September 1107, they were already well-informed of Abbot Hugh's
works at Cluny – among the marvels of western monasticism – and they knew
what a monastery should look like. Thetford accordingly, early though it is,
preserves a model monastic layout: a geometric plan only slightly distorted in the
south range of the cloister (the refectory) and making provision, as was becoming
usual in the period, for a chapter-house and a first-floor dormitory east of the
cloister, with stores and further lodgings to the west. Subsequent major additions
to the house would include a smaller infirmary cloister at the south-east angle,
with a new range of prior's lodgings to the north-west, both of them fully
developed only much later in the Middle Ages. But the essentials of the monastic
plan at Thetford belong to the twelfth century, and they must surely have been
taken account of in 1107, at the start of the building campaign.[23] Very different
indeed were sets of buildings like these from that random scatter of miscellaneous
early structures which the first Norman abbots – Abbot Paul of St Albans, Abbot
Thurstan of Glastonbury, Abbot Scotland of St Augustine's (Canterbury) –
became notorious for sweeping clear from their sites. From respect for the past so
strongly felt in the Anglo-Saxon Church to a characteristic Norman confidence in
the present: a new world had opened round about them.

2 Change and Growth: the Twelfth Century

Of course the Normans were energetic: they had plenty of incentives for being so. But they did not transform England's economy on their own. Everywhere in twelfth-century Europe, the pulse of life was quickening. Most particularly, this would show itself in the towns.

In urbanization, as in so much else, we shall have to be on our guard against underrating the achievement of the Anglo-Saxons. Stamford (Fig. 15), for example, although continuously prosperous for one reason or another through the rest of the Middle Ages and later, might be said to have reached its apogee already before 1066 as one of the Five Boroughs of the Danelaw. Similarly, the distinctive grid plan of Bury St Edmunds (Fig. 16), marking out a settlement of considerable size, can scarcely be much later than the immediate Conquest period and undoubtedly suggests earlier roots. Yet both Stamford and Bury St Edmunds have something to tell us also about the special character of Anglo-Saxon urbanization which distinguishes it sharply from what came afterwards. Stamford is a town of many churches, reflecting its pre-Conquest partition among a number of great landowners, each of whom built a church on his estate. Bury St Edmunds, in contrast, was to be under-churched, continuously dominated by the great abbey to which it owed its first growth and from which it would try, unsuccessfully, to escape. Other former Anglo-Saxon urban communities were to have to shoulder the same debilitating inheritance, whether it were expressed in the multitudinous parish churches of York or London, many of them too small to

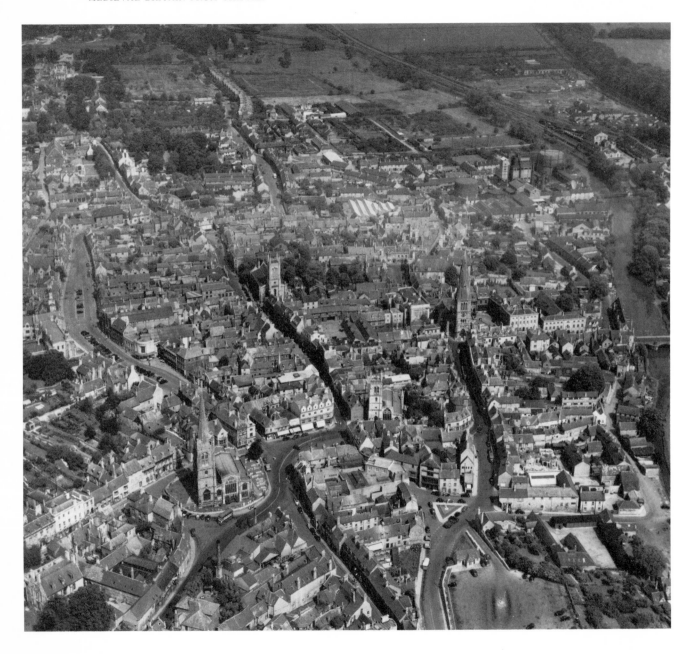

15 Stamford, Lincolnshire

When the Normans came to England, Stamford was already a wealthy borough, nudged by three counties at what is still an important crossing of the ways. Like many pre-Conquest urban communities, among them major cities like York and Lincoln, Canterbury and London, Stamford had more than its measure of parish churches, the majority of which had started life as the private chapels of individual landowners. Survivors today are All Saints (on its island at the main crossing), St John Baptist, St Mary, St Michael (rebuilt 1835–6), and St George, with St Martin (south of the river and off the photograph) in Stamford Baron. Continuing prosperity ensured expensive rebuildings of these churches, in particular during the thirteenth and the fifteenth centuries. In addition, Stamford attracted communities of all four major orders of friars, and became the site of a fine hospital – Browne's Hospital on Broad Street – which is one of the best surviving examples of its kind. Stamford's

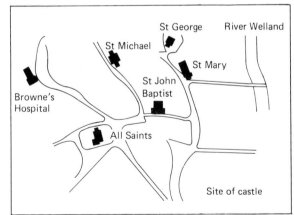

castle, its motte now flattened and its bailey built over, was placed at the south-west angle of the borough, north of the Welland. (1952)

16 Bury St Edmunds, Suffolk

In marked contrast to Stamford's irregular sprawl, the distinctive geometry of Bury St Edmund's plan is believed to date to Abbot Baldwin's time, in the decades immediately following the Conquest. As a deliberately planned settlement, although few are as regular as this one, Bury has parallels both before and after 1066. However, its interest lies also in the obvious dominance of a mighty abbey, the placing of which has clearly determined, even to the siting of the cross streets, the entire layout of the borough. Bury's two parish churches (St James and St Mary) were included within the precinct, being appropriated rectories of the abbot and convent. And when, in the fourteenth century, the townspeople's discontents overflowed, the abbot's immediate answer was to build himself a second, more formidable gatehouse, without abandoning one iota of his rights. (1969)

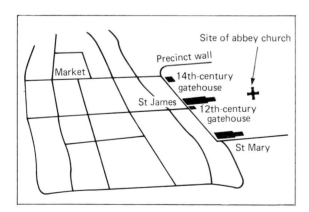

45

survive, or in the bullying presence of an over-privileged religious community, as at St Albans or at Glastonbury, jealous in the protection and even the extension of its rights.

Some of the same abuses are recognizable in later settings, as in the sufferings (worse than most) of the men of Cirencester at the hands of their Augustinian abbots. However, towns of the twelfth century, if they were indeed fortunate enough to achieve their greatest growth at that time, were more likely to develop in a different mould. They might, of course, still focus on a fortress or an abbey. We have already seen this happen at Richmond (Fig. 2) and at Ludlow (Fig. 8); although on a smaller scale, the same was true of Pleshey (Fig. 7), of Clare (Fig. 10), and of Castle Acre (Fig. 4). But it was more usual for them to grow beyond the shadow of a fortress and safely out of reach of the monks. If the origins of Stow-on-the-Wold (Fig. 17) are even yet to be found in an initiative of the abbot of Evesham, to whom Henry I granted a 'port' and a market on the spot as early as 1107, Stow's purpose was commercial from the beginning. It headed a new generation of market-towns at which administrative considerations, where present at all, were secondary to the business of making money.

The abbot had chosen well. Stow is situated on the Foss Way, at an important junction of ancient trading routes which converged here from all four points of the compass. At the heart of Stow is its market-place, partially built-over now with substantial islands of shops, but still the central feature of the town. Next to the market is the parish church, one of Evesham Abbey's more valuable possessions.[1] And it was exactly this association of single parish church and market that was repeated at small towns up and down the length of England, providing the necessary circumstances of growth.

Consider Swaffham (Fig. 18), in Norfolk, which developed in the twelfth century contemporaneously with Stow, again at a major crossing of the ways. Swaffham's spectacular funnel-shaped market-place has been built over in much the same way as Stow's. Yet the open market remains very obviously the

17 Stow-on-the-Wold, Gloucestershire
Important road junctions, of which Stow-on-the-Wold is one, are natural sites for markets. And it was here that the abbot of Evesham, in an early example of entrepreneurial drive, obtained a royal licence in 1107 to establish his market and 'port'. Stow has no castle or other fortifications. Its elements are the road crossing (seen at the top of the photograph), the market square (centre), and the parish church (left). Still, even today, though the main road bypasses it to the west, the heart of the little town is the great open space assigned by Evesham's abbot to his market, soon to become a celebrated collecting point for the high-quality wool of the Cotswolds. Partly hidden by trees and shut off from the open market by a later island of shops, Stow has its typically grandiose 'wool church', built on the profits of a resilient trade that was one of the chief generators of medieval England's exceptional wealth. (1962)

18 Swaffham, Norfolk
Even more obviously than at Stow-on-the-Wold, the little town at Swaffham centres on a great open market-place, only partially built over in later years. Long known as Swaffham Market, it followed the practice of other East Anglian towns – Downham Market is a near neighbour – in incorporating its prime function in its name. Next to the market, on the east, Swaffham's fine parish church is a fifteenth-century rebuilding of an earlier church, for which John Botright (rector 1435–74) was principally responsible. Botright kept a record, preserved in the so-called Black Book of Swaffham, of local contributors to his project, prominent among them being John Chapman (the 'Pedlar of Swaffham') who, with his wife Catherine, financed the rebuilding of the north aisle of Botright's church and gave generously, in addition, to the tower fund. A lively carving of the Pedlar, pack on back and dog at feet, survives on bench-ends re-used for a present-day clergy stall; on another set, Chapman is shown at the front of his shop, with Catherine at the window above. Dr Botright himself is buried in the chancel, in a wall-tomb north of the high altar. (1965)

dominant element of Swaffham's plan, round which everything of importance is accommodated. To the east is the parish church, a fifteenth-century rebuilding on a very much earlier core.[2] And here, as at Stow, there was never any need, despite the swift growth of the town, for more than one church in the parish. Those multiple churches we have seen at Stamford (Fig. 15) belonged to an earlier ecclesiastical tradition which had grown up in conditions of private sponsorship. In pre-Conquest England, the ownership of a church (manorial or estate-based in the first instance) had long been recognized as status-conferring, being one of the distinguishing characteristics of a thegn. Accordingly, it had been landowners usually who had built the churches, and it was the estate, in many instances, that made the parish. Against Stamford's many churches and the single church at Swaffham, a quite minor rural settlement like Aldwincle (Fig. 19), in Northamptonshire, might perpetuate the original division between the two manors of the village by building for each its individual parish church, one at either end of the street. It was not until towards the end of the nineteenth century that the two Aldwincles – All Saints at the bottom of the picture, St Peter's near the top – were brought together to comprise a single parish.[3]

Few great institutions grow tidily all the time, and even the Church was not immune from its hiccups. Although on very different scales, Stamford and Aldwincle exemplify that growth, essentially haphazard, when church provision was at the whim of the landowner. By the late twelfth century, if not before, the rules were everywhere changing. It was already too late for the parishes of England to be neatly apportioned and divided. However, it is clear all the same that the new initiatives of this century, in towns and in their parishes as much as in the contemporary planning of fortress or monastery, had become infused with a fresh sense of order. We know the little market-town of New Alresford (Fig. 20), in Hampshire, to have been the deliberate creation of Godfrey de Lucy, bishop of Winchester (1189–1204), beginning with the grant of a market charter in 1200 and closely followed by the right to hold a fair. In due course, successive bishops of

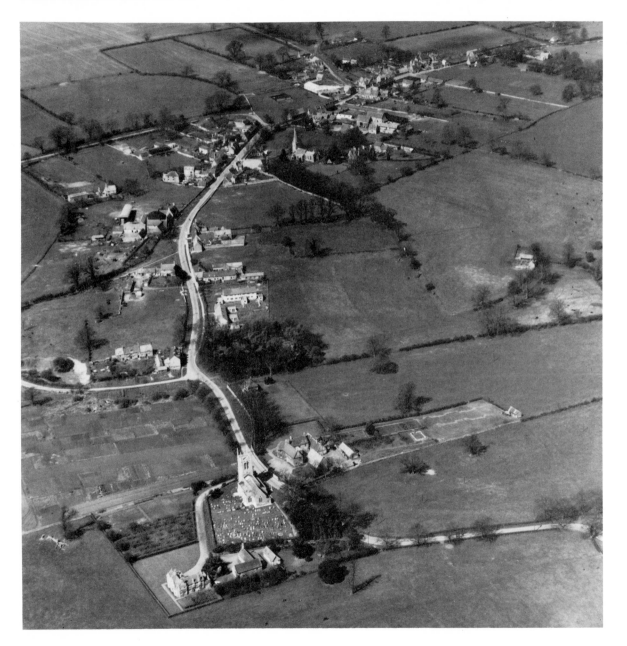

19 Aldwincle, Northamptonshire

John Botright's good fortune at Swaffham was to be rector of a fair-sized parish centred on a prospering market-town. Constituted in that way, the parish made excellent sense. But the division of parishes, originally so often along much earlier estate boundaries, quite frequently produced serious anomalies. Aldwincle is one of those cases where a manorial division was perpetuated in the parishes, resulting in a parish church at either end of the village street. Other instances exist of two churches sharing a churchyard, or of near-neighbours separated only by a stream. At Aldwincle, All Saints (bottom) remained in the gift of the Aldwincle family, while St Peter's (top) was one of the churches of the Benedictine monks of Peterborough Abbey. The union of the parishes was finally brought about not much more than a century ago. (1953)

20 New Alresford, Hampshire

Whereas Aldwincle's growth had been largely haphazard, New Alresford in contrast was a deliberate creation, laid out at one time with a great market-street and with a single parish church of its own at the top end. This small Hampshire town, founded by Bishop Godfrey de Lucy in 1200, was to be carved out of the greater parish of Old Alresford to the north. Like other contemporary borough-founders, the bishop of Winchester had to promise his settlers adequate plots on which to establish their houses, yards and gardens. And it is these, recognizably of standard dimensions and plan, that extend today to the left and right (east and west) of Broad Street, on either side of the former open market on which each had its valuable frontage. Across the top of this market, just below the church, the main road to Alton and London still carries its steady stream of traffic. Bishop Godfrey's plan, linked also with a scheme to canalize the River Itchen as far as his new reservoir at Alresford Pond (off the picture at the bottom), had been to remove his settlement to a more promising location, where the passing trade might provide a better livelihood for Alresford's burgesses, increasing the rent roll of the see. (1959)

Winchester were to become experienced founders of boroughs, six at least being attributable to their enterprise. New Alresford, though, was the first of these, and its foundation was not exclusively an entrepreneurial market-based initiative, having to do also with Godfrey de Lucy's canalization of the River Itchen from Winchester towards his manor at Bishop's Sutton, of which an element was the dam and reservoir at Alresford. One immediate consequence of these works was to show up the disadvantages of the existing settlement's location, to the north at what is now known as Old Alresford. The bishop's response was to establish a 'New Market' (*Novum Forum*) on the present site, where both road and river transport were more accessible. What he then laid out – and what survives to this day – was a broad market-street, with the church at one end and the river near the other, and with substantial burgage plots on either side, very much as the present houses and their gardens have preserved them. As part of this plan, an individual parish, to accommodate the new borough and its fields, was carved out of the original Old Alresford. And the artificially created market-town was given a further boost when the main road to Alton, crossing the market-place just north of the parish church, was improved by royal order in the 1260s.[4]

New Alresford is typical of the now orderly layout of the borough foundations of its period. Its plan is logical; the town is well provided with open space for market-stalls; its tenements are both generously-sized and regular; it has a parish church entirely of its own. All this makes sense. And it tells us something too of the profits of good government and of a growing public respect for the law. Alresford is undefended. It seeks the highway rather than retreating from it, making do without the shelter of a castle. The most important consideration in the planning of New Alresford had become the individual needs of its burgesses.

One of those needs, important to both lord and townsman alike, was for a clear definition of the standard house-plot on which taxes could be fairly assessed. Standardization of tenement plots is an obvious feature of many twelfth-century towns. It has been well established, for example, at Stratford-upon-Avon, the

successful entrepreneurial foundation of John of Coutances, bishop of Worcester (1196–8), almost exactly contemporary with New Alresford.[5] And the same thing, for identical reasons, was to be repeated once again in the much humbler circumstances of rural settlement, where the most striking characteristic of village and common field alike might be a deliberately planned regularity of layout. In the North-East especially, a region devastated and left waste during the Conqueror's notorious 'harrying' of the North, a village like Wheldrake (Fig. 21) of the two-row plan is very far from being an exceptional survival. Wheldrake –

21 Wheldrake, North Yorkshire
A regular plan, as both Bury and New Alresford have already demonstrated, may be one of the marks of strong lordship. And while the origins of Wheldrake are certainly pre-Conquest, its present form is more likely to be owed to a deliberate seigneurial initiative at some point in the twelfth-century agricultural recovery. Other northern villages, devastated by the Conqueror and subsequently re-settled, exhibit the same regular linear plan, where settlement stretches along the line of the main road, with standard-sized plots on either side backed in each case by a service lane. At Wheldrake, the church is in the usual position at one end (top) of the village. Beyond it, the road has been straightened but ran off originally towards the right. Round about were the common fields in which Wheldrake's peasant farmers cultivated their strips, later swallowed up by enclosure. (1956)

with others like it in the area – seems to belong to a period of resettlement when a seigneurial initiative in the restoration of villages is clearly reflected in their striking uniformity of plan. The two rear service lanes of Wheldrake, with standard house-plots running back from the main road frontage to join them, are typical, for example, of the twelfth-century village foundations attributable to the bishops of Durham. And they may be recognized again as obviously, albeit in a somewhat different form, in the now largely deserted Northumberland hamlet of Ogle (Fig. 22), where the two rows of cottages had a manor-house at one end, with a village green to separate them in the middle.[6]

Ogle's cottages were backed by its fields, again uniformly divided into strips. And while there is no certainty as yet about the date of such arrangements – the argument about the remote origins of the medieval common field still remaining

22 Ogle, Northumberland
Whereas Wheldrake grew out along the line of its highway, Ogle developed round a central green. This Northumberland village has been largely depopulated. However, its exceptionally well-preserved earthworks have kept the lines of peasant houses and their gardens on either side of the green (centre), with the site of the former manor-house (bottom) at the east end. The surrounding ridge-and-furrow clearly relates to these early boundaries, and must itself be medieval in origin. (1967)

23 Onley, Northamptonshire
The site of Onley, a Northamptonshire deserted village, has remained clearly identifiable amongst its fields, but little is left of the houses themselves except the clay platforms on which many of them were built. Notice the way that comparatively modern ridging (narrow and regular) has run over village earthworks at the top centre of the photograph, suggesting an early abandonment of this quarter. The same type of ridging on the near side of the site (bottom) stops short on the line of the village gardens. The broader and better marked ridge-and-furrow at the top and left, outside the boundaries of the medieval settlement, pre-dates enclosure and has the S-bend characteristic of early ploughing, where the team prepared its turn before the headland. (1969)

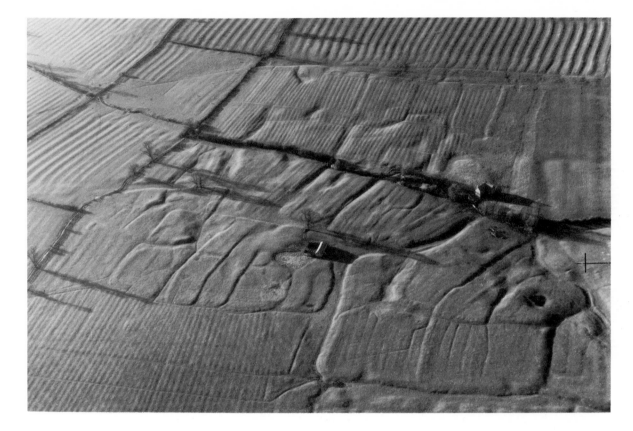

unresolved among historians – there is good reason to associate the beginnings of systematic cultivation at a site like Ogle with the initial layout of the settlement itself. In effect, what the earthworks at Ogle preserve to this day is a post-Conquest lord's decision to establish a peasant community at his gate, followed by his villagers' agreement, surely countenanced or even suggested by the lord himself, to organize a fair apportionment of the arable lands in which all had clear interests in common.

Now take another village site like Onley (Fig. 23), in Northamptonshire, where just a single farm is set among the earthworks. Surrounding Onley, the prominent

ridge-and-furrow which is still so characteristic of the Midland counties is certainly of more than one date, reflecting different stages in the desertion. However, what remains especially obvious in an aerial view of this kind is the necessary association between a community and its fields which modern farming has more usually disguised. On the increasingly over-crowded landscape of medieval England, where a peasant family's holding could be reduced to five acres and often less, farming came very close to horticulture. Particularly essential in these circumstances to the survival of each household was the equitable distribution, agreed in common, of the better-placed arable strips.[7]

So marked are the ridges in Onley's fields that it might be tempting – though quite wrong – to identify them now with the individual strips or holdings of peasant cultivators. At Laxton (Fig. 24), similarly, last of the open-field systems to remain in operation, the present crop divisions are no kind of guide to the medieval 'furlongs' into which such strips were habitually assembled, resulting rather from a comparatively recent consolidation (1903–7). Nevertheless, both sites retain features of importance. Some of the earliest ridge-and-furrow at Onley, bent at base and head, carries the mark of pre-mechanical ploughing, where a plough-team prepared to make its wide turn as it came up towards the headland of the furlong. Laxton, since consolidation, has lost its ridges. But the characteristic sweeping bend of Laxton's field divisions is still basically medieval. At Laxton as at Onley, the ridges that had been raised originally to assist drainage of the land had come to be used in the delimitation of plots. Thus within the separate furlongs of the medieval open field, a peasant's individual holding might typically include groups of ridges, three or more at a time. It was the convenience of the ridge as a unit of measurement that recommended the technique, causing it to be applied to land which, for drainage, could just as well have been left un-ridged and flat.[8]

Of course, common-field farming is of very great antiquity; on the Continent, it has been traced back to the Carolingians in the ninth century, and its origins may

24 Laxton, Nottinghamshire
The open fields of Laxton, in this photograph taken soon after the Second World War, still carry traces of the medieval ridge-and-furrow which has since almost entirely disappeared. The swirling curves of these ridges are typically medieval, while the different crop colours, although not of course repeating the early divisions, at least suggest the variety of holdings in the fields, where a peasant's land might be scattered in parcels of ridges, three or four at a time. More regular field patterns, on every side of Laxton, have resulted from post-medieval enclosures, the common fields themselves being much reduced in area by the enclosures of the first decade of this century. But Laxton's unique quality as a tenant-farming community, working its land in common, has been preserved to this day, making the surviving unenclosed fields a relict landscape of exceptional importance. (1947)

well be earlier than this. Ridge-and-furrow also, in the form in which we can still recognize it at Ogle or at Onley, has been identified in English contexts of the late eleventh century, being surely widespread practice by the twelfth. Nevertheless, important though such precedents might have been, it was certainly the case that agricultural reorganization, in the twelfth century in particular, was taking a giant stride forward. As population increased, the pressure on existing resources continued to rise, and the frontiers of cultivation moved outwards. In every village community where such opportunities were still available, a first resort would have been made to the clearance of waste, subsequently reapportioned among the cultivators. But for many, cultivable waste was in short supply well before the end of the twelfth century. The urgent need for another solution placed a new constructive emphasis on change.

Two possibilities presented themselves. Either productivity must be raised on the land under cultivation, or expensive programmes of drainage and reclamation would have to be undertaken by those with the capital to do so. Both were carried about as far as they would go. In eastern Norfolk, for example, there was to be an intensification of farming which, through the unsparing use of abundant labour, would achieve levels of productivity scarcely paralleled even today. With few other resources to fall back on, the peasant family subdivided its lands, nursing the soil to improve its yield and hand-breeding whatever stock it could maintain.[9] In due course, eastern Norfolk came to support by this means a population considerably above average, even during those oppressively overcrowded decades that immediately pre-dated the Black Death.

Similarly overpopulated was the western half of the county, although here the circumstances of growth were very different, being almost entirely the product of reclamation. Indeed, the drainage and settlement of the silt fens round the Wash was to be one of the great triumphs of medieval agricultural initiative. 'Concerning this marsh', as Matthew Paris would write in the mid-thirteenth century, 'a wonder has happened in our time; for in the years past, beyond living

memory, these places were accessible neither for man nor for beast . . . a place of horror and solitude. This is now changed into delightful meadows and also arable ground.'[10] At Domesday already, back in 1086, a township like West Walton (Fig. 25) had enjoyed a busy and varied agricultural regime, specializing in sheep-farming, but with pigs and cattle, arable and salt-pans as well. Yet the settlements of the Marshland were still widely dispersed, and its population was comparatively thin. Prosperity at that period had resided in the adjoining uplands, not as yet on the waterlogged fens. By 1334, when a comparison is next

25 West Walton, Norfolk
Both the planning of villages and the reorganization of their fields may have begun long before the twelfth century. Nevertheless, it was the population expansion of that century in particular, aided by a favourable climatic regime, that pushed out the frontiers of arable farming, feeding the new mouths in town and country alike. West Walton, in the Norfolk Marshland, was already prosperous in 1086, when recorded as a centre for sheep-farming. But it was the draining of the fens in the following century that brought West Walton and its neighbours to special prominence. Over the years, field boundaries have changed, and only a very few of the existing dikes and ditches are those of the Marshland's medieval reclaimers. Yet the character of the landscape remains as it has been since at least the twelfth century: flat and featureless, but rich. That wealth, peaking in the first decades of the thirteenth century, overflowed into an ambitious campaign of church-rebuilding at West Walton where one of the works it financed was the building of a tower which is certainly among the noblest in England. Although dwarfed by this tower, West Walton's contemporary nave and chancel are of equally high quality, being themselves on the grandest of scales. What they remind us about the landscape is the opulence it experienced when the silt fens had only lately been reclaimed. (1962)

possible in the lay subsidy accounts of that year, the position had totally changed. West Walton and its neighbours – Walsoken, Walpole, and the Wiggenhalls – had moved up to take their place among the wealthier communities of the region, overshadowed only by major ports like King's Lynn. Collectively, the Marshland townships were the richest in Norfolk: assertive, densely populated, and secure.[11]

West Walton is comparatively far back in the Marshland, and wealth had come there quite early. Isolated among the flat reclaimed fields that had brought it such unusual prosperity, Walton was to be equipped with an extraordinary church, of great elaboration and the highest quality. A noble free-standing tower dominates the surrounding countryside. It is among the first local flowerings of the Early English style, and it dates, like the comparably sophisticated body of the church, to a single building period in the 1240s, fully a century before the testimony of the lay subsidies. Even allowing for the enlightened patronage of Bishop Grosseteste of Lincoln, to whom West Walton's rebuilding on this scale is perhaps attributable, what we are left with is a church which, at parochial level, must have had to draw on exceptional resources.

The reclaimed Marshland, rich in great churches, may serve as one example of the prosperity brought to comparable regions by the agricultural initiatives of the period. Another, of course, is the contemporary reorganization of the village community: the conscious planning of the twelfth-century settlement and its fields. But more likely to profit by the accumulation of surpluses were those who were already at the summit of society, and it is here especially, in the buildings of the great, that the evidence of new riches is most obvious. In a fortress like Castle Rising (Fig. 5), begun in the late 1130s, the display of wealth was clearly a consideration in the design. However, Castle Rising was to begin to look old-fashioned within scarcely a generation of first building. More satisfactory as an indicator of the way things were going was a new breed of castles, characterized especially by expensive curtain walls with towers along their length, becoming the mode before the end of the twelfth century.

The mural, or interval, tower had not been unknown to castle-builders in the past. An obvious device for propping-up and strengthening a free-standing wall, it occurs, for example, in the east wall of Richmond (Fig. 2), usually dated to the last quarter of the eleventh century. What was new, though, was the systematic deployment of the interval tower, regularly spaced along the line of a castle's curtain wall as a device to improve the fire-power of the garrison. Lessons like these had been learnt by the crusaders in the Holy Land. They had been given a burnish in southern Europe and were being applied in England during Henry II's reign, when a multi-towered curtain would seem to have been a feature of the king's innovatory fortress at Orford, in Suffolk, completed before 1173. Orford's curtain wall has now disappeared. But Henry's fourteen mural towers on the inner curtain of Dover Castle, put up in the 1180s, are still identifiable through the work of later military engineers. And it was the model of Dover and, more probably, of neighbouring Orford that would be reapplied shortly afterwards at the Bigod fortress of Framlingham (Fig. 26), already so formidable as a major earthwork castle of that troublesome baronial family that the king had had to build Orford to counteract it.[12]

Framlingham, of course, is much smaller than Dover. Yet it has almost as many towers along the length of its defended circuit, and these also have been evenly spaced. Reoccupying the summit of the earlier motte, Framlingham does without a separate keep of its own. But the keep, as strong tower and place of last resort, was already becoming something of an anachronism by the time that Roger Bigod (d.1221), second earl of Norfolk, rebuilt his castle. And it was plainly the sheer bulk of Framlingham's new towered curtain that now made such precautions unnecessary. Below this wall (to the right of the picture, beyond the castle), the squared-off outline of a contemporary lower court preserves Bigod's arrangements for the protection of his postern, the main gate opening south (to the left) into a large outer bailey which survived from the castle of his ancestors. Significantly, neither court nor bailey were ever to be walled in stone, though

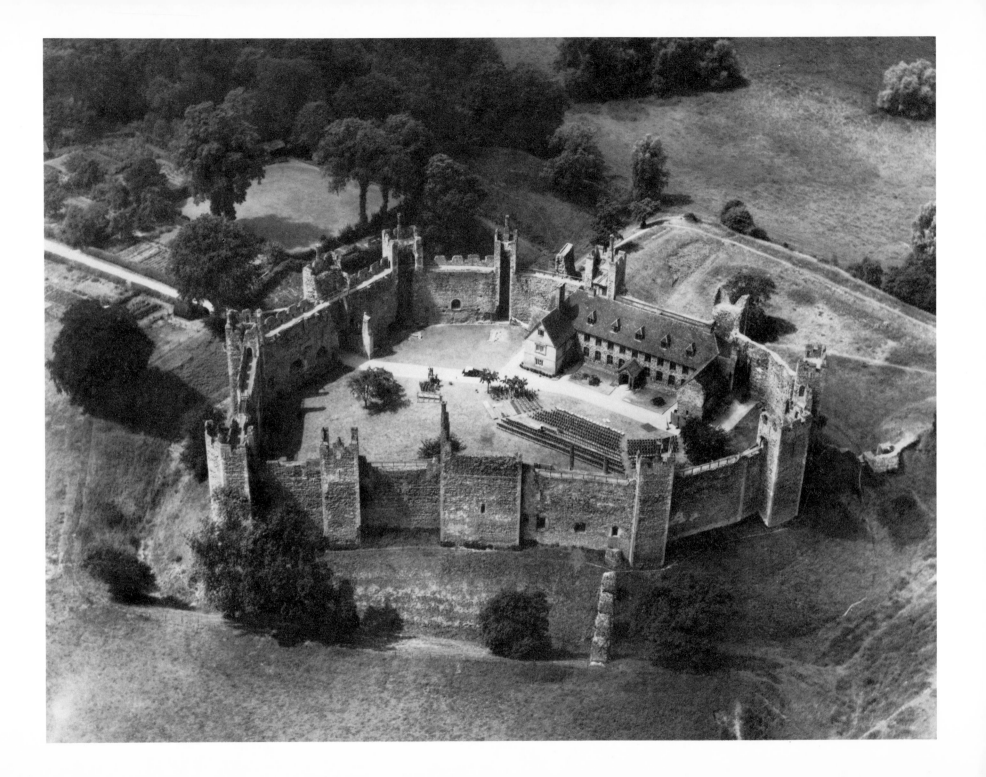

both had the protection of strong palisade defences at least as late as the final years of the thirteenth century. Framlingham was not the only Bigod fortress in East Anglia. When Earl Roger remodelled it in the 1190s, what he had done was expensive enough. He had other pressing calls on his purse.[13]

More sophisticated than Framlingham, yet only a decade or so later in date, was Robert de Roos's geometrically planned fortress at Helmsley (Fig. 27). Robert de Roos, before retreating to his Yorkshire estates in 1203–4 when King John lost western France to Philip II Augustus, had fought for many years in Normandy where his family had been landowners on a large scale. It was probably his choice of England over France that led him to build Helmsley. And certainly Robert's personal history in the wars was of importance to his work, for Helmsley incorporates many features that associate it with the best of contemporary French castle-building, in which Philip Augustus especially became expert. Helmsley has the geometry and the once prominent drum towers, showing now only at foundation level, that Philip Augustus would shortly re-use to even greater perfection in the planning of his castle at Dourdan. And it features too what was to become almost a trade-mark of the French king's fortresses, an experimental tower-keep, apsidal towards the east, reminiscent of the beak-shapes and other plans – triangles and polygons, quatrefoils and cylinders – so familiar in France at that period.[14]

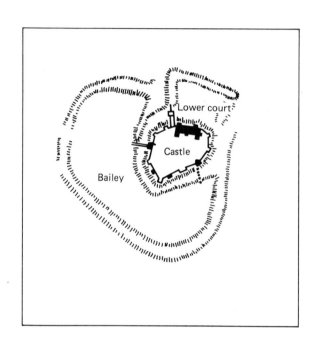

26 Framlingham Castle, Suffolk
The surge of prosperity, in country and town, was to be felt most particularly among great landowners, many of whom, as profits rose, began to take a more direct interest in their estates. The Bigods had held Framlingham for almost a century before Roger Bigod, in about 1200, undertook the castle's reconstruction in stone. And what resulted has a strong element of display. Framlingham had started life as a large motte and bailey, of which the earthworks are still visible on the site. Earl Roger put a modern multi-towered curtain wall round the platform of the motte, doing away altogether with the concept of the tower-keep, but achieving his effects in strong angle-towers and in the sheer overwhelming mass of his masonry. Already formidable earthworks – a great crescent-shaped bailey to south and east (left and bottom) and a rectangular lower court to the west (top right) – protected the Bigod fortress on those quarters. Neither of these lower courts was ever fortified in stone except at their junctions with Earl Roger's inner curtain, where masonry links defended the moat. (1947)

63

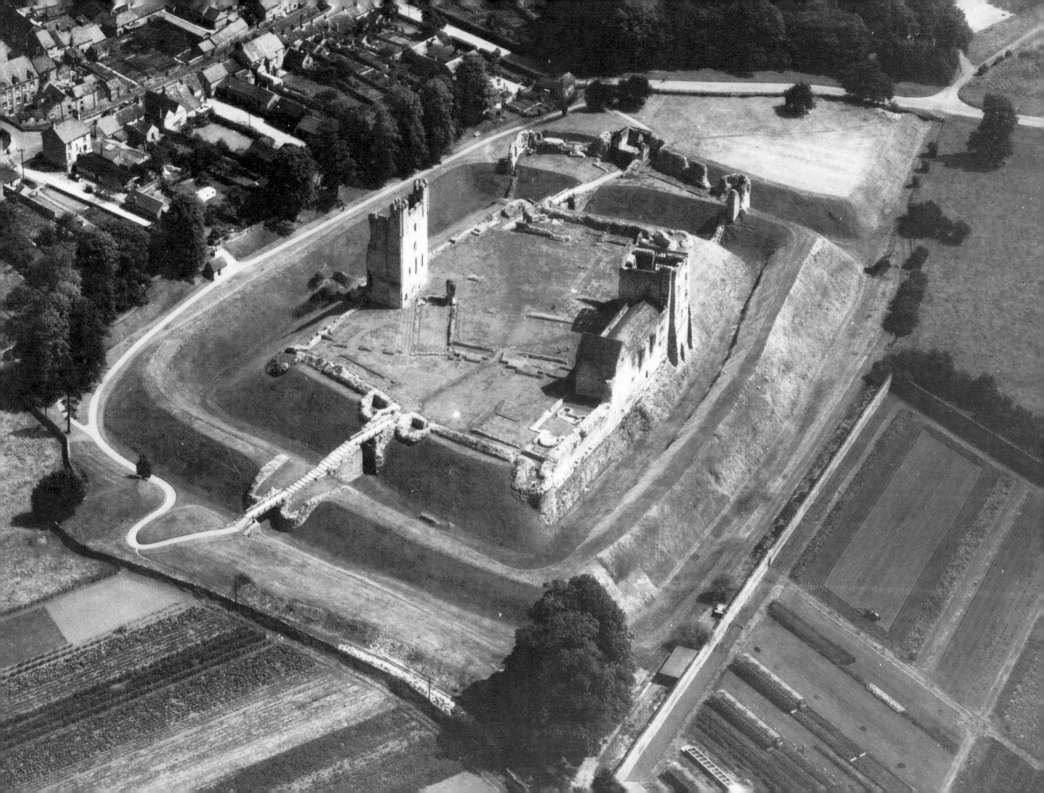

27 Helmsley Castle, North Yorkshire
Framlingham, although expensive, had been relatively unsophisticated, chiefly a replacement in stone of an existing less permanent timber circuit. In contrast, Helmsley exhibits an impressive unity of design which links it rather with the most progressive contemporary work on the Continent. At this major Yorkshire fortress, the crisp banks and ditches may be owed in part to Walter Espec's earlier castle on the same site; the barbicans, defending Helmsley's gates to north (nearest camera) and south, are improvements of the mid-thirteenth century. Everything else on the inner circuit, including the keep on the east (left) and the square tower almost opposite it on the west, is by Robert de Roos, an experienced soldier who had learnt his craft in the struggle to hold Normandy for King John. Notice in particular the thoroughly up-to-date use of drum towers at the angles, with two others to flank the north gate. Even the prominent tower-keep, heightened a century later but in other respects much as Robert left it, was once rounded on its external face, confirming its association with that whole class of similarly sophisticated experimental keeps contemporaneously favoured by the French king, Philip II Augustus. (1964)

Within half a century, Helmsley had acquired the elaborate barbicans, guarding its gates on the north and the south, which were to be the next major refinement in castle-building. Yet despite these and other alterations, the castle remains an unusually pure example of the kind of fortress that a military man of wealth and experience might exceptionally hope to build in the decades on either side of 1200. It was not open to many in England to do as much. Robert de Roos, as an old campaigner and former companion-at-arms, had at first enjoyed the confidence of King John. In his later years, he turned against the king. But his castle was already built, and he himself would never have been allowed to take it so far if he had shown his rebellious tendencies any earlier. John was not a conspicuously successful soldier; one of his better-known sobriquets was 'Softsword'. Yet before the end of his reign, his reputation as a castle-breaker stood high. Few would have the courage to close their gates when John and his troops were in the neighbourhood.

Indeed, though a baron might know well enough how to build a castle – and occasionally a fine example like Helmsley might slip through – at least two circumstances had combined by this period to control and discourage such initiatives. First of these was the attitude of the king himself, reluctant to allow the advantage to any potential opponent of his regime, and quite strong enough to prevent it if he wished. Unlicensed castle-building, under any of the early Angevins, could lead to immediate forfeiture. Second was the expense that building in stone was bound to bring down upon the patron. Only the most secure of baronial fortunes could be expected to survive the strain of castle-building to the standard now required in contemporary warfare. For the future, initiatives in castle-building commonly remained with the king as alone fully able to afford them.

Helmsley's defensive earthworks are so regular in plan as to look later than they probably are. Certainly, at least some of this regularity would have been owed to the configurations of the rock outcrop on which Robert de Roos built his fortress.

And it is likely that these would already have determined the form of an earlier castle on the site, the residence of Walter Espec (d.1153). Walter had been one of the great figures of the Anglo-Norman Settlement in the North. He was a successful soldier and administrator: a man of considerable presence – tall, full-bearded, broad in feature, and known for his 'trumpet voice'. He was also exceptionally devout.

Like Robert de Roos himself in a later generation, Walter Espec was to end his days in the company of men of religion. And where he chose to rest was at Kirkham Priory (Fig. 33), to the south-east of Helmsley, an Augustinian house which he had founded early in the 1120s. Walter's choice of Kirkham as a burial place was again that of his successors, the de Roos lords of Helmsley, who similarly took the canons' interests to heart. But Kirkham was not the only religious community to be settled on Walter's estates, nor was it at all times his most favoured. Within a decade of the founding of the Augustinian priory at Kirkham, Walter was to become a major sponsor of the new Cistercian settlement of England. It was Walter who first welcomed the 'soldiers' of St Bernard's great 'army' to the North. He established the 'white' monks – so described to distinguish them from the 'black' Benedictines – on the valley site up-river from Helmsley for which they chose the attractive name Rievaulx. Not many years later, he was assisting them again in their colonizing drive, settling a party from Rievaulx on his estates in Bedfordshire, where they founded a new abbey at Warden (1136).

Walter's resources were unusual, but his preferences were not. And they show important new developments in the faith. Less than a generation before, the best that could be found in contemporary monasticism had usually been identified with the Cluniacs. This had certainly been the reason for the founding of Thetford Priory (Fig. 14), and additional Cluniac endowments were still not uncommon much later in Henry I's reign. However, what the Cluniacs could offer was a traditional regime which, for all its splendour and high quality, had begun to look distinctly old-fashioned. Progressives, both within the Church and outside it,

favoured the more austere path now offered by a whole galaxy of new orders. Initially, too, they were to see the monastic reform as a means of solving some of the more pressing administrative problems of the Church.

In England certainly, it was the Augustinian canons – essential maids-of-all-work in the Church – who enjoyed the support of the principal officials in Henry I's efficient, if sometimes predatory, administration. Walter Espec himself was to serve as an itinerant justice for the king. And it was natural enough that he should seek out Augustinians, as his companions were doing contemporaneously all over England, for his first religious community at Kirkham. Priests living in common under the ill-defined Rule of St Augustine, Augustinian canons could be expected to tend the parish churches that usually came to them as a major part of their initial endowment. Nor was it unusual for other Augustinian communities, depending on their placing, to manage hospitals or retreats, to run schools, to serve as chaplains in the castles of the great, or to take over the responsibility for some necessary facility like a road, a causeway, or a bridge.

Very much influenced by what he already knew of the first Augustinian settlement of Yorkshire, Alexander I of Scotland brought Austin canons, recruited from the still youthful community at Nostell in West Yorkshire, to tend two of his country's most sacred places: Scone in about 1120, St Andrews before 1124. They came in each case with a practical purpose, as guardians of a shrine of great political significance and as the custodians of a projected new cathedral.

Very little survives today of the cathedral and of its adjoining priory buildings at St Andrews (Fig. 28). And of what is left, nothing goes back to Alexander I's original settlement, which became subject to a succession of delays. Yet St Andrews' splendid situation on the edge of the North Sea recalls the very similar siting of other ancient holy places in the North, among them Tynemouth (Fig. 67) in Tyne and Wear and Whitby in North Yorkshire. And these too, although predating the emergence of the Augustinians as potential custodians, had only recently been recolonized by the monks. After the decay of religion in the dark

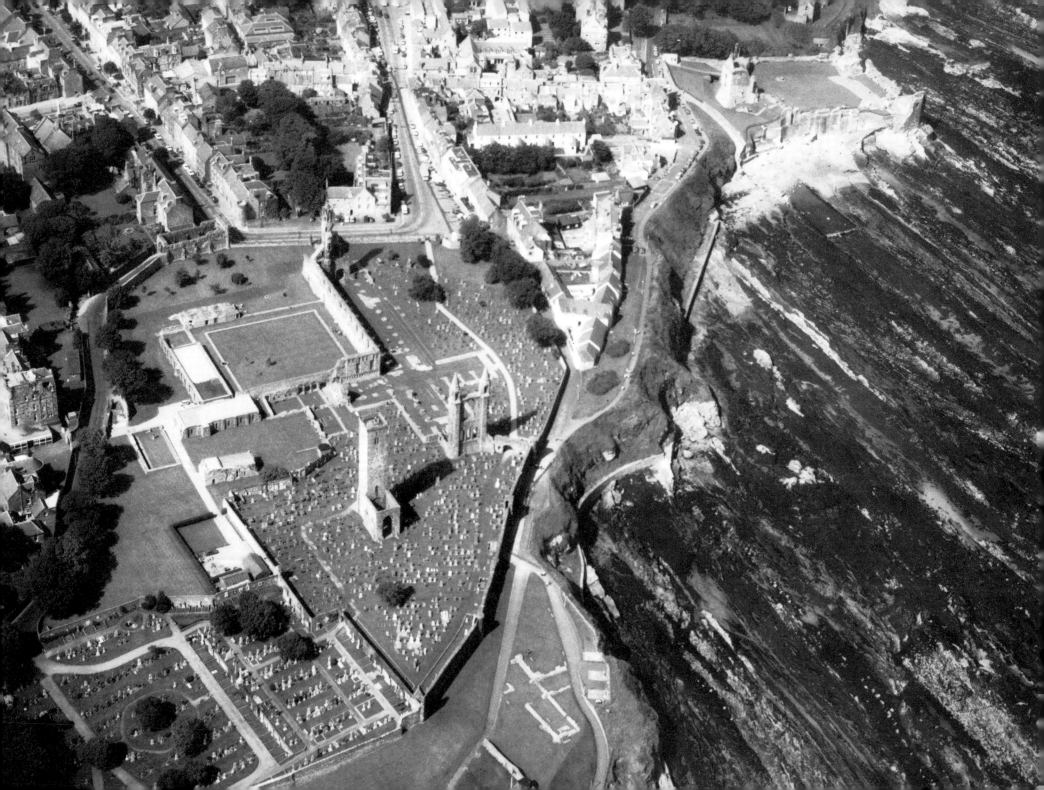

years of repeated Scandinavian assaults, a deliberate effort was being made, up and down the coast, to patch, to heal, and to restore.

Associated with Alexander I in the endowment of St Andrews was his younger brother, the wealthy Earl David, shortly to succeed him as David I (1124–53). David had spent his youth at the English court where Matilda, his sister, was queen. So to his inherited predilection for monks and canons, no matter what Rule they might obey, was added a very thorough knowledge of each new variant on the market as it was brought to the attention of his circle. David liked everything he saw. While in England still, David had been a patron of the Cluniacs of Northampton, in whom he had a family interest by way of his wife, Maud, widow of Simon de St Liz, their founder. But in Scotland, at just that time, it was Tironensians that David brought to Selkirk, setting up one of the first outposts of the new French abbey at Tiron, and showing himself to be, even as early as this, already in the vanguard of reform. Nothing that David did after his accession to the throne showed any retreat from this frontier. While not averse to helping monks of an older allegiance where he could, David's interest was more obviously in the contemporary reform and, increasingly, in the favouring of its extremes. Accordingly, his early support of the Cluniacs of Northampton was never to result in a similar foundation in Scotland after he became king. In

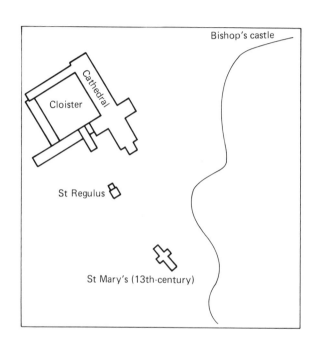

28 St Andrews Cathedral, Fife
England's enrichment and modernization through the course of the twelfth century was in harmony with what was happening elsewhere. It was in the first decades of the same century that Scotland's kings launched a programme of works, beneficial to the Church, which had another purpose in the promotion of the State. Contrast at St Andrews the diminutive but loftily towered church of St Regulus (centre) with the great cathedral

priory which grew up alongside it later in the twelfth century. Alexander I's deliberate promotion of his country's ancient holy places, another of which was Scone, was an episode in the birth of the unified nation which he and his younger brother, David I, did so much to pull together. Both Alexander and David were generous patrons of the contemporary monastic reform, seeing the Church (as other rulers had done in the past) as a powerful agent of centralization. With

relatively restricted resources, in a poorer kingdom, the completion of the cathedral at St Andrews spread over more years than might have been the case further south. Nevertheless, the final product bears striking witness to what had been achieved in Scotland within the twelfth century by the kings of the Canmore dynasty. The times were clearly ripe for such change. (1980)

contrast, it was David I who finally settled the Augustinians (or 'black' canons) with an adequate endowment at St Andrews, as well as giving that same order, among other things, the site for its important Edinburgh abbey at Holy Rood. Characteristically intrigued by the more austere contemplative branch of the large Augustinian 'family', David brought the Arrouaisians to Stirling. He was one of the first great patrons on this side of the Channel to welcome the reforming 'white' canons of Prémontré, helping to attract them from Alnwick, in Northumberland, to settle Dryburgh as early as 1150–2. And of course, like others of his class and his persuasions, David became especially active in the support of the Cistercians who had themselves been so influential at Prémontré.[15]

Earliest and always richest of the Cistercian communities in Scotland was David I's foundation at Melrose (Fig. 73), Borders. David and Walter Espec knew each other well, and it was from Walter's Rievaulx, in North Yorkshire, that Melrose was settled as early as 1136. Among their close associates in the government of the North at this period was Roger de Mowbray, younger than either David or Walter Espec, but as deeply engaged in the fostering locally of a monastic settlement which all saw as a stabilizing force. Roger had been brought up at Thirsk, west of Helmsley. And it was to Thirsk that a migrant Savigniac community came, to be welcomed by Gundreda, Roger de Mowbray's mother, and to be granted the vill of Byland in 1143, from which it then took its name. The community, originally from King Stephen's Savigniac foundation at Furness, had already wandered restlessly from site to site, and its travels were not over and done with even yet. The site at Byland where Roger de Mowbray and his mother had at first intended to settle their monks, was soon found to be too close to the Cistercian community at Rievaulx, immediately down river and within earshot. Forced to move again to a temporary site at Stocking, Byland's monks took another generation to establish and to clear, 'manfully' and by the sweat of their brows, the present 'ample, fitting and worthy site' below the scarp of the Hambleton Hills.[16]

The long-drawn-out saga of the early tribulations of Byland Abbey (Fig. 29) is particularly important to an understanding of its remains. In 1147, just when the move to Stocking took place, the Savigniac and the Cistercian orders had merged. But although the Savigniacs, from that time onwards, were to describe themselves as Cistercians, they retained a taste for exceptionally grand buildings which, as distinct from their Cistercian brethren under the austere regime of St Bernard, had been an early characteristic of their order. Whether for this reason or as a result of the competitive patronage of Roger de Mowbray, or perhaps indeed for no better cause than that time had passed and the Cistercians themselves had already begun to move in that direction, the buildings at Byland were unusually large and well-constructed. Byland's great cloister is bigger than those of its nearest rivals, Rievaulx and Fountains, both of which had been Cistercian communities from the first. Its famous west front, many times photographed for the broken half-circle of its rose window, is in the reigning high fashion of early-thirteenth-century France, very un-Bernardine in its insistence on fine ornament. Its handsome tiled floors, although later certainly than the first building period, were to be an expensive additional embellishment.

The splendour of Byland was not the only consequence of its long-delayed building, another being the very perfect geometry of its plan. By the time that Abbot Roger and his assistants marked out the new buildings, a full two generations after Roger Bigod had attended the same ceremony at Thetford (Fig. 14), there was no longer room for serious dispute about the elements now essential to their form. Early Cistercian houses had frequently followed the Benedictine practice (employed at Thetford among others) of keeping the monks' refectory (frater) parallel to the cloister, adjoining the south cloister walk. Yet Byland, in contrast, adopts the perpendicular plan. And it does so because, at Byland as elsewhere, sufficient room had to be made for the lay brethren. These 'pious draught oxen of Christ', as a famous abbot of Fountains later described them, had long made themselves indispensable to the monks. Many were employed for most

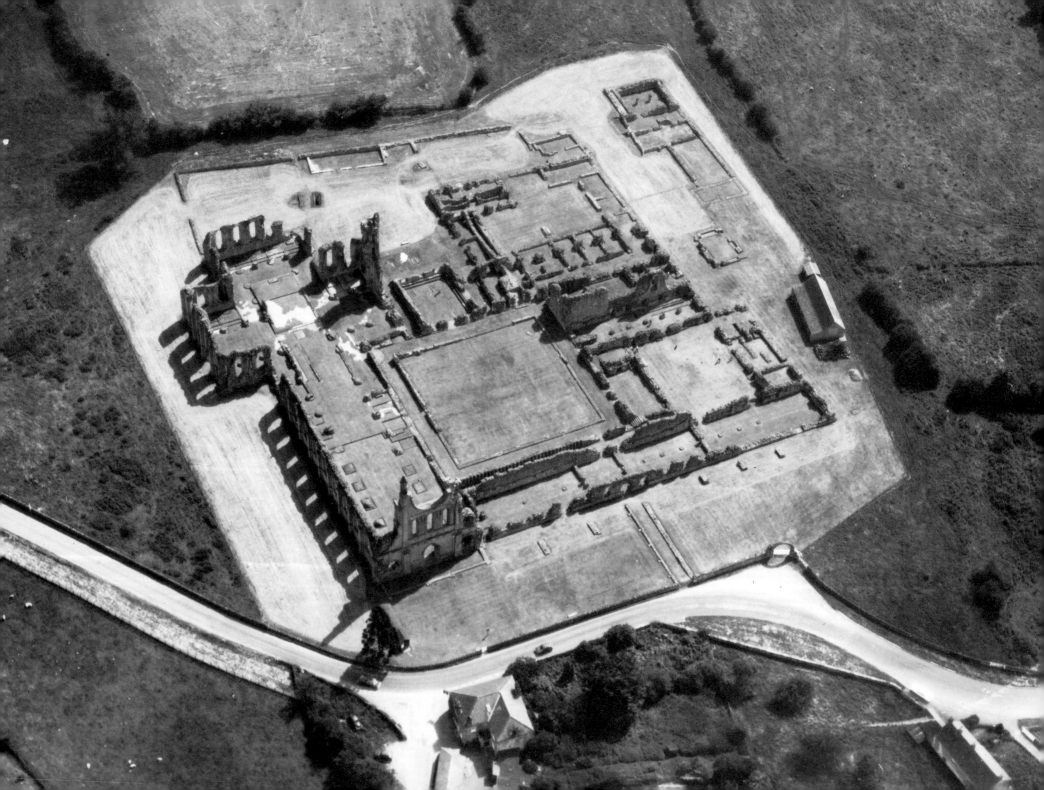

of their lives on the outlying estates, or 'granges', of each community. But all, sooner or later, would have had to be found accommodation at the abbey itself, to which they returned regularly for worship. Their presence had implications for Cistercian planning which are readily demonstrated at Byland.

Fleeing the world, the Cistercians had not welcomed outsiders to their churches. However, with lay brethren to accommodate, they had found themselves still required to build on a grand scale, all but the easternmost bays of Byland's great nave being assigned to the use of the lay brethren. Similarly, the monks' quarters, east and south of the cloister, had virtually to be duplicated on the west for lay brethren. While a shared great kitchen, between the monks' refectory and the west range, met the needs of all, the lay brethren had to be provided with a refectory of their own, with a dormitory (like the monks) at first-floor level, and with independent access on both floors to the abbey church.

This access, by a night stair from the dormitory and by a walled-in cloister lane, has been unusually well preserved at Byland. Cloister lanes of this kind, keeping the two communities distinct, are rare survivals. And they signify a separation which, over the course of time, would come to be gravely resented. Already other orders – the Gilbertines in the 1160s, the Grandmontines still more seriously in the 1180s – had encountered difficulties with their lay brethren over questions of

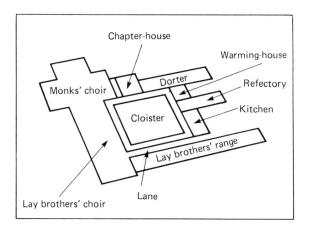

29 Byland Abbey, North Yorkshire
The Cistercian community at Byland, like the Augustinian one at St Andrews, took time to establish itself permanently. But when, in the 1170s, work began on the abbey buildings in their final location, all was ready for the very grandest of building programmes. Byland, as laid out on a virgin site, is a classic demonstration of what we must regard as the mature Cistercian plan. First to be constructed was the great lay brothers' range to the west

of the cloister, and Byland preserves (most unusually for England) the closed-in lane, adjoining this range on the east, which kept the cloister reserved for the monks alone and the lay brethren confined to their quarters. Contemporary with the west range was the south wall of the abbey church, but the next major stages took another twenty years to complete, by which time (c.1200) presbytery, choir and crossing had been finished in the church, with the bulk of the monks' claustral

buildings to south and east. Last in the sequence was the lay brothers' choir, completed by about 1225. Like the rest, it is work of the highest quality, on which no pains or expense had been spared. The Cistercians, in this time and place, were experiencing great prosperity, healthily endowed and strikingly successful in their role as sheep-farmers. Byland was to be as finely built as their considerable resources could secure. (1972)

30 Cymmer Abbey, Gwynedd

Not all Cistercian abbeys were as rich as Byland, among the poorest being those established in Wales. Cymmer was founded at the very end of the twelfth century when the order already had its critics. The community made slow progress in assembling an adequate endowment, and never completed the full set of buildings originally anticipated on the site. Cymmer's cloister, only half the size of Byland's, extends to the east (right) just beyond the end wall of the church to where the south transept should have been. Modern farm buildings occupy the site of the unfinished presbytery, the chapter-house, and the undercroft with dormitory above. To the south of the cloister, the refectory is on the old parallel plan, leaving no space on either side for the warming-house and kitchen which a larger community, as at Byland, would have required. If, as seems likely, the west range was never built, recruitment of lay brethren must have been limited at Cymmer from the start, reflecting a growing inability among the lesser houses of the order (particularly noticeable in Wales) to maintain proper discipline in communities divided between privileged monks and illiterate 'draught oxen of Christ'. (1948)

status and the assignment of duties within the community. Before the end of the twelfth century, it had come to be the turn of the Cistercians. Strata Florida (Dyfed) had been one of the wealthier of the Welsh Cistercian houses, founded in 1164. It might have been expected to look after its lay brethren better than most in the locality. Yet already in the 1190s there were to be stories of brawling in Strata Florida's community, while the Welsh lay brethren were to become known in general for their drunkenness, their chronic ill-discipline, and their violence.[17]

Understandably, when a new Cistercian community, in 1199, established itself at Cymmer (Fig. 30), north of Strata Florida in Gwynedd, its building plans remained highly uncertain. Cymmer, unlike Strata Florida, was poor from the start, with only a fraction of the resources of a great house like Byland and with few hopes of improving its position. Its monks built an aisled nave for their church of conventional plan. But they never completed the transepts or the presbytery of the much larger cruciform building which they had clearly intended at the beginning. Already required themselves to worship in the nave, more usually given over to lay brethren, the monks of Cymmer seem to have got no further with providing the facilities which a fully-developed double community would have needed. Cymmer has no west range now, nor does it appear ever to have had one. To the south of the cloister, where it is clearly marked in the grass, the refectory is laid out on the old parallel plan more suited to a community without lay brethren to accommodate, even if some continued to be recruited through the thirteenth century for labour on the outlying estates.[18]

Last of the great twelfth-century reforming orders to colonize England were the Premonstratensians, followers of St Norbert, a friend of St Bernard, and closely modelled on St Bernard's Cistercians. Although professing the rule of St Augustine, appropriate for canons like themselves, the Premonstratensians practised an austerity of observance that was very much closer to the original Cistercian ideal than was usual in the wider Augustinian family. Like the Cistercians, they believed in hard manual labour, in simple clothing, and in a

frugal diet; they retreated far from the company of their fellow men, and set up their houses in the wilderness. Yet by the time that the Premonstratensians achieved their highest favour in England, significant differences between the orders had opened up. The Premonstratensians appealed, most importantly, to another class of patrons altogether. For it had been among the magnates, in particular, that the Cistercians had found their friends, and the greatest families, having given generously to the Cistercians before the mid-century, were for the most part too committed to religious houses of their patronage to welcome additional responsibilities. Accordingly, those who were likely to espouse St Norbert's white canons were the rising men of the next generation, successful court officials like Henry II's justiciar, Ranulf de Glanville, founder of Leiston Abbey (Fig. 71), or the lesser nobility whose resources were enough to back personal preferences in religion but whose generosity was limited by their means. Premonstratensian endowments, in these circumstances, were not usually substantial, and it was highly exceptional (although not entirely unknown) for a community of the order to be rich.

One of the poorest of these new houses was Egglestone (Fig. 31), in North Yorkshire, founded in the late 1190s contemporaneously with Cymmer, and similarly modest in scale. Egglestone's plan is a patchwork. The abbey church – here showing to the right of the remains, with the cloister sited to its north – was originally very small, although substantially enlarged within half a century or so, when the canons secured an addition to their endowment. As first planned too, the cloister at Egglestone may also have been smaller, for the church stops well short of the west claustral range to which, in common practice, it would have joined. That range itself was an addition, replacing a screen wall such as that which at Cymmer continued to shelter the cloister on the west. The Premonstratensians had their own difficulties in controlling their lay brethren – 'illiterate men who turn to us from secular life, having left all to bear the yoke of Christ.' Although employed (in ever smaller numbers) at Premonstratensian

31 Egglestone Abbey, North Yorkshire
The main thrust of monastic reform was already over in England by the time that most Premonstratensian houses were founded. Accordingly, the great majority of 'white canon' communities started life small and ill-endowed, among the most fragile being Egglestone, a contemporary of Cymmer and in difficulty soon after its birth. Egglestone's initial plan was very modest indeed, with a small cruciform church and diminutive cloister, both of which were subsequently enlarged as further benefactions came in. The greatly extended presbytery (top) is of about 1250, the west range (bottom) and south transept (right) being added a quarter century later. After the Dissolution, the east range at Egglestone was converted by the site's new owner into a country-house, necessitating a major rebuilding during the course of which most of the medieval work was removed. It is this mid-sixteenth-century mansion, with the upstanding parts of the church, that is all that survives of the abbey above ground. (1947)

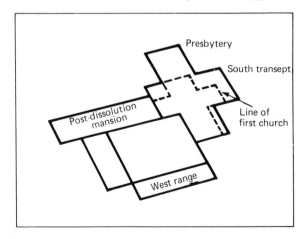

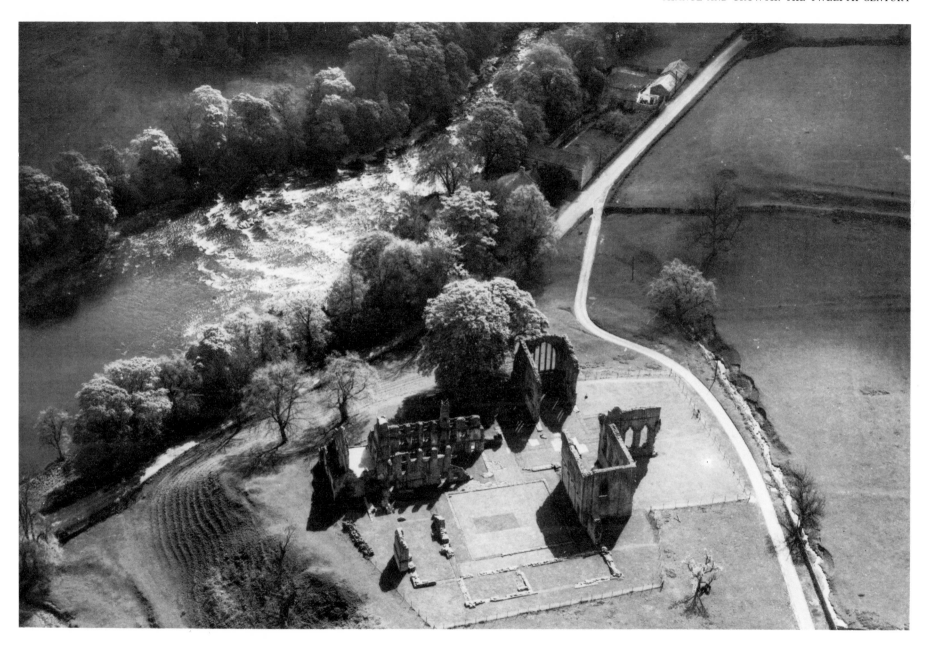

communities through the next two centuries, lay brethren were only rarely assigned individual accommodation, at least on the model of the Cistercians. At Egglestone, for example, the west claustral range, when eventually added in the 1270s, is very much more likely to have served the needs of the abbot or to have been intended to accommodate his guests. Earlier in that same century, Egglestone's mother-house at Easby (Fig. 32) had built a west range of its own, of lavish style and interlocking complexity, for the use of the canons and their visitors. It was an ingenious building, making clever play with the fall of the land towards the river. But it had nothing to do with the housing of lay brethren, whose place in the community was of declining importance to the canons and who might expect to be accommodated more humbly.[19]

3 Affluence: the Thirteenth Century

Take another look at Easby Abbey (Fig. 32), for its situation and plan have more than one thing to tell us about the nature of a society both willing and able to keep Easby's canons in comfort and in moderate affluence. Easby had been among the first of the Premonstratensian communities in England, founded in the early 1150s by Roald, then constable of Richmond (Fig. 2), just up-river. Like other houses of its order, as had already been the case with the Augustinians, Easby was to draw a substantial part of its revenues from parish churches, including the church which survives on its site and which came to the canons with their initial endowment. Lay owners of parish churches, with men like Roald in the van, had become anxious to shed their responsibilities for such buildings, under pressure from reformers within the Church who insisted on the return of Christ's dowry. Very probably, the canons of Easby were indeed more able to undertake the cure of souls at Roald's church than either the constable himself or his heirs. Under the canons' regime, the parish church was decorated with a fine set of wall-paintings – a great Creation Cycle – which is one of the best such survivals in the country. Nevertheless, Easby Church, dominated and overshadowed by the adjoining abbey, remained a modest building, no more than merely adequate for its purpose. Its role was smaller in the spiritual welfare of the laity than in the generation of wealth for the canons.

Consider the great refectory it adjoined, their gables almost touching. The canons' refectory at Easby was a building of exceptional size and quality, lying

parallel to the cloister and extending further east to close off the southern end of the east range. Rebuilt early in the fourteenth century over an existing sub-vault, it had been one element only of a general programme of reconstructions which included the addition to the church of a grand new presbytery and the completion of the handsome gatehouse to the east. Another significant extension of a similar date was the insertion of a memorial chapel next to the abbey church, in the angle between nave and north transept. Its associations traditionally are with the Scropes of Bolton, and what a chapel like this most insistently brings home is the continuing dependence of the abbot of Easby and his canons on the interest and benevolence of their patrons. Sir Henry, founder of the Scrope family fortunes, died in 1336. Before this, however, he had taken on for his family the patronage of Easby, and the canons were to owe as much in later years to Richard, his son, builder of the great fortress at Bolton (Fig. 61). It was Richard, first Baron Scrope and a very wealthy man since holding office as Treasurer of England (1371–5), who rescued the canons from the poverty into which they had descended by the 1390s, substantially enlarging their endowment. Scrope tombs and monuments were to pack the east end of the abbey church, which the family made increasingly its own.[1]

In just the same way, but a century earlier, the de Roos lords of Helmsley had exploited the patronage they inherited from Walter Espec to make Kirkham Priory (Fig. 33) the tomb-church of their dynasty. Most obvious at Kirkham, here seen from the west, is the disproportionate scale of its choir and presbytery, redesigned to these dimensions by the mid-thirteenth century and entirely dwarfing the earlier nave. The rebuilding had continued with a total reconstruction of the canons' chapter-house in the east range of the cloister, south of the crossing. It is on a scale appropriate to the rebuilt church, and it lies back from the cloister on the new line which other enlargements of the claustral buildings would have required at Kirkham had the entire programme been brought to completion. In the event, a major financial crisis overtook the priory.

32 Easby Abbey, North Yorkshire

The Premonstratensians of Easby Abbey, like other communities of regular canons, undertook the care of parish churches both as a responsibility and as an important source of revenues. On their own site, a pre-existing parish church has clearly dictated some of the eccentricities of Easby's plan, distorting the cloister and no doubt helping to suggest the unusual concentration of dormitory and guest lodgings in the west claustral range where these were better sited also for drainage. Easby's impressive first-floor refectory, lying parallel to the cloister in the south range, is a rebuilding of the early fourteenth century. And it is to this period of obvious prosperity that the gatehouse belongs, with extensions of the church attributable to the interest of the Scropes. It was probably Scrope munificence, a generation or so later, that financed further

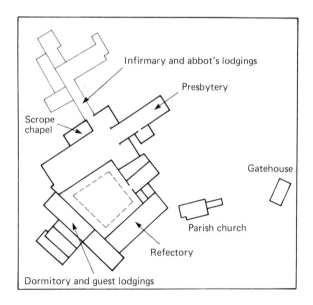

late-medieval rebuildings at Easby, including work on the infirmary and abbot's lodgings north of the church, again unusually sited to avoid the parish church on the south-east. As a Scrope memorial, the community was enlarged in the 1390s, surviving the economic hardships of the later Middle Ages in reasonable order and going down fighting in 1537 as a local centre of resistance against the suppressions. (1969)

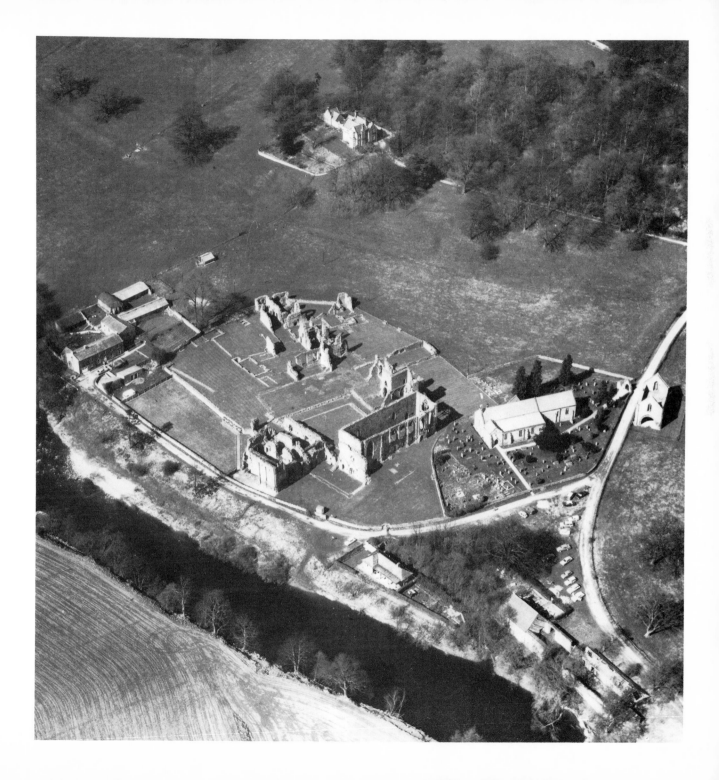

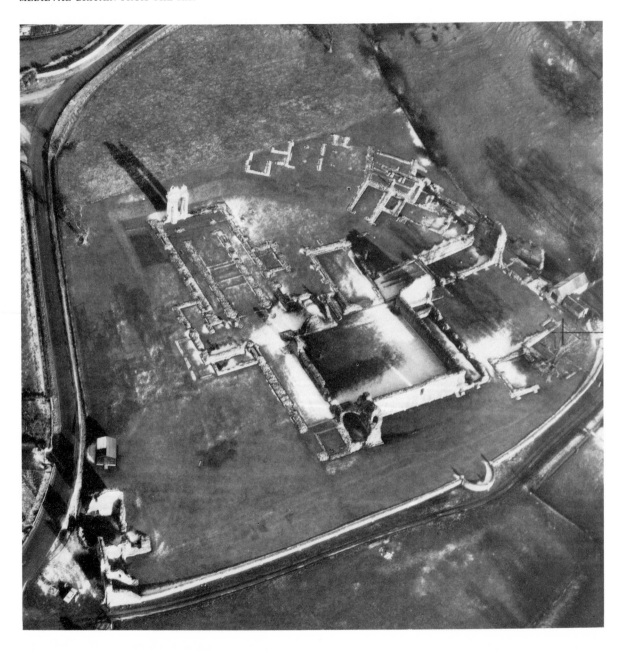

33 Kirkham Priory, North Yorkshire

Founded as early as the 1120s by Walter Espec, the great Yorkshire landowner, Kirkham Priory was comfortably endowed from the start. But the Augustinians of Kirkham were to enjoy a further considerable boost to their fortunes in the thirteenth century when the de Roos lords of Helmsley, successors to Walter Espec, selected the priory as the burial place for their family. The plans for enlarging Kirkham were never carried out in full. As a result, the original nave (north of the cloister) was left disproportionately small when rebuilding came to a halt at the crossing. Similarly, the enlargement of the cloister itself, pushing out the south range, failed to take place, one consequence being that the ambitious new chapter-house, planned to be the central feature of the

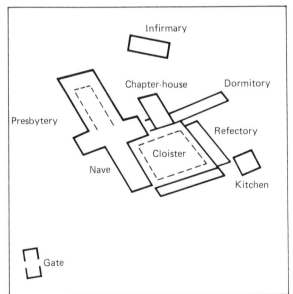

redesigned east range, remained cramped against the dormitory in the south-east angle, far too large for the cloister it adjoined. The great crossing tower, although prepared for, was never built. However, what the priory did acquire was a grand new choir and presbytery, fully appropriate in scale to the high rank and dignity of Kirkham's noble patrons. On the gatehouse facade, also rebuilt at this time with the help of the de Roos lords, all comers were informed of their benevolence. Should they visit the church, they would have found themselves in the company of successive generations of de Roos lords, lying at rest in positions of honour by the high altar. (1970)

The projected tower on the crossing was never built; Kirkham's nave remained diminutive; its cloister, having been tampered with to accommodate an inappropriately grand chapter-house, was kept down to its original size. However, the lords of Helmsley had already got what they wanted in a reconstructed presbytery quite large enough to serve as their resting-place. William de Roos (d. 1258), in recognition of this work, lies immediately in front of the high altar at Kirkham, with his successors to left and to right. No contemporary would have found it in the least bit disturbing that they should have exacted such a price for their support.[2]

At Kirkham, the building work of the de Roos period was of particularly high quality, much better than what had gone before. In addition to the expanded presbytery, of which only a single lancet survives to its full height at the east end, de Roos patronage has left us a fine late-thirteenth-century *lavatorium* (wash-place) in the west wall of the cloister, with a gatehouse at the extreme north-west angle of the precinct which is again of great decorative merit. A notable feature of the gatehouse facade, to be repeated in a similar location at many monastic houses in later years, was a prominent display of appropriate heraldry: de Roos and Espec, fitz Ralph and de Fortibus, Scrope, Clare, and Vaux. In the next generation, the de Roos arms would occur again on the gatehouse of another Augustinian community, even richer than Kirkham, at Butley. And there, on this Suffolk facade, they would take their place in a grand heraldic line-up stretching from the Holy Roman Empire at one end of the sequence to the local county gentry at the other, calling on the help of almost every lay power for the support of this one community of canons.[3]

Such alliances, of course, were understandable. And they found frequent reflection in major building works of which the patronage was seldom left in doubt. When Edmund of Cornwall, in 1270, gave his Cistercians of Hailes Abbey (Fig. 34) the phial of Holy Blood which was to become their most treasured possession, he at once radically transformed the future prospects of a community

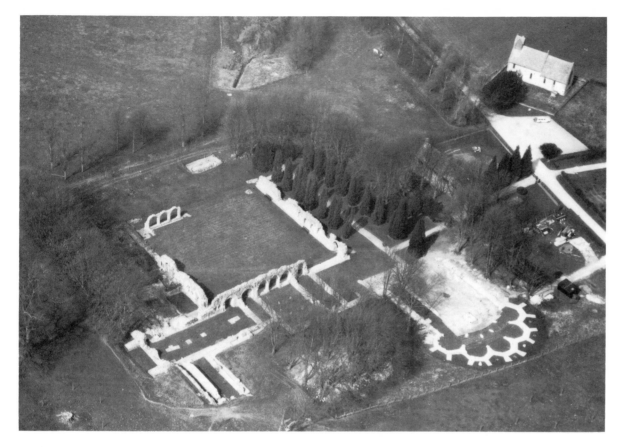

34 Hailes Abbey, Gloucestershire

Most prominent at Hailes Abbey today is the elaborate ambulatory with radiating chapels built in the 1270s to accommodate worshippers at the shrine of the abbey's Holy Blood. Such a relic cult, bringing pilgrims in scores, would have been forbidden by the earlier Cistercians. But Hailes was established in 1246, over a century after the first Cistercian settlement of England, and many of the old prohibitions of the Order, including its rejection of parish churches, either had been forgotten or were deliberately ignored. Certainly, the Holy Blood of Hailes, authenticated by the highest authorities in the Church, was to prove a very potent relic, bringing continuing prosperity to its guardians. It was at least partly on the profits of pilgrim donations that the entire cloister was rebuilt in the fifteenth century and that the west range, no longer in use for lay brethren, was converted into a fine new

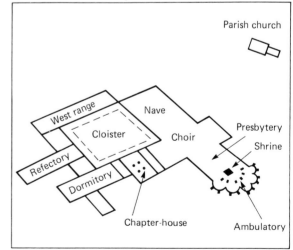

which his father had founded only a little over twenty years before. Hailes's Holy Blood, bought at high cost from the count of Flanders and fully authenticated by the patriarch of Jerusalem, was an immediate crowd-puller. Within a few years of the relic's arrival, the entire east end of the abbey church at Hailes was to be rebuilt, both to make room for the many pilgrims who flocked to admire the Blood of Christ and to provide an appropriate setting for its shrine. Prominent on the photograph of the site, and displayed now in the recently cleared foundations of the east end, is the elaborate *corona* of radiating chapels with which the church at

abbot's lodging. The phial of Holy Blood had been the gift of Edmund of Cornwall, son and heir of Earl Richard, the founder. As at Kirkham, the community was not to be allowed to forget the source of its good fortune. On the floor-tiles of Hailes's presbytery, recovered during the recent excavations on the site, the heraldic devices of the earls of Cornwall and their relatives are prominent and insistent. They occur again in the wall-paintings of the parish church, where they similarly date to the main building period, a finishing touch of about 1300. (1968)

Hailes, originally square-ended, was extended and re-equipped at this date. As seen here, the shrine-base and presbytery are still in course of excavation, and one of the more important products of this work at Hailes has been the recovery of some sections of tiled pavement. The tiles are inlaid, and they carry the heraldry of Earl Edmund (d. 1300) and of his father, Richard of Cornwall (d. 1272), king of the Romans and younger brother of Henry III. Next to the eagle of the Romans and the leopards of England were the arms of the principal magnate families – the Clares of Gloucester, the Warennes of Surrey, the Ferrers, the Beauchamps, and the Staffords – with whom the earls of Cornwall were associated.[4] A display like this, underlining the dependence of the monks on their patrons and achieving an immoderate magnificence, would have been anathema to Cistercians of St Bernard's day. In the late thirteenth century, it might even yet have found its critics within the Order. But a royal donor was not lightly brushed aside.

Hailes Abbey was founded in 1246, among the last outriders of the great Cistercian expansion, and there are other signs of change in its arrangements. In the early years, it had not been the practice of Cistercian houses to accept the charge or the revenues of parish churches. Yet here at Hailes, just to the north of the abbey, is the little parish church which came originally to the monks with their endowment. As at Easby (Fig. 32), the parish church at Hailes never grew to a great size. Overshadowed by its neighbour, it kept the simple two-cell plan of the little village church which had been built to serve the parish in the twelfth century. But as at Easby again, Hailes Church was to be equipped before 1300 with a fine set of wall-paintings, still remarkably complete, those of its chancel repeating the heraldry of the abbey – the eagle of Richard, king of the Romans, with the castle of Eleanor of Castile, queen of Richard's nephew, Edward I.

The relaxation of the Rule at a Cistercian house like Hailes, and the increasingly lavish life-style of its monks, were of a piece with a period of relative affluence and of generally untroubled growth. It was at times like these that the Benedictines of Tewkesbury, always among the richer of the black monk

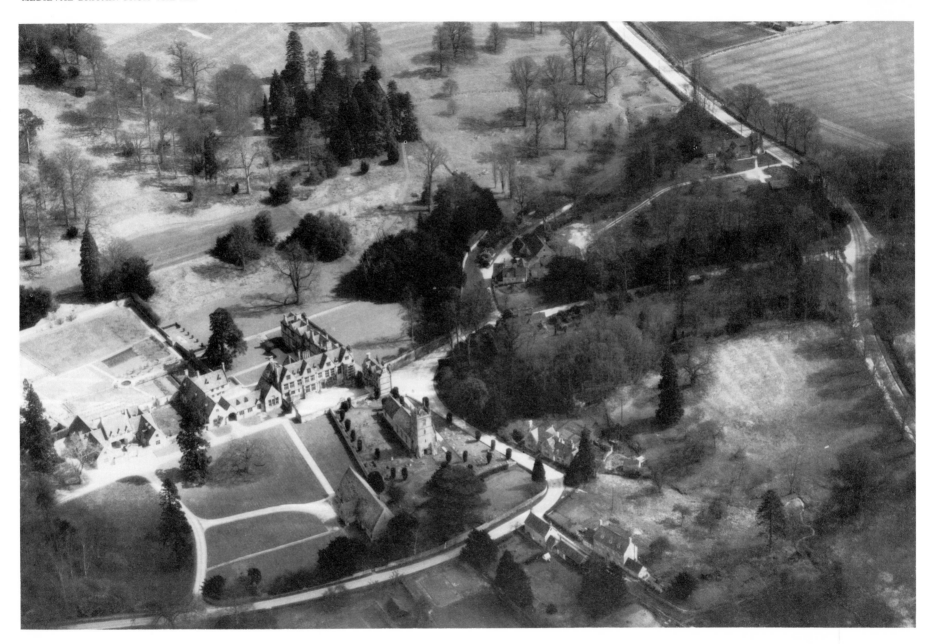

communities, could find the surplus funds to re-equip their manors, among them Stanway (Fig. 35), just a few miles north of Hailes. Stanway was a valuable rectorial manor, one of the jewels in Tewkesbury's crown. Coming to the monks as early, they claimed, as their foundation gift of 715, Stanway was still in 1540 among the first rank of Tewkesbury's possessions, so tempting as to engage the interest of the Protestant reformer, Richard Tracy, even before the dismissal of the monks. Today it is the post-Reformation Stanway House, built for the Tracy family, that dominates the site, replacing the manor-house of the abbots. But the relative locations of manor to church, and then of both to the abbey's great tithe-barn to the north-west, have been preserved at Stanway by Tracy's swift action, resulting in a group that is one of the most complete such survivals in the country.

Stanway's great stone barn is still in excellent condition. And it dates, as do such a number of its class and size, to a period of maximum profits on the monks' demesnes – to those golden decades characteristic almost everywhere of the late thirteenth century before the crop failures and epidemics of the next. Barns like these, as monumental as churches, have kept their purpose over the years, surviving comparatively frequently. Much rarer is the entire complex of monastery and home farm, with vicarage and parish church in addition, which has been kept intact at Muchelney (Fig. 36), in Somerset, isolated on its former island in the marsh. At first, life had been hard for the monks of Muchelney in the wastes of Sedgemoor, still waterlogged and only slowly reclaimed. Nor were they ever to approach the wealth of their Benedictine brethren at Glastonbury, nearest neighbours and rivals in religion. But the agricultural prosperity of post-Conquest England, exploited by Glastonbury, came to be reflected at Muchelney too. And it was within the twelfth century already that the church as we now see it was first laid down, to be extended almost immediately in its eastern arm and to engulf altogether its Anglo-Saxon predecessor, the line of which it preserved as a crypt.

Holding the rectory at Muchelney, it was probably quite early that this black monk community built a separate church for the use of its parishioners, adjoining

35 Stanway, Gloucestershire

Rectorial manors, where a monastery held both the parish church and its adjoining manor-house, were often among the richest possessions of religious communities in the Middle Ages. Stanway was one of these, held by the monks of Tewkesbury since the foundation of their house and always an asset of high importance to them. Nothing now remains of the abbot of Tewkesbury's manor-house at Stanway. It was replaced by Richard Tracy's Stanway House, shortly after the suppression of the community. But the church remains in its original location – over-restored but retaining some good Norman work in the carved corbel table which circles the chancel. And another fine monument of Tewkesbury's ownership is the great tithe-barn, north-west (left) of the church, dating to the last years of the thirteenth century when farming profits on demesne estates like Stanway were peaking in conditions of low wages and high prices. The splendid gatehouse at Stanway (between church and house), for which most would now visit the site, retains the tradition of the medieval entrance while carrying it out in the merriest and least military of northern Renaissance styles. (1964)

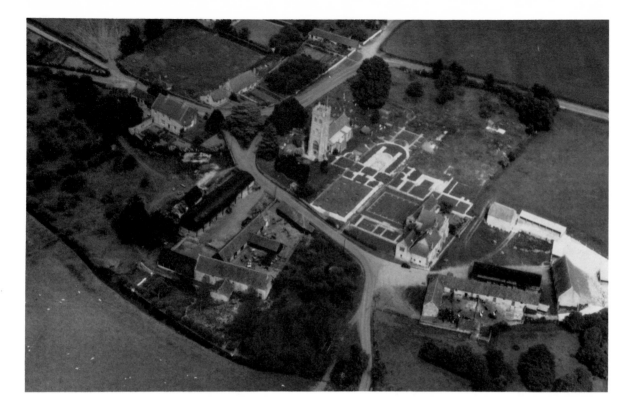

36 Muchelney, Somerset

A typical monastic establishment, usually equipped with its own home farm, brought together many elements on the one site. At Muchelney an exceptional number of these have been preserved, and they include – again not untypically – a parish church which, as at Stanway, was an important generator of wealth. Looking after this parish church, dwarfed and overshadowed by their own, was an acknowledged responsibility of Muchelney's Benedictine community. Early in the fourteenth century, by arrangement with the bishop, the monks built the vicarage which still survives to the north of the whole complex. Remains of their almonry, for the relief of the poor, are incorporated in buildings to the south, while the former home farm (west of the two churches) retains an early-sixteenth-century barn. Like many such communities, Muchelney's finances were experiencing an up-turn just about when this barn was built. At much the same period, the abbey cloister was remodelled and the abbot's

(but distinct from) its own. One reason for this would have been the convenience of the monks themselves, not wishing to be disturbed in their devotions. Sooner or later, many monks and canons, similarly placed, would come to an identical decision. But there is something here too of the growing recognition throughout the Church of a responsibility, not to be too lightly shrugged off by monastic rectors, for at least an adequate cure of souls in the parishes. At Muchelney, the community was to ordain a vicarage in 1308, agreeing formal terms which included the definition of the responsibilities of the priest and some provisions about where he might live. And there, just across the green to the north of the church, is Muchelney's vicarage, modified certainly in the fifteenth century, with

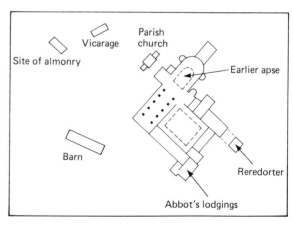

lodgings entirely reconstructed. Commodious and modern when the community dispersed in 1538, the lodgings were retained for further long service as a farmhouse and have only recently been fully restored. (1955)

minor additions and improvements since that time, but still very much as it had been at the beginning of its life and as nice an example of a parish priest's dwelling as one could hope to find, covetable even today.

Spiritual care was the province of the vicar. In extreme adversity, Muchelney's parishioners might turn for material relief to the abbey's almoner, operating from a building just across the road from the vicarage, of which the site but not the structure has been preserved. What enabled the monks to shoulder such responsibilities was their long-term success over several hundreds of years in the drainage and enclosure of the waste. Reclamations continued at Muchelney into the late fifteenth century. On the home farm, or barton, a new barn (still surviving) was to be erected just a few years later, while the complete reconstruction of the especially handsome abbot's lodgings (for Abbot Thomas Broke) was again work of the early sixteenth century.[5] Today, it is these late-medieval elements that are dominant at Muchelney – the vicarage and the parish church (remodelled in the fifteenth century), the barn and the contemporary abbot's lodgings. However, Muchelney's prosperity had begun much earlier, taking its part in that great movement of economic expansion, characteristic especially of the thirteenth century, during which Hailes had been built and both Kirkham and Easby transformed. Those had been the years of the bread and butter of growth. Everything later was the jam.

Nothing makes the point about such riches so clearly as does the contemporary refashioning of our cathedrals. Of course, there were several reasons why Richard Poore, bishop of Salisbury (1217–28), should have wished to transfer his cathedral to a new and more convenient location. As originally sited at Old Sarum (Fig. 1), the cathedral had been overshadowed by the castle, cramped by ramparts and by an encroaching town, waterless and often damaged by high winds; its canons had found themselves troubled by the cold, unable to find lodgings or to make themselves heard above the tempest. Each of these might have been reason enough to go. But determination and means, brought together in the 1220s, could

not have coincided at any other time than in a period of high commercial optimism. Richard Poore's new cathedral at Salisbury (Fig. 37), of which the famous spire is the only major addition to the works of the initial campaign, is a building of soaring ambition. To its north, a new town was laid out with parallel streets and standard-sized plots, to become an instant commercial success.

Salisbury's rapid rise to wealth was founded on privileges that only the bishop could give it and on an exceptionally well-judged situation. It had a fair and a market of its own from the beginning, with freedom from tolls everywhere in England and with a range of other privileges modelled on those of Winchester, which had been accumulated and polished over centuries. One of the rights that Bishop Poore had secured for his borough in the royal charter of 1227 was the licence to divert roads and to build new bridges in the best interests of Salisbury's trade. And it was the new community's location at an important road junction, with good river crossings, which gave it the advantage over an existing local market at Wilton, leaving Old Sarum itself to decay. Within less than a century, Salisbury would rise from nothing to rank among the greater provincial centres of the realm. Its citizens – a 'chosen race' as their own bishop described them in 1306 – had built their fortunes as market traders and as dealers in wool and in cloth. Their city, continuing to expand in later centuries after a temporary reversal at the Black Death, had already taken on its present lines. Before 1300, the bishop's investment had multiplied many times over.[6]

Very different from Old Sarum, and attractive to traders, had been the new spaciousness of Salisbury's layout, with a great central market-place only built-over much later, and with a grid of generous streets. In just the same way, the cathedral and its close could be lavishly planned, and it is this sense of space, contrasting with older and less contrived environments, that remains Salisbury's outstanding characteristic. Compare the situation of another great cathedral at Lincoln (Fig. 38), where rebuilding was in progress at this time after a start under the saintly Hugh of Avalon (d. 1200). Both cathedrals took shape in the early

37 Salisbury Cathedral, Wiltshire

The great cathedral at Salisbury, laid out on a virgin site and very largely complete within a generation, is a monument to the optimism and commercial drive which so often came together in early-thirteenth-century England. It was Bishop Richard Poore (1217–28) who launched the project and Giles of Bridport (1256–62) who consecrated the new building in 1258, with only the west front to be added. In the next decade, between 1263 and 1270, the cathedral acquired its magnificent cloister, with the noble octagonal chapter-house completed not many years after. The spire, designed by that great master, Richard Farleigh, as one of many contemporary commissions, is an addition of the mid-fourteenth century. Farleigh was not the first English architect to be acknowledged as such, but certainly ranks among those whose careers and works brought the profession to full recognition. His spire, which is Salisbury's best-loved feature, would be a signal achievement even now. (1959)

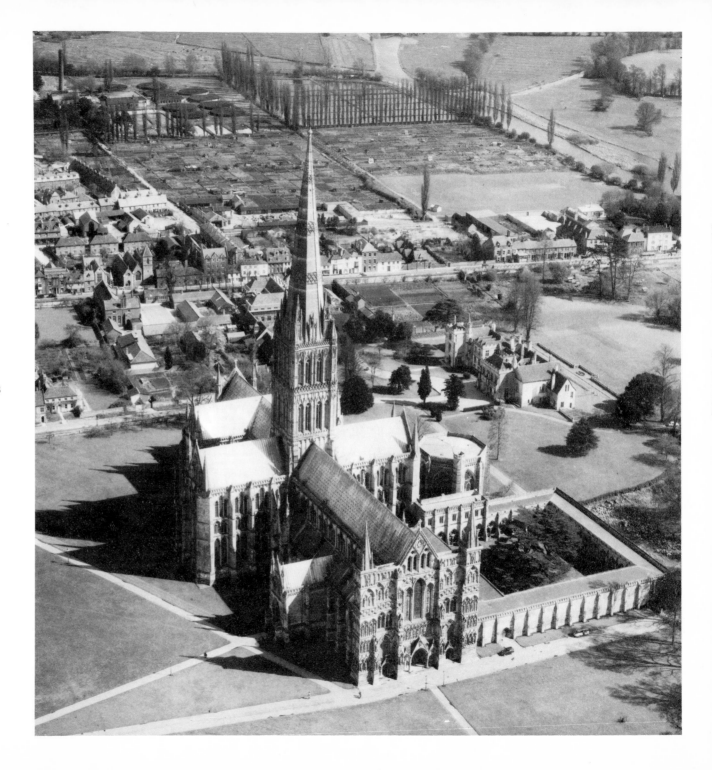

thirteenth century, and each owed its scale to the confident vision of one of the most notable ecclesiastics of the day. But Lincoln carried with it the inheritance of an earlier Norman building, still visible here in important details (including the recesses) of the west facade. Lincoln's final extension to the east, the Angel Choir, could be accommodated only by the demolition of the existing town wall, for which licence was granted in 1255, initiating a campaign that would spread out through another quarter century of building. Salisbury, in contrast, is a single-period building, unconstrained by its site and substantially complete within scarcely a generation of its beginning. Inevitably, it is the purer of the two.

Aesthetics aside, what the two buildings establish is a contemporary ability to mobilize resources on a scale that even today would be impressive. Nor were opportunity and means limited to the South. At Elgin (Fig. 39), in Grampian, work began on a new cathedral in the 1220s, making it the exact contemporary of Salisbury. Like Salisbury too, Elgin's cathedral could be laid out on a virgin site, for though the bishopric of Moray had been established by Alexander I a full century before, the intervening decades had been characterized by repeated migrations only resolved by the election of Andrew of Moravia and by his decision to settle finally for the site at Elgin, where the ruins of his cathedral still remain. Two conditions favoured such a programme at that date, the first being the wealth of Bishop Andrew and his family, the second the coincidence of an ecclesiastical renewal just then overtaking the cathedrals of Scotland and everywhere resulting in new building. The two most notable products of the building programmes of these years were to be Bishop William de Bondington's cathedral at Glasgow and Andrew of Moravia's new work at Elgin. And it was characteristic of the reform that the Scottish bishops should have found their models for the organization of their cathedral chapters not at home in Scotland but south of the Border – Bishop William looking to Salisbury for his constitution, Bishop Andrew turning rather to Lincoln.[7] Both worked in the context of a general tidying-up of the secular church for which a programme had been laid

38 Lincoln Cathedral
The reconstruction of Lincoln, replacing an existing Anglo-Norman cathedral in all but the core of its west end, continued throughout the length of the thirteenth century, the last major work being the addition of a lofty bell-stage to the great crossing tower, carried out in 1307–11. However, here (as at Salisbury) the scale of the new building was owed to one man, Hugh of Avalon (d.1200), as powerful after death as in life. Following the bishop's canonization in 1220, and even before, the cult of St Hugh drew pilgrims in large numbers to Lincoln. And it was this fresh source of funds that made possible the building of the lavish Angel Choir at the east end during the 1260s and 1270s, to which the relics of the saint were translated in 1280. Among St Hugh's successors, Robert Grosseteste (1235–53) was again a major figure in the Church, with a reputation extending substantially beyond his own diocese. Lincoln Cathedral is a memorial to Bishop Grosseteste as well. But what it principally evidences is the wealth of a society for which nothing but the best would be sufficient. (1959)

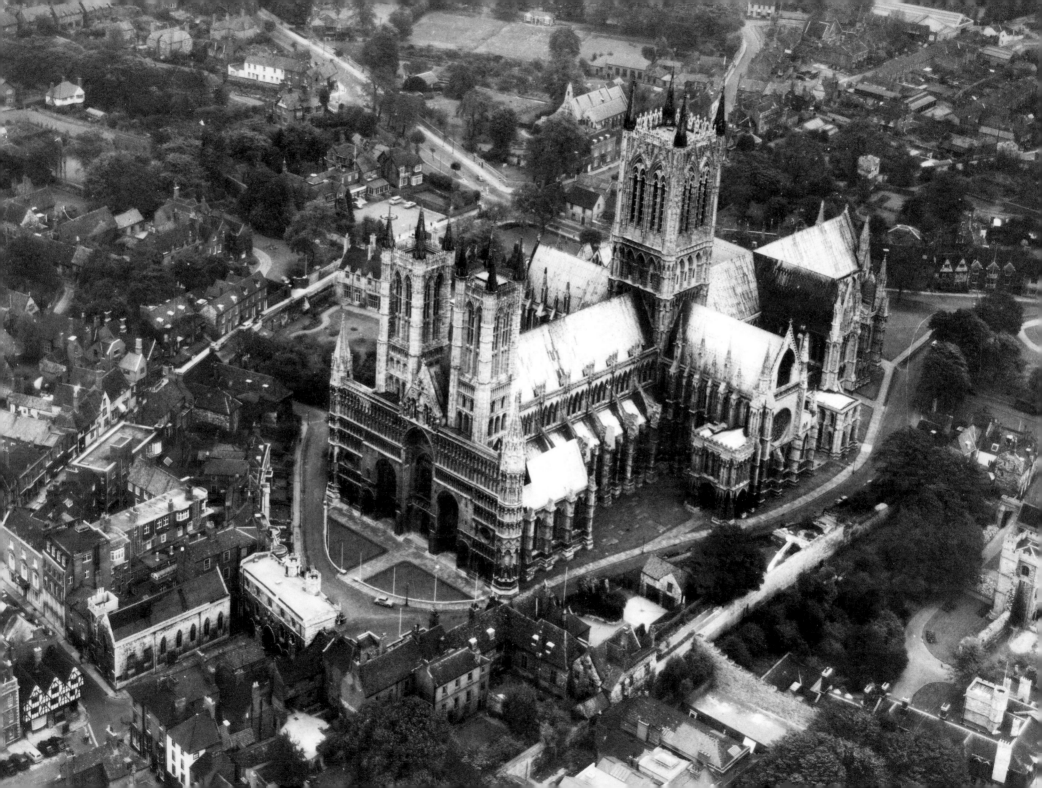

39 Elgin Cathedral, Grampian
On a much smaller scale than the great contemporary works at Salisbury and at Lincoln, Andrew of Moravia's cathedral at Elgin was nevertheless the product of the same economic forces, fitting also into the ecclesiastical mould of its period. It was Bishop Andrew's personal wealth that launched Elgin's building programme, and the high quality of the work is still evident today in the tiered lancets of the choir and in the impressive bulk of the twin-towered western show front. Cathedrals at this time were the recognized fortresses of a reinvigorated secular church. Bishop Andrew modelled his cathedral's constitution on that of Lincoln. Elgin's canons were to meet, as were those of both Salisbury and Lincoln, in an inspirational octagonal chapter-house, there to discuss and pass on the latest doctrine from the papacy at Rome, just then at the very summit of its power. The bishop himself had become an administrator, at the head of an impressive organizational structure only recently perfected in such general meetings of the Church as the Fourth Lateran Council of 1215, the crowning achievement of Innocent III. A fine cathedral was the frame that Bishop Andrew required. (1977)

down centrally at Innocent III's Fourth Lateran Council of 1215, and which was to be brought to completion by some of the greatest scholar-administrators the British Church has ever known, among them Robert Grosseteste of Lincoln.

A man like Grosseteste, known beyond his diocese as a mighty figure in the Church, could himself be influential in the progress of a building. And Lincoln Cathedral, as we know it now, owes a good deal to the draw of his name. But Grosseteste had behind him also the formidable resources of one of England's richest dioceses and the powerful reputation of St Hugh. Indeed, the Angel Choir at Lincoln, begun shortly after Bishop Grosseteste's death in 1253, was intended from the start to house the shrine of St Hugh, whose remains were translated there in 1280 when the work was eventually complete. Architecturally, the Choir is closely related to that other great contemporary shrine-building enterprise, Henry III's reconstruction of Westminster Abbey, while in its lavish deployment of Purbeck marble shafts it resembles the work at Bishop Poore's Salisbury,

completed just about as it began. In every one of these buildings, the hand of the king is clearly present. Henry III's revenues supported the transformation of Westminster into a receptacle for the body of St Edward. It was Henry III, with whom Robert Grosseteste had not always worked in harmony, who sanctioned the eastward extension of Lincoln's choir. At Salisbury, it was Henry III again, from his neighbouring palace at Clarendon, who helped finance the work, along with his wealthy relative, William Longespée, earl of Salisbury, an illegitimate son of Henry II and husband of that devout heiress, the Countess Ela, a great patron of the Church in her turn.

Unquestioning piety and the self-assurance of vast wealth: these were the props of a thirteenth-century optimism in building which, in the cathedrals as much as in the monastic houses, promoted programmes of unparalleled extravagance. Sometimes ambition over-reached itself. Henry III, despite heavy and continuous expenditure, never completed his remodelling of Westminster. At St Albans (Fig. 12), a further lengthening of the nave and a grandiose scheme for the west front of the abbey church, to be carried out in the new Gothic style, came to grief in humiliating failure. The present west front of St Albans is almost entirely Victorian. It replaces a compromise facade that William de Trumpington (1214–35) finished on the imperfect beginnings effectively abandoned by his predecessor, Abbot John de Cella (1195–1214). As the St Albans chronicler tells the story:

'Abbot John threw down to the ground the wall of the front of our church, built of ancient tiles and enduring mortar . . . He began to bring together beams and to accumulate no few stones, with columns and slabs. Very many chosen masons were summoned together, over whom was Master Hugh de Goldclif – a deceitful and unreliable man, but a craftsman of great reputation; the foundations were dug out, and in a very short time a hundred marks, and much more, not counting the daily allowances of food, were spent and yet the foundation wall had not risen to the level of the ground. It came about by the treacherous advice of the said Hugh that carved work, unnecessary, trifling, and beyond measure costly, was added; and before the middle of

the work had risen as high as the water table the abbot was tired of it and began to weary and to be alarmed, and the work languished. And as the walls were left uncovered during the rainy season the stones, which were very soft, broke into little bits, and the wall, like the fallen and ruinous stonework, with its columns, bases and capitals, slipped and fell by its own weight; so that the wreck of images and flowers was a cause of smiles and laughter to those that saw it. So the workmen departed in despair . . .'[8]

Despair again, although on this occasion of quite another kind, would have been the lot of a Welsh patriot confronted by the defences of Caerphilly (Fig. 40). Gilbert de Clare's great castle, begun *c.* 1268, is a monument to magnate wealth in the thirteenth century, as ambitious as any cathedral. Gilbert the Red, ninth earl of Clare, seventh earl of Hertford, and eighth earl of Gloucester, was a very rich man, wealthier by far than any magnate of England with the exception of the royal earls of Cornwall and of Lancaster. In Glamorgan, Earl Gilbert had the right, according to the law of the March, to build himself a castle without licence. His estates in South Wales were threatened by Llywelyn ap Gruffydd, placing as much as a third of his great fortune at risk, nor was he secure in the favour of the king. Gilbert de Clare had every incentive to build generously at Caerphilly, with ample means to complete what he had planned.

In the circumstances, Caerphilly was to be no ordinary castle. Earl Gilbert himself was an experienced soldier. Although only a young man at the time, he had taken a central part, first on one side and then on the other, in the baronial rising against Henry III. He knew the virtues of water defences, for he had participated in the prolonged siege of Kenilworth in 1266 when they had proved their value by keeping the royal forces at a safe distance. Moreover, he had grown up in a circle which included Prince Edward, later to become, as Edward I, the mightiest castle-builder of his day. Caerphilly is a very sophisticated fortress, far in advance even of a castle like Helmsley (Fig. 27) and in a totally different league from improvisations like Framlingham (Fig. 26), conversions from timber into stone. Most individual at Caerphilly is the great stone dam, protected by fighting

40 Caerphilly Castle, Mid Glamorgan
As impressive in its own way as the cathedrals of the same period was the great bulk of a magnate fortress like Caerphilly. Gilbert de Clare's Glamorgan estates, under threat from the Welsh, undoubtedly required protection in some degree. But Caerphilly is much more than a defence against local insurgents. Earl Gilbert's extraordinary wealth and his noble lineage, neither of which he did anything to conceal, promoted an uneasy relationship with the Crown. An experienced soldier with unusual resources to back him, he was able to employ the best military science of his time in the building of a fortress that was well-nigh impregnable but was also something of a personal monument. Notice especially the exploitation of water defences at Caerphilly, later more fully developed by a mighty stone dam and fighting platforms. On its inner island, the castle lacks a keep but has the concentric defences and strongly protected residential gatehouses that are characteristic again of Edward I's contemporary fortresses in North Wales. Much stress is put on the outer shield of the barbican and on maximizing the fire-power of the garrison, just as it would be at a castle like Rhuddlan. Earl Gilbert well knew, and so did the king, that it would take a powerful army to dislodge him. (1965)

platforms on the north and the south, which held back the waters of an artificial lake wide enough to make the use of siege engines impracticable. There is nothing like it anywhere else in the British Isles. Yet in other respects Caerphilly's design assembles all the elements already developed and tested in the best work of the period, whether in France or the Holy Land, and being employed contemporaneously in North Wales. As at Helmsley, where they had dated to the mid-thirteenth century, Caerphilly's barbicans – the dam and its fighting platforms to the east of the fortress, the great island of the hornwork to the west – are of particular elaboration and expense. They were to be protected themselves by subsidiary barbicans and by drawbridges of their own, while the gates they guarded were those of an outer ward, commanded by the lofty mural towers and the opposing gatehouses of Earl Gilbert's central enceinte.[9]

What Caerphilly demonstrates is the full development of concentric castle planning, as first practised systematically a century before in the layout of the defences of Dover. It had been Henry II's son and his grandson, John and Henry III, who had refined the outer curtain at Dover. But already Henry II's engineers, having completed Dover's keep and its towered inner curtain, had begun work on an outer ring as well.[10] The precedent was taken up at the Tower of London, which owes its inner ring of towers to Henry III, its outer to Edward I. And in the 1270s, it had come to be recognized, in South Wales as elsewhere, that the efficiency of a castle would depend on these rings: not on one alone, but on several. After these in importance came the gates.

Caerphilly's outer defences, particularly obvious on the photograph, are the waters of its lakes and its moats. But look again at the serried gatehouses, one behind the other, of its vulnerable east front, and consider especially the arrangements on the central island at Caerphilly, where the tall inner curtain, strongly towered at the angles, both overlooked and commanded an outer ward which was itself a major line of defence. At Rhuddlan (Fig. 41), in Clwyd in North Wales, Edward I was building himself a new castle at exactly this time which

41 Rhuddlan Castle, Clwyd
Of Edward I's ten Welsh fortresses, six were of especial importance, one of these being Rhuddlan. Rhuddlan and its neighbour Flint were the first of these North Welsh castles, to be followed by Conway, Caernarvon and Harlech as a group, with Beaumaris as the last and most perfect. It was Edward I's imported Savoyard engineer, Master James of St George, who designed and built Rhuddlan in 1277–82. And his experience and sophistication can be seen here already in the mobility his plan encouraged among the defenders. Like Caerphilly, Rhuddlan is a castle of gates. Strong double-towered gatehouses cut off the east and west corners of the inner ward. There are four further gates in the outer ward, with sally-ports opening onto the moat. Some of these gates and posterns were to be blocked in the next generation. However, their presence in Master James's initial plan demonstrates very clearly that a castle like Rhuddlan was not to be seen as a retreat but as an active instrument of aggression and of war. Notice in particular the concentricity of Rhuddlan's design, its geometry broken only on the western quarter where the land slopes down towards the river. Each ring of defences was overseen by another, becoming a succession of traps for the assailant. At high and eventually at crippling cost, Edward I's castles left nothing to chance. (1971)

incorporated many of the same principles as Caerphilly. Rhuddlan does not have now, nor did it ever enjoy, the water defences of Caerphilly. But its mural rings are at least as systematically developed as those of Earl Gilbert's mighty fortress, and they make use again of that same device of a low outer curtain, defending a ward which, in the event of successful assault that far, could become just a murderous trap. Like Caerphilly, Rhuddlan makes do without a keep. In compensation, the principal inner gatehouses at each of these castles are of unusual size and strength, accommodating (as a keep might otherwise have done) important elements of the garrison. These were castles designed, with great sophistication and inevitably at high cost, for the active government of a potentially hostile community. They had to be as easy to get out of as they were hard to get in. No besieging force, encamped beyond the walls, could feel safe from assault from within.[11]

Rhuddlan's master mason was James of St George, a native of Savoy whose wide experience of castle-building in different terrains enabled him to respond appropriately to each new setting. Thus at Flint, just along the coast from Rhuddlan, Master James built a moat-defended tower at an angle of the inner ward, which he probably modelled on the Tour Constance at Louis IX's Aigues-Mortes. Harlech, in contrast, was built high on a headland, where the small space available for outer defences had to be compensated for by the exceptional

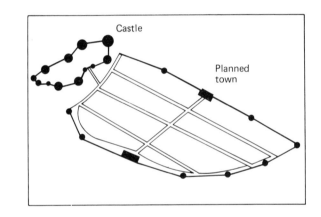

of the upper ward (left, nearest camera). But the remedy came in multiple mural towers, massively octagonal, commanding every face and aspect of the great curtain. Caernarvon gains its effects by height, by mass, and by a splendid skyline. It is particularly dramatic seen across the water, where its multangular towers and its banded masonry, standing out most clearly, deliberately evoked, to those that knew them,

42 Caernarvon Castle, Gwynedd
Grandest of the North Welsh castles, and politically the most significant in the conquest and successful annexation of the principality, was Edward I's personal fortress at Caernarvon, birthplace of the first Plantagenet Prince of Wales. Caernarvon's uncharacteristically irregular plan was owed to an earthwork castle formerly on the same site, of which the mound became the make-up

the Theodosian defences of Constantinople. Behind the Edwardian castle, Caernarvon's contemporary borough is again strongly walled. Like the castle itself, this 'planted' town – its single date showing obviously in the uniform grid of its streets – was an element in the permanent settlement of alien territory. It provided a sheltered base for the officials charged with governing North Wales, as well as the nucleus for regional trade. (1953)

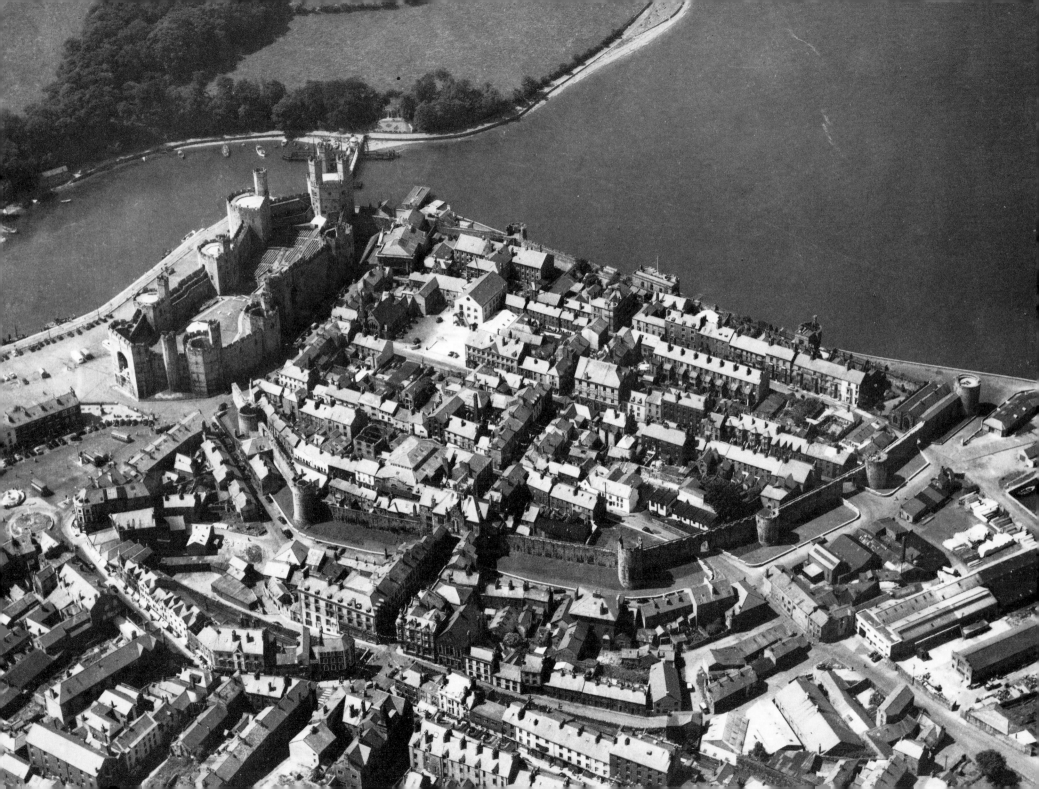

development of the castle's gatehouse, almost to the point of converting it into a tower-keep. Conway got its strength from its eight drum towers and from the particular elaboration of its barbicans, while Beaumaris was to be the ultimate essay in concentric defence, characterized by a Renaissance-like symmetry. Yet it is Caernarvon (Fig. 42), its narrow-waisted plan predetermined by an existing fortress, that has most to tell us about the politics of Edward I's conquest of North Wales. It was at Caernarvon that the first Plantagenet Prince of Wales, Edward of Caernarvon (later Edward II), was born on 25 April 1284. The fortress was to serve, in later life, as a symbol of the union between the peoples.[12]

It was to prove an unwelcome union, both then and later, and its irreversibility required to be publicly stated. Harlech's eye-catching clifftop location was not chosen for military reasons alone, nor did Conway, whitewashed and beflagged, trouble to minimize its strength. Still more than the others, Caernarvon particularly had a role to play in emphasizing the permanence of Edward's settlement. Caernarvon was to be the residence of the representative of the Crown in the principality, the birthplace and headquarters of Edward's heir. Accordingly, little was spared in its construction and embellishment. An entirely mythical association with the Christian emperor Constantine, thought to be useful to the English king, was picked up in the distinctive banded masonry and multangular towers of Caernarvon, modelled on the Theodosian defences of Constantinople. On Caernarvon's largest tower, especially prominent at the western tip of the fortress, great sculptured eagles were to echo the legend of the imperial connection, crowning each of the pinnacle-like turrets. Meanwhile, sheltered by the castle, which it adjoined on the north with the waters of the Menai Strait to the west, was the little borough, again formidably defended, which was to be another planned element (as at Rhuddlan and at Flint) of the new English presence in North Wales.

Edward's six great castles, ringing the coast, constituted a systematic programme, ultimately successful, to overawe and subdue the native Welsh.

Together, they display contemporary military thinking at its most professional. But they were to require a deployment of resources and an expenditure of capital which even Edward's considerable revenues could not bear. Among the reasons for Master James of St George's failure to complete Beaumaris was the diversion of the royal armies to Scotland. And it was England's empty treasuries, drained in North Wales, that helped the Scots beat off the most serious invasion threat in their history.

The Scottish victory over England was not immediate. For decades, in the wake of the succession crisis and interregnum of 1290–2, the independence of Scotland remained in jeopardy. Nevertheless, a strong national identity had been shaped already during a century and more of relative prosperity under William the Lion (1165–1214) and his able successors, Alexander II (1214–49) and Alexander III (1249–86). The circumstances were right for patriot leaders – William Wallace and Robert Bruce – to emerge and to command a following. They could work from a recognizable base.

Scotland's gravest handicap, immediately obvious in the contest with Edward's war-hardened troops, was its shortage of well-equipped heavy cavalry. William Wallace, for one, was to suffer from this at Falkirk in 1298. And there remained in his time far too few knights and esquires amongst Scotland's nobility prepared to come out unequivocally against the English. Andrew Moray, who was Wallace's co-commander in the successful rising of 1297, had been one of those few. As a member of a family which had only recently raised itself by marriage into the landed aristocracy, acquiring great wealth in the process, Andrew Moray was representative of that strong ruling class which Scotland badly needed to protect its territories but which had barely begun to emerge.

Characteristically Walter, founder of the Moray family fortunes, was also in his day a castle-builder. Bothwell (Fig. 43) had come to Walter Moray by marriage into the Olifard inheritance, and he used his wife's wealth to begin a great fortress of astonishing ambition and sophistication. As laid out at first, with a bold

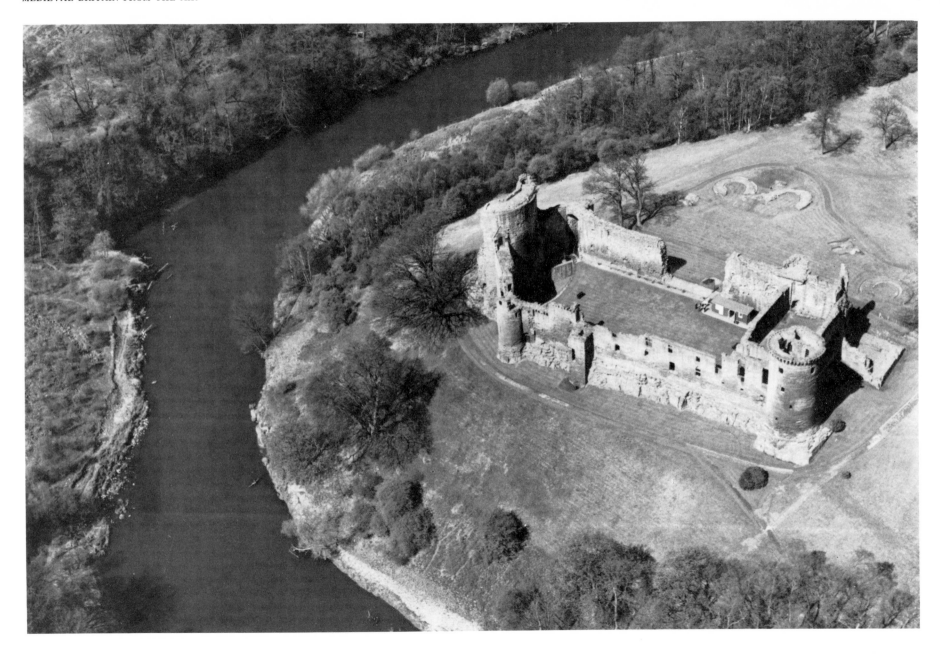

towered gatehouse to the north of the castle showing now only as foundations, Bothwell was far too grandiose to be completed. In many of the details of its plan, Walter Moray's Bothwell resembled Coucy, the home of Alexander II's French queen. But it was obviously out of scale with the Morays' resources, as it was with those of the Scottish nation which the family was helping to build.[13] In the event, the planned northern court of the kite-shaped fortress stayed where it was, at foundation level. Yet the high quality of the late-thirteenth-century masonry at Bothwell, particularly evident still in the great Coucy-like tower at the west end of the enclosure, is significant in itself, nor was it unique in its period. Not seen again afterwards in medieval Scotland, such quality is an indication of the optimism of the times and of the nation's drive towards what it saw as civilization.

Many of Scotland's leaders, including initially the Morays, had worked closely with the English, fighting alongside them in their wars. Consequently, Scottish castles of this time may reflect English influence as much as French, nor is it always entirely certain whether it was the English or the Scots who first planned them. Caerlaverock (Fig. 44) is a case in point. A perfect triangle in plan, Caerlaverock's links are clearly with the Edwardian fortresses of contemporary North Wales and with the geometric tastes of the royal master masons, Walter of Hereford and James of St George, both of whom served also against the Scots. The

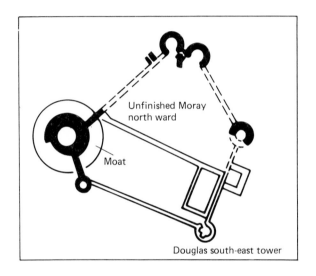

Unfinished Moray north ward

Moat

Douglas south-east tower

43 Bothwell Castle, Strathclyde
Although the science of fortification was well enough understood in mid-thirteenth-century Northern Europe, the means were not always present to match up to it. Bothwell, laid out over-ambitiously in the third quarter of the century, was to be the fortress of one of Scotland's wealthiest families, very probably modelled on the great French castle at Coucy, itself only recently completed. Certainly, Bothwell shares Coucy's drum-like keep,

entirely circled by a moat of its own. Moreover, as originally planned, it would have had the kite-like outline of Coucy again, although here was where compromise set in. Bothwell's tower-keep and the adjoining spur walls are of the first building period. But the defences of the great ward to the north (top), including a projected double-towered gatehouse, seem never to have risen above foundation level, their cost exceeding the resources of the Morays. It was only much

later, when the Douglases held Bothwell at the turn of the fourteenth and the fifteenth centuries, that Bothwell's inner ward, east of the great tower, acquired its present rectangular outline. At the south-east corner, a fine machicolated tower (bottom right) is again characteristically French, although of a generation far removed from Coucy. It no doubt stems from the experience of the Douglas earls in France, where they took their part in the wars against the English. (1968)

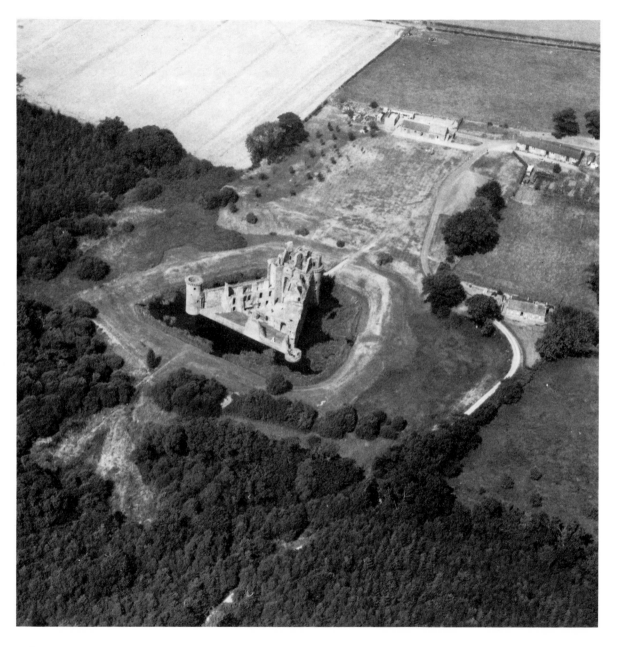

44 Caerlaverock Castle, Dumfries and Galloway

The bold professionalism of late-thirteenth-century castle design is nowhere better illustrated than at Caerlaverock, an Anglo-Scottish fortress. Caerlaverock has experienced many rebuildings. However, its unusual triangular plan with a strong keep-gatehouse at the apex on the north, belongs securely enough to the castle's earliest building period, certainly no later than the 1290s. Very similar residential gatehouses had been a feature already of such castles as Caerphilly, Rhuddlan, and Harlech. At Caerlaverock, the superior quality of the earliest masonry and the overall sophistication of the design, while not unparalleled in contemporary Scotland, suggest the hand of an English or other imported military engineer, supported by generous funding again hard to find in the North. A castle like Caerlaverock, finely built to a regular plan, was the source of satisfaction to contemporaries as much as to ourselves. Like Harlech on its rock, or Conway and Caernarvon on their waterfronts, Caerlaverock had its purpose as a statement of authority, as important in times of peace as in the wars. (1976)

situation of the castle could well be seen as best suited to an English bridgehead on the coast. But the debate on origins is largely immaterial. Until 1297 and often later, Scottish castle-builders were quite as likely to enjoy the confidence of their acknowledged overlord, the English king, as were their equivalents in the South. If Caerlaverock's fully worked-out concentricity is rare in Scotland and its keep-gatehouse is the earliest in the country, it was Scots, nevertheless, who defended the fortress against Edward I in 1300:

'. . . so strong a castle that it feared no siege before the King came there . . . In shape it was like a shield, for it had but three sides round it, with a tower at each corner, but one of them was a double one, so high, so long and so wide, that the gate was underneath it, well made and strong, with a drawbridge and a sufficiency of other defences. And it had good walls, and good ditches filled right up to the brim with water. And I think you will never see a more finely situated castle . . .'[14]

Of course, successive demolitions followed by rebuildings have robbed Caerlaverock of much of its earliest character. Yet the pure geometry of its design is very much of the period, as is the quality of the masonry which again, like Bothwell, was highest in the first phase of building. This manifest sophistication, obviously present in military architecture in the North, was to show itself equally in other branches of Scottish society. It had been for political reasons as well as religious that Scotland's kings of the Canmore dynasty had promoted and endowed their nation's Church. And just the same motives encouraged their support of the fledgeling towns, barely known as yet in Scotland before the twelfth century and yet essential to the economic growth of the kingdom. Among the ways in which David I helped promote his brother's new monastic cathedral at St Andrews (Fig. 28) was by granting leave to Bishop Robert to found a burgh, the principal streets of which may still be seen to focus on the ruins of the former cathedral priory.[15] Just to the south, the little town of Crail (Fig. 45) seems to have become established no earlier than the first years of the reign of William the Lion,

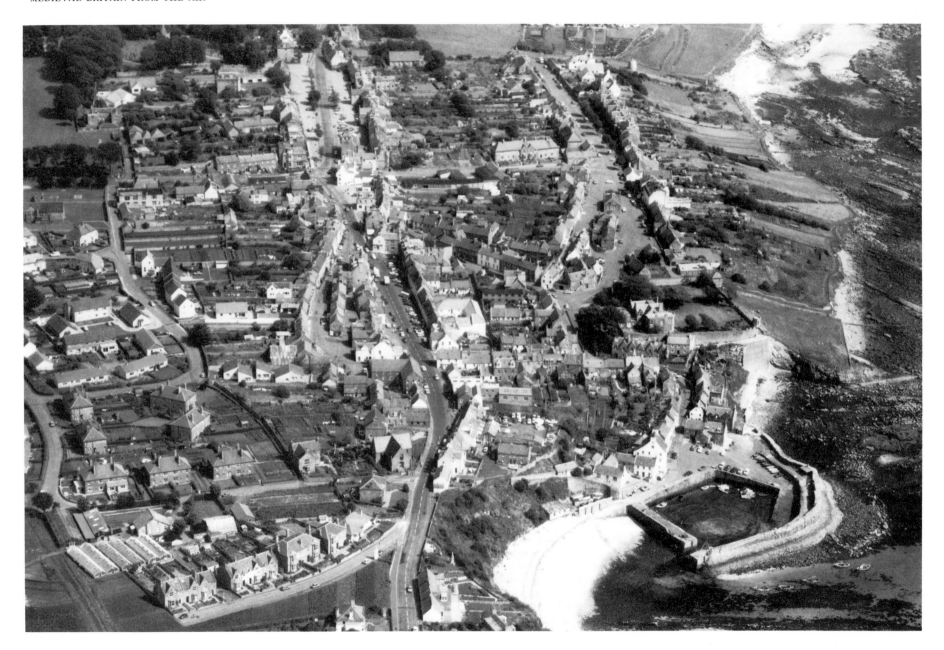

being one among an obvious concentration of such ports – including the much larger Perth and Dundee – along the line of the prosperous east coast.[16]

Crail stretches from the former castle site, just above the harbour at the south-east corner of the town, northwards to the parish church at the opposing angle. Between them, the burgh's two parallel streets suggest an original planned layout. But Crail's most striking characteristic is the swelling of both streets, towards the harbour, into large market spaces, each of them now colonized by shops.[17] All this development, between castle and church, is likely to have occurred within the final decades of the twelfth century. And it signifies a quickening of economic activity which, although especially true of the fortunate eastern lowlands, touched also the remoter west coast where twelfth-century Glasgow, well situated on the Clyde, was another fast-growing cathedral city, second only to St Andrews in the east.[18] Naturally, it would never do to make too much of Scotland's medieval urbanization. Glasgow's population in the mid-fifteenth century was only fifteen hundred or so, and the more than fifty so-called 'burghs' of the kingdom, many of them scarcely bigger than villages, continued to house a tiny fraction of the Scots. However, the burgesses of Scotland, like its churchmen and its nobles, enjoyed an influence and esteem always totally out of proportion to their numbers. By the thirteenth century, they had taken control of the nation's overseas trade, over which they had acquired a monopoly. Internally, too, they had rights and privileges superior to most in the land. King and burgesses

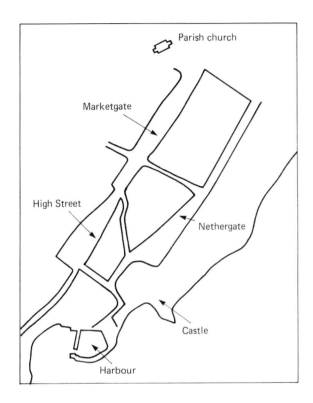

45 Crail, Fife
The port of Crail was one of those boroughs, especially characteristic of the east coastal plain, which developed under royal sponsorship in the twelfth century. Its first growth occurred between the harbour and the king's castle, just above the haven to the north. Then Nethergate (right) was laid out as the earliest market street, to be followed by High Street (left) and its subsequent extension northwards into Marketgate. Crail's parish church, at the north-west corner of the town, was there already before the end of the twelfth century, to be substantially enlarged and rebuilt in the thirteenth. The expansion of such artificially promoted towns being market-based, the swelling of Crail's streets to accommodate markets is a particularly obvious feature of its plan. Marketgate, south of the church, was the last of these spaces, and may be as late as the sixteenth century. Nearer the royal castle and the haven, both Nethergate and High Street broaden to the south, though the subsequent permanent colonization of former open market-places has partly obscured the original twelfth-century arrangements. (1980)

prospered together, the tacit exchange of protection for the gathering in of the royal customs being a partnership beneficial to them both.[19]

Included among those in Scotland against whom the burgesses had secured their protection were the 'earls, barons, or secular persons', who at this time similarly were experiencing exceptional prosperity. The peace of the Alexanders, favouring the towns, had also brought new confidence to the countryside. Alongside the greater castles – Bothwell and Caerlaverock, Dirleton and Kildrummy – there had come to be room by the late thirteenth century for another class altogether of stone-built hall-houses, only lightly protected, of which Morton (Fig. 46), in Dumfries and Galloway, is one of the more complete survivals. Morton was a handsome building, originally expensively finished, attractively placed on its promontory overlooking the loch. A great first-floor hall, with undercroft below, had a fine range of windows on the landward side, where there were also other windows lighting the ground floor, making of the whole an impressive show-front. Defence was not ignored at Morton. A tall gatehouse of two towers, only one of which survives, was built at an oblique angle to the hall, giving access to a small courtyard towards the lake. At the far end of the show-front, another tower projected from the second landward angle where it might have offered some protection to that front. But Morton was a secure country-house – a defendable rural palace – much more than it can ever have been a castle. It could resist a brigand or turn away a thief. It could not have survived a lengthy siege.[20]

Such a house 'as thieves will need to knock at ere they enter' was exactly what the English chancellor, Bishop Robert Burnell, was building himself contemporaneously at Acton Burnell (Fig. 47), as was Lawrence of Ludlow at Stokesay (Fig. 48). Both houses are in Shropshire, towards the Welsh March, and both have come to be known as castles. Nevertheless, it is plain that each, like its Scottish equivalent at Morton, had been planned at least as much as a country mansion, in which the principal accent was on comfort and convenience. Robert

46 Morton, Dumfries and Galloway

One of the products of good government in
twelfth- and thirteenth-century Scotland was a
modest but significant urbanization; another,
lasting only as long as that good government
persisted, was a degree of security in the
countryside. Morton is a rural manor-house,
built towards the end of this period of relative
peace, in which fortification is clearly
secondary to the lord's comfort. Its principal
apartment is a grand first-floor hall, well lit
by large windows on the landward quarter
which, of course, was the most vulnerable to
attack. Morton's obliquely-set gatehouse and
circular angle tower provided covering fire
along the line of this facade. On the
promontory side (facing the camera), a small
court was protected by a strong wall. But had
the owner of Morton chosen to do so, he
could have built more securely than this. Like
others of his class, he had come to place his
confidence in a rule of law which the Wars of
Independence would shortly destroy. (1980)

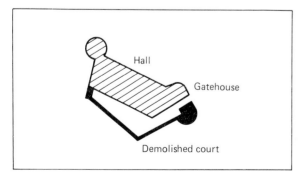

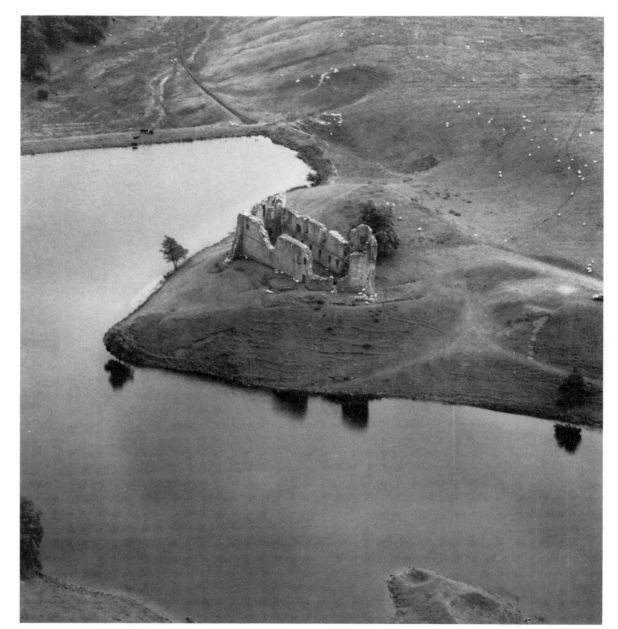

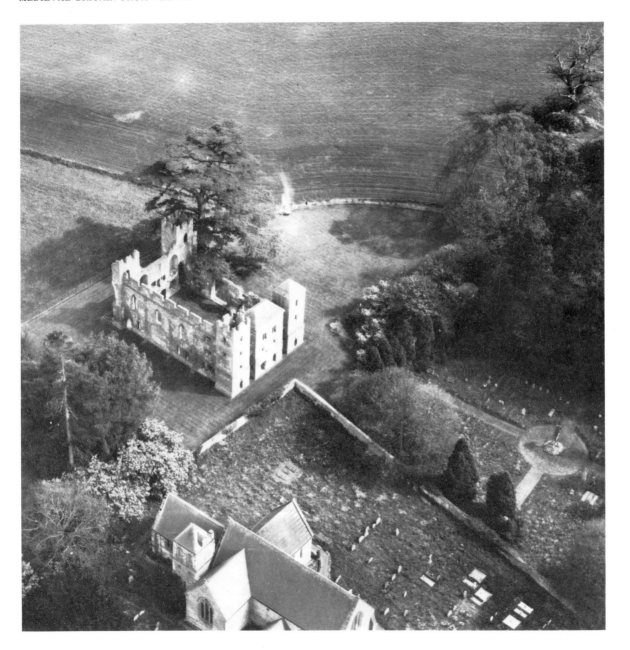

47 Acton Burnell, Shropshire
In England, as in Scotland, when a wealthy man chose to build himself a house in the late thirteenth century, he could feel safe behind token fortifications. Acton Burnell, although now called a 'castle', is in fact nothing of the kind. It is a rebuilding of the family manor-house by Robert Burnell (d.1292), chancellor of England and bishop of Bath and Wells, and its defences are very largely for display. Acton Burnell's accommodation is appropriately spacious, with well-lit apartments on the two principal floors, and with a comfortable private suite for the bishop himself on a third stage in the central western tower (right). A grand building like this might be dressed up as a castle, with angle towers and with prominent crenellations. But it functioned much more obviously as a country palace, for which the king's peace was the principal guarantee and protection. Any assailant here, despite Acton Burnell's remote Shropshire location, would have Edward I and his successors to reckon with. A royal chancellor deserved nothing less. (1972)

Burnell and Lawrence of Ludlow were wealthy men – the one a royal servant of exceptional ability, the other from a dynasty of wool-merchants. It was their wish to establish themselves in houses of appropriate dignity, but it must be doubted whether either, in his own time and context, ever felt seriously threatened or at risk. Notice the entirely domestic situations of both these putative fortresses. They adjoined parish churches as a manor-house might do, and they were there because manors had preceded them.

Of the two, Acton Burnell is even less of a castle than Stokesay. True, the building is fearsomely crenellated. It has stout towers at the corners, and was no doubt intended to chill and deflect the aggressor. Yet its entrances on the ground floor are broad and unprotected, and the windows at this level are generous also, impossible to make secure in an emergency. Significantly, the only direct access to the wall-walk, or defensive platform, behind Acton Burnell's crenellated parapet was by way of the chancellor's private apartments on the top stage of the rectangular western tower. Robert Burnell, as a very great man, clearly valued his privacy, for which he was prepared to pay highly. The whole layout of his building, exposing petitioners and other visitors to a series of filters before penetrating to the presence of the bishop, was obviously designed to protect it. He would not have welcomed the intrusions of the watch.[21]

Acton Burnell is a one-period building. At Stokesay, in contrast, the north tower (next to the church) pre-dates the rest, while the gatehouse is a late-sixteenth-century rebuilding. However, the main features of the castle remain Lawrence of Ludlow's, and they show a blatant carelessness in the dispositions for defence which would have been inexcusable in a military engineer of the same period. Stokesay's principal defences are probably datable to the early 1290s. They followed the grant of a licence to crenellate in 1291, and were thus the precise contemporaries of the enclosures of castles like Caerlaverock (Fig. 44) or Beaumaris, with which Stokesay had nothing in common. There is little sophisticated about Stokesay's fortifications. They included a water-filled moat

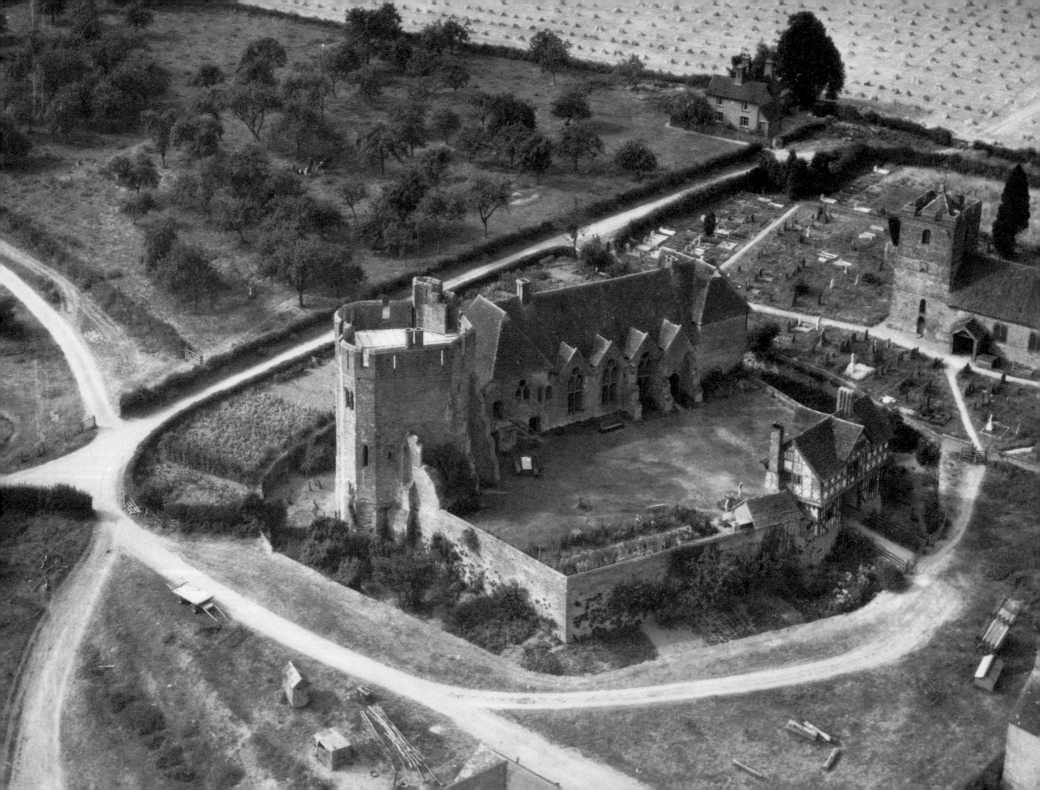

48 Stokesay, Shropshire

Another Shropshire 'castle', contemporary with Acton Burnell and a prey to the same contradictions, is Lawrence of Ludlow's fortified manor-house at Stokesay. Like Chancellor Burnell, Lawrence of Ludlow was a very wealthy man, one of England's most successful traders in wool. He could have afforded the latest fortifications had he wanted them. However, Stokesay is primarily a comfortable residence, which started with an earlier tower almost next to the parish church, and which then grew out lengthwise as hall and solar blocks were added, to be rounded off by another tower on the south-west (left). Stokesay's setting is domestic, and its general appearance has been made more so by the addition of a Late Tudor timber-framed gatehouse (right). But the present image is not far from the truth. Even in Lawrence of Ludlow's day, when the moat was water-filled and when the courtyard wall was considerably higher than it is now, great windows pierced the outer walls on the west. A determined intruder, having swum the moat, would have had no real difficulty getting in. Such confidence was impressive but was by no means exceptional in the late thirteenth century. It was only afterwards that the rich, exposed by weak government, took more care in the threatened areas to protect themselves. (1947)

and a strong curtain wall, much higher than the curtain as we now see it. But those large two-light windows which are such a feature of Lawrence of Ludlow's great hall on the courtyard side, are repeated as generously on the more vulnerable west front. If Lawrence had feared for his personal safety, he would have had no alternative but to retreat to his mighty angle-tower, which was indeed part of the 1290s refortification.[22]

In effect, Stokesay Castle was nothing more than a thirteenth-century moated manor-house of conventional design – great hall at the centre, with a residential solar block at either end – to which a substantial tower-house had then been added. Such large-scale tower-houses, apartment-filled, would be met again quite commonly in the later Middle Ages: in Scotland, at Hermitage (Fig. 64); in England, at Wardour (Fig. 58) or at Tattershall (Fig. 81). They were usually French-influenced, and might be built with considerable splendour and great dignity. But what they also represented was the lesser man's attempt to come to terms with two requirements – the first of these being the construction of a house that was at least adequately imposing, the second the protection of worldly goods. Few private individuals, even among magnates and great churchmen, could contemplate building to match the scale of just one of Edward I's North Welsh fortresses. In its place, what the tower-house conferred on its builder, rising above the trees as a church tower might do, was dignity at an affordable price. Valuable plate and linen might be locked away. The tower itself, in times of grave trouble, could serve as a temporary retreat. But government existed to protect law and order, and a country-house builder like Lawrence of Ludlow had evidently come to rely on it. A wool-merchant paid his taxes to leave the fighting to others. His concern was with a different profession.

4 Hearth and Home in the Late Middle Ages

Plainly, what many castles shared in late-thirteenth-century Britain was a common emphasis on high quality and great cost. Standards everywhere had risen, and landowners were equipped, at this period in particular, to gratify their instincts to live well. Nevertheless, all was not as it ought to have been, with catastrophe just round the corner. Increasingly through these favourable years, a rising population had driven men out onto the margin. Some had failed there already before 1300. On the older established manors and on the champion lands, crowding was endemic and getting worse. Throughout Britain, the best soils were being required to feed more mouths than the crops could adequately sustain.

Depending on one's viewpoint, the major demographic crisis of the mid-fourteenth century can be interpreted as a disaster or a relief. Indeed, historians are still unable to make up their minds whether the Black Death (1348–9) did more harm to the economy than good. However, what is also now obvious is that some levelling-off had begun rather earlier. The agrarian reverses of 1315–22, brought about by successive harvest failures and by sheep and cattle murrains, might have been overcome more readily had the population not already been excessively calamity prone. The poor, in these years, had very little fat left to live on. The rich, confronted by starvation and by the desperate violence of the hungry, lost their nerve.

Among the relics on today's landscape of this time of despair are a number of half-completed projects. Kirkham Priory (Fig. 33), certainly, had experienced

49 New Winchelsea, East Sussex
Many had prospered in the fortunate economic circumstances of the thirteenth century, and when New Winchelsea was laid out in the 1280s, a mood of optimism still infected the planners. In the event, Edward I's planted town was to be one of the more obvious casualties of the recession. What is now under grass to the south (bottom) of the built-up area was originally settled in the early fourteenth century when the borough enjoyed its only major period of prosperity. But many building plots, even then, were never taken up, and other projects – the parish church among them – languished as the fortunes of Winchelsea descended. In the middle of today's settlement, the church of St Thomas (one of originally two parish churches in the new borough) can be seen to have been allocated a full block, or 'quarter', by the planners. What was built, very grandly, was the chancel alone, and it is this that now does duty as the parish church. Work halted at the crossing; neither tower nor transepts were ever completed; the nave, though projected and allowed-for across the width of the quarter, was not begun. The struggle with France, gathering pace in the second quarter of the fourteenth century, was a particular misfortune for Winchelsea, in its exposed Sussex coast location. But this was the time too of the onset of plague, and those who might once have come to settle the new town found themselves in demand, much more temptingly, elsewhere. (1964)

more optimistic times, and we have seen already how the grand rebuilding of the mid-to-late thirteenth century had come to an end there soon after 1300. But Kirkham's canons were not unique in their troubles. From the king's unfinished castle at Beaumaris, in Anglesey, to a very much smaller project like the Delamere rebuilding of a family church at Northborough, abandoned with just the south transept complete, the story was frequently the same. Ambition, soaring in better times, had had to be curbed when they ended.

Among the more complete of the failures attributable to these years was that of the royal borough of New Winchelsea (Fig. 49). Coastal erosion and damaging

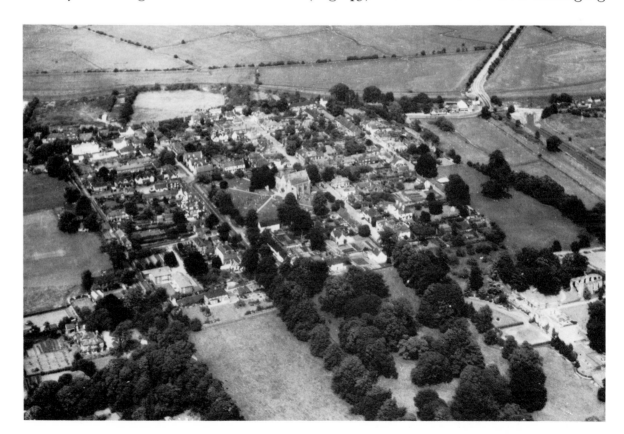

storms, at their worst in the mid-thirteenth century, had made Old Winchelsea so vulnerable by 1280 that Edward I was persuaded to take a hand in the re-siting of a community, one of the Cinque Ports, which had long been of material assistance to him in the defence of the south coast. It was in 1280 that Edward acquired the manor of Iham, secure on its hill, commissioning his officers to lay out a new borough there not later than 1283. New Winchelsea started with every advantage. It had the wealth and trading connections of the former town, shortly to be swallowed altogether by the sea. Moreover, it had the favour of a king whose engineers, having learnt their trade already in North Wales and in Gascony, were experienced town planners, accustomed to setting out the grid of streets and 'quarters' which remains Winchelsea's most striking characteristic. As originally planned, Winchelsea was to have been a major borough, fully equipped with broad thoroughfares, with two parish churches (both re-located from Old Winchelsea), a friary, a market, and stone defences. Its thirty-nine quarters were laid out generously through the grid, and a fair proportion, in these earliest years, were indeed immediately subdivided and settled. Yet already by the 1330s – well before the French coastal raids of 1360 and 1380 could lay their final blight on the community – Winchelsea's young economy was in retreat. What remains settled today of Winchelsea's quarters is a small part only of the king's original plan for the borough. The church of St Thomas, now centrally placed, was to have been set towards the north-east angle of a much larger community, extending to the south and south-west. Assigned a full quarter of its own, the church itself is no more than the merest fragment, lacking crossing and transepts and the much larger nave with which, originally, it had been the intention of its builders to supply it. Yet one reason, undoubtedly, for their failure to do this had been over-ambitious beginnings. Winchelsea's surviving chancel can compare in bulk with many parish churches elsewhere that were fully completed, and was more elaborately furnished than most. Its spectacular window tracery and internal fittings, characteristically complex, are in the most expensive Decorated

tradition. Its rich canopied wall-tombs, commemorating successive Admirals of the Cinque Ports, are among the most ornate in the country.[1]

Winchelsea's sad chronicle of storms and of plague, of violence and of a faltering economy, was to be repeated throughout Britain at varying levels and in differing degrees of intensity. Some communities, as is always the way, continued to do well in these circumstances. But they did this too frequently at the expense of their neighbours, and the retreat from the agricultural margin was very general. Old Winchelsea's fatal storms were merely one manifestation of an overall climatic deterioration, to be felt most keenly on the waterlogged coastal plains and on the thin cold soils of the uplands. Those earlier reclamation programmes of the more optimistic years – in the Cambridgeshire fenlands, in Yorkshire north of the Humber, in coastal Kent, and in Sussex on the Pevensey Levels – had come to an end well before 1300, to be succeeded by defence against the sea.[2] On Dartmoor and in similar exposed upland contexts, the retreat of the peasant cultivator had begun.[3]

Bodmin Moor, in the remote South-West, was one of the uplands so affected. There, on Garrow Tor (Fig. 50), fields that had been under cultivation in the thirteenth century, leaving their boundaries as a scar on the landscape, ceased to be viable in the centuries that followed. Occupation at Garrow, as the archaeological record suggests, could have continued as late as the fifteenth century.[4] However, there was little at this point to keep men tied to the hostile soils when there were opportunities in plenty on the more welcoming ones. It was not a change in the weather alone that drove the Cornishman of Garrow from his plot. Only a few settlements – and Garrow was not among them – succumbed absolutely to the plague. Rather, what happened in Britain generally in the later Middle Ages, shifting the balance on the land, was a redeployment of resources as plague mortalities robbed the landowner of his advantage and as labour, increasingly in demand on the champion lands, could at last begin to claim a fair price.

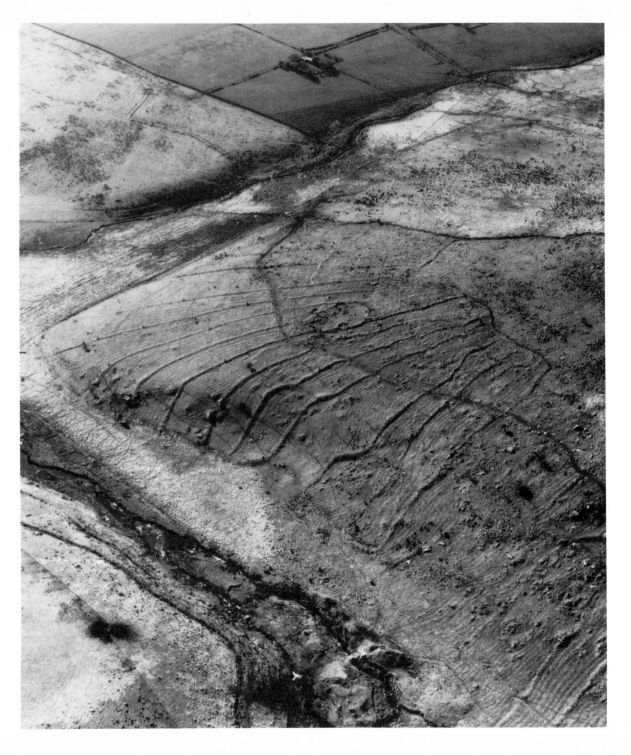

50 Garrow Tor, Cornwall

Winchelsea's re-siting was a direct consequence of the swallowing-up of the old borough by the sea. Of course, coastal erosion can happen at any time, and still does. However, in Old Winchelsea's case this had been aggravated by a succession of violent storms which themselves accompanied a pronounced deterioration of Britain's climate. Another consequence of climatic change was the abandonment of lands now too barren and too cold to sustain productive arable farming. At Garrow Tor, on the moors above Bodmin, the medieval fields that have left their mark on the landscape have remained uncultivated since the fifteenth century, and may well have been abandoned even earlier. Here field boundaries and ridge-and-furrow indicate an intensity of cultivation that could only have been worthwhile in more crowded times and when the sun could be relied upon to shine more strongly. There was nothing to hold the peasant cultivator on thin soils like these when better lands beckoned from the valleys. (1966)

51 Wharram Percy, North Yorkshire

At the other end of the country from Garrow Tor, the much larger and better-situated settlement at Wharram Percy, on high ground in North Yorkshire, was similarly experiencing difficulties from as early as the first decades of the fourteenth century. Final depopulation did not take place at Wharram until the 1490s, when the village and its fields were enclosed. But the erosion of settlement had begun much earlier, one of its consequences being a steady shrinkage of the parish church (centre left), which had lost both north and south aisles before the sixteenth century, although not eventually closed for worship until quite recently. In 1349, Wharram Percy and its neighbours were visited by the Black Death, and the plague and its recurrences may indeed have contributed to the retreat of peasant settlement on the Yorkshire Wolds. However, a more likely cause of the abandonment of Wharram's longhouses and garden plots – both clearly visible at foundation level under the snow (bottom right) – would have been the deliberate decision of the villagers themselves to move to a more favourable environment. Only after the men of Wharram had left their village was the land free for the enclosers to move in. (1978)

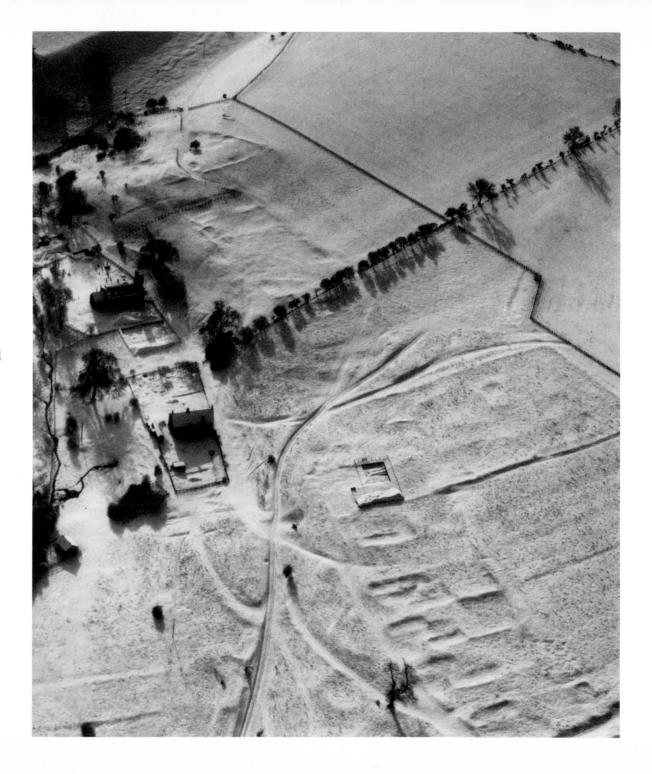

Garrow and its kind, the so-called 'lost' villages of England, have been remembered with sentiment and regret.[5] But, in truth, the slow drain of peasant cultivators away from such marginal settlements in the Late Middle Ages was to be determined as much by themselves as by their landlords. Wharram Percy (Fig. 51), high on the Yorkshire Wolds, was among the many villages which, in trouble already in the fourteenth century, then took a long time to die. Wharram has been meticulously excavated over the last decades, the result of this work being a settlement sequence which has been established with unusual precision. Within the historical period, the parish church at Wharram (showing roofless and black against the snow) may have originated as early as the eighth century. It had become a substantial stone building, even in this remote locality, before the Conquest, to be extensively rebuilt just before 1200, and to reach its maximum extent in the half-century preceding the Black Death. In the village itself, the late twelfth century was similarly a period of rebuilding, while the settlement was evidently at its largest and most prosperous during that century, continuing so through the next. Yet before the 1320s, and probably as a consequence of the agrarian crisis of the previous decade, decline had already set in. The Black Death, we know, visited Wharram in 1349. But it struck at a community already on the move by that time, although not finally dispersed by deliberate depopulation until as late as the 1490s.[6]

When the enclosers came to Wharram in the late fifteenth century, there were few remaining tenants to be removed. Like others of their kind, the men of Wharram had most probably left the village of their own accord, attracted by the promise of a fresh start elsewhere or moving sideways to a locally more favourable environment. Yet abandoned lands had to be used for something, and it would become common practice in late-medieval England to turn over former arable to sheep. Enclosure for sheep-farming, deliberately contrived in the 1480s for the profit of local gentry, the Clintons, seems to have been the fate of Ditchford (Fig. 52), in Gloucestershire, one of the relatively few known cases of a major late-

52 Middle Ditchford, Gloucestershire
Arbitrary depopulations must always have been rare. But John Rous, who knew the area well, was probably right in denouncing the enforced enclosure of the Ditchfords as an event that had occurred within his lifetime. Rous compiled his record in the 1480s. Just thirty years before, Middle Ditchford at least had been a thriving settlement, and it seems likely to have been the entrepreneurial activity of the sheep-farming Clintons, a local gentry family, that cleared the site within less than a generation. Today, Middle Ditchford remains under grass, surrounded by the ridge-and-furrow of arable lands that were once the common fields of the community. Some of this ridge-and-furrow is medieval, but the straight boundaries of the fields are those of the enclosers, as the former village lands were apportioned anew. (1968)

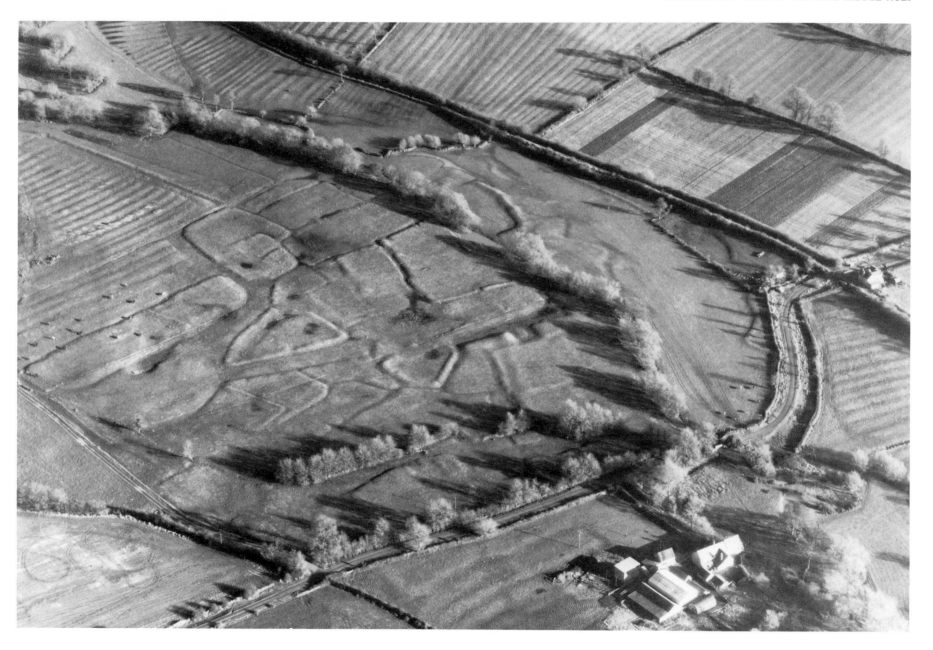

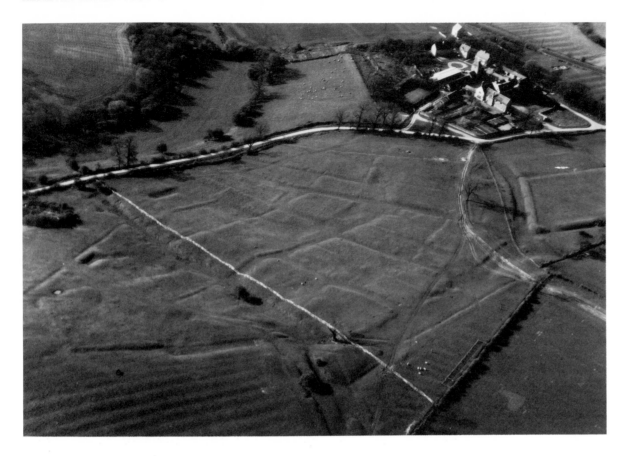

medieval depopulation likely to have been brought about clearly against the wishes of the dispossessed.[7] Another, better documented than most, was Leicester Abbey's depopulation of the settlement at Ingarsby (Fig. 53), cleared and enclosed in 1469 to leave the earthworks still visible today.

Ingarsby was not one of Leicester's oldest estates. It had come to the canons in 1352 by gift of Simon Islip, archbishop of Canterbury, having been intended then as partial endowment of a new chantry. Initially, too, the manor had not been of great value to the abbey, for the archbishop had reserved certain rights and

properties to himself, including twelve village houses. But the estate had real advantages to its new owners. It lay in a pleasant and secluded valley, too steep to be of value as arable land but a mere six miles to the east of the abbey. Ingarsby is still largely laid down to grass, which accounts for the preservation of the village earthworks. And it was as grazing for the canons' beef cattle and their sheep, absolutely necessary – as the last abbot of Leicester would explain with some force – for the maintenance of hospitality at their house, that both the village site and its fields had their worth.

A stage-by-stage consolidation of lands at Ingarsby characterized the first century of the canons' interest in the manor, of which they quickly acquired the full lordship. Thus enclosure, when it came in 1469, was the final episode in a lengthy process matched everywhere in England as land-use changed and as the great ploughed fields of more crowded centuries either were reapportioned or reverted to grass and to waste. At Ingarsby, the conversion to pasture was entirely successful, for it raised receipts from the manor to such a level that what had come to the canons as an insignificant endowment, later ranked high among their interests. Celebrating their profits, they rebuilt their manor-house on its present site very much in the form it retains. Ingarsby's east wing, showing most prominently on the photograph, is the late-fifteenth-century chamber block of a substantial stone mansion, of which the central hall range and annexed kitchen have been replaced. In a peace undisturbed by adjoining villagers, the canons of Leicester were to make use of their manor-house as a rural retreat and secluded resort – just the kind of establishment that many great abbeys had come to maintain by this period for relaxation from oppressive routines.[8]

Leicester Abbey had kept cattle for its guests and sheep to meet the demand of the wool-merchants. At Ditchford, it would be sheep again that, a few years later, were to 'eat up the men' of the village. Such enclosures, induced in part by labour shortages, also reflected a new emphasis in the economy. Both Ingarsby and Ditchford, in their own parts of the country, were singularly well-placed to take

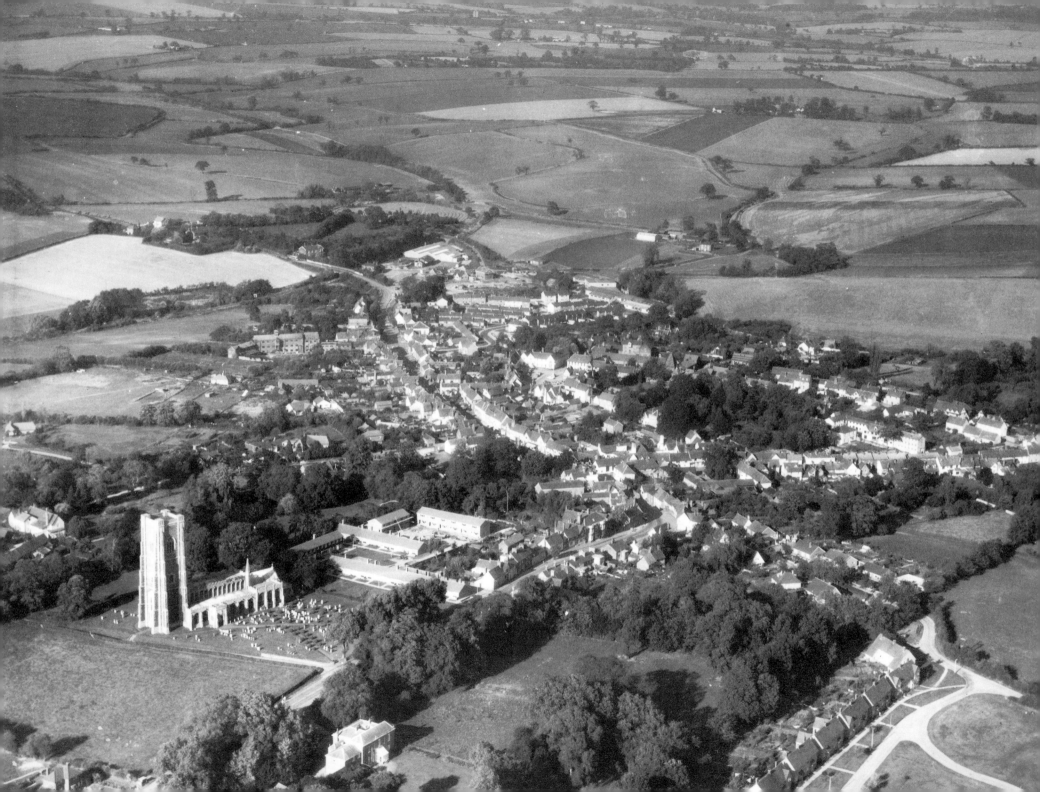

advantage of this emphasis, and the times indeed were ripe for such a change. From before the Norman Conquest, wool exports had been important to England. They had made the kingdom, in proportion to its size, one of the most economically privileged in the West. Yet it was only in the later Middle Ages that English cloths won favour, with exports climbing steadily from the mid-fourteenth century as raw wool shipments equivalently declined.[9] In the major shake-up of the industry that occurred at this period, some of the original cloth-producing centres felt the draught. But for the smaller towns with easy access to wool, conditions could scarcely have been more favourable. Free of the long-standing restrictive practices of major urban communities, they came fresh to a trade in the full spate of expansion, unencumbered by the baggage of the past. Next to the decay of an older system, the prosperity of these growing settlements stands out. It was there that an entrepreneur could make his way.

A view of Lavenham (Fig. 54) now, or of Thaxted (Fig. 55) in the next county, cannot fail to establish the exceptional favour these communities enjoyed in the fifteenth century. Both were situated in a cloth-working region, with its more important market centres at Bury St Edmunds (Fig. 16), to the north of Lavenham, and at Ipswich, about the same distance to the east. Small towns and industrial villages – Clare (Fig. 10) and Hadleigh, Boxford, Long Melford (Fig. 84) and Kersey – prospered in the shadow of the great. Happily, much survives of their days of glory, and nowhere is this more obviously the case than at Lavenham. In addition to Lavenham's magnificent parish church, rebuilt largely at the expense of a local clothier, the town is well known for its vernacular buildings of the fifteenth and early sixteenth centuries. A splendid gildhall of this period, put up by the community's rich Corpus Christi Gild, fronts the market-place on the rise at Lavenham's centre. Below it and to the south, contemporary shop-fronts have survived on Lady Street, while just round the corner, in Water Street, is the rich facade of the De Vere House, an extravagant masterpiece of Suffolk wood-carving in the most expensive full-dress manner of its times.

54 Lavenham, Suffolk
Among England's country towns to profit most generously from cloth-making was Lavenham, headquarters of the wealthy Spring dynasty of Suffolk clothiers. At Lavenham, the monumental west tower of an already handsome church was the gift of Thomas Spring III (d.1523). And throughout the little town, the high quality of the burgess buildings, even those of modest size, has preserved many of them intact to this day. Noblest of these is the early-sixteenth-century Corpus Christi gildhall, fronting on Lavenham's market-square (centre). Corpus Christi gilds, like the expanded cloth trade itself, came to special prominence in the fifteenth century, not being known much in the towns before that time. They had their special function in the burial and commemoration of past members of the gild, sharing this role with the local parish church which likewise profited in the later Middle Ages from society's plague-induced preoccupation with sudden death. (1970)

Little enough has changed at Lavenham since the mid-sixteenth century. Yet it is Thaxted, with its sinuous main thoroughfare and built-over market-place, that now looks the more antique from the air. Thaxted, like Lavenham, was a clothiers' town. But it had another interest too in the cutlery trade, which brought it additional prosperity. Certainly, it was the cutlers who took a major part in the rebuilding of Thaxted's parish church, dedicated to St Lawrence (of the grid-iron), their patron saint. And it is the cutlers' own gildhall, facing east across the market-place, that is still the most prominently sited building in the town. To the left and right of the market-street at Thaxted are the narrow tenement plots of these favoured Essex craftsmen. Together, they make a characteristically medieval urban group, with shops and other properties partitioning the most valuable commercial frontage on either side of the market, with an island of permanent colonization where temporary stalls used to be, and with a parish church prominently sited at one end. It was in just this way that the great majority of English towns were to establish themselves and grow through the later Middle Ages. We can find them still everywhere around us.[10]

The times, plainly, were not bad for everybody. Plague mortality, in late-medieval Britain, continued very high. Taxation was heavy, and it would stay that way as long as the French wars continued, as rebellion threatened in English-held Wales, and as the Scots fought to protect their independence. In such conditions, law and order would be difficult (and often impossible) to maintain. But for those who had the good fortune to be spared the plague and who could afford to protect themselves, in one way or another, from the tax-collector and his associate, the brigand, circumstances might never have looked more favourable. In the countryside, land was plentiful and rents were low. The old servile ties, weakening much earlier, had mostly disappeared by 1500, and a free peasantry, given industry and good fortune, could hope to pull itself up into the yeomanry and beyond. Of course, markets had shrunk in the towns. However, townspeople could (and did) protect themselves through trade associations, sharing out

55 Thaxted, Essex

The late-medieval prosperity of Thaxted was again based, like Lavenham's, on the cloth-making industry of the region. However, it was the trade of cutlers that was dominant in this little Essex town, and it was the master cutlers of the gild who were largely responsible for the fifteenth-century rebuilding of Thaxted's parish church to make it the splendid monument of today. To the east of the church, its twin gables plainly visible (centre) at the upper end of the market-street (nearest the camera), was the cutlers' own gildhall, more prominently placed even than the Corpus Christi gildhall at Lavenham. From gildhall to gild church was but a short procession, emphasizing here in the most practical way the union that existed between them. Further east again, the market-place of Thaxted has subsequently been colonized, characteristically, by a permanent island of shops and other buildings. With its parish church at one end and market beyond, Thaxted is representative of those linear-plan towns which grew up everywhere in twelfth-century England, independent of castle and monastery alike, and making their living principally by trade. It was the king's peace that allowed them to do so. (1957)

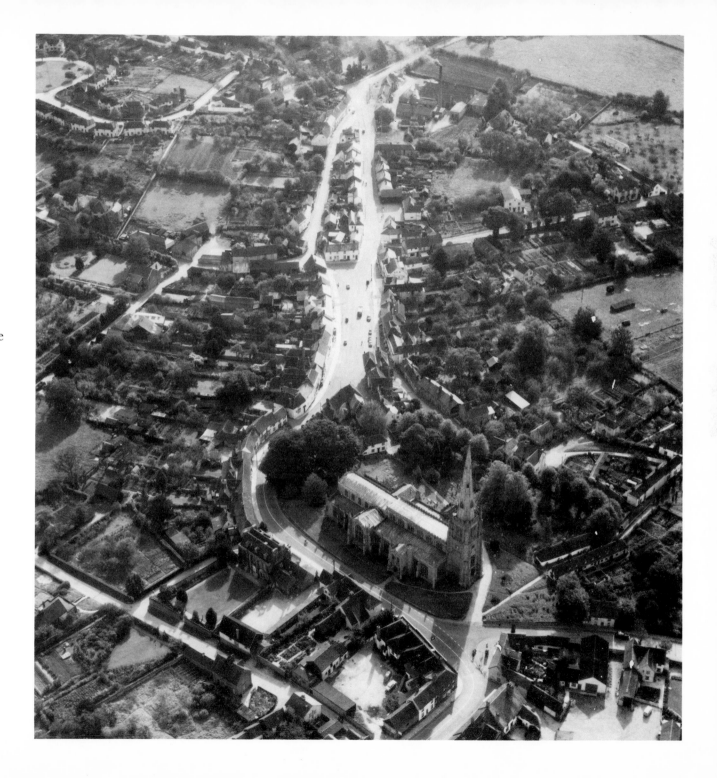

whatever business still remained. In the clothier communities, as at Lavenham or at Thaxted, they could usually sell everything they produced.

The contrast, so obvious in the towns, between the pushing new settlement and the old community in lethargic retreat, is also visible in some measure amongst the aristocracy. The familiar late-medieval descent of rents, reflecting the high cost and relative scarcity of labour, had brought about a serious shortfall in the anticipated revenues of the majority of the greater landowning families. But this was not the only difficulty they might face. Expectations in life-style were ascending fast just as the resources to gratify them were on the wane. More serious still was a common failure of heirs, a faltering or a dying-out of the ancient family lines, and an increasing amalgamation of inheritances. Edward I had done nothing to remedy what his grandson was to see as a 'serious decline in names, honours and ranks of dignity'.[11] And while a few new creations and revivals, among them the short-lived earldom of Carlisle (1322–3), had characterized Edward II's reign, a deliberate policy of management of aristocratic stock had had to await the long ascendancy of Edward III, when the ideal of cooperation between the king and his baronage came as close as it ever would to being realized.

Such cooperation, indeed, had seldom been more essential than it was to become in that prolonged and bloody struggle with France which came to be known as the Hundred Years War. The war began in 1337, and it was in that year that Edward III, on the threshold of conflict, created no fewer than six earls. The experiment was not conspicuously successful. For the most part, the new earldoms were short-lived. Nevertheless, what the action demonstrated was the need the king felt to build up his closest associates to the point at which, through their rank and wealth, they could be of most use to him in the conduct of government. William de Clinton, newly created earl of Huntingdon, was one of the four leading members of the royal household who Edward chose to promote at this time. William's rise in the king's service and its consequences in new building

56 Maxstoke, Warwickshire

It was not just the towns that could be prosperous in late-medieval England. Individuals also, among them William de Clinton (d.1354), builder of Maxstoke, might run against the tide with a lucky marriage or, as in this case, through good service to the king. William de Clinton was already a Warwickshire landowner of some prominence when promoted by his master, Edward III, to the long vacant earldom of Huntingdon. His response was to set about the rebuilding of his family manor-house in the full-dress style of such comital castles as he would have seen in his travels in France. Maxstoke is not a professional fortress like Rhuddlan or Caerlaverock, already a generation old by the time it was built. Nevertheless, it has the water defences, the symmetry, and the polygonal towers of the Edwardian castle, with the prominent private angle-tower and residential gatehouse that were becoming common form in castle-building. Earl William's personal quarters were in the north-west angle (top centre), with the great chamber and chapel, hall and kitchen, occupying the west range (left) and south-west tower. In the north range, a sixteenth-century building replaces apartments the earl shared with his guests, while further lodgings surrounded the courtyard, backing onto the curtain and extending into the gatehouse and eastern towers. Maxstoke was a great man's country-house as much as a fortress, and it had to accommodate the swelling company with which a magnate of the later Middle Ages surrounded himself. For Earl William, certainly, his castle was an assertion first of rank. (1970)

provide a fine illustration of the opportunities still available for those with the luck and the ability to take advantage of them.

It had been an essential part of Edward III's policy to endow his new earldoms with the resources thought appropriate to maintain them. Already rich in 1337 when he got his promotion, William de Clinton was appreciably richer (by the king's deliberate design) after this date, and he had a new position to keep up. One of his first actions, taken on the same day that he was created earl, was to upgrade the collegiate chantry he had already founded on his family's Warwickshire estate to the full status and condition of a priory. Another was to begin the rebuilding on the grandest scale of his existing manor-house at Maxstoke (Fig. 56), which he promoted more fittingly to a castle.

The main elements of Maxstoke, as we see them today, are very much as Earl William must have planned them. Maxstoke is a four-square enclosure surrounded by a broad moat, symmetrically planned except that there is a three-storey tower (the Lady Tower) at the north-west angle and a great projecting gatehouse, also of three storeys, on the east. Post-medieval buildings now occupy the corner against the Lady Tower where the earl would have had his private quarters. Next to these, in the west range, was the great hall (its line still retained by the present house), with the kitchen to its south and with suites of individual lodgings in the remaining towers and on the other three sides of the court.[12] Maxstoke has at least some of the characteristics of the professional Edwardian fortress. It has the prominent gatehouse and the systematic water defences of Caerphilly (Fig. 40) and again of Caerlaverock (Fig. 44). It has the great tower, personal to the lord, of the king's mighty fortress at Caernarvon (Fig. 42). To all outer appearances, Maxstoke was very much the typical castle of its time. Nevertheless, there is a domestic quality about Earl William's fortress that links it also with a defended manor-house like Morton (Fig. 46) or like Acton Burnell (Fig. 47), and that signifies a coming-together of different purposes. William de Clinton, newly recruited to the top ranks of chivalry, required a fortress to commemorate his achievement. Yet he stood high already in the favour of the king, risked nothing from foreign invasions in land-bound Warwickshire, and had little to fear from his neighbours. The fortification of Maxstoke, licensed by the king in 1345 some years after work had begun there, had its legitimate purpose in the protection of the earl's household goods against casual marauding or other violence. It also reminded his friends of what the earl had only lately become.

William de Clinton died without posterity (*sine prole*) in 1354, taking the earldom once again into abeyance. However, Maxstoke Castle survives to remind us – as its creator surely intended it to do – of a brilliant career, suitably rewarded, in the king's administration and his wars. In the 1350s, those wars were still going well for the English. They had been triumphant at Crécy in 1346, at Poitiers a

decade later. The Peace of Brétigny, confirmed at Calais on 24 October 1360, was to bring fighting to a temporary halt. But the terms of Brétigny had not been by any means as favourable to the English cause as many, after Poitiers, might have anticipated. The French had been humiliated, and both sides viewed the settlement as a truce. 'Although by God's will', wrote the chronicler, 'peace had been declared, misfortune and suffering did not on that account cease.'[13] Indeed, they had barely begun.

What principally caused the suffering was an offensive strategy conducted on both sides for the most part through marauding, both at sea and on the land. In the late spring of 1360, just before Brétigny, there had been another of the many French invasion scares which had brought terror to the south coast since the 1330s. On 15 March, Winchelsea (Fig. 49) had been captured and sacked by the French. And it was this, together with a second disastrous raid in 1380, that would later be cited as the principal reason why Winchelsea's burgesses had withdrawn, leaving the town 'so desolate and almost destroyed [by 1384] that the proprietorship of vacant plots and tenements can scarcely be known'.[14] From the start, Edward I's purpose in the re-siting and the fortification of New Winchelsea had included the provision of a more effective bastion on the coast. The stepping-up of the French wars during his grandson's campaigns converted the threat of coastal raids into reality.

In general, Edward III was to show himself more ready to assist others in improvising fortifications than to embark on a systematic coastal defence programme of his own. Such measures would have to wait until the sixteenth century and the building of Henry VIII's expensive chain of artillery forts, of which Camber (Fig. 95) is one of the least tampered-with survivals. Nevertheless, there were to be two important castles on the Thames estuary – Hadleigh on the north shore, Queenborough on the south – in which Edward III, during his later years, came to take a keen personal interest. Only Hadleigh (Fig. 57), badly damaged by a landslip, still remains.[15]

Work began on both castles in 1361, within months of the confirmation of the Peace of Brétigny and certainly in contradiction of its spirit. Edward III enjoyed the building process, spent lavishly upon it, and visited his castles repeatedly. However, his purpose was clear from the start. Queenborough (as an entirely new castle of experimental plan) and Hadleigh (as an older one expensively refurbished) were to help seal off the Thames against seaborne attack, protecting London and the chief wealth of Edward's kingdom. The king's personal quarters, on the south flank of Hadleigh, have been lost down the slope towards the Thames. But time has been kinder to the twin towers on the east, which Edward must have seen as his major addition to the defences. They stare out still, in the general direction of the Continent, over the flat wastes of the estuary. Nobody, seeing them completed towards the end of the decade, would have had many illusions about the intentions of a king who, on the collapse of the truce in 1369, claimed the Crown of France once again as his own.

Edward's claim, now seemingly in contradiction of the entire spirit of history, could not lightly be dismissed at the time. Through his mother, Isabella of France, Edward had been the nearest male heir of Charles IV (d.1328), last of the long line of French Capetians. Only youth and the troubled circumstances of his own English succession had prevented Edward from urging his claim at a time when it might have proved irrefutable. Moreover, a permanent English presence in south-west France had become so much a fact of life by the mid-fourteenth century that many of the barriers currently taken for granted between the nations could barely have been said to exist. Even before the outbreak of war in 1337, it had been usual for the more energetic and ambitious of England's soldier-administrators to spend some proportion of their working lives in France. For them, and still more for their successors later in the same century, the tastes and habits acquired during service abroad were impossible to dismiss back at home.

Wardour (Fig. 58), in Wiltshire, is a case in point. It is work of the 1390s, built for John Lord Lovel, an old campaigner who had assembled a substantial fortune

57 Hadleigh Castle, Essex
William de Clinton owed his promotion, among other things, to his king's overweening ambitions in France. Another consequence of Edward III's wars was to lay a threat on the south coast which could be countered only by more castle-building. Most precious to the king, and consequently most vulnerable, was his own capital city of London. Accordingly, after Windsor itself, the two major castle-building enterprises of Edward III's reign were Hadleigh, boldly placed on the north of the entrance to the Thames estuary (behind Canvey Island), and Queenborough-in-Sheppey on the south. Queenborough, the more experimental of the two castles, has now gone. But Hadleigh remains, its most prominent feature being the great pair of drum towers on the eastern facade which were to present a brave face to the French. To the west of these, a landslip has carried away the south curtain, with the apartments the king built himself on that flank. However, it is certain that the view of Hadleigh from across the flat marsh would have made the most of its multi-towered profile, not unlike the sight one can still get of Edward's fortress at Windsor on the way out from London on the M4. (1967)

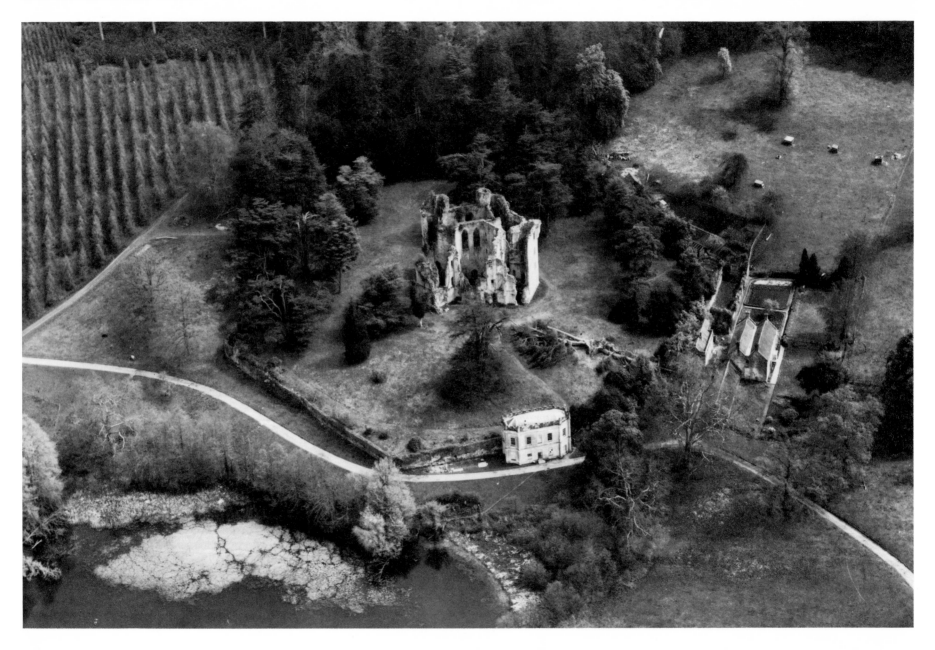

in the wars. The source of Wardour is obviously French. In plan, the building is a great hexagon, flattened on the east to accommodate a hall, on the first floor over the main entrance. Only the hall block and the adjoining kitchen range to the south remain reasonably intact. The west range, intended to close off the central court, has now vanished, nor is there a great deal left on the north. However, quite enough remains of Lord Lovel's ambitious tower-house to show that Wardour, both in spirit and in the execution of its individual details, would have been very much more genuinely at home on the Continent. Polygonal tower-houses of this kind – Concressault in Berry, Largoët in Brittany, Septmonts in Aisne, and many others – were enjoying a favour in contemporary France which, while certainly reflected in late-medieval Scotland, never caught on similarly in England. Wardour, built at the very end of the fourteenth century during a period of temporary truce, was an important exception, having all the perverse ingenuity required of such a building, as separate suites of lodgings were piled on one another, and as gestures were made, in roof-line turrets and a machicolated fighting gallery, towards the provision of some sort of a defence. The lofty paired windows of Wardour's first-floor hall, plainly visible here on the protected courtyard face, are repeated as casually as at Stokesay on the more exposed outer

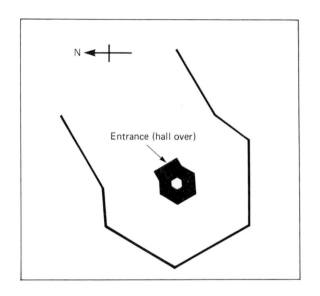

N ←

Entrance (hall over)

58 Wardour Castle, Wiltshire
The wars in France were to take many English magnates overseas, keeping them there for at least long enough to pick up foreign habits in castle-building. John Lord Lovel's Wardour, built in the 1390s, is a complex tower-house, French in style and from the same source as the better known tower-houses of fifteenth- and sixteenth-century Scotland. Tucked securely into the folds of rural Wiltshire, Wardour had no need of the elaborate defence works of a more directly

threatened coastal fortress like Bodiam (Fig. 60). In their place, Lord Lovel chose to build high, partly to give protection to his household in the contemporary French manner, but also to confer dignity on the country-house he had elected to clothe in the chivalric habiliments of a fortress. On the east side of Wardour, over the entrance, is the lord's hall, brilliantly lit by great pairs of windows, on the outer wall as well as on the inner. The opposing west range of the castle's hexagon has now gone, but it would have

contained, like the other ranges that circled the courtyard, separate suites for Lord Lovel's family and his entourage, again adequately windowed, above the dimly-lit stores and offices of the ground floor. Round the castle, the hexagon of the bailey, although re-walled late in the sixteenth century when Sir Matthew Arundell brought Wardour up-to-date, probably repeats Lord Lovel's original plan, as contrived and mannered as that of the tower-house itself. (1947)

front, where their vulnerability makes a mockery of defensive arrangements which included machicolations and a formidable portcullis. At Wardour, the only significant defence of the tower was the sheer height of Lord Lovel's costly building. And it was on height, precisely, that the building relied for its prestige and which gave it dignity.[16]

There may be other ways, of course, of showing off a building, and one of them is to circle it with water. Two decades before Lord Lovel began work at Wardour, Roger Ashburnham had built himself a dam and diverted a small river to make a lake-like moat round the rhomboid island on which he was to put up his castle.

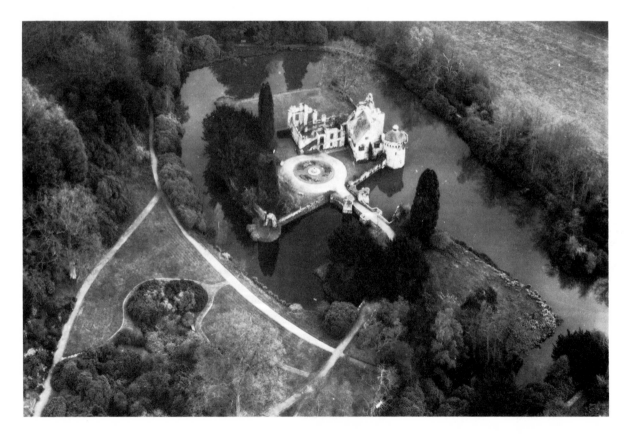

59 Scotney Castle, Kent

Roger Ashburnham's fortified manor-house at Scotney, on which he began work in the late 1370s, may never have been finished. However, enough remains of it to show that Ashburnham intended his new 'castle' to have machicolated towers at each of the four corners of its rhomboid island, with a strong gatehouse, barbican protected, on the west front. Like other castles of its time, Scotney exploits the mirror of its moat to make it seem larger than it is. On the one surviving angle tower, bold machicolations (probably French-inspired) put over an illusion of military strength. But in other ways Scotney was thoroughly domestic, its accommodation (hall, chamber, and kitchen) laid out in a great central range only part of which was preserved in the major seventeenth-century remodelling. Whereas both security and comfort were considered at Scotney, there can be little doubt that, of the two, it was 'ease and state' that ranked the higher. (1968)

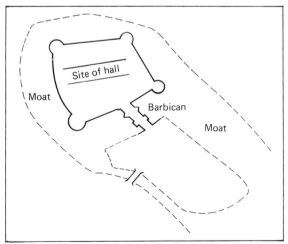

Scotney (Fig. 59) these days is a well-gardened monument, the focal point of a contrived vista in one of the great Romantic gardens of Late Georgian England. But the picturesque qualities we recognize today are not those of our period alone. French castles of the fourteenth century had already made similar use of the mirror of a lake to reflect and to exaggerate their walls and turrets, creating two buildings where one had been before. And Scotney's surviving corner tower, with its ring of prominent machicolations intended to support a fighting gallery, is thoroughly French in appearance. It is not known whether Scotney was ever completed. If so, the result might well have been similar, albeit on a much smaller scale, to a French fortress like Sully-sur-Loire. What is certain is that the motives of the castle's builder were very mixed. Roger Ashburnham's original family manor-house, just off the main road from Hastings to Tonbridge, was perilously close to one of the more obvious routes north from the coast. In 1377, immediately before Roger began the refortification of Scotney, the French had carried out an unusually damaging succession of raids which had included the sacking of Hastings. Consequently, a genuine threat, at least, was present, and Scotney turns its show front cautiously towards the road up which the French might have been expected to advance. Yet Roger had obtained his supply of water by siting his castle on the floor of a steep valley. Overlooked and commanded from both sides at once, Scotney's fortifications were largely a sham. Although fully clothed in the defensive panoply of the period, they seem to be there almost entirely for effect.[17]

Roger Ashburnham's close associate in the defence of the south coast, serving with him locally as a Conservator of the Peace, was Sir Edward Dalyngrigge, builder of Bodiam (Fig. 60), on which work began in the late 1380s. Bodiam, like Scotney, was surrounded by an artificial lake. Like Scotney again, Bodiam was deliberately picturesque. But the castle's avowed purpose was, in this case, quite explicitly the protection of the locality against 'our enemies' (the French). And although there is much at Bodiam that is surely no more than the realization of an old campaigner's desire for a personal monument, the practical soldier in

Dalyngrigge was still dominant. In his youth, Dalyngrigge had served in France with Sir Robert Knollys, one of the more illustrious of the English war captains. In tribute to his former commander, Dalyngrigge was to include the Knollys arms with his own family heraldry over the south gate at Bodiam. The castle itself is a remarkable testimony to what Sir Edward had learnt on campaign.

As a one-period fortress, doubling as the country palace of a successful but ageing soldier, Bodiam has a good deal to tell us about the standards and requirements of its time. Its careful symmetry is that of an Edwardian fortress. In the stress placed at Bodiam on the use of water defences, the links with French castle-building are obvious. Just for these characteristics alone, Bodiam would be recognizably the work of a professional. But where the skill of the old soldier was to be deployed most successfully was in the quite extraordinary elaboration of the approaches. At Bodiam, the southern show front (which the French, advancing up the Rother Valley, could be expected to see first) accommodated no more than a postern. On the far side of the castle, Sir Edward's main gatehouse (to the left on the photograph) could be reached only by way of a right-angled causeway, closed by a barbican and cut by three drawbridges, the whole exposed to continuous fire. In the gatehouse itself there were gun-ports, representing the latest in military

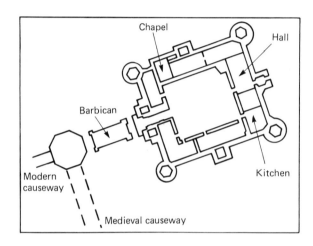

60 Bodiam Castle, East Sussex
Unlike Wardour and Scotney, of which it was the exact contemporary, Bodiam was a castle in more than name, built under royal licence in the late 1380s as a new element in the defence of the south coast. Of course, Bodiam was a country mansion as well. But its hall and chambers, its chapel, kitchen, and multiple private lodgings were packed, like a honeycomb, within the strong frame of its defences, water-girt in the usual manner of its

time. Sir Edward Dalyngrigge, the builder of Bodiam, was an old and experienced soldier, with a long history of campaigning in France. His main gate on the north (left) was especially formidably defended, having a right-angled causeway (the west arm of which is now lost), a barbican, and three sets of drawbridges before the gatehouse was reached, after which there were the defences of the gate passage. A century before, the best of the Edwardian castles had been even harder to

enter than Bodiam. But they had usually failed to combine, as successfully as Bodiam, the functions of fortress and residence. Bodiam, typically, could deflect a raid, but was not built against the onslaught of an army. Dalyngrigge had retired from his soldiering days, and did not expect to meet the French in any considerable force. His castle was a warning to come no further; it was also a personal monument and retreat. (1967)

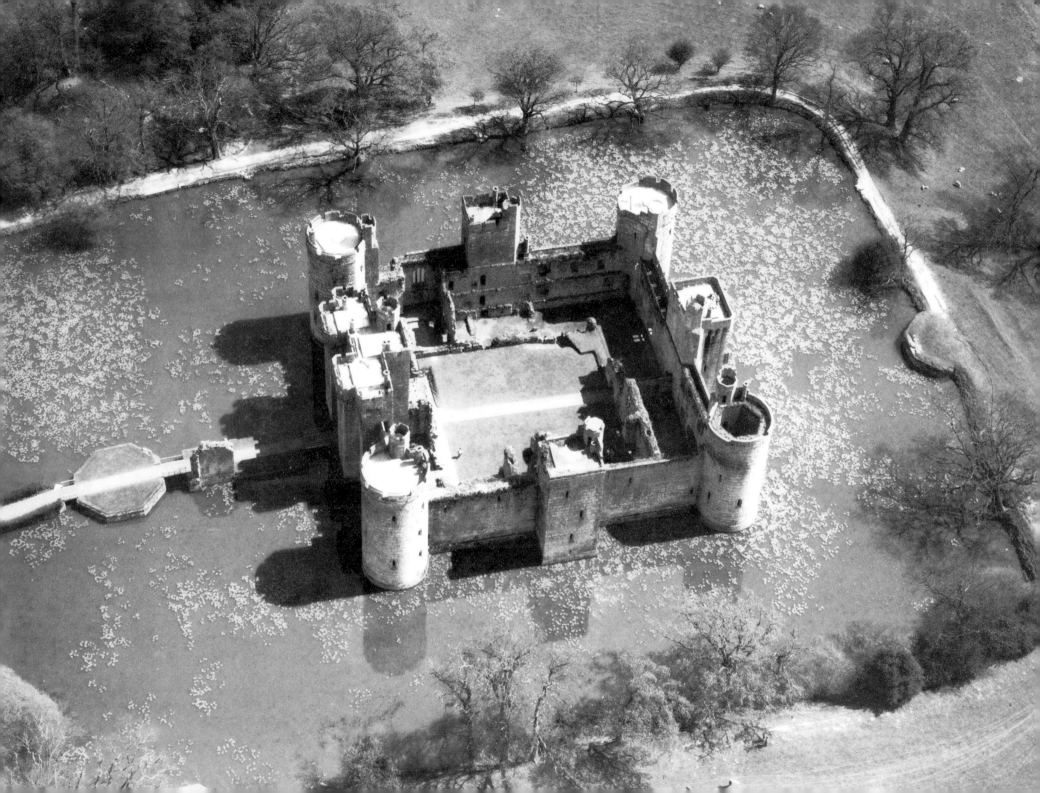

technology. Three separate pairs of gates were supplemented by portcullises, and there were 'murder holes' concealed in the vault of the gate passage.[18]

Once within the courtyard, everything changed. Behind its aggressive militaristic facade, Bodiam was to be a well-equipped country palace in which a wealthy ex-soldier, enriched by his campaigns and by his wife's inheritance, could relax in dignity and in conspicuous affluence. Much of the accommodation at Bodiam has now gone. Nevertheless, we can still get some impression of the scale of Dalyngrigge's personal quarters in the east range of his castle (far side), with a chapel piercing the range at its northern end (left) and with the great hall adjoining the lord's chamber on the south (right). To the west of the hall were the service rooms and kitchen, while on the north of the courtyard, and again on the west, were the halls, the separate offices and the other public rooms of the old knight's sizeable entourage. Indeed, quite as striking as the defensive arrangements of a castle like this are the numerous private suites it contained, each of them individually heated by an open fire and each with a garderobe of its own. Dalyngrigge was a rich man. He kept a fine table at Bodiam and practised hospitality at the level thought appropriate to his rank. Nothing less would have been expected of him at the time.

Very much of Dalyngrigge's way of thinking, being of similar background and experience, was Richard le Scrope (d. 1403), Treasurer and twice Chancellor of England. By his own efforts, both as soldier and administrator, Richard had won the title Baron Scrope of Bolton, piling up great wealth in the wars and in the king's service, being the two methods most open to his class. It would become Scrope's ambition, just as it was Dalyngrigge's, to lay out his fortune before his death in the building and furnishing of a great house. Bolton (Fig. 61) these days is a sombre ruin, closing off the west end of the long village green, with the parish church in its shadow to the north. Although four-square still, around its small internal courtyard, there is now very little standing of Bolton's north-east tower, only the west range and the south-west tower being preserved in anything like

61 Bolton Castle, North Yorkshire

In the Northern Marches, Bolton again had to serve a dual purpose, both housing Richard le Scrope in appropriate state and protecting the former Treasurer and his goods. Completed in the 1390s, Bolton was a four-square castle with strong towers at each angle, one of which (top left) has subsequently collapsed. Compared with Bodiam, its gatehouse defences in the south-east angle of the court (top right) were rudimentary. However, if penetrated, they allowed the assailant no further than the sombre inner court which had all the characteristics of a death-trap. Around this court, the four ranges of Bolton had room in plenty for the many comfortable private lodgings which Baron Scrope assigned to his 'affinity'. In addition, there was a great hall in the north range (left) and a chapel in the south, Lord Scrope's personal quarters being in the still roofed west range (facing the camera). Dwarfed and overshadowed to the north of Scrope's castle, the parish church is a building of the same date as the fortress, though seemingly of little interest to the Treasurer. Scrope favoured instead the Premonstratensian canons of Easby (Fig. 32), of which his family, since his father's day, had been the patrons. He wanted burial in some other place than his back-yard. (1948)

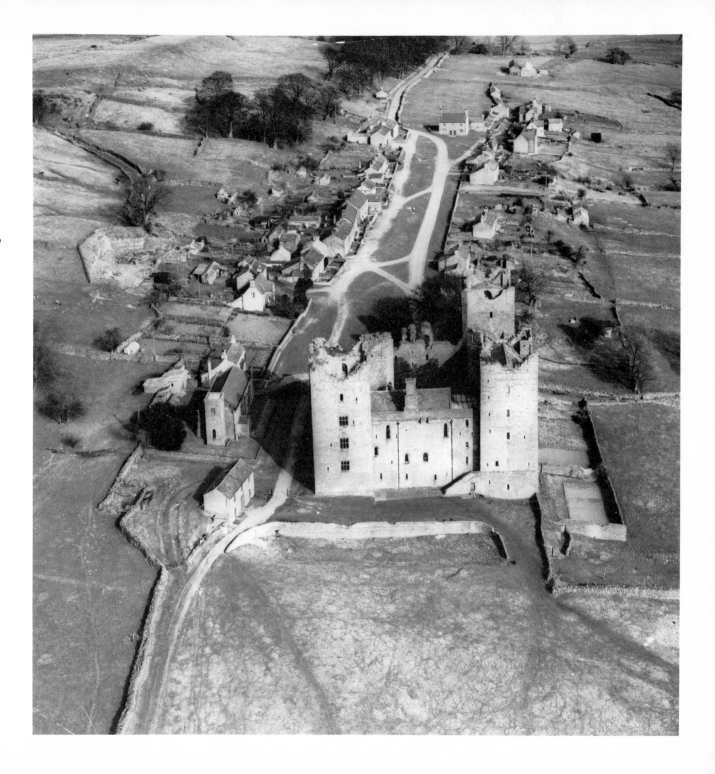

habitable condition. But picture Bolton in its prime as a fortified block of flats and you will not be far wrong about its function. Bodiam had been characterized by generous public spaces, even if private apartments had been plentiful as well. In contrast, Bolton was to be divided almost exclusively into individual suites, as intricately planned internally as any French tower-house, with apartments in every range and at most levels.[19]

Like Dalyngrigge, Richard le Scrope had long experience of the wars. Even in his last years, he continued to serve the Crown in the defence of the Northern Marches, and his castle was not to be thought of as a toy. But the protection of a man of Baron Scrope's position and resources resided chiefly in the strength of his affinity. Guarded on all quarters by the strong arms of his household, Scrope sacrificed his privacy but slept secure. Furthermore, he could maintain a style among the great company at Bolton which would have been denied to him if he had lived there alone. In the fashioning of Bolton, a large part of Scrope's effort was given over to the business of display. It was no mere fortress that Scrope was building. What he created, in this remote but beautiful location, was a way of life.

That life-style, full of contrasts, had come to take on a particular significance for the men Scrope accepted as his model. At one extreme, known to Scrope who would have visited the castle many times, it could be realized at a great fortress like Windsor (Fig. 62), being the Plantagenet equivalent of the Valois Vincennes or of the Holy Roman Emperor's Bohemian palace at Karlstein. Of course, Windsor (like the others) had a special purpose. It was to be a celebration of Edward III's dynasty and a fitting home for that king's noble and exclusive Order of the Garter, for which no expense need be spared. No other single building project throughout past history had ever cost a king of England so dear. But the most obvious characteristics of a royal castle-palace like Windsor – its multiple lodgings, its emphasis on great height, and its passing brave display[20] – were to be precisely those again of many lesser buildings, the tastes and preoccupations of the leaders of society rubbing off predictably down the line.

62 Windsor Castle, Berkshire
Not a great deal of Windsor, this most familiar of royal fortresses, has escaped the cosmetic hand of the restorer. Nevertheless, Windsor's outline and the massing of its towers are still those of the castle-palace that Edward III, at appalling cost, refashioned in the 1350s and 1360s in direct competition with the Valois fortress at Vincennes, near Paris, and with Charles IV's Karlstein, close to Prague. St George's Chapel, in the lower ward (foreground) is a Yorkist and Early Tudor rebuilding on a still grander scale of the original collegiate church of Edward III's pioneering Order of the Garter, founded in 1348. And it was the pomp of chivalry, taken to unusual lengths in the rebuilding of Windsor's anachronistic central keep, that spurred Edward III forward in his project. Windsor is a celebration of the Plantagenet line and of its very special relationship, in Edward's own time, with the leading magnates and other aristocracy of the realm. It set a pattern which others, in a manner more appropriate to their inferior resources, did whatever they could to follow. (1956)

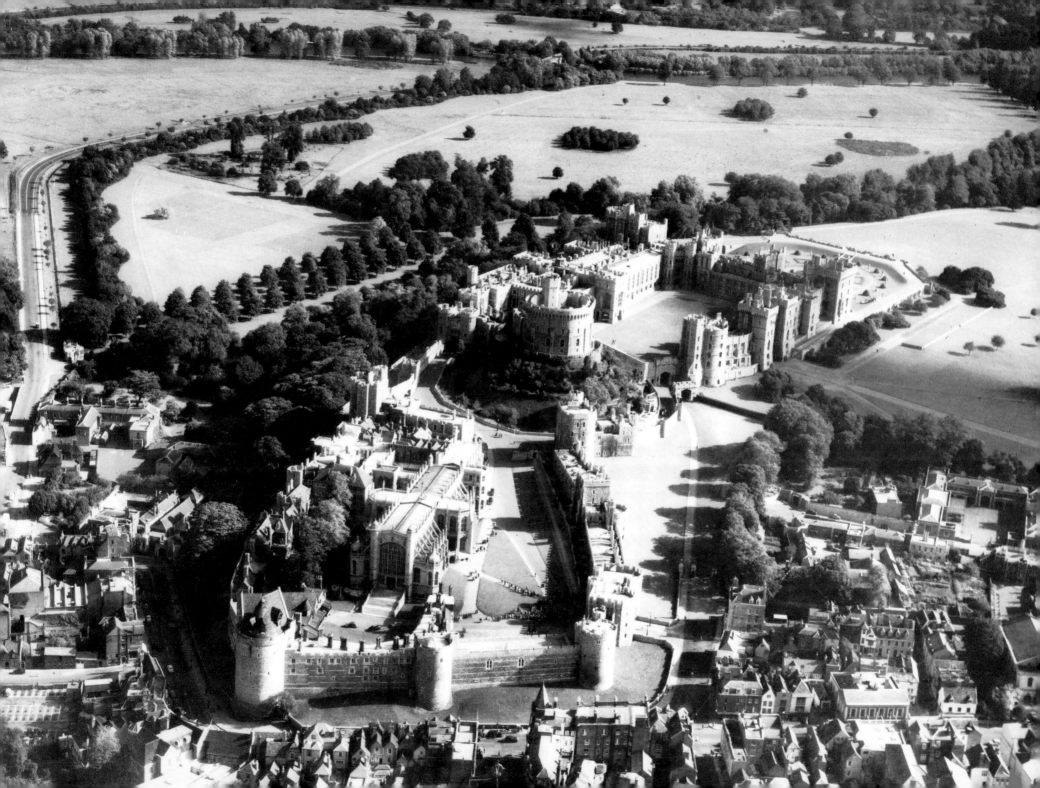

In Scotland, there were to be few magnates as rich as those of England. Nothing in the northern kingdom compares with Windsor, and there would be little on the scale of such contemporary chivalric extravagances as the Beauchamp rebuilding of the east front of Warwick or John of Gaunt's remodelling of Kenilworth.[21] Yet Scotland too, in the long after-glow of its successful struggle for independence, was recovering an individual identity, one of the manifestations of which was in building. David II's long sojourns in England had given him a taste, soon shared by his aristocracy, for the more flamboyant trappings of chivalry. And it was David, certainly influenced by what he had witnessed at Windsor, who began in the 1360s on a major refashioning of his own castle at Edinburgh, to be followed up subsequently by the first Stewart kings at other royal fortresses through the land. Most Scottish kings, and almost all their leading noblemen, were to spend an appreciable part of their lives out of Scotland. They sought allies in foreign courts, negotiated marriage alliances among many of the ruling families of Western Europe, and hired swords overseas for the continuing struggle at home against the English. Although not as wealthy as their opponents and beset, as were the English, by a similar post-plague recession, Scottish aristocrats found themselves moved, both by inclination and experience, to favour the same conspicuous display.

Rebuilt at this time was the incomplete Bothwell (Fig. 43), now a Douglas fortress, where the money had run out in the late thirteenth century, leaving much of the planned circuit as mere foundations. At Bothwell, the north and east curtains are most probably attributable to Archibald 'the Grim' (d. 1400), while the south curtain and the especially handsome south-east tower are likely to have been the work of his son. Both the Douglas earls fought in France, where they took the French side against the English. Both had cause to know and to appreciate the French building fashions current in their day, and Bothwell's south-east tower, corbelled out prominently at its parapet to carry machicolations, is indeed thoroughly French.[22]

63 Tantallon Castle, Lothian

Among the major confrontations of fourteenth-century chivalry was Poitiers (1356), the Black Prince's great victory over the Valois John II, founder of the Order of the Star and originator of the works at Vincennes. Present at the battle on the French side, and one of the few who escaped capture, was William Douglas, shortly to be created first Earl Douglas (1358) and later to be the builder of Tantallon. On the coast of east Lothian, with its back to the Firth of Forth, Tantallon was unusually strongly sited, permitting the defensive emphasis to be placed on one quarter alone, facing south at the neck of the short promontory. What resulted, reflecting the earl's experience both in England and in France, was a massive show front of central gatehouse and flanking angle-towers, linked by a curtain wall of great strength. Tantallon is a building of the 1370s, and it makes the same statement about the nobility of its owner as do contemporary English fortresses like Windsor, Hadleigh, or Warwick. This message required bold and lofty works, and at all these castles, unthreatened as yet by effective artillery, the builders' first preoccupation was with height. By the mid-sixteenth century, with the development of the gun for siege warfare, all this would change. Tantallon's triangular ravelin (top centre) and defensive banks and ditches are the half-hidden works of a professional artillery engineer. The headlong brave mêlée of proud chivalry at Poitiers had been overtaken by the arms-length precision of the gunner. (1981)

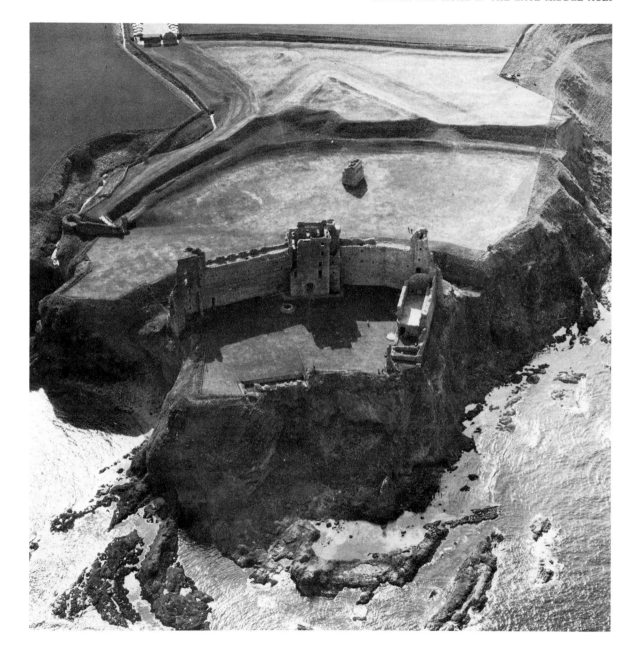

Another Douglas castle, the great fortress at Tantallon (Fig. 63), again brings together these separate influences. William Douglas (d. 1384) had fought at Poitiers in 1356, as indeed had Archibald the Grim, and among their opponents in the Black Prince's army had been Thomas Beauchamp, earl of Warwick, already a veteran of Crécy. Douglas spent much time in England as well as in France, and it is not unlikely that he knew (and perhaps visited) the Beauchamp works at Warwick, for which the inspiration would undoubtedly have been familiar. Warwick's east front, with its huge forward-projecting gatehouse at the centre and its prominent multangular towers at either end, is French both in concept and in detail. And it finds a precise parallel in Tantallon's three-part south facade, on which work most probably began in the 1370s, soon after Douglas got possession of the castle. At Tantallon, as at Warwick and their many French equivalents, the gatehouse and its flanking towers are multi-purpose. Together they present a bold face to the world, an opportunity for chivalric display; each is equipped to house many lodgings; with an entrance well-protected by elaborate foreworks, the plan is well conceived for flanking fire.[23]

Tantallon remains a noble fortress, spectacularly sited and rendered almost impregnable by the mighty barrier that successfully cuts off the headland. But it has to be seen also as a monument to its period – the work of an aristocrat who, by the time he came to build it, had had a lifetime of experience in Europe's courts, far removed from society at home. Tantallon, in consequence, is an exception. And very much more common in contemporary Scotland were variations on the theme of the single great tower, bestowing status at an acceptable cost. A third Douglas stronghold is Hermitage (Fig. 64), on the Border, which from the simple beginnings of a rectangular tower grew to its present strange shape. What the Douglases started with at Hermitage was the central court of an English-built manor-house, which they converted to form their first tower. Then, some decades later in about 1400, angle-towers were added to the Douglas tower, one of these being further extended within a few years to make the longer wing (or 'jamb') to

64 Hermitage Castle, Borders

Another Douglas castle which would later be remodelled for artillery was Hermitage. It was probably in the mid-sixteenth century that the foreworks (towards camera) were re-cut and that gunloops were inserted in the castle's walls. However, Hermitage remains in every other respect a witness to the strategy of great height. Dating to about 1400, the plain intention of Hermitage's builders was to lift the main activity of the defence to a timber fighting gallery which circled the upper courses of the walls. Some of the corbels of this gallery are still visible in Hermitage's walls below the square-topped window openings and over the great supporting arch (left), while the line of it has been preserved by the neat, if inaccurate, modern parapet. Taking advantage of the gallery's projection, the Douglas defenders of Hermitage could command the base of their walls, being high enough also to oversee an attack and sufficiently mobile to anticipate its main onslaught. What might look, on the face of it, like a clumsy retreat from the standards of Caerlaverock (Fig. 44), was in fact well adapted to the border-style fighting of its day. The French had tried the technique and had liked it well enough in such grander castles of their own as the contemporary Pierrefonds and Tarascon. Hermitage was no backward-looking shuffle to the security of the strong tower. Its Douglas earls, within the limits of what they were prepared to spend on Hermitage, knew their business well enough to make a job of it. (1976)

Entrance

N

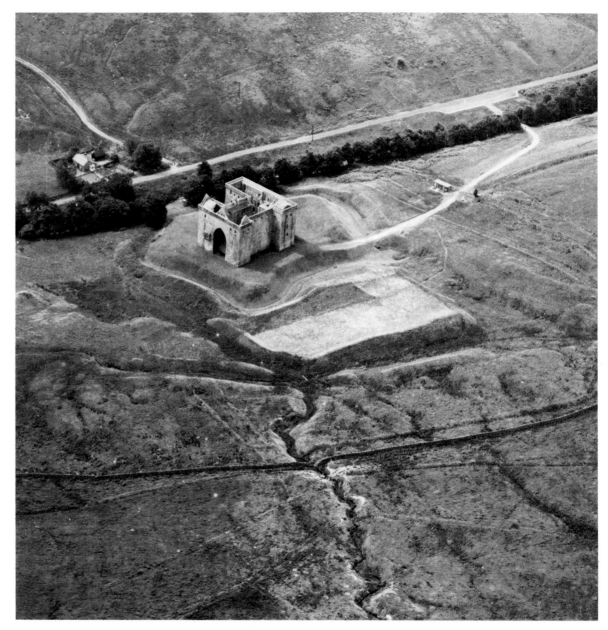

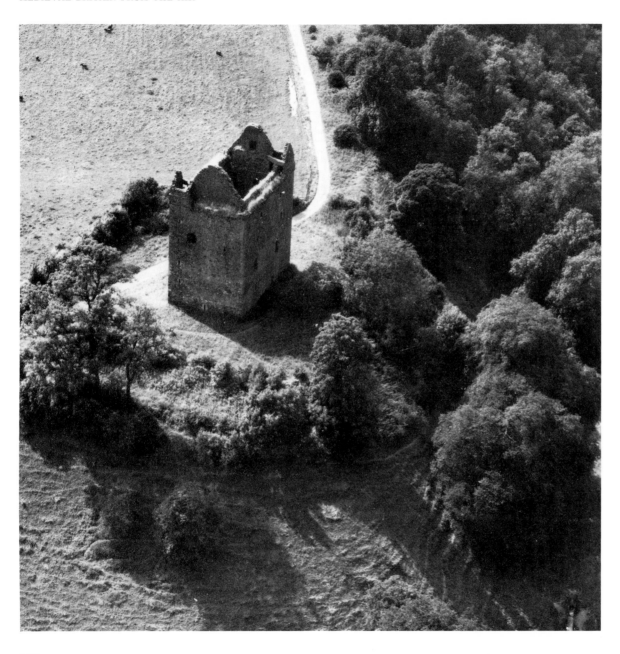

65 Newark, Borders

The tower-house plan, pioneered at Hermitage and at even earlier Scottish castles like Threave, came to be widely adopted throughout the North, almost equally on both sides of the Border. Reduced to its essentials, as at mid-fifteenth-century Newark, it accommodated the lord and his family between their stores (at ground level) and the fighting platform immediately over their heads. Many refinements could be added to this, of which projecting angle-turrets were certainly the most common. But the principle in each case remained everywhere the same, the efficiency of the tower becoming generally recognized both as symbol and as means of self-defence. Over the years, the proliferation of these towers was to become a sad comment on the persistence, especially in the Northern Marches, of local violence. Endemic warfare, little checked by the Crown in the later Middle Ages when both Scottish and English kings were comparatively weak, had opened the way to ungovernable faction and feud. The wise man did more than merely close his door; he bolted and barred it as well. (1947)

the south-west. Since that time, the picturesque gables and continuous corbelled parapet have been nineteenth-century embellishments of Hermitage. Nevertheless, surviving putlog holes and corbels, lower in the walls, have established that a continuous fighting gallery, fashioned in timber, was indeed a part of the late-medieval equipment of the castle. It was to carry this gallery, again characteristically French, that flying arches were built to link the angle-towers on both of the short sides of the castle. The entrance was on the long side to the south.[24]

Complete with its angle-towers and its French-style projecting gallery, Hermitage was to become a building of some sophistication, both militarily and – on account of the added accommodation – as a residence. Yet what it represented essentially was a blockhouse, for which the chief and almost the only defence was the sturdy construction of its walls. Even more utilitarian, and very far removed from the grand chivalric display of a mighty royal fortress like Windsor (Fig. 62), was the simple tower-house of which Newark (Fig. 65), Borders, is only one of many examples in Scotland. There is nothing whatsoever grand about Newark. However, it served an adequate purpose in providing secure accommodation for the lord and his family, and the plan was very widely adopted. While completely out-classed by a near-contemporary English tower-house like the very different mid-fifteenth-century Tattershall (Fig. 81), Newark nevertheless belonged to a more enduring tradition, as long-lived as the Scottish castle itself.

5 The Late-Medieval Church

The troubles that kept castle-building alive in late-medieval Britain were not without their consequences in the Church. In the Border country, in particular, and of course on the coast, monastic communities found themselves repeatedly under threat. Twice in the fourteenth century, in 1322 and then again in 1385, Melrose (Fig. 73) was to be looted and all but destroyed. During the following century, the rebuilding of this important royal foundation, first of the Cistercian communities in Scotland, would be interpreted by many as an act of national pride.[1] Another Scottish Cistercian house, the abbey at Sweetheart (Fig. 66), had itself been a child of the Wars of Independence, only to find itself caught up as their victim. Sweetheart had been founded as late as 1273, to become embroiled almost immediately in the succession crisis and to be forced, unhappily, to take sides. With Dumfries to the north and Carlisle just across the Solway Firth to the south-east, Sweetheart lay in contested country, rarely certain of its allegiance for very long. Edward I and his army were at Sweetheart in the summer of 1300. Seven years later, the abbey was petitioning the English Crown for recovery of damages, inflicted on the community by Welsh mercenaries. Both in the interim and later, it would find itself accommodating the Scots. Small wonder, then, that a great precinct wall, built of granite boulders and almost four metres high, should be among the site's most prominent survivals. With very good reason, the monks would have felt themselves, throughout their time at Sweetheart, intolerably vulnerable without it.[2]

66 Sweetheart Abbey, Dumfries and Galloway

Just south of Dumfries, by the Solway Firth, the Cistercian foundation of Sweetheart (Dulce Corde) lay in the same vulnerable region as Caerlaverock (Fig. 44), of which it was a precise contemporary. Established only in 1273 as one of the last houses of the Order, this was not a fortunate time for new beginnings. Sweetheart took no major role in the Wars of Independence, but it stood in the track of opposing armies and inevitably took punishment as a result. Along with other religious communities in remote or war-torn areas, the monks of Sweetheart, with nobody else to protect them, had to look to their own defence. Their great precinct wall, even today, is a rare and notable survival. Truncated on the east by the modern graveyard, it formerly enclosed the abbey on all sides but the south, where it was probably replaced by a ditch. While not a defence work as a professional soldier might have understood it, Sweetheart's wall was nevertheless a formidable barrier, quite enough to deter the brigand's gang and to give pause to the most daring of pirates. (1977)

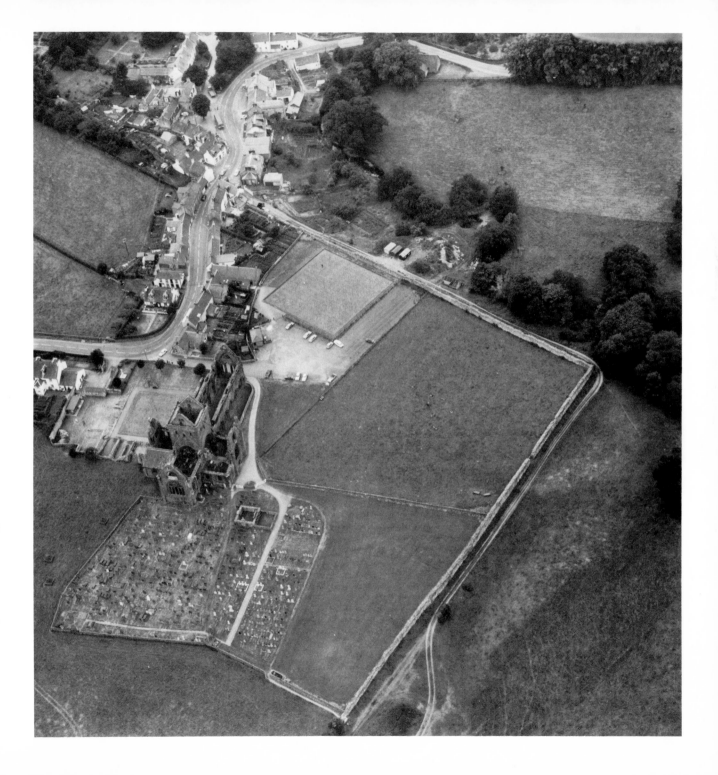

Over the Border, on the English side, there was at least as much cause for alarm. The wealthy and long-established Benedictine priory of Tynemouth (Fig. 67), famed as the home of the potent miracle-working relics of St Oswin and St Henry of Coquet, was strongly sited on a promontory protected by steep cliffs. Yet Tynemouth's natural defences were clearly not enough, even with the assistance of God and his Saints. In 1296, with the Scottish wars already well under way, the monks of Tynemouth applied for a licence to crenellate. It was to that time that their first defensive circuit dated. However, Tynemouth's fortifications were to be continually repaired and improved in later years, the most important of subsequent additions being the great landward-facing gatehouse on the western edge of the site, completed by Prior John of Whethamstede in the 1390s. Prior John's gatehouse, taking the form of a tower-keep, was residential. It had a hall on the first floor, with kitchen adjoining. On the second floor, over the hall, there was a chamber with a garderobe of its own. But though use was made of the bulk of the tower to house a fine suite of apartments, the clear purpose of the building was defensive. Thus a substantial stone barbican, with its own portcullis and with a set of guardrooms on either side of the entrance passage, fronted the main tower, from which it was divided by a drawbridge. Through the tower itself and under its residential storeys, another vaulted passage was again strongly defended. It was backed by a further barbican on the tower's inner face, having no direct access to the apartments above, which had their separate drawbridge-protected approach.[3]

Closely paralleling Prior John's work at Tynemouth was the almost contemporary gatehouse and barbican at Alnwick Castle, Northumberland, some way further up the coastal plain towards Scotland. Alnwick had come to the Percies early in the fourteenth century, and the family's prominent role in the defence of the Northern Marches ensured that it was often under threat. Those men of religion who lived in the locality, and of whom the Percies themselves were the patrons, had to take whatever measures they could in their own defence.

67 Tynemouth Priory, Tyne and Wear
The English Benedictines of Tynemouth first sought a licence to fortify their site in the mid-1290s, just when Sweetheart was about to experience its worst trials. At Tynemouth, at least a part of the existing circuit wall may date to this early initiative. However, the priory's most effective defensive work, Prior John of Whethamstede's great western gatehouse (top right), belongs a century later in the 1390s, when the Scottish problem still refused to go away. A gatehouse on this scale, complete with an elaborate barbican, transformed Tynemouth itself into a castle. Although a dependency of St Albans Abbey, Tynemouth was rich by the standards of its time, being better able than most to defend itself. In addition, the strategic value of the community's site attracted the help of Richard II, whose interests coincided with those of the monks in holding the north-east coast against the Scots. (1973)

68 Hulne Priory, Northumberland

Problems of defence might mount larger than ever in the vicinity of a castle, drawing hostile armies to itself like a magnet. Hulne Priory, a Carmelite house, was as poor as any other community of its Order. Nevertheless, with the Percies' great fortress at Alnwick to the south, the friars had to find the funds for a strong precinct wall, supplementing this in the late fifteenth century with a tower-house (left). In front of this tower, facing into the former cloister, is a Gothick summer-house, built for the dukes of Northumberland in the 1770s. And there were other contemporary tamperings with the ruins, showing the same Romantic intent, including the addition of a new gatehouse on the east (right). But the south and west walls of Hulne's church are still well preserved to the north (top right) of the cloister, while among other remains are the late-medieval gatehouse on the south (bottom centre) and the adjoining detached infirmary with eastern chapel. (1947)

Alnwick Abbey, next to the Percy fortress, was a Premonstratensian house of no more than modest means, as was usually the case in the Order. Yet it had to enter into quite abnormal expenditure in the late fourteenth century, spending considerable sums – no doubt with Percy assistance – on the building of a strong precinct wall on the northern quarter, pierced by a formidable gatehouse.[4] Only the gatehouse survives now at Alnwick Abbey. In contrast, Hulne Priory (Fig. 68), a small Carmelite house immediately to the north-west, has retained its defended circuit remarkably intact, together with the fifteenth-century tower-house subsequently built to reinforce it.[5] Hulne's precinct wall is the English equivalent of the great granite barrier at Sweetheart Abbey. Its tower-house, similarly, belongs clearly to the contemporary tradition of such defended tower residences, favoured by landowners on both sides of the Border. Plainly, neither the Carmelites of Hulne nor the Premonstratensians of Alnwick could rely on their cloth to protect them. The Scots burnt Alnwick in 1449. That same year, only just up the road from Sweetheart Abbey, the English put the torch to Dumfries. Nobody in those conditions was secure.

On the south coast of England, the enemies were the French, but the consequences of course were the same. Among the first to defend themselves were the Benedictines of Battle, whose exposed situation on the main road north to London gave them special cause for anxiety. Obtaining a licence to fortify their precinct in 1338 – the year of a successful French raid – they built themselves soon afterwards the mighty gatehouse which survives today as the most important single building on their site.[6] Later in the same century, French plundering excursions along the south coast had become so regular that other less obviously vulnerable communities were likewise persuaded of the need for fortifications of some kind. John Leem, prior of Michelham (Fig. 69), was among those local landowners, including Ashburnham of Scotney and Dalyngrigge of Bodiam, who served for some years as a commissioner of array. In the 1370s, Abbot Hamo of Battle had proved himself the most vigorous local captain of them all. Michelham

itself is only a few miles to the north-west of Pevensey. Although tucked away on its own in the security of the Sussex countryside, Prior Leem's small community nevertheless drew comfort from the defences supplied on his initiative in about 1400 – the substantial gatehouse and wide water-filled moat which are both likely to date to his priorate.[7]

Prior Leem was a superior of unusual energy, undertaking a wide range of responsibilities in the region and remaining in office for a full four decades at Michelham. Consequently, his priory was to be better protected than most. A more characteristic response to the perils of the times was the improvisation of defences at a little house like Ulverscroft (Fig. 70), hiding behind its wall and its ditch. The Augustinians of Ulverscroft, always a poor community anyway, were not at risk from the French or the Scots. However, they lived out on their own in Charnwood Forest, to the north-west of Leicester, where there was 'no good toune, nor scant a village', and their valley-floor buildings stood 'in a waste ground, very solitary'. For communities like themselves, there might be no succour at hand against brigands. They took their chance as any landowner would do, seeing their best hope of security in a moat.[8]

Ulverscroft's defences, insubstantial though they are, provide a useful comment on the poor state of government in late-medieval England, when few could put their faith in a rule of law which the king was not strong enough to maintain. However, the priory has another value too in the example it gives us of the morass of difficulties, most of them financial, into which many of the smaller religious houses had by now sunk. In 1465, a union would have to be negotiated between Ulverscroft and Charley, even smaller than itself, which was plainly going bankrupt at that period. And while outright failures of this kind remained comparatively rare among communities, the great majority somehow managing to hold on, the troubles of the monastic houses were already legion, sapping their purpose and cutting them adrift from their friends.

Leiston Abbey (Fig. 71), on the Suffolk coast north of Aldeburgh, was in the

69 Michelham Priory, East Sussex
At Sweetheart, at Tynemouth and at Hulne, it was the Anglo-Scottish wars that created the need for defence. At Michelham, in contrast, it was French raiders who presented the threat. By the late fourteenth century, the south coast had endured such a history of piracy that it must have seemed as though the menace would never go away. And it was at just that time, under Prior John Leem (1376–1415), that Michelham experienced the benefits of effective and energetic rule, enabling it to anticipate the danger. Some part of Michelham's moats may be earlier than Prior Leem's time. However, we know him to have been active personally in the defence of the coast, and the substantial gatehouse (centre right) almost certainly dates to the middle years of his priorate, when the river was diverted and the moats either dug for the first time or refashioned. Within this barrier, Michelham remained a small and never very prosperous community of Augustinian canons. Its church (marked out in the grass) and claustral buildings were on a minor scale, and its discipline, under later and less able superiors than John Leem, failed repeatedly during the course of the fifteenth century. In the circumstances, the elaboration of Michelham's defensive works is a good measure of the alarms of the times. (1972)

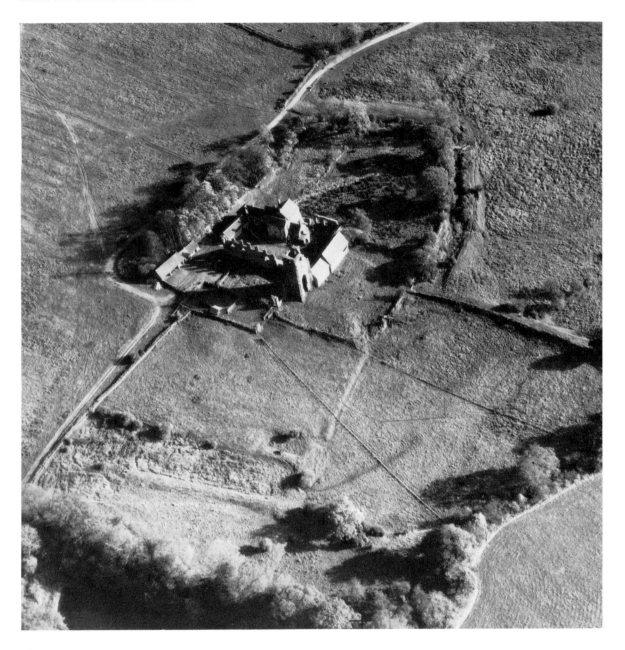

70 Ulverscroft Priory, Leicestershire

Trouble concentrated on the coasts and in the Marches, but these were not the only areas at risk. Ulverscroft Priory, in Charnwood Forest, stood 'in a waste ground, very solitary'. With only half the resources of an already small house like Michelham, the canons of Ulverscroft had no means of surrounding themselves with the servants and dependent farm workers who might otherwise have offered some protection. Returned soldiers and other disappointed and desperate men haunted the forests of late-medieval England, making their home in the wastes. Accordingly, those whose lot was to live there already had to do what they could for their own security. Ulverscroft's moat and ditch, marked out by lines of trees on three sides of the house, illustrate a typical response at this period.

Every landowner with something to protect would react in the same way in such circumstances. In their poverty and isolation, the slight defensive earthworks of the Augustinians of Ulverscroft were both the most and the least that they could afford. (1969)

71 Leiston Abbey, Suffolk

Ulverscroft in its final years rose above its troubles, to become one of the best governed of the lesser houses in the 1530s, cited as a model for others. And in the same way, a somewhat richer house like Leiston, provided it could live through its immediate difficulties, might usually expect to survive. Leiston's present site is the one to which it moved in the 1360s when severe coastal erosion threatened its original location. It had been lucky at the time in securing the patronage of Robert de Ufford, newly raised to the earldom of Suffolk. The new buildings, in consequence, were of good quality, as can still be seen in the expensive detailing on the surviving east end of the church (left). Yet within just a few years, all but the church had been consumed by fire, leaving the canons of this only moderately wealthy Premonstratensian community unable to pay their taxes or to meet their debts. It was a set-back only, for the buildings were restored and the canons returned to them in good order. But it underlines the need, felt by every religious house at this period, to cultivate the continuing support and practical interest of its friends. (1970)

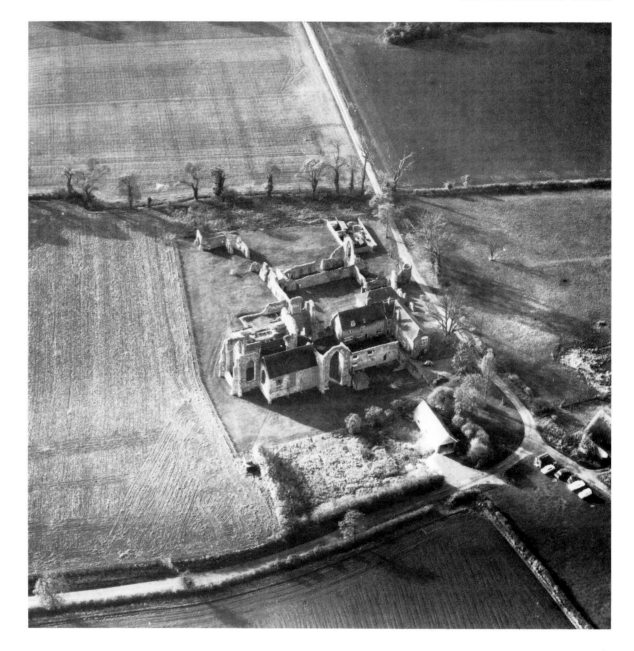

long term one of the luckier of these lesser houses, remaining especially fortunate in its patrons. Yet Leiston's story is a catalogue of disasters. The abbey had begun life, promisingly enough, under the protection of the great Ranulf de Glanville, Henry II's justiciar, whose immediate family and friends were especially generous in their promotion of the Premonstratensian settlement. However, Leiston's first misfortune was the justiciar's dismissal from office in 1189, when he had only half-completed the abbey's endowment. Its second misadventure was an accident of siting, close to an eroding eastern shore. By the canons' own account, when petitioning the king in 1380 for tax exemption, their first buildings were 'long ago destroyed and drowned by flooding of the sea . . . their possessions . . . in great part useless and barren'.[9] Earlier than this, the community had found another patron in Robert de Ufford (d.1369), first earl of Suffolk, one of Edward III's new creations. And it had been with Robert's help, along with that of Margaret, countess of Norfolk, among others, that the canons had been able to provide themselves with a fine new set of buildings, more securely sited inland. But the reason for their petition was a further disaster, striking almost as soon as they were settled. Shortly before they sought the king's assistance in 1380, their abbey – 'newly built . . . in a safer place at grievous cost' – had been 'totally destroyed by fire with their corn and goods of no small value', only the church being spared. So burdened were the canons with debts at this time that 'they may not content their creditors, pay the said tenths [the royal tax] and support other charges, and have not the means honourably to maintain themselves'. Richard II's advisers were in no doubt that this was true.[10]

Leiston found the means to rise above its troubles. Moreover, it remained the case that whatever the difficulties met by religious communities at this period, the monks had not lost their penchant for new buildings. As the re-siting of Leiston itself had shown, this could in part be the result of lay patronage. And if the intervention of a noble patron carried its own price, it was rarely brushed aside for that reason. Tewkesbury, for example, was a wealthy community, with abundant

72 Tewkesbury Abbey, Gloucestershire
Not even the wealthiest community, in the later Middle Ages, could afford to turn away a great benefactor. The Benedictines of Tewkesbury, for example, had never been poor. Since the early twelfth century, when massively rebuilt, their abbey church had been among the grandest in the land. Yet two centuries later they were to be ready again for a major reconstruction that would convert their church, in choir and presbytery, into the last resting-place of a clan. East of Tewkesbury's great crossing tower, the noble vaulted presbytery, with its broad surrounding ambulatory, was built on Clare money and subsequently became the tomb-church of Eleanor de Clare's relatives by marriage, the Despensers. Benefactions like these, although gratefully received, eventually exacted their price. The company typically kept by a late-medieval abbot of Tewkesbury in his final repose was not that of his brethren but of knights. (1954)

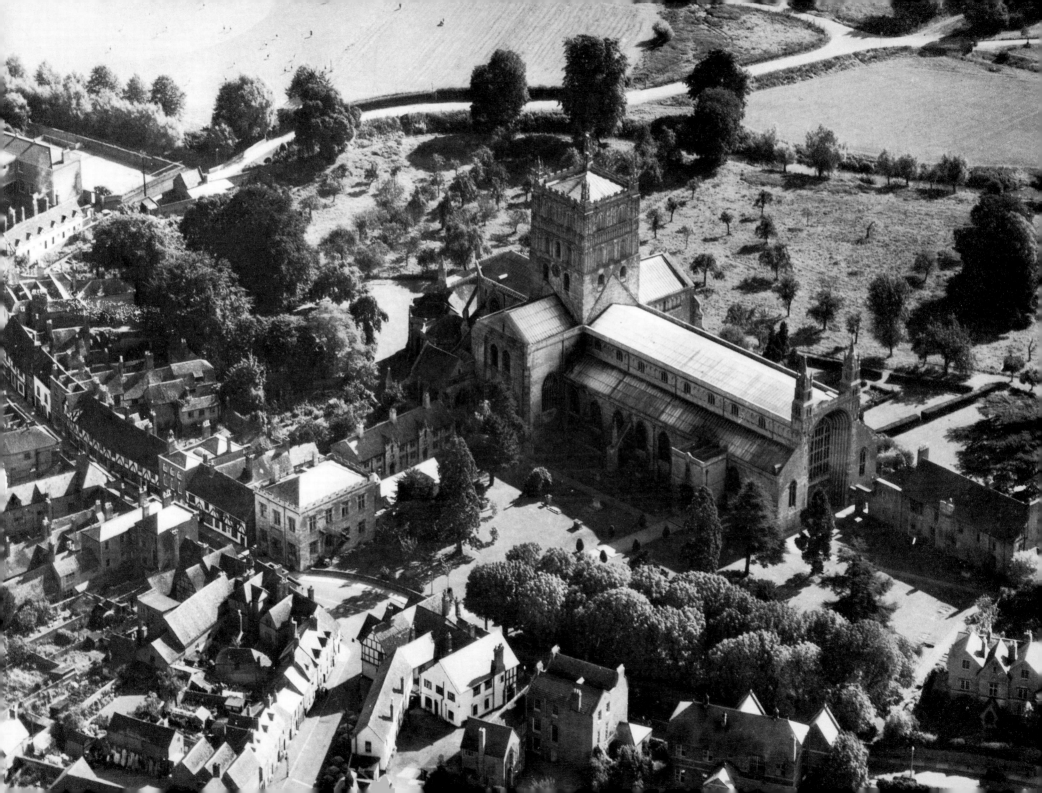

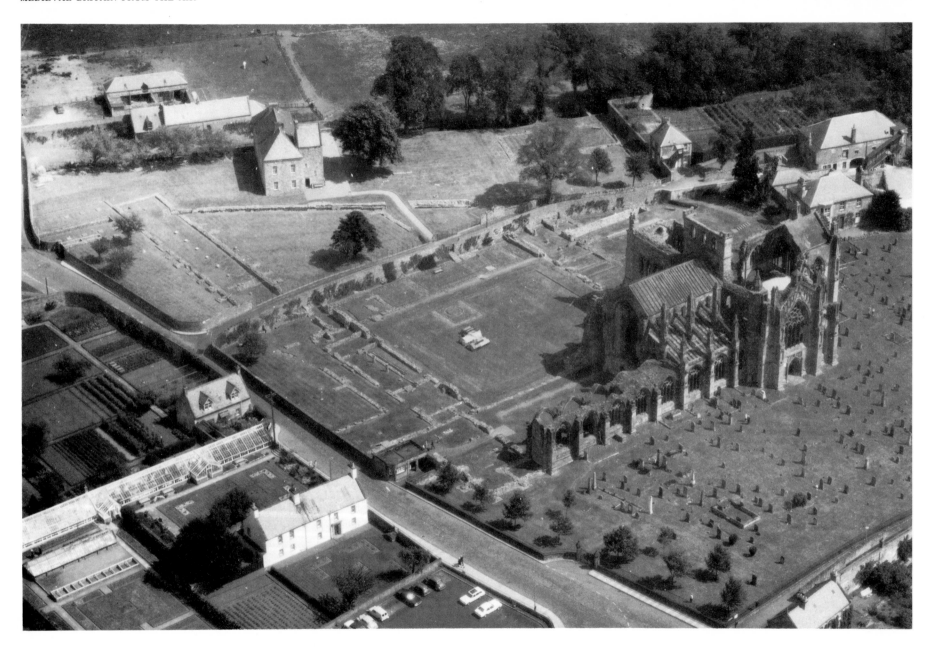

resources to maintain or enlarge its own buildings. Yet the high quality remodelling of Tewkesbury's already grand church (Fig. 72), concentrated especially on the choir, would probably not have occurred without the self-interested cooperation of the Clares and Despensers, for whom Tewkesbury was to become a mausoleum. It was the fortune of a great heiress, Eleanor de Clare, daughter of Gilbert (builder of Caerphilly), that financed the work, providing a fit setting for the family tombs as magnificent as any in England. Hugh le Despenser, Eleanor's son and himself a generous contributor to the rebuilding, lies in the place of honour in Tewkesbury's choir, immediately north of the high altar. Another Despenser, Edward (d.1375), who was one of Edward III's original Garter knights, has his own handsome chapel to the south. Around them, resting in the company of Tewkesbury's abbots, are the noblest of their successors and their kin.

A community of Benedictines, meeting regularly for worship in the midst of such commemorative splendour, could not fail to be reminded of its obligations. Among the grandest of the documents preserved from Tewkesbury's famous library were a benefactors' book, illustrated with portraits of the Despensers and their associates, and a particularly splendid armorial roll presenting a pedigree of the community's noblest patrons. The roll is fifteenth-century. But the book is a compilation of almost a century later, within just a few years of the suppression of the house.[11] Neither Eleanor nor Hugh, nor indeed any of their fellow patrons whether before or after, could be said to have misplaced their trust.

In just the same way, and with similar consequences, Melrose (Fig. 73) was to become a place of burial, maintaining a special relationship with the Scottish Crown. Already grown wealthy on the gifts of its twelfth-century benefactors, it was to preserve the body of Alexander II (d. 1249) and the heart of Robert I (d.1329). Accordingly, repeated English sackings of this border abbey came in due course to be seen as an affront to Scotland herself. As at Tewkesbury, nothing the monks could have done on their own could have equalled what was pressed on

73 Melrose Abbey, Borders
Not a great deal survives of the late-medieval magnificence of Melrose, just north of the Scottish border. However, the exceptionally high quality of what is left at Melrose is still obvious in the south transept facade (right), and it is clear that rebuilding, following the English raids of 1322 and 1385, could only have been undertaken on this lavish scale in the confident expectation of lay support. Melrose, founded by David I in 1136, had become the custodian of the remains of Scottish kings. Its reconstruction took on the status of a gesture of nationhood, for which nothing less than the best would be enough. In its new post-raid clothing, Melrose has a French look, anticipating in its decorative extravagance the later excesses of the *style flamboyant*. Rejecting the austerities of an earlier time, it still more decisively cocked a snook at the English. (1972)

them by their patrons, for Melrose's rebuilding was to be that of a nation and it required exemplary magnificence in execution. The elaborate and expensive south transept facade at Melrose, now the best preserved fragment of the abbey, is work of the very highest quality, entirely beyond the reach of a Border community had it not had the help of the Crown.[12]

Among Melrose's contemporary patrons was a contrite Richard II of England. And the abbey, it is clear, would have gathered in assistance from whatever source it could. Gone were the early Cistercian misgivings about building with distracting magnificence. Gone too was the Order's first reluctance to allow burials in Cistercian churches and its original prohibition of relics. One of the surviving elements of the abbey's late-medieval rebuilding was the addition of a new line of chapels, adjoining the south aisle, for the display of relics and for the burial of the good and the great. Back in the early days of the Cistercian settlement at Melrose, Abbot William (1159–70) had made himself unpopular within his own community by refusing to credit miracle stories, centering on the tomb of his saintly predecessor Waltheof, which might have brought pilgrims in large numbers to the abbey.[13] Abbot William, taking his views from the great St Bernard and from the earliest legislators of the Order, had sought peace and seclusion for the purer practice of a life of religion. But even in his own day, such sentiments, though admitted, would commonly be brushed briskly aside. By the fifteenth century, they had lost force or authority of any kind.

Medieval monasticism never lacked its critics, and Gloucester Abbey (Fig. 74) in the later Middle Ages was among those singled out for special blame. The monks' life-style, it was said, was objectionably luxurious, and there was distrust of the system of individual cash doles by which some members of the community, thriftier than the others, could build up appreciable private fortunes. Nevertheless, few but the Lollards (from the late fourteenth century) would have found cause for dismay in the community's exploitation of what came to be its most precious charge, the body of the unfortunate Edward II, murdered in 1327.

74 Gloucester Abbey

Like Tewkesbury and Melrose, Gloucester Abbey was already rich when circumstances favoured, in the later Middle Ages, a lavish rebuilding of the church. Preserved as one of Henry VIII's new cathedrals following the suppression of 1540, Gloucester is a monument to a successful cult, owing its reconstruction to the alms of pilgrims at the tomb of the murdered Edward II (d.1327). When, that is, building faltered at other religious houses during the difficult times of the later fourteenth century, the Benedictines of Gloucester found the resources, under a succession of able abbots, to rebuild the east end of their church, its choir and transepts, later turning to a total reconstruction of their great cloister (right). A century or so afterwards, they were still building, raising the impressive crossing tower in the 1450s and 1460s, and following this by the addition of the grand Lady Chapel (left) which partly obscures the huge east window, itself a memorial to the English victory at Crécy (1346). Gloucester's east window, finished in about 1350, set a precedent in English church architecture which was to open up the ends of many lesser buildings in similarly ambitious spreads of glass. Here the device was to be repeated more conventionally at the east end of the Lady Chapel, as in the chapter-house and adjoining library to the right. It became one of the distinguishing marks of English Perpendicular – a style admired and imitated across the face of Europe, from Spain, in the west, to Bohemia. (1946)

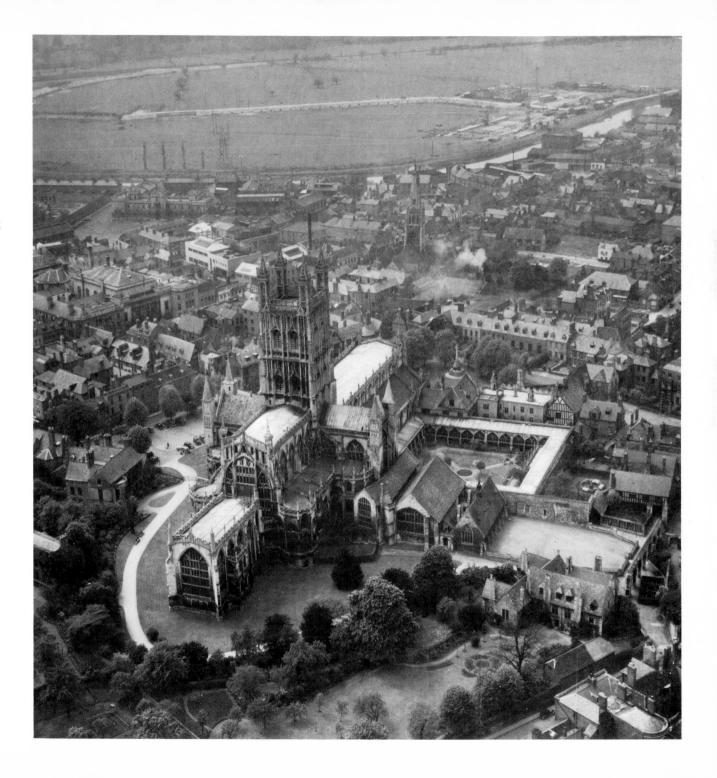

Abbot Thoky's resourceful capture of this most promising of relics was to bring about an immediate turn-round in Gloucester's finances. The cult was a success, and in the rush of pilgrims crowding into the abbey church, Thoky's building instincts could be gratified. Memories of earlier misrule now faded swiftly in the more general recollection that Abbot Thoky had 'obtained many good things in building and other ornaments'.[14] In effect, he had launched a rebuilding of church and cloister which was to be powerfully influential in English architecture, pioneering a national style.

Gloucester has become known as the home of Perpendicular, or at any rate of a number of Perpendicular's more important elements. Its great fourteen-light east window, partly obscured by the later addition of the Lady Chapel, made a wall of glass across the presbytery's east end, setting a precedent which would be followed again at the Lady Chapel itself, as well as at almost every rebuilt parish church throughout the country. Completed by about 1350, the window was a memorial to England's recent military success, for it carried the heraldry of the heroes of Crécy (1346), occurring in the company of the murdered King Edward and of the Virgin in Glory at her Coronation. Almost immediately following the completion of this work, the remodelling of the conventual buildings at Gloucester began. And it was here in an unstinting reconstruction of the abbey's great cloister that the characteristically English fan vault was given birth. Among the later triumphs of this technique were to be the vaults of Henry VII's memorial chapel at Westminster and of the incomparable King's College Chapel, in Cambridge. At Gloucester, where first applied to the east cloister walk, the vault was already remarkably well developed.[15]

Over the central crossing at Gloucester, the abbey's noble tower was a work of the mid-fifteenth century. And it was later in the same century that Canterbury (Fig. 75) too would sprout the great tower which has come to be known as 'Bell Harry'. Both churches were cult centres, and both continued to draw a substantial (though decreasing) proportion of their revenues from the offerings of

75 Canterbury Cathedral Priory, Kent

The cathedral priory of Christ Church at Canterbury had been a major cult centre – the repository of saints' bones – even before the martyrdom of Archbishop Thomas Becket in 1170 gave the monks their most lucrative of relics. Throughout the rest of the Middle Ages, pilgrims continued to arrive in large numbers, marvelling at the great assemblage of 'skulls, jawbones, teeth, hands, fingers, and whole arms' which a sixteenth-century humanist like Erasmus could dismiss with some scepticism but which the majority still viewed as a potent armoury in the everlasting struggle with the Devil. Canterbury's building budgets depended on such visitors. However, they could be influenced too by the success of an administrator in adjusting more swiftly than his fellows elsewhere to the economic realities of his era. Thomas Chillenden, formerly treasurer of the community, was prior through two decades – the 1390s and 1400s – during which the majority of religious houses, under less certain direction, suffered a severe erosion of their receipts. Whereas it had been earlier policy to hold onto the priory lands, cultivating the estates directly through salaried bailiffs, Prior Chillenden leased the Christ Church demesnes within months of taking up his new office. It was this that enabled him to find the finance for a reconstruction of the nave (left), with many other projects designed to bring the accommodation of the priory up to date. Rightly, he earned himself the reputation of a formidable builder; albeit in difficult times, perhaps the greatest the monks of Christ Church had ever seen. (1968)

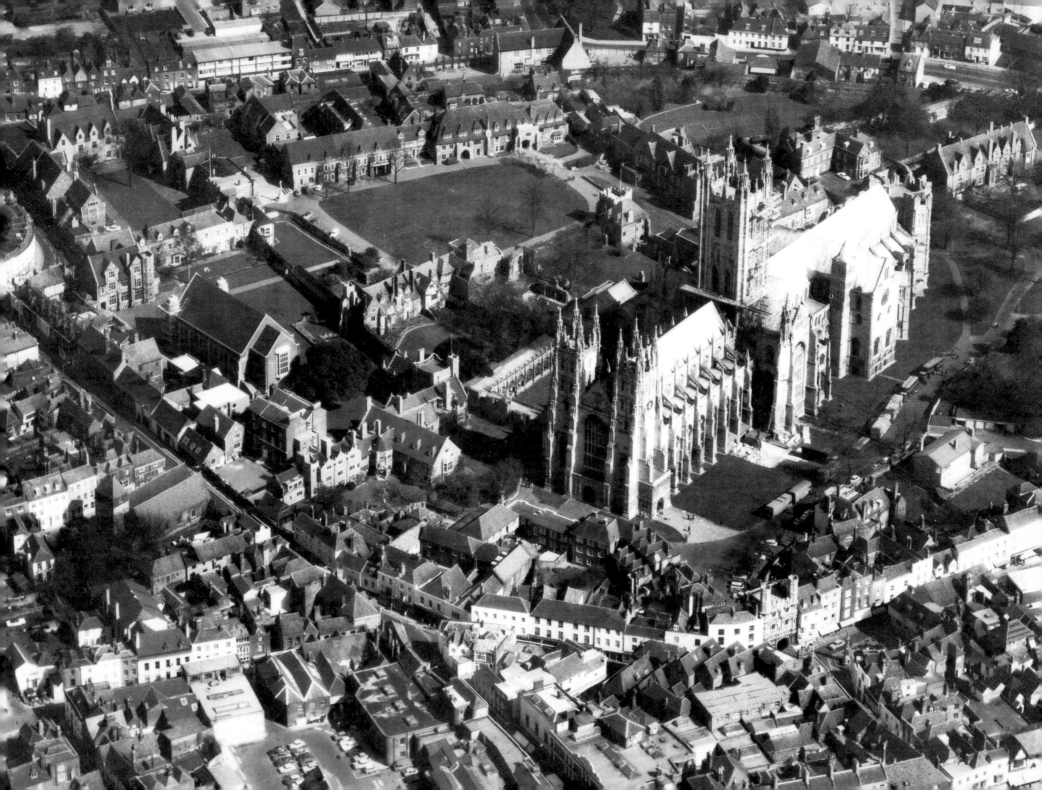

pilgrims at their shrines. However, great endowments in the past had secured for them also that, in the hands of a skilful and experienced administrator, they might continue to prosper even while others round about them were in decline. Gloucester's expensive cloister (and much else) was to be completed during the long and remarkable abbacy of Walter of Frocester (1381–1412) when, entirely against the prevailing economic tide, the abbey's manors were restocked and its finances set right by the systematic appropriation of parish churches. Abbot Walter was interested – this being one of the causes of his success – in the keeping of adequate records. And it was a comparable expertise in the techniques of accounting that enabled his contemporary, Prior Chillenden of Canterbury (1391–1411), to take the drastic measures which, within his own span, were to reverse the community's long slide into insolvency. Thomas Chillenden had been treasurer of Christ Church before his promotion to prior, and he knew very well how to deploy the powers which he united now in one person. Far from re-equipping his priory's manors, as Walter of Frocester had done at Gloucester Abbey, he leased the greater part of them at a stroke. Freed from the cares of management and with a regular inflow of rents, Prior Chillenden could turn his enormous energies to the fashioning of a personal memorial.[16]

John Leland's later assessment of Thomas Chillenden as the 'greatest Builder of a Prior that ever was in Christes Church' was little better than an informed sixteenth-century guess. But it seems likely to have been substantially correct. To Prior Chillenden's day, following up an earlier scheme, belongs the total reconstruction of the cathedral nave in a style more magnificent than before. Lesser projects included white-washing and the repair of paving in the church, new accommodation for the sacrists, the completion of the new chapter-house, the re-roofing of the refectory, and 'also the new work on the cloister which is still not finished'. In Chillenden's time, the twelfth-century water system, once among the glories of the Anglo-Norman house, was put back into service 'at great expense', to the considerable benefit of the community. Over the centuries, Canterbury

Cathedral Priory had become a place of many private chambers, and it was a significant characteristic of Prior Chillenden's work that he did much to extend and improve these facilities. His reconstruction and refurnishing of Canterbury's great and privy dormitories no doubt took the form of the introduction of partitions, making separate cells for the monks of the community, as was happening contemporaneously at Durham. In the infirmary, by tradition a great hall, four private chambers were re-equipped at this time, while Chillenden's personal quarters were substantially rebuilt, the prior's chamber 'newly ceiled and repaired with new windows and a new fireplace', a new study supplied, better privies, and 'a decent bath'.[17]

Today, only the nave at Canterbury preserves the memory of this remarkable man. Nevertheless, the contemporary description of Prior Chillenden's works is certainly explicit enough, and what it helps underline is the growing emphasis on privacy in building which was simultaneously overtaking the other monasteries. At Thetford (Fig. 14), for example, the extended north-west range of that Cluniac house was a fourteenth-century rebuilding of the prior's lodgings and his guest-house, multiplying private chambers for those purposes. At Easby Abbey (Fig. 32), similarly, it was to be the abbot's quarters and infirmary of this Premonstratensian community that would be considerably enlarged in the later Middle Ages as the canons relaxed their regime. Hailes Abbey (Fig. 34) was to be one of a number of Cistercian houses where the west claustral range, vacated by the lay brethren, would be converted during the fifteenth century into abbot's lodgings. At Muchelney (Fig. 36), a remarkable abbot's house in the south-west angle of the cloister, completed only a few decades before the Suppression, would owe its subsequent survival to the modern comforts which so well suited the new owners of the site.

Among conversions such as these, two of the best preserved are at Castle Acre (Fig. 76), in Norfolk, and Much Wenlock (Fig. 77), in Shropshire, both of them Cluniac foundations of the late eleventh century to which French monks had been

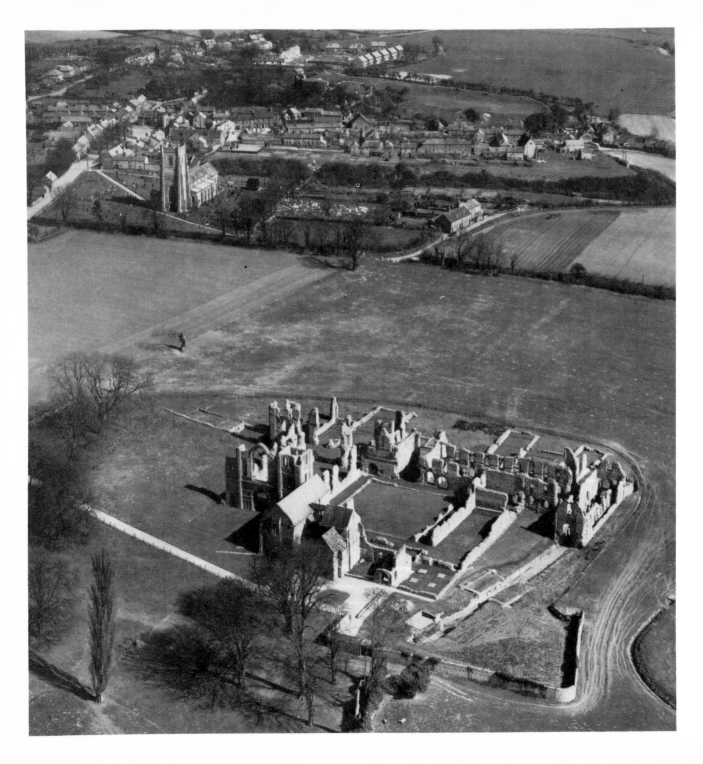

76 Castle Acre Priory, Norfolk

Among Prior Chillenden's works at late-fourteenth-century Canterbury had been the remodelling of his own lodgings. Elsewhere, while communities dwindled, the status of the superior paradoxically rose as he appropriated more buildings and resources. The prior of Castle Acre, at one time scarcely more than the chaplain of the Warennes at their neighbouring castle (Fig. 4), was among those who advanced in status through the years. By the fifteenth century, as a major landowner, he was expected to maintain an appropriate state, offering hospitality in the warmth and comfort of his fine suite of lodgings in the west claustral range, next to the west door of his church. At the Dissolution, the prior's quarters at Castle Acre were of such scale and quality that they were preserved by the site's new owner. In their present condition (nearest the camera), with the skeleton of the former priory on three sides of them, they still have the look of a Norfolk country mansion, very unlike the traditional image of the austere cell of a man of religion. (1948)

imported during the first phase of the Anglo-Norman reform. Over the years, persistent stone-robbing at Castle Acre has stripped the ruins of much of their surface detail. However, there has been one area of the former priory, in the north-west corner of the cloister, which has remained unharmed. And the reason for the survival of the prior's lodgings at Castle Acre is quite clearly, as at Muchelney, their supreme comfort. What the prior enjoyed, in this quiet country location with its little market settlement just a field or two away to the north-east, was the cushioned ease of a substantial landowner whose duty it was – and pleasure it might be – to behave as a generous host. At Castle Acre, the prior's study and his chapel, on the first floor of his lodgings, were warm and well-lit apartments. Next to the chapel, the prior had his bed-chamber, with another fireplace and a garderobe attached. On the same level, there was a guest-hall and other quarters for distinguished visitors, the whole arranged over a full suite of domestic offices, cellars and stores, and entered by way of a grand porch.[18]

Castle Acre's west range is a complex building of several periods. In contrast, the equivalent prior's range at Much Wenlock is of one date only, being almost certainly the work of Prior Richard Singer (1486–1521) who, during his long priorate, is known to have been especially active as a builder. Rejecting the more conventional site west of the great cloister, Prior Richard chose to build where he had more space and freedom to do so, alongside the infirmary court to the east, with the existing twelfth-century infirmary hall wedded into his range on the north. What resulted was a building of very individual appearance, stylish and splendid, among the very best of its time. Behind the multi-windowed corridors and the swooping roof of its show front, are the prior's hall and chamber on the first floor of the range, with guest chambers on that and on two other levels, and with a new infirmary chapel below. Accommodation of this standard, still in excellent condition at the Reformation, was such as any man might have wished for and as few could have experienced by this period. Hardly surprisingly, it escaped demolition.[19]

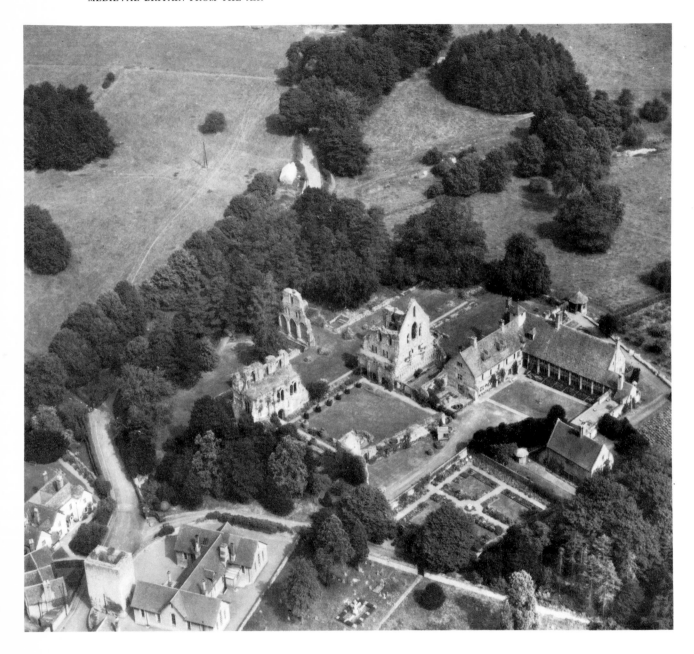

77 Much Wenlock Priory, Shropshire

In distant Shropshire, on the other side of the country from Castle Acre, another Cluniac superior was equipping himself still more lavishly at about this time. Richard Singer, prior of Much Wenlock from 1486 to 1521, was a dedicated builder, and it was probably he who rebuilt the east range (right) of the infirmary cloister as new lodgings for himself and his guests. Under the middle of its great roof, the prior's hall was an especially dignified apartment, well suited to the entertainment of important visitors. Next to it, at the south (right) end of the range and again at first-floor level, was Prior Singer's chamber, with other chambers north of the hall and fine apartments on the ground floor below. As at Castle Acre, a building of this quality, only recently completed, was too good to be got rid of at the Dissolution. With the twelfth-century infirmary hall, north of the same cloister, the prior's lodgings at Much Wenlock were retained by the lay owner when the church and other buildings were destroyed. They have been occupied, little changed, to this day. (1947)

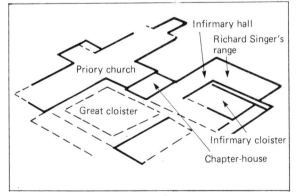

Prior Richard himself avoided the consequences of his extravagance, but these were dangerous times for display. In the late summer of 1523, just two years after Richard Singer's death, there would be a visitation of Wenlock, generally hostile in its conclusions, conducted by Dr Allen as commissary-general of Cardinal Wolsey. The cardinal himself had already headed an attack on the black monks which they had warded off only at great cost. And when Dr Allen came to Wenlock at the particular request of Roland Gosenell, its new prior, who had had trouble enforcing discipline in his community, he brought Wolsey's articles of enquiry along with him. Many of the resulting injunctions, delivered in the chapter-house on 7 September, were routine enough. The monks of Wenlock were to avoid conversation with women; they were to dress more modestly; they were to keep refectory, eating in the proper places at the appointed hours, and were to limit convivial drinking; they were not to wander abroad without the licence of their superior, and were to be careful not to gabble through their services. Instructions like these would have been received at Wenlock, as at every other similar monastic community over the past three centuries, many times before. But more particular to Wenlock were the additional 'counsels and exhortations' which Dr Allen appended to his main text. Beginning with the sound advice to ward off ennui by practising the 'mechanical arts' – by which he surely meant 'embroidering or writing books with a very fair hand, making their own garments, carving, painting, or engraving' performed contemporaneously under a better regime at Ulverscroft[20] – Dr Allen turned from general advice to the community as a whole to a consideration of the prior's personal life-style:

'It is advisable that in maintaining his household of servants or lay folk the prior shall be careful to keep within the bounds of moderation in proportion to the charges laid upon the monastery, so that he may not seem to waste the goods of the monastery imprudently on the pretext of hospitality, and also that he may not incur the stigma of luxurious living by an excessive retinue of servants and ceremony at his table.'[21]

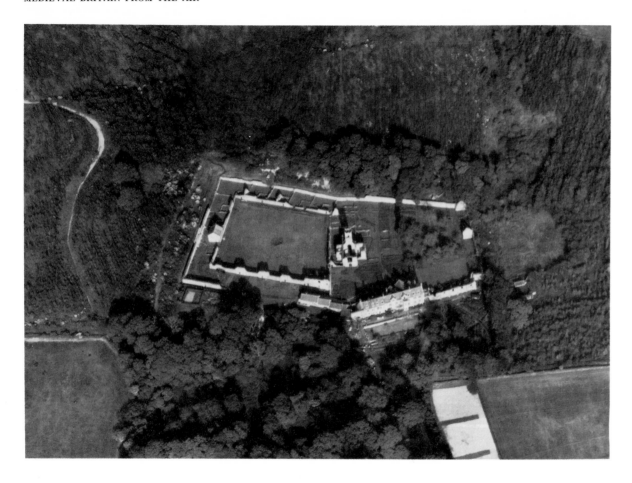

78 Mount Grace Priory, North Yorkshire
Far removed from the aristocratic splendour of
the Cluniac priors of Castle Acre and Much
Wenlock was the austere isolation of the
hermit monks of Mount Grace. Finding
themselves in tune with contemporary
spirituality, the Carthusians enjoyed a revival
in the Late Middle Ages, attracting patrons
much more readily in post-plague England
than they had done even back in their
founding years when overshadowed by busier
orders like the Cistercians. Mount Grace,
founded by Thomas de Holand as late as
1398, was utterly different in plan and scale
from Cistercian Byland (Fig. 29), one of its
nearer neighbours in religion. Whereas the
monks of Byland had both lived and
worshipped in common, seeking to experience
their personal vision of God in the fellowship
of cloister or choir, those of Mount Grace
locked themselves away in individual cells,
each with its garden-plot, cheek by jowl round
the sides of their great cloister (left). One of
these cells has been reconstructed in its
original two-storey form: sleeping-chamber
above, study below. It faces, across the
cloister, the diminutive church, rarely used by
the monks except on Sundays and feast-days,
and accordingly much less important in the
life of a Carthusian community than it would
be for a Cistercian or a Benedictine.
Carthusians took their meals in the privacy of
their cells, so there was no provision for a
common refectory at Mount Grace. South
(right) of the church, a second enclosure held
farm and other buildings, with some
additional cells, provided when the
community expanded. Like the rest of the

Indeed, it had been just such luxurious living, attended by a 'varied and irregular
array of servants', that Henry V, a full century before, had found cause to criticize
in the monastic superiors of his day, finding it in particular among the
Benedictines. His adviser on that occasion had been a very different sort of man –
Robert Layton, prior of Mount Grace.[22]

When Prior Layton attended the king in 1421, lending force to his arguments
against the black monks, Mount Grace Priory (Fig. 78) was one of the most recent

house, it was strongly walled against the intrusions of that impure outer world on which the Carthusians, much to the wonder and admiration of the better sort of their contemporaries, had resolutely turned their backs. (1967)

– and almost the last – of the monastic foundations in England. Established in 1398 on the initiative of Thomas de Holand, duke of Surrey, Mount Grace had played its part in the brief but significant revival of the Carthusians in England which had reached completion already by 1414 on the foundation of Henry V's own community at Sheen. In their well-regulated retreat from the world and in their deliberate asceticism, the Carthusians touched a chord in contemporary spirituality, exemplifying a life which few had the strength to follow for themselves but which all might readily admire. Still, in 1521–2, when the black monks were again under attack from Cardinal Wolsey, the Carthusians were among those who the Benedictines chose to cite as examples of unattainable austerity.[23] The dangers to contemporary monasticism were not wholly from outside. Some of the threat came from zealots within.

Today, the calm of Mount Grace has been largely destroyed by the hum of a busy trunk road to the west. Yet it must, in its time, have been absolute. Round the great cloister to the north of the church were the individual garden-plots and cells of the community. These *domunculae* were the spiritual homes and prisons of the Carthusian hermit-monks, from which they only rarely emerged. Within was the equipment for a life of self-denial and of full-time religion, carefully enumerated in the Carthusian customal and everywhere standardized through the Order: two hair-shirts, four pairs of socks, a straw bed with coarse coverlets, two pots, two spoons, a jug, a bread knife, a salt cellar etc. There was to be little human contact in a Carthusian community, but neither would there be opportunities for ennui. First among every Carthusian's objectives would be the rescue and permanent salvation of his own soul. But second was the useful copying of devotional works, for which most Carthusian communities became noted manufactories, so that the scribe might be a 'preacher with his hands'. Some years ago, during the excavation and clearance of one of the cells at Mount Grace, evidence was found of experiments, still rare in the period to which the material belonged, with printing.[24] Before the invention of printing, writing equipment

had been among the main items listed in the Carthusian *consuetudinarium*. It included a writing-desk, pens and two ink-horns, a pencil, a rule, two pumice stones, chalk, a plumb-line and pointer, a knife, an awl, and two razors.[25]

In the event, it would be from Mount Grace that Henry V, filling the libraries of his new reforming houses at Sheen and its neighbouring Syon (Bridgettine nuns), would obtain some of the classics of contemporary mysticism. Endowing these houses, Henry was to rely largely on the proceeds of the plunder of the alien priories, suppressed in 1414.[26] Both actions, inescapably, implied a threat to other branches of monasticism in his kingdom. For mysticism, as admired and practised in the seclusion of Mount Grace, made much of the individual as against the collective devotion on which traditional monasticism had been structured. It was to be an especially keen blow that the standard-bearers of the new devotion should have been equipped out of the properties of the older houses, originally the product themselves of a reform.

Of course the alien priories, mere satellites and revenue-generators of the Norman abbeys, were natural victims of the Hundred Years War. But xenophobia was only one of the problems met by men of religion in the fifteenth century, more serious overall being a very general deterioration of their public image. In particular, those very magnate patrons who had once been the prop of the monks in their youth, deserted them increasingly in middle age. Already in the thirteenth century, the challenge of the Mendicants had been serious enough. However, it had been possible to accept that the friars, taking their preaching mission to a wide lay audience, had enjoyed a different role from the monks and canons who, broadly speaking, had withdrawn from the world to bring about its salvation through prayer. What the black monks and their colleagues found less easy to take was the still continuing popularity of the friars in later centuries while the stock of their rivals descended. By the late fifteenth century, this high esteem had opened the door in England for the austere Friars Observant, under direct royal patronage, to be another stick with which to beat the Benedictines. But the

79 Walsingham Friary, Norfolk
The Franciscans, also known as the Grey Friars or Friars Minor, were as popular as the Carthusians, although for different reasons. Almost since the day they had first settled at Canterbury in 1224, the Franciscans had encountered hostility within the Church. And when brought to Walsingham by Elizabeth de Clare in 1347, they could establish themselves there only against the strongly-voiced objections of the Augustinian custodians of Walsingham's famous shrine. However, what attracted the hostility of the friars' rivals in religion was also what recommended them to their lay friends. The Lady Elizabeth, a great heiress, was a discerning patron of the Church. She would have expected the Franciscans to welcome the poorer pilgrims, and indeed a large guest-house, west of the cloister (top centre), remains the most prominent survival on the site. And she would have looked to them also for enlightened

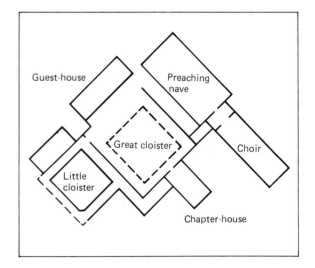

preaching in the deliberately spacious 'preaching nave' of their church. With these obvious exceptions in guest-house and nave, the scale of the friary remained small. Frugal and ill-endowed, a Franciscan community kept itself alive by well-organized begging circuits in the locality, gathering in the alms which others in the Church believed to be their own by superior right. At Walsingham, both the parish church and the priory would have suffered by their presence. The poor had everything to gain by it. (1956)

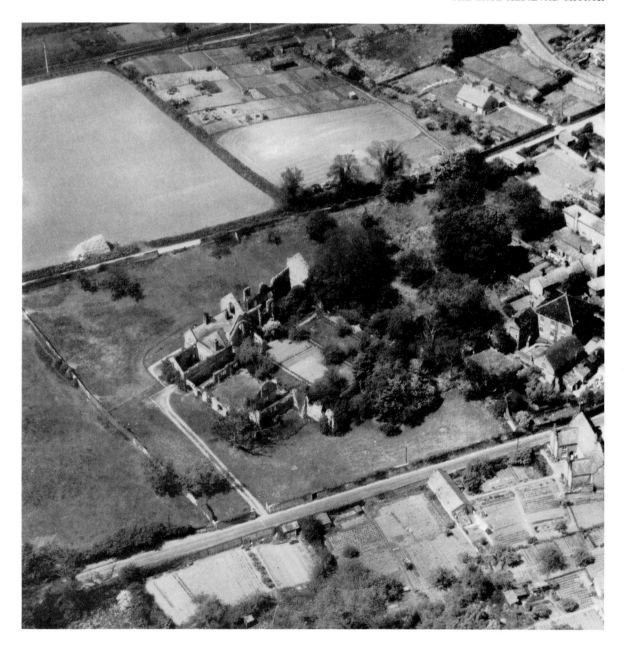

special favour of the friars had already long been a problem within the broad community of the Church, making itself felt in just that area – the assignment of bequests and other gifts – where its consequences were most likely to be resented.

The Franciscan friary at Walsingham (Fig. 79), founded in 1347, was a comparatively late arrival for that Order. And the fears that accompanied the establishment of this small Norfolk community in a region already thoroughly staked out by the Augustinians, well illustrates how tensions had accumulated. Walsingham was the site of the miraculous Holy House, renowned for its image of Our Lady. Since the mid-twelfth century, under the guardianship of a community of Augustinian canons, the Holy House had become a centre of pilgrimage, very profitable to its curators and custodians. A Franciscan presence at Walsingham could result only in a decline of receipts at the Augustinian priory, and the canons fought the threat as best they could. Addressing their petition to Elizabeth de Clare, whose project it was to introduce the friars, they appealed to her as patroness of their house. The Franciscans, they argued, would rob them of their tithes, collecting property in the area even though forbidden to do so by their own Rule. Offerings and fees would go to the friars as they had been seen to do already in other locations wherever a friary was introduced. In addition, there were the special problems of an economy dependent on pilgrims. The site proposed for the Franciscan friary was directly on the approaches to Walsingham itself, adjoining the pilgrimage route. Hospitality in such circumstances could be a weapon. A pilgrim who had spent the night with the friars on arrival could be relied upon to be less generous to the canons in the morning.[27]

That 'egregious and noble Lady de Clare', to whom her 'humble chaplains' of Walsingham appealed, turned a deaf ear to their complaints. Like her sister Eleanor, the benefactress of Tewkesbury, she was a very devout lady. However, her interests had shifted away from the established orders, and the pious work for which she is now, among many, particularly remembered was the refoundation and endowment of a Cambridge college. Scholarship, increasingly, was

experiencing the benefits of that useful characteristic of a collegiate organization – the perpetual life which equipped it to commemorate the dead. Thus to William of Wykeham (d.1404), bishop of Winchester, we owe the school at Winchester and its sister foundation (New College) at Oxford. To Henry VI (d.1471), who can be thanked for little else, we are nevertheless indebted for Eton and for King's College (Cambridge). The particular purpose of establishments of this kind was usually spelled out in the foundation documents. Archbishop Chichele's Oxford college of All Souls was specifically intended as a training ground for administrators like Chichele. But at least as important to the founder himself was the college's role as a personal chantry. Chichele (d.1443) had taken a major part in the planning of Henry V's French campaigns, to which he had contributed out of his archiepiscopal revenues. Accordingly, it became the duty of the warden and fellows of the College of All Souls, carefully laid down for them in their statutes, to offer prayers for the souls of Henry V, of Henry's brother Thomas, duke of Clarence, himself slain in those wars, and of all those Englishmen, whether captains or mere soldiers, who had fallen with the duke in the struggle. After these, they were to remember their founder Chichele, his relatives, and all the faithful departed.[28]

Archbishop Chichele had a special affection for Oxford, of which he was a graduate in law. But he had risen from humble origins, and where he wished to be remembered was at least as much among his own folk and kinsmen at Higham Ferrers, his birthplace and the scene of his youth. In this Northamptonshire town, there are still plentiful memorials of Chichele's interest – a college, a bedehouse, and a school, all of them founded within the 1420s. However, in a busy commercial centre such remains tend to be swamped, and a more poignant reminder of the values of the period are the earthworks of Fotheringhay Castle (Fig. 80), to the north in the same county, together with that splendid fragment, Fotheringhay Church, which is all that remains of the once great collegiate chantry of the Yorkists.

80 Fotheringhay Collegiate Chantry, Northamptonshire

Elizabeth de Clare, in favouring her friars above the canons of Walsingham, was not the only great patron effectively lost by this period to the older established institutions of the Church. In the twelfth century, a magnate might found a religious house – the best he could discover – as the most appropriate memorial for his line; by the late fourteenth, it would be more usual to place his money instead in a chantry. Among the grandest of these, the collegiate chantry at Fotheringhay was founded in 1411 by Edward, second duke of York, in fulfilment of an earlier scheme of his father. Fotheringhay Church lies to the west of the former Yorkist castle, of which only the earthworks (bottom) survive. Like the castle itself, it is a fragment only, having lost its chancel in the sixteenth century, with the collegiate buildings that stretched to the south (left of church). Yet it was richly endowed in its time, supporting a considerable establishment, the major purpose of which was the celebration of masses on behalf of the accumulating Yorkist dead. For the artisan his gild, for the knight his chaplain, for the magnate his community and his choristers – to every man according to his means. (1948)

Not much is left of Fotheringhay Castle, and nothing at all of the domestic accommodation of the college. Even the church has long since lost the choir in which the dukes of York had their fifteenth-century memorials. Nevertheless, what survives is appropriately monumental. It was Edmund of Langley (d.1402), fifth son of Edward III and first duke of York, who first conceived the idea of a family college at Fotheringhay. But it was his successor Edward of York, the second duke, who realized his father's original scheme in the formal foundation of 1411. And much of Fotheringhay's subsequent endowment, as indeed was common form at the time, was put together from the estates of the alien priories. Edward was killed at Agincourt in 1415. His body, returned to Fotheringhay for burial, was placed in the care of an entire community – a master and twelve chaplains, eight clerks and thirteen choristers – charged with keeping his memory alive. As at Henry Chichele's All Souls, the precise duties of this community were made clear in the original statutes of the college. Daily, after compline and before retiring to bed, Fotheringhay's chaplains, clerks and choristers were to gather round the tomb of Edward, their founder, to chant a *De profundis* in his name. There was to be a quotidian mass of requiem for Richard II, for Henry IV, for Henry V (when departed), for Duke Edward and his parents (Edmund and Isabella), and for all Christian souls. On the last day of February, there would be a special mass for Richard II; on 20 March, for Henry IV; on 1 August, for Edmund of Langley; on 23 December, for Isabella. On the mind-day (the obit) of the founder himself, there was to be a distribution of pocket-money to the community.[29]

Associated with Fotheringhay College, as at Chichele's Higham Ferrers or at such other near-contemporary foundations as the de la Pole collegiate chantry at Ewelme (Oxfordshire), was the traditional bedehouse for the deserving poor of the region. It was a happy local circumstance that brought such support, and one dictated wholly by chance. Ewelme, for example, was the family home of William de la Pole's duchess, Alice Chaucer, who subsequently survived him many years.

81 Tattershall, Lincolnshire

Scarcely less well endowed than Fotheringhay was the near-contemporary college at Tattershall, founded by Ralph Cromwell in the mid-fifteenth century on a site just to the east of his new castle. Cromwell had fought in France in his youth, afterwards accumulating a considerable personal fortune in the office of Treasurer of England. His fashionable brick tower-house (centre) is among the most notable of its time, showing clear French influence in the machicolated fighting gallery which links its turrets, and with a luxuriously fitted interior. The rest of his castle, now largely gone, would certainly have been as expensive and up to date. But Cromwell died childless, and he had anticipated this condition by laying out his fortune for his soul. The collegiate church (bottom left), finished after Cromwell's death, is the principal survival of his chantry. But the seventeenth-century almshouse to the north of the church (right) very probably replaces the bedehouse built there in 1486 by Cromwell's executors. And we know the college itself to have been functioning to some purpose in the early sixteenth century, for it was there that John Taverner, the composer, had his training. Ralph Lord Cromwell died in 1456. His college was suppressed in 1545, during the decade in which other similar institutions like Fotheringhay (dispersed in 1548) went down. Anticipating the Last Trump, both Lord Cromwell and the Yorkists had their armament in a century of prayer. (1951)

Higham Ferrers, as Archbishop Chichele's birthplace, and Fotheringhay, as a Yorkist family estate, likewise were significantly better served than their neighbours. Another such group is to be found at Tattershall (Fig. 81), in Lincolnshire, where castle and college, with associated bedehouse, were brought together again in just that union which every great man, in late-medieval England, would have acknowledged to be an appropriate memorial.

Ralph Lord Cromwell (1394–1456), builder of Tattershall, was among the select few in fifteenth-century England who had done particularly well out of the royal service, both at home and overseas in the French wars. While still a young man, he had fought at Agincourt; he had married an heiress and held for a decade (from 1433) the lucrative post of Treasurer of England from which, like others, he had drawn profit. Tattershall, as an estate, had been in Cromwell's family since the mid-fourteenth century. And it was here, without direct heirs to succeed him, that the Treasurer resolved to invest a substantial part of his fortune in the foundation and endowment of a memorial college, of which the church is the principal survival. Nothing at Tattershall was to be meanly done, while everywhere too the Treasurer's badge (a purse) was to be prominently displayed to remind the visitor, whoever he might be, of the first fount and origin of this bonanza. The badge occurs on the chimney-pieces of Cromwell's brick tower, itself an exceptionally splendid later cousin of such similarly French-influenced palatial tower-houses as John Lord Lovel's Wardour Castle (Fig. 58). The purse is there again in the stained glass of the Treasurer's collegiate church, and would certainly have been an ornamental feature of all associated buildings, including the adjoining bedehouse of which the line, though not the fabric, has been preserved.

Cromwell's bedehouse, like much of the college he had founded, was completed long after his death in accordance with the terms of his will. An agreement to build it, concluded between the Warden and Henry Halsebroke (master carpenter), is dated 14 January 1486. An existing older building was to be

dismantled and its timbers re-used to construct a range 172 feet in length and 19 feet across. On the south side, a gallery and a porch were to face the church; each of the thirteen bedesmen was to have his private chamber, 'every chamber of the same thirteen chambers to have two windows, either window to be of two lights of a competent height'; there was to be a hall 'with lights and windows in the same', an adjoining buttery, a chapel, and a garden.[30] A man in old age must commune with his heart, making his peace with his Maker. Some decades before, the duke of Suffolk, who never achieved such tranquillity for himself, had sought the same calm for his bedesmen at Ewelme, where every man might enjoy 'a certeyn place by them self . . . that is to sayng, a lityl howse, a celle or a chamber with a chemeney and other necessarys in the same, in the whiche any of them may by hym self ete and drynke and rest and sum tymes among attende to contemplacion and prayoure.'[31]

Close parallels exist between the bedesman's chamber and the cell of the Carthusian monk. In daily life, as in religion, privacy had become a mark of the period. Thus Cromwell's great tower at Tattershall was essentially a private house, distinguished deliberately from those more public buildings – the hall, the kitchen and other offices – given over to the use of his entourage. The Treasurer's church and his college were private ventures, built and endowed at his personal cost and dedicated to the saving of his own soul. In much the same way, Ralph Boteler, successor to Cromwell at the Treasury, was to build himself a country mansion of which one essential element was his own private tower, another a personal mortuary chapel as large as a church. Like Cromwell, Ralph Boteler had served in the French campaigns, and it was out of the profits of these, as well as of office under successive Lancastrian regimes, that he financed the building of Sudeley Castle (Fig. 82), on which work began in the mid-fifteenth century. Subsequently, much of Boteler's original work at Sudeley was to be obscured by Richard of Gloucester's remodelling of the inner court, carried out in the 1470s, and by a complete rebuilding, a century later, of the outer quadrangle in the

82 Sudeley, Gloucestershire
Cromwell's successor at the Treasury, Ralph Boteler, was again a builder on a considerable scale. Sudeley was his family home, and it was here that he began building in the mid-fifteenth century, on the profits of office under the Crown and of soldiering overseas in the French wars. Much of Sudeley, as it has since become, is the work either of Richard of Gloucester, who built the great hall (now in ruins) or of Edmund Brydges, second Lord Chandos, remodeller of the intact outer court (centre top). Nevertheless, what remains of Boteler's mansion is significant. Sudeley was a castle in little but name. Boteler had his strong tower at the south-west angle (bottom left) of the inner court. But his barn (top left) is a better indication of what he thought to be important, as is the chapel, intended as Boteler's private place of worship and his family mausoleum, to the east of the Elizabethan outer court. A personal church, in Boteler's day, was what was required of his wealth and his station. If there were no neighbouring church or chapel to be adapted to this purpose, it would most certainly have had to be built. (1967)

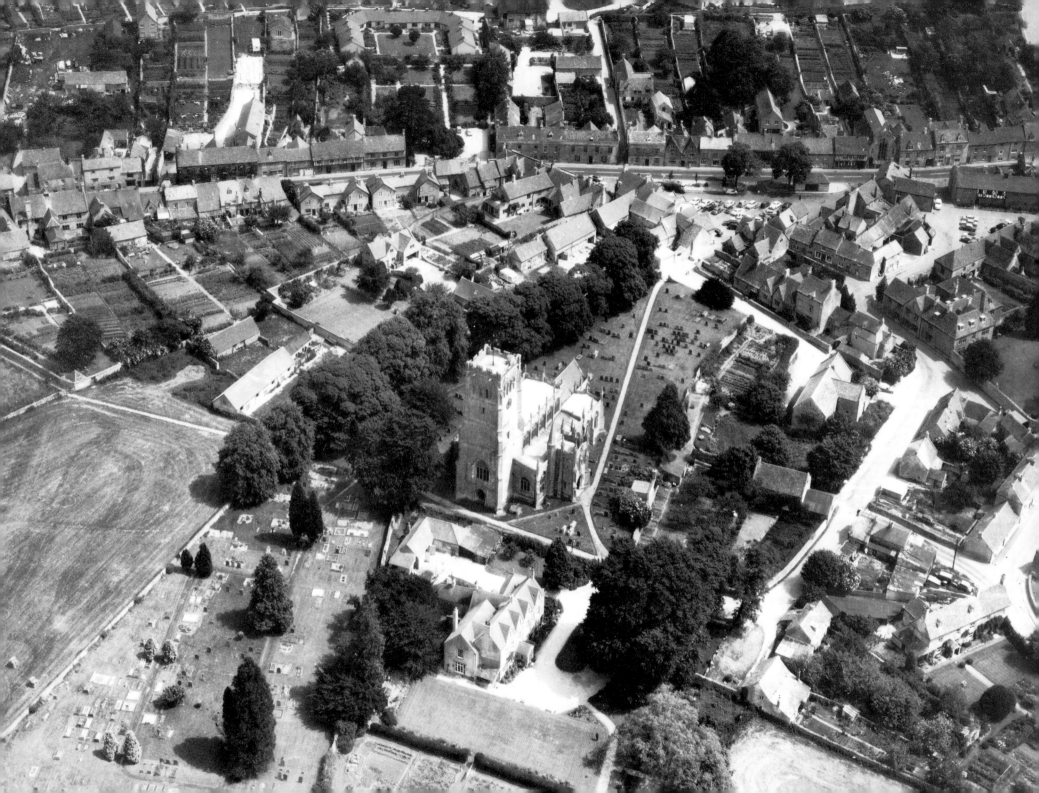

83 Northleach Church, Gloucestershire
What a man of Boteler's resources could achieve for himself, others might do still better in association. Northleach Church, not far from Sudeley and again in the Cotswolds, was a team effort, owing much in particular to the Fortey family but dependent also on the Bushes and the Serches, the Taylors, the Bicknells, and the Midwinters. These woolmen and their wives, through whose efforts Northleach grew, made no pretence about the source of their prosperity. As depicted still on the memorial brasses which are the chief glory of Northleach parish church, they are fashionably dressed but have their feet firmly planted on the sheep or the wool-packs of their trade. Some of this wealth they would set aside to the long-term advantage of their souls. Thus Thomas Fortey (d.1447), of whom his brass boasts that he was a 'restorer of roads and of churches', very probably took the leading part in the rebuilding of Northleach's nave arcade. His son John (d.1458) left the parish church a considerable sum to complete, on the noblest of scales, its present clerestory. Contemporary with the nave is the exceptionally grand porch, with the tower only a few decades earlier. 'Pray for the souls . . .' is the common formula on each of Northleach's commemorative brasses. It was a bid, not unsuccessful in the event, for immortality. (1968)

manner of an Oxford college. Nevertheless, Boteler's tower still stands, and his chapel – pinnacled, embattled, and handsomely fenestrated – ornaments Sudeley's gardens to the east. Before his death, Boteler's pious deeds would include generous support for his neighbours at Winchcombe, who had found themselves over-extended by the rebuilding on a grand scale of their collapsed parish church. Others might have settled for the parish church as memorial. Boteler, characteristically, preferred to go it on his own.

Certainly, had the lord of Sudeley decided differently, he would have had to share his commemorative glory with the wool-merchants of Winchcombe whose church, great though it was even by the exaggerated standards of a Cotswold market-town, was overshadowed by a neighbouring abbey. Other mighty churches in the vicinity, similarly rebuilt at huge cost in the fifteenth century, included William Grevel's Chipping Campden, to the north of Winchcombe, and the Fortey church at Northleach (Fig. 83), at about the same distance to the south-east.

Northleach is a fine parish church by any criterion. It has a splendid south porch and a formidably lofty clerestory, each in the best Perpendicular tradition. But what we remember Northleach for today is its remarkable collection of memorial brasses, assembling a whole gallery of Cotswold woolmen. Best known among these is the brass of John Fortey (d.1458), whose substantial legacy to the church fabric fund made possible the building of the clerestory. Fortey and his companions were wealthy men, confident in their prosperity and in their trading expertise, and richer than many of the nobility. Amongst them and between similarly-placed communities in the region, rivalries inevitably were fierce. Chipping Campden's parish church, a little later than Northleach, is nevertheless very close in its details. The nave arcades and the two clerestories, in particular, are so similar in style that they must have shared an identical source. In the same way, too, the rebuilding of Chipping Campden through the fifteenth century was a demonstration of mercantile pride. The brass of William Grevel (d.1401), next

to his wife Marion, preserves the name of Chipping Campden's greatest late-medieval benefactor. Grevel has left his mark also in a fine stone house on the High Street, one of the best such survivals of this period. Grevel money, accumulated in the wool trade, launched the rebuilding of the parish church.[32]

As at Winchcombe, at Northleach, or at Chipping Campden, it was the increasing concern shown by many parishioners for the fabric and furnishings of their churches that gave the parish church of late-medieval England a powerful fillip towards rebuilding. Of course, there were regions where the means were lacking, and where no such rebuildings could occur. And inevitably, too, there were other reasons, among them a developing ritual and a new emphasis on preaching, why church interiors should be remodelled at this time. But the direct association of a building programme with an individual, a family or a gild, as recorded by inscription or in a will, underlines the usual purpose of such works. Thus at Stamford (Fig. 15), All Saints was to become the church of the Browne family, a wool-merchant dynasty, also responsible for the founding of a fine new hospital, or almshouse, in the town. Swaffham Church (Fig. 18) would be rebuilt on the initiative of an enlightened rector, John Botright (d.1474), with the support of every notable in the locality. Lavenham (Fig. 54) is the memorial of Thomas Spring III, a wealthy Suffolk clothier who died in 1523 and whose fortune helped finance the completion of the great tower and the building of a handsome chantry chapel against the south aisle. Thaxted (Fig. 55) came to serve as the gild church of the cutlers of that borough.

Amongst all these works, and many more, Long Melford Church (Fig. 84) was undoubtedly one of the most ambitious. Long Melford's prosperity, like that of neighbouring Lavenham, was built on the cloth industry. One family in particular, the Cloptons of Kentwell, had risen to great wealth in the trade. And it was John Clopton, rather as a magnate might have been for a twelfth-century monastery, who came to be known as the 'founder' of Long Melford's parish church. Clopton rests, as that magnate would certainly have done in his time, in a

84 Long Melford Church, Suffolk
The message of pious remembrance, earned by good works, comes over as unmistakably at Long Melford as it does at Northleach. All that the Gloucestershire Forteys had been for Northleach would be repeated by the Suffolk Cloptons at their own parish church, a short distance from their family house at Kentwell. Long Melford's west tower is a modern rebuilding; its nave (as this photograph reveals) has been the subject of extensive renovations. Yet the parish church remains, for all that, very much as it was in John Clopton's day, with his tomb and chantry chapel up against the high altar, and with his extraordinary triple-gabled Lady Chapel to the east, still in service for winter devotions. John Clopton, even now remembered as the 'founder' of Long Melford, died in 1497. Just the year before, he had finished the Lady Chapel as the last of his contributions to the church. Although unusual in the scale of the works he had undertaken, Clopton was far from unique in his practical piety. All over the country – and especially, of course, in the rich wool and cloth-making regions – parish churches were remodelled in the fifteenth century, accommodating congregations in greater style and seating them more comfortably before their preachers. It was there that they were informed of Purgatory and of Hell, together with the measures, including church-building and the endowment of masses, to make short work of them. (1970)

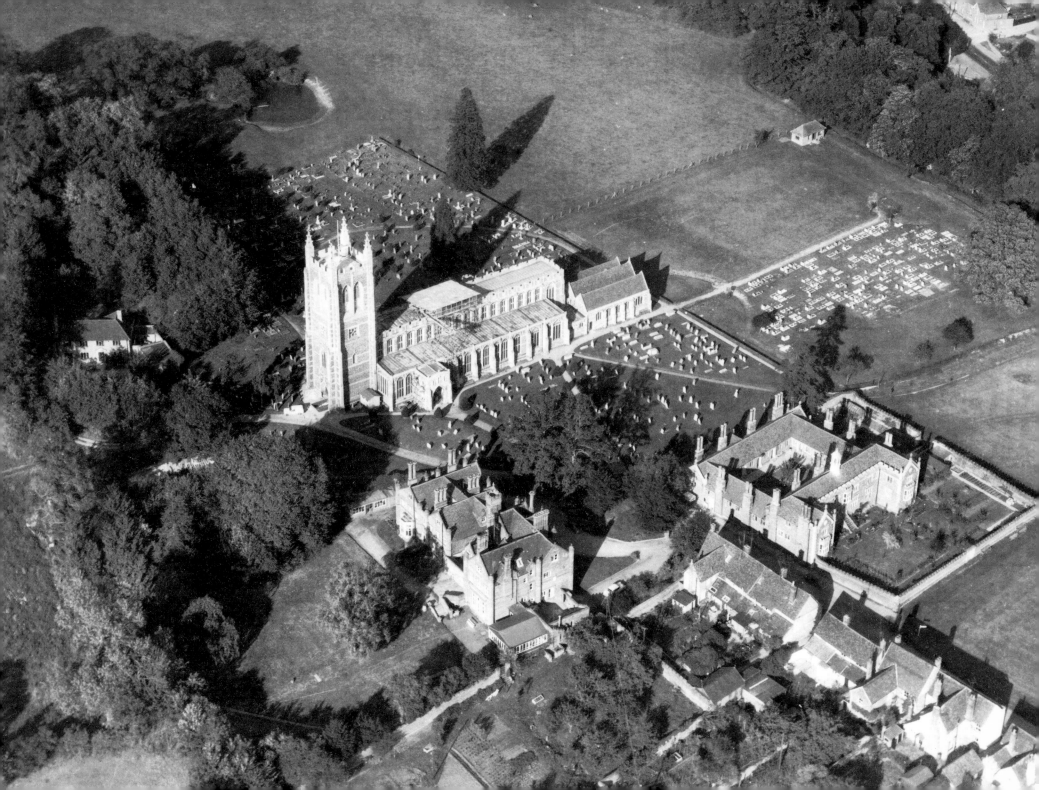

position of honour next to the high altar. On his far side is the Clopton Chapel, housing the family chantry, while in the windows of the north aisle John Clopton reappears in the company of Our Lady of Pity. Indeed, that rich fount of lay piety which had once promoted and endowed the religious orders, now flowed strongly in the direction of the parish churches. John Clopton's generosity did not dry up on the completion of the main building at Long Melford. Against the church's east end, he built a Lady Chapel which, although a frequent feature of both monastic and cathedral churches, was highly exceptional in a parish. The chapel was finished in 1496. And it carries this date in a lengthy inscription which includes Clopton's statement of intent. 'May Christ be my witness', he tells the curious traveller, 'that I have not done these things in order to earn praise, but so that the Spirit should be remembered.'[33]

6 Old Habits and New Beginnings: the Tudors

Shorn of the men they might have counted on as patrons, both monks and canons, in the last decades of their existence, could nevertheless still put on a brave show. At St Osyth (Fig. 85), in Essex, the fine embattled gatehouse of this former Augustinian abbey, always one of the richer communities of the order, is work of the highest quality, datable to the 1480s. Its completion was to be followed by further remodellings as John Vyntoner, last-but-one abbot of St Osyth, created round about him a mansion of vast dignity, of which important elements yet remain. Like Thomas Broke of Muchelney (Fig. 36) or Richard Singer of Wenlock (Fig. 77), either of whom he could have known, Abbot Vyntoner spared no expense in the modernization and embellishment of his quarters. Clearly showing on the photograph is the great oriel window which overhung the entrance of Vyntoner's lodgings and which lit the southern end of his new hall. Windows like this one, before the end of the sixteenth century, would become common enough in the greater houses, as glass itself became relatively less expensive. Yet in Vyntoner's time, such an oriel as his remained an object of great cost, and it carried, moreover, unusual ornament, significant of the changing mood of the times. Carved at the window head are the nudes and foliage of the emerging Renaissance tradition. John Vyntoner was a cultivated man, aware of the new fashions at Court. But these fashions themselves could be a dangerous luxury, for they were the surface expression of that free-thinking humanism

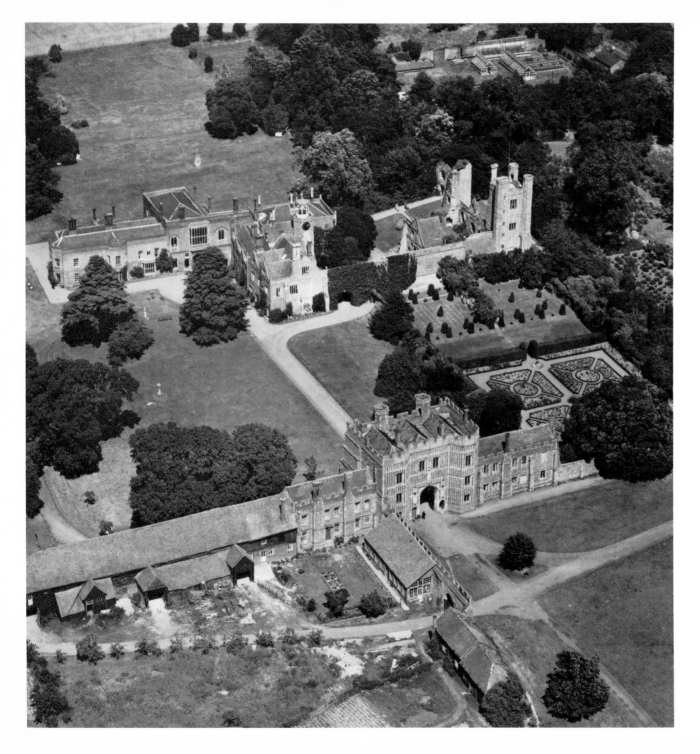

85 St Osyth Abbey, Essex

Few Augustinian communities were as well
endowed as the canons of St Osyth, and by
the late fifteenth century, as the advantage
swung to the landowner once more, they
began building again with great energy. The
handsome embattled gatehouse (bottom), with
its expensive flint flushwork, is an ambitious
addition of the 1480s. At the other end of the
drive (top) are Abbot Vyntoner's new lodgings,
rebuilt in grand style in the 1520s. Among
many subsequent extensions and updatings,
the first was Lord Darcy's remodelling from
the late 1550s, one element of which was the
great tower (top right), east of the cloister and
north of the site of the former church
(between it and formal garden). Just a
generation apart, Vyntoner and Darcy, for all
their differences in religion, were men of a
similar mind, each of them dedicated builders.
Lord Darcy himself lies in Abbot Vyntoner's
rebuilt parish church (off the photograph to
the right), surrounded by others of his kin.
The canons had gone, but lordship remained
securely where it had always been, attached to
the freehold of the estate. (1951)

which, within scarcely a decade of the carving of the ornament, had created the climate for the dismissal of the monks.[1]

The abrupt cutting-off of an ambitious building programme, left incomplete by the events of the Suppression, remains visible today at the parish church of Bolton-in-Wharfedale. What is left at Bolton (Fig. 86) now is the merest skeleton of what was once a great church, formerly of a community of Augustinian canons, of which presbytery, crossing and transepts are in ruins, while the nave has been re-used by the parish. Another open ruin, continuing the line of the nave roof, is the pathetic stub of a great west tower which, had it ever been completed, would have been one of the very grandest in the North. Begun as late as 1520, the tower was the work of Richard Mone, Bolton's last prior, who clearly viewed it as a personal memorial. Prior Richard's tower, in the original design, was to have been even more magnificent than Marmaduke Huby's tower, a few years earlier in date, at the rival Cistercian community at Fountains, just to the north. Almost certainly, Huby's tower was the spur. But Bolton was not a wealthy house, having less than a fifth of the resources of the Cistercians. Accordingly, work proceeded only slowly as finances allowed, and Prior Richard, two decades later, would live to see the day when his tower would have to be abandoned, like Babel, to the mockers.[2]

Bolton, surviving as late as 1540, was among the last of the religious houses to be suppressed. Others had been less lucky, the smaller houses – those with an income under £200 – going down in 1536, the greater beginning to follow them two years later. In the meantime, some of the survivors had become implicated in the civil disturbances (the Pilgrimage of Grace and the Lincolnshire Rising) which had followed the initially harsh treatment of the monks. Certainly, it was to this that the Cistercians of Kirkstead (Fig. 87), a Lincolnshire house, owed their dismissal in 1537, accompanied by an exceptionally thorough demolition of their conventual buildings. Just a year later, the king's commissioner in the same county would have to confess that the task of pulling down Lincolnshire's many

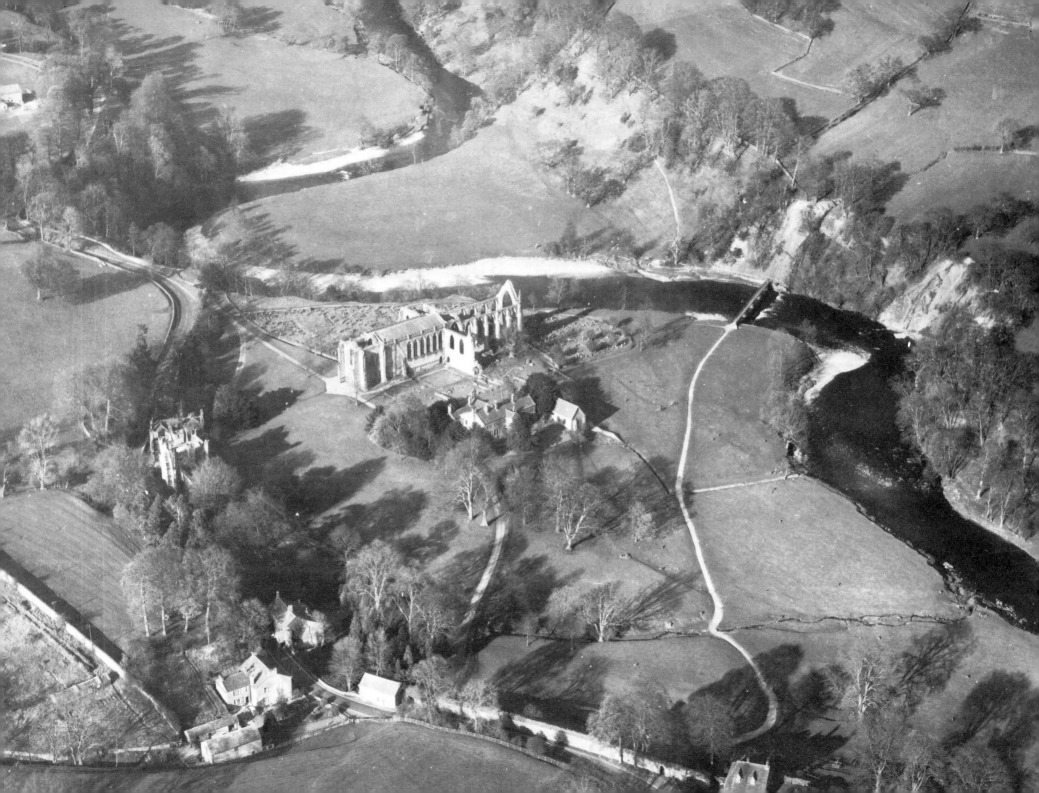

86 Bolton Priory, North Yorkshire

Competitive building, always the vice of the monks, was just as likely to occur in the final decades of monastic ownership as in the first. Prior Richard Mone's west tower (left end of nave) at Bolton, begun in 1520 but still only half complete when the priory was dissolved twenty years later, was to have rivalled Abbot Huby's great tower at neighbouring Fountains. In the event, it never got beyond the roof-line of the nave, itself subsequently preserved as the parish church. Today, Bolton is a great skeleton of a church, its choir and transepts roofless to the east of the parochial nave, its tower incomplete to the west. Of the domestic buildings, only the fourteenth-century gatehouse (left, in the trees) survives in anything like its original form, and this has been largely swallowed in the nineteenth-century mansion now known as Bolton Hall. The site itself is idyllic, not unlike that of Kirkham (Fig. 33), and it shows Augustinian canons as content in the isolation of their Wharfedale setting as were the Cistercian monks of Fountains in Skelldale, to the north. Maids of all work in the medieval Church, the black canons had some of the qualities also of the chameleon. (1966)

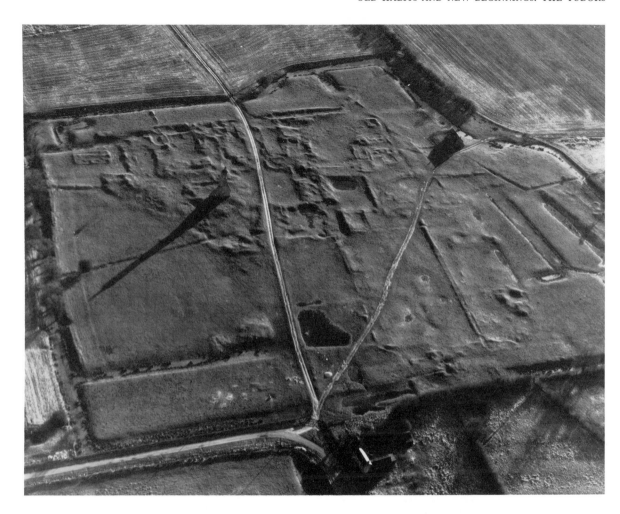

87 Kirkstead Abbey, Lincolnshire

Ruin though it is, Bolton preserves much more than does Kirkstead, originally one of the first and wealthier daughter houses of Fountains. At Kirkstead, only a fragment of the south transept still stands above ground, casting a long shadow across the site. Elsewhere, the present tangle of earthworks hides more than it reveals, in a clear bid for the attentions of the archaeologist. The monks of Kirkstead's implication in the Lincolnshire Rising was certainly the reason for the early dissolution of their house (1537) and may help explain the unusual thoroughness of the demolition. But other longer-lasting communities, including that of Kirkstead's sister-house at Meaux (Humberside), dissolved in 1539, could leave as little mark. And what kept a building standing in the mid-sixteenth century was almost always its immediate utility. (1969)

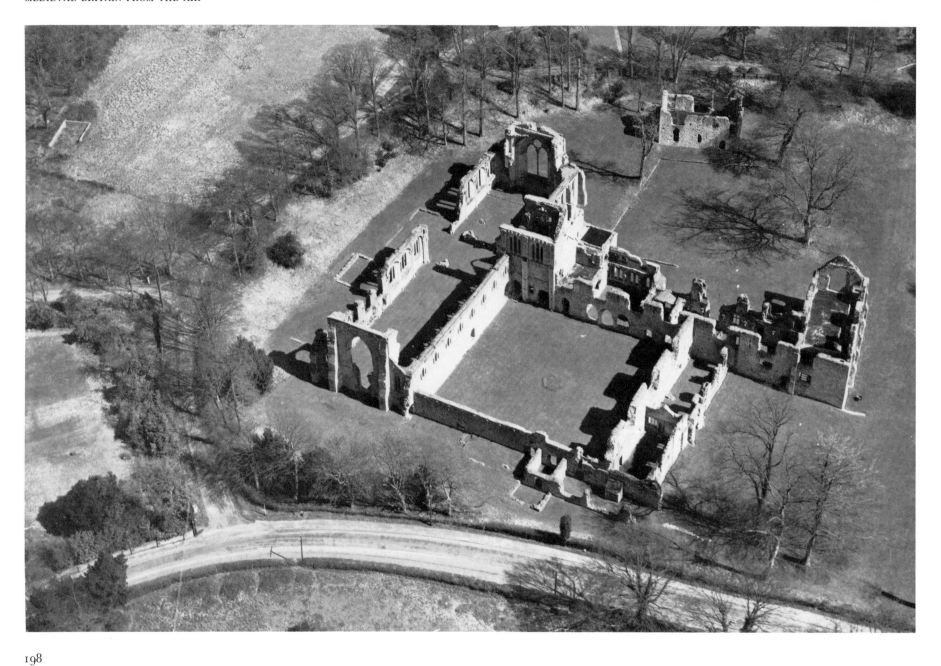

religious houses – 'with thick walls and most part of them vaulted' – was quite beyond him; there were not enough ready buyers of surplus building materials, he explained, to make the demolitions self-financing.[3] Usually, the royal officials took whatever they believed had immediate market value – the lead, in particular, and the bells – and left the rest as a quarry for the locality.

From the start, the instructions to the commissioners had been specific. They were to 'pull down to the ground all the walls of the churches, steeples, cloisters, fraters, dorters, chapter-houses, with all other houses, saving them that be necessary for a farmer'. In reality, they were to find themselves settling for much less. Byland Abbey (Fig. 29), for example, another Cistercian house similar in wealth to the less lucky Kirkstead, was to be left with much of its fabric comparatively intact. And the same would be the case for many other houses of religion, even for those like Easby (Fig. 32) which had resisted the Suppression and which had gone down fighting among the earliest. Frequently, too, there were to be excellent reasons for preserving at least a portion of the fabric. Netley Abbey (Fig. 88), in Hampshire, had never been a rich house, having experienced difficulties in its initial endowment. Yet during the first crucial decades of the setting up of the community, it had attracted the interest of Henry III who, in taking on the role of patron of Netley in 1251, made sure that its church at least

88 Netley Abbey, Hampshire
Interpretations of utility differ, and one new owner's intentions for the re-use of vacant monastic buildings rarely coincided exactly with another's. Netley was one of the smaller Cistercian houses, dissolved in 1536 even before Kirkstead, during the first round of monastic suppressions. It came to Sir William Paulet, already prominent at court, and was almost immediately adapted for his own use. The speed of the conversion no doubt

accounts for its comparatively amateurish character. Paulet's solution was to demolish the refectory, formerly projecting south from the cloister as at Byland (Fig. 29), to replace it with a gatehouse centrally placed in the south range. The cloister then did duty as a courtyard, with private apartments in the former east range, replacing chapter-house and dormitory, and with hall and kitchen in the body of the church. Contemporaneously at neighbouring Titchfield Abbey, Thomas

Wriothesley was to reverse Paulet's plan in 1537, siting his gatehouse in the church and re-using the former refectory as his hall. And there were to be other variants on these conversions, equally ingenious or perverse. However, a monastic building, put up for a specific purpose, was not easily adapted to another. Many preferred demolition and a fresh start altogether, laying the ghosts of the past. (1951)

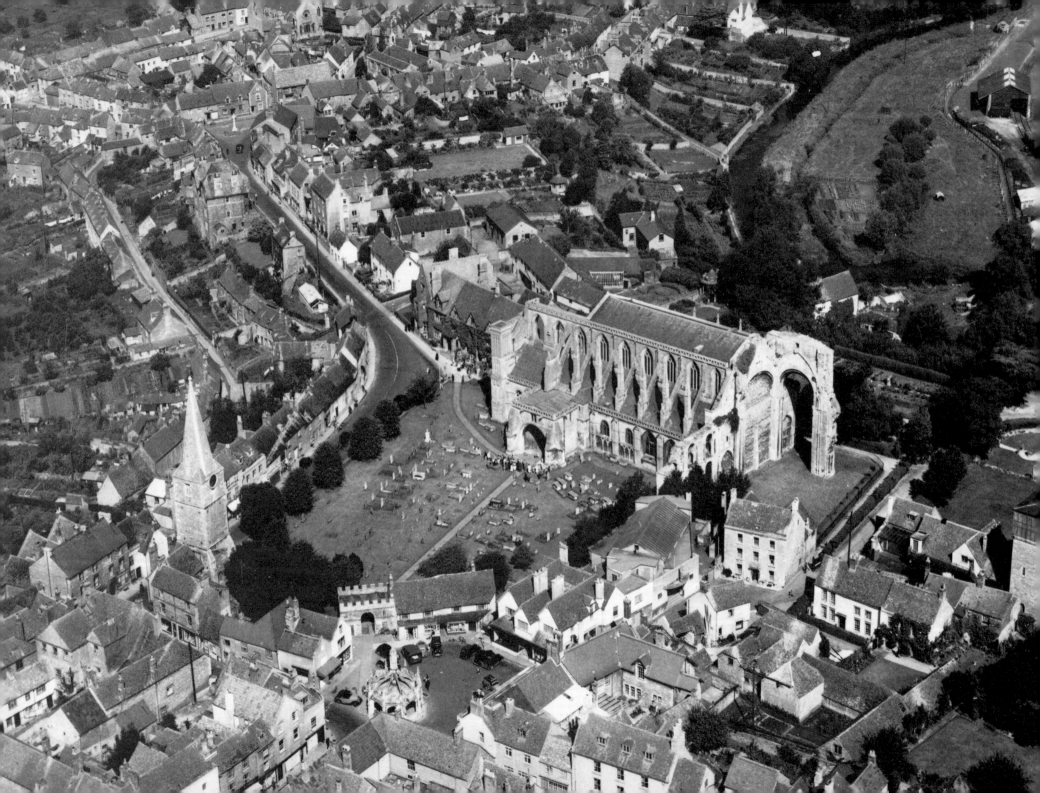

was particularly splendid. It was probably for this reason that Sir William Paulet, when granted the abbey in 1536 in recognition of his services to the Crown, lost no time in beginning what turned out to be an over-hasty and ill-considered conversion. Paulet was a Hampshire man, with family roots at Basing. And it was Basing House that he later chose to build up into a country palace, more appropriate in style to the earldom of Wiltshire and the marquisate of Winchester to which he was subsequently elevated. However, Netley in the meantime had set him just those problems which every new owner of a former monastic house would have found himself having to confront. Paulet's individual solution, happily interfering little with the remains as we now see them, was to make himself a courtyard mansion, centred on the cloister, of which the great hall and the kitchen reoccupied the church, while entrance was gained through a new gatehouse on the south, taking the place of the original refectory.[4]

After their different fashions, other landowners in the region, associates of Paulet, tried their hands at individual styles of conversion. To the east of Netley, at the former Titchfield Abbey, Thomas Wriothesley was to drive a pompous gatehouse through the centre of the nave of the disused abbey church, re-using Titchfield's one-time refectory as his hall. To the west, William Lord Sandys at Mottisfont Priory made his mansion almost exclusively from the church. But such remedies, ingenious and economical though they might have seemed at the time, were rarely satisfactory in the longer term. Of the three Hampshire landowners, only Wriothesley chose to make a permanent base for himself at the new mansion he had fashioned out of Titchfield, Paulet retreating to Basing House and Sandys to his family home at The Vyne. Experience had shown up the disadvantages of such conversions. When Sir Richard Lee, a noted military engineer, applied his science to the transformation of Sopwell Priory in the 1550s, his original intention of making the cloister (as others had done) into a single open court was soon overtaken by a fresh scheme. Lee's Place, still under construction on Sir Richard's death and never subsequently completed, would have come out of the second

89 Malmesbury Abbey, Wiltshire

In the towns, vacant monastic buildings could be put to a greater variety of uses, although they might also prove more vulnerable in the long term. Little survives, for example, of the great Benedictine house at Malmesbury. But what remains is largely owed to the initiative of a local entrepreneur, William Stumpe, who bought the site and its buildings from the Crown. It was with Stumpe's help that the parish kept the nave of the former abbey church, west of the crossing, itself now preserved only in the north transept arch (right). Other buildings, originally of the monks' outer courts to the south and east of their church, were re-used by Stumpe to house the looms of his cloth-making business, 'every corner of the vaste houses of office that belongid to thabbay' being filled with 'lumbes to weve clooth yn'. North of the church, the claustral buildings have disappeared, as have Stumpe's workshops to the south-east. Happily Malmesbury's nave, preserved even so to only part of its original length, continues in service for the parish. (1948)

conversion as a much more imposing double courtyard mansion, comparable in plan to the later Sissinghurst (Fig. 93). While preserving the orientation of the earlier priory buildings, it otherwise effectively ignored them.[5]

Indeed monastic buildings, traditionally designed for a specific routine, were rarely all that easy to re-use. Certainly, there would be some urban situations where surplus accommodation, suddenly available on this scale, would tempt the more imaginative of entrepreneurs. And Malmesbury (Fig. 89) turned out to be one of those, the nave of the abbey church being preserved for the parish, while William Stumpe, 'an exceding rich clothier', built a new mansion for himself to the north of the demolished presbytery, housing his looms in the workshops and other offices of the outer precinct.[6] But Stumpe's purpose and his resources were exceptional. Much more common was the demolition of monastic churches and their associated buildings whether in part or whole, leaving 'bare ruined choirs' to scatter the land in a whole galaxy of memorable fragments.

Among the saddest of these fragments, as at Malmesbury itself, were the scaled-down churches where the faithful still gathered in just that part they could afford to maintain. Crowland Abbey (Fig. 90), a Lincolnshire house suppressed in 1539, had been among the richer and more ancient of the Benedictine communities, wealthier than Malmesbury but with a local population that was comparatively thin, not in need of great spaces for worship. Accordingly, what was preserved at Crowland was the parochial north aisle, rebuilt not long before in the fifteenth century during an ambitious remodelling which had included the addition of the monumental west tower and a reconstruction of the now roofless nave. In effect, what was abandoned was all that part of the monastery which the monks themselves had used and which had therefore fallen to the king as Crown property. The parish held on to its own, although it took it much patching and botching to do so.

Clearly, for too many parishioners the events of these years would have occasioned much anxious debate. Those of the prospering borough of

90 Crowland Abbey, Lincolnshire

The parish church at Crowland is another of those fragments which a continuing use for worship has kept in being. At the Dissolution, the Crown's normal practice was to dispose immediately – by gift, lease, or sale – of all those parts of a monastic building exclusively in the occupation of the monks. Thus, if a church were preserved, which was not uncommon, it usually lost its presbytery and choir immediately, being cut off (as at Malmesbury) at the crossing arch where the nave, open to laymen, began. In a great church like Crowland, the north aisle had been sufficient for normal parochial use, and it was this that was preserved at the suppression of 1539, together with the west tower with which it had been equipped rather less than a century before, shortly after the aisle itself had been enlarged and remodelled. Everything else, with the exception of the skeleton of the nave, has now been removed above ground-level at Crowland. And yet this, in its time, had been one of the greater of the Lincolnshire houses, grown wealthy on the reclamation of the Fens. (1950)

203

Tewkesbury (Fig. 72), having long used the abbey's nave for worship, bought the entire building soon after 1540 and moved their services from that time onwards into the monks' choir. At Pershore, similarly, the parishioners bought the choir but abandoned the cavernous nave. At Sherborne and Great Malvern, existing parish churches would be given up by their congregations in favour of disused monastic buildings themselves only recently rebuilt. There was nothing to say that it would be the monastic church, of the two, that would survive. At Muchelney (Fig. 36), as at Kenilworth in similar circumstances, it was the abbey church that went down with all the other claustral buildings, while the parish church, long dwarfed by it, was preserved. An exception had been made at Muchelney of the newly completed abbot's lodgings, and comfortable suites of apartments like those, re-usable by the next owner with little or no conversion, were always obvious candidates for preservation. They survive again at Castle Acre (Fig. 76) and Much Wenlock (Fig. 77), next to abandoned churches for which the parishes had acceptable substitutes already.

Strangest of anomalies at the English Reformation was the survival, almost unharmed, of the cathedrals. Of course, the great cathedral priories like Norwich (Fig. 13) and Canterbury (Fig. 75) had long been the centres of important sees, with the consequence that a dean and prebendaries, under the direction of the bishop, could take the place of the prior and his monks. Similarly, the always secular cathedrals, among them Salisbury (Fig. 37) or Lincoln (Fig. 38), would continue to maintain those over-extended establishments which an Elizabethan puritan subsequently trounced as 'very dens of thieves, where the time and place of God's service, preaching and prayer, is most filthily abused in piping of organs, in singing, ringing, and trouling of the psalms from one side of the choir to another, with squeaking of chanting choristers . . . in pistelling and gospelling with such vain mockeries, contrary to the commandment of God'.[7] However, a more unexpected (and now entirely gratifying) initiative at the Reformation was the rescue of at least a handful of the greater monastic churches – Westminster and

Oxford, Chester, Bristol, Peterborough and Gloucester – to be the cathedrals of newly founded sees. Westminster's new cathedral status lasted no more than a decade. Yet even that was enough to preserve both the church and many of its associated buildings, including the famous chapter-house, intact. At Gloucester (Fig. 74), the huge, newly-reconstructed pilgrimage church, with its adjoining cloister and other buildings, remained temporarily in the charge of half its original community, later transmogrified into the cathedral's dean and chapter.[8]

Of course, the religious houses were not the only building complexes outmoded by the times, nor cathedrals the only anachronisms to persist. In Tudor England, chivalry in the strict sense of the word was far from dead. Yet the castle as one of its most obvious expressions had come to the end of its term. Thornbury Castle (Fig. 91), in Gloucestershire, has often been seen as the last private fortress in the old tradition. And this verdict on Thornbury has particular force in view of the tastes and the character of its builder. Edward Stafford, third duke of Buckingham, was still a young man when granted a royal licence in 1510 to fortify his manor-house at Thornbury. But he had assumed the responsibilities of an ancient line, and his inclinations made him older than his years. Thornbury Castle, as we see it now, is less than half complete. Only the great tower at the south-west angle and the duke's adjoining lodgings in the south range have survived to their full height since Stafford's time, owing much of their present detail to Anthony Salvin, most noted of Victorian restorers. Nevertheless, the elements are plainly recognizable at Thornbury of a castle-palace very much in the tradition of Ralph Lord Cromwell's Tattershall (Fig. 81), even to the placing of Thornbury's rebuilt collegiate church within a stone's throw of the duke's privy garden. A Stafford chantry chapel survives at Thornbury Church, but the college was never properly established. Similarly, the duke's execution in 1521 cut short building works at his castle. However, both the scale and intention of Stafford's scheme remain abundantly clear, and it was precisely these that had fuelled Henry VIII's distrust of a subject whose lineage was at least as good as his own and who maintained an

91 Thornbury Castle, Gloucestershire

Another memorable fragment, recalling the ancient line of the Stafford dukes of Buckingham and similarly left stranded on the landscape by the Tudors, is Thornbury Castle. Work was halted at Thornbury, after only a decade of building, on the execution for treason in 1521 of Edward Stafford, third duke of Buckingham. Yet enough remains of Stafford's project to demonstrate a scale sufficient to alert and alarm Henry VIII. A striking feature of Thornbury is the great outer court, now wholly in ruins, surrounded by the lodgings of Duke Edward's affinity. But almost equally impressive is the castle's west front (centre), incomplete as it has been since Stafford's death. Only the duke's strong tower at the south-west angle (right) and his lodgings in the range to the rear (obscured by the tower) were taken in his time to their full height. Yet applied across the full front and continued round the court, these were the dimensions of a full-scale country palace, self-indulgently supplied with all the comforts of its day but dangerously well sited as a musterpoint for the duke's considerable interest in the West. Next to the palace and sheltering its vulnerable south front, are the lofty crenellated walls (right) of Stafford's privy garden. Beyond these again, the parish church is very largely a sixteenth-century rebuilding, intended by the duke as a collegiate chantry but left unendowed on his death. (1972)

92 Layer Marney, Essex

Thornbury, for all its contradictions, remains a castle, adequately equipped for such a role in an emergency. Against this, the contemporary Layer Marney is a country-house, while retaining the military fiction of a central gatehouse. Layer Marney's builder, Sir Henry Marney, died in 1523, leaving his ambitious project (as had Stafford at Thornbury) incomplete. Like Stafford again, he had already taken the precaution to secure his soul by rebuilding the adjoining parish church (bottom left) as a mausoleum. But there the parallels end. Marney was no rival to the king. After years of loyal service to the Tudor line, he could afford to put aside the constraints of defence in favour of the pursuit of fashion and effect. Although planned on traditional courtyard lines, Layer Marney was to be supplied with an extraordinary eight-storey gatehouse which, together with the range immediately to its west (left), was all that Sir Henry had the means and time to finish. The gatehouse is an expensive and an innovative building, with equal-sized window openings at every level, and with fashionable terracotta ornament. Behind it would have lain the inner courtyard and hall of a northern Renaissance courtier and man of fashion, paralleling the extravagance of Sir Richard Weston's Surrey mansion at Sutton Place and in tune with the tastes of a king who, in his time, became notorious for his love of novelty in building. (1967)

over-extended affinity. Laid out at the front of Thornbury's inner gate is the great court once surrounded by the lodgings of Stafford's household. On the duke's payroll towards the end of his life were some 150 men, the nucleus potentially of a private army such as his father, Duke Henry, had led against Richard III. Neither father nor son, with ambitions like these, could be permitted to die peacefully in his bed.[9]

Very different in intention, though scarcely less handsome, was Sir Henry Marney's contemporary gatehouse at Layer Marney (Fig. 92), in Essex, the most elaborate and impressive of its time. Duke Edward's gatehouse had been defended by gun-ports, his towers equipped with usable machicolations. At Layer

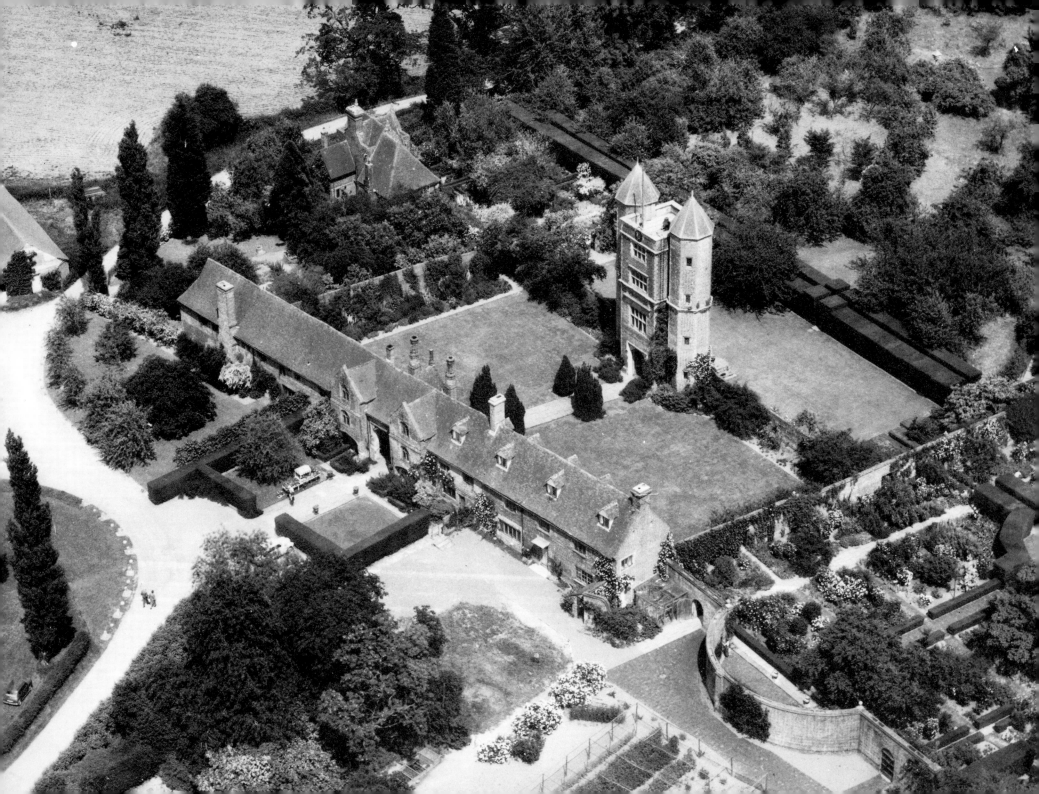

Marney, in contrast, the machicolations, though still present, are vestigial only, while large windows have become a feature of every stage of Sir Henry's tower, at the bottom quite as much as higher up. Certainly Sir Henry, without the ambitions of Stafford, was more secure at court than the duke. He had served as a privy councillor under both Tudor kings, and in the year of his death, in 1523, was to be appointed Lord Privy Seal. But his tastes, in any event, were more advanced than those of Stafford. And the house he began building for himself on the family estate, although still not as advanced as Sir Richard Weston's contemporary Sutton Place, was antiquarian only in its gate tower. New at both houses was the generous use of terracotta in the Italian manner, carrying decorative Renaissance motifs. At the parish church at Layer Marney, rebuilt by Sir Henry to commemorate his line, terracotta again was the family's choice for the innovative Northern Renaissance Marney monuments.[10]

Of course, there are clear elements of conservatism in the buildings of Layer Marney, not least in the creation of a family tomb-church. Nevertheless, the natural associations of Sir Henry's house are very much more with an Elizabethan country mansion like the Kentish Sissinghurst (Fig. 93), a generation later in date, than with the fortified residence in which both might have claimed some remote ancestry. Sissinghurst, in its present form, preserves little of the great double courtyard mansion into which it grew during the course of the sixteenth

93 Sissinghurst, Kent
Some generations would go by before the prominent 'military' gatehouse would pass entirely out of the country-house tradition. And Sir Richard Baker's tower at Sissinghurst, made the more spectacular by its present isolation, was still not the last of its kind. Built in the 1560s, it fronted the three ranges of Sir Richard's privy court, all of which, with the exception of the south-east angle (off the picture to the right), were demolished a couple of centuries ago. Sir Richard's tower gave tone and dignity to the fashionable brick mansion he built in place of the family house he had inherited on the death of his father, Sir John Baker, in 1558. Sir John himself was a builder, and his own gatehouse, to the west (left), drives a passage through the range of lodgings which, at a slightly earlier date, had been constructed to close off the long entrance-front of the outer court. Even with these two barriers to deter the intruder, Sissinghurst is still thoroughly domestic. It has the style and the ease of the wealthy country squire, of which Sir Richard was representative in his day. When Queen Elizabeth visited there in August 1573, she would have felt unthreatened and at peace. (1965)

century. What remains is a front range in part attributable to Sir John Baker (d.1558), lawyer and parliamentarian, and a tall inner gate tower through which entrance was gained to the private court entirely remodelled by Sir Richard (d.1594), inheritor of the generous family fortune. Sissinghurst, even in the Bakers' day, was not a castle. It acquired that label only two centuries ago, when housing French prisoners-of-war. But for both Bakers, father and son, an impressive gatehouse, whatever else might be left out, remained a prerequisite for their building. Sir Richard's lofty gatehouse set a style for his mansion, being an expensive but very necessary conceit. Typically for his period, the son would not be content with his father's house. He tore it down and built himself another.[11]

What that mansion might have looked like, in the most general terms and of course on a quite different scale, was the archbishop of Canterbury's country seat at Knole (Fig. 94), again in west Kent, to which additions were made by Henry VIII and which was subsequently remodelled by the Sackvilles. At the core of Knole still is the courtyard residence of Archbishop Bourgchier (d.1486), more like a college or a monastery, with the archbishop's gatehouse tower in the west facade, with his hall on the far side of the fifteenth-century Stone Court, and with a variety of service courts and guest quarters beyond. In all probability, it was Henry VIII who subsequently extended the accommodation at Knole by adding the Green Court in front of Bourgchier's gatehouse, equipping it with another great gate tower in the archaic tradition to break the otherwise utilitarian facade. On this facade, as on those of the inner court, the ornamental gables are a lighter touch, introduced at the time of the general re-roofing of Knole in 1603–5 with which Thomas Sackville, Lord Buckhurst and first Sackville earl of Dorset (from 1604), began his own programme of works. Sackville was a cultivated man, interested in literature and the arts. His wife, Cecily Baker, was the daughter and sister of the two Baker builders of Sissinghurst. Today, Knole remains much as Sackville left it, with his modernized interiors finely fashioned in the Late Elizabethan manner and with his own addition, the Stable Court, tacked on to

94 Knole, Kent
More complex in its building history than the Bakers' Sissinghurst, another west Kent mansion at Knole (near Sevenoaks) brought new and old, sometimes jarringly, together. Knole was re-roofed early in the 1600s, and it is to this major Sackville remodelling that it owes its uncharacteristically light-hearted Flemish gables. However, where Knole began was in Archbishop Thomas Bourgchier's Stone Court (centre), a sober composition with service courts behind (top), given dignity by its strong central gatehouse and angle towers. Recognizably a near-symmetrical courtyard mansion of the familiar late-medieval claustral or collegiate plan, Knole was equipped with a still larger outer court in the 1540s, when it came into the hands of the Crown. Henry VIII's Green Court (bottom centre) is thoroughly traditional, with a gatehouse that would have been at home in the fifteenth century. It is adjoined on the north by Thomas Sackville's Stable Court (left), which was the last major addition to the assemblage. Even in Bourgchier's day, Knole had not been a castle and was never thought of as such. It was a country palace for which certain trappings – the gatehouse and angle-tower – were seen as badges appropriate to rank. With such obvious social connotations as these, it is hardly surprising that gatehouses continued to be built long after they had lost the role they had formerly filled in defence. (1956)

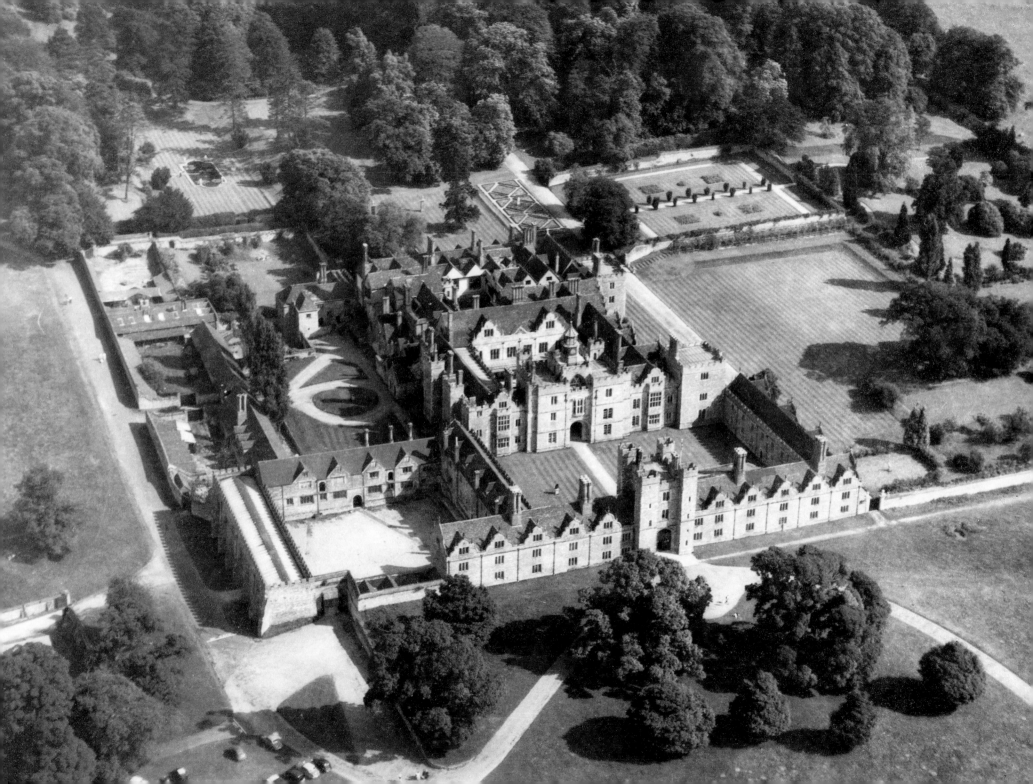

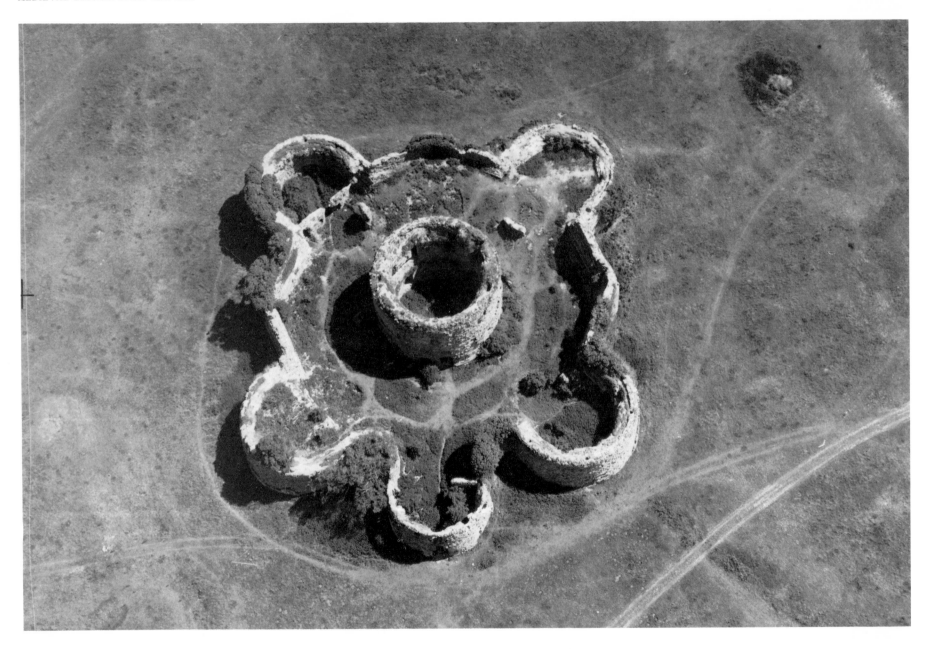

the Green Court on the north. Yet it is a house which, for all Sackville's modernity and the sophistication of his tastes, belongs essentially to an earlier generation, unwilling to shake free of the past. Part castle, part college, part religious institution, Knole inherited too much from its archbishop owners to show any of the sheer gaiety of contemporary Sissinghurst, where the spirit of the Renaissance was let loose. Between them, the courtyard plans and the gatehouses share roots in common. But there is little else to bring the two mansions together.[12]

When, in the 1540s, Henry VIII put his antiquarian show-front on the former archbishop's country palace at Knole, he had only recently completed a huge programme of coastal defence works which was to establish his standing among the greatest artillery engineers of all time. As a much younger man, Henry had already shown deep interest in military technology and in the science of the gun. And the circular artillery tower which was to remain the focal point of Camber Castle (Fig. 95) had been one of his responses to an early invasion threat, during the first of his campaigns against France (1511–14). Over twenty years later, when invasion seemed more likely than ever on the alliance of Henry's principal rivals and enemies against him, the systematic fortification of the entire south coast, from Sandown in the east to Pendennis in the west, was a swift and characteristic reaction. Sandown has now gone, swallowed by the sea. But Deal and Walmer, its near-neighbours, have been preserved and re-used, exhibiting (like Camber with its elegant girdle of semi-circular bastions) a geometrical perfection of plan in which deliberate artistry was undoubtedly an element, alongside the growing contemporary understanding of the gun.[13]

What this understanding came to mean in practical terms is exhibited most clearly in the hasty adaptation, wherever possible, of existing castles to meet this new kind of threat. Tantallon (Fig. 63), at the mouth of the Firth of Forth, was particularly strongly sited from the sea. But its tall south front, slicing off the headland, was a work of the late fourteenth century when the gun, although known, had yet to establish its role in effective siege warfare and was more likely to

95 Camber Castle, East Sussex

If Henry VIII's gatehouse at Knole has an old-fashioned air, it is certainly not that the king himself had been left behind by contemporary developments in fortification. Camber, on the Sussex coast near Rye, is one of those artillery forts (carefully restored since this photograph was taken) by which Henry proposed to ward off attack as his former allies gathered against him. Moreover, its particular interest is in the successive changes the fort underwent as the engineers perfected their techniques. At Camber's core, the circular tower dates back to the first building campaign of 1512–14, although it was subsequently to be modified and heightened. In the second campaign, under the direction of Stephen von Haschenperg in 1539–40, an innovatory plan for an octagonal fortress half-hidden in the ground was itself modified at great cost half way through the works as stirrup-shaped towers were inserted at the angles and as the gatehouse (bottom centre) received a rounded front. Finally, in 1542–3, great circular bastions were built against the towers, hiding the stirrup plan, and the central keep was taken to its full height. What the fortress lost in its secure low profile, it gained as a more emphatic deterrent. (1948)

be used in defence. By the mid-sixteenth century, height had ceased to be an advantage. Tantallon's central gate tower required to be remodelled and strengthened, a new forework added and gun-loops inserted. Beyond this barrier to the south, Tantallon's dry ditch and east gatehouse are sixteenth-century additions, with a triangular ravelin projecting forwards to deflect and control an assault.[14]

In effect, Tantallon had been made secure against an artillery-supported attack by beginning all over again. And this would be the experience, even more obviously, of the ancient fortress of Carisbrooke (Fig. 96), on the Isle of Wight, which had originally begun life under the Romans. Carisbrooke today, in its outer defences, is a textbook exercise in late-sixteenth-century artillery defence, more complete than the better-known fortifications at Berwick-upon-Tweed (Fig. 97), although of course on a much smaller scale. It had been the Italians who, earlier in the sixteenth century, had developed the arrow-head bastion which is the dominant characteristic of each defensive ring. And it was Italians – Federigo Giambelli at Carisbrooke in the last years of the century, Giovanni Portinari at Berwick in the 1560s – who were brought in as consultants at both these projects, refining the work of the less experienced English engineers. Berwick's new defences were hugely expensive, becoming the subject of much critical debate. They replaced the border town's medieval walls on its landward quarters, making a fine show of strength towards the Scots, but did nothing towards reinforcing the equally vulnerable sea approaches, where the earlier wall remained largely unmodified. In every respect Carisbrooke, coming later in the day at less challenging cost, was the tidier and more elegant project. However, Giambelli's solution, wrapping the entire castle in a new defensive ring which re-used nothing of the medieval fortifications, displayed the contempt of the engineers of his own generation for whatever had been put there before. The scarps and counterscarps, cavaliers and terrepleins, flankers and orillons, which were the commonplaces of design for Giambelli and his kind, belonged to another world altogether.[15]

96 Carisbrooke Castle, Isle of Wight
Before the end of the sixteenth century, military engineers everywhere had adopted the principles by which Stephen von Haschenperg had begun operating at Camber. In southern Europe, systematic earthwork defences had long been recognized as the best available protection against the gun. And it was an Italian, Federigo Giambelli, who was called in to redesign the defences of Carisbrooke on which work had begun in 1587 to another less professional design. Giambelli's arrow-head bastions, completed between 1597 and 1600, are typical of the best Italian work of his day, in which much emphasis was placed on protecting the wall-face by flanker batteries behind the shoulders ('ears' or 'orillons') of the arrow-heads. Encircled by Giambelli's deliberately low-lying bulwarks and curtains, the post-Conquest motte and bailey had itself re-used the squared-off earthworks of a former Roman fort, and had made a virtue, characteristically, of their height. The boldly projecting gatehouse (centre left) at Carisbrooke, rebuilt in the late fourteenth century with some of the earliest English gun-ports in its upper stages, belonged to a period when the bark of a gun was still a good deal worse than its bite. A century later, when Charles VIII's siege artillery delivered northern Italy to France, the day of the upstanding fortification was almost over. (1957)

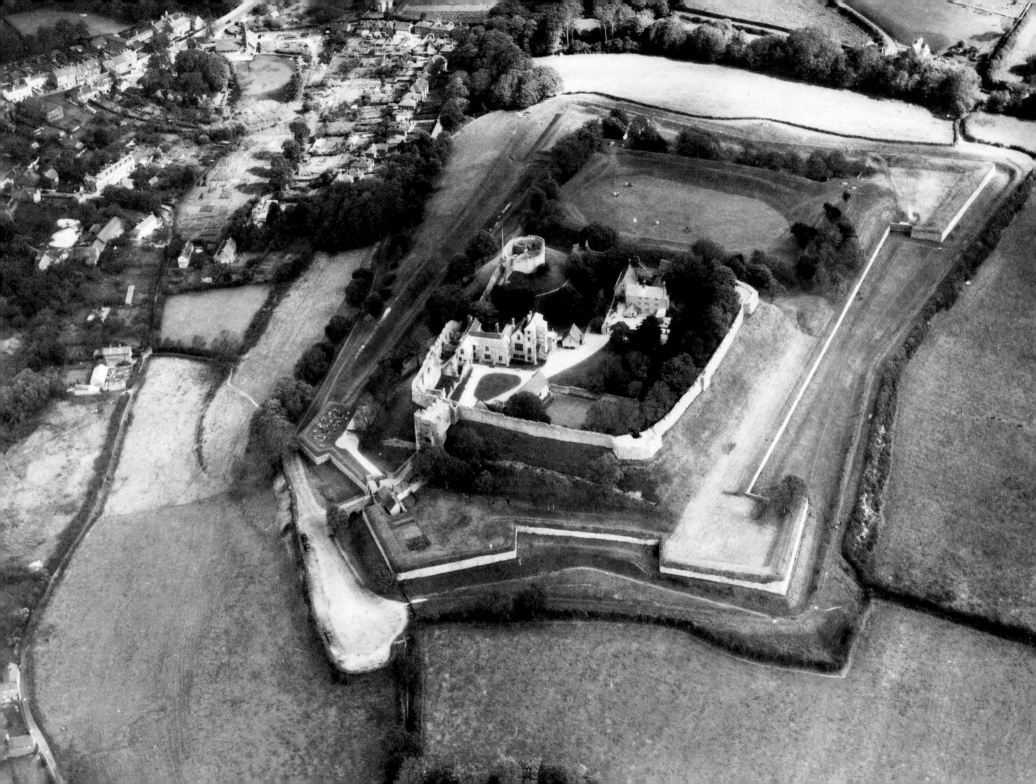

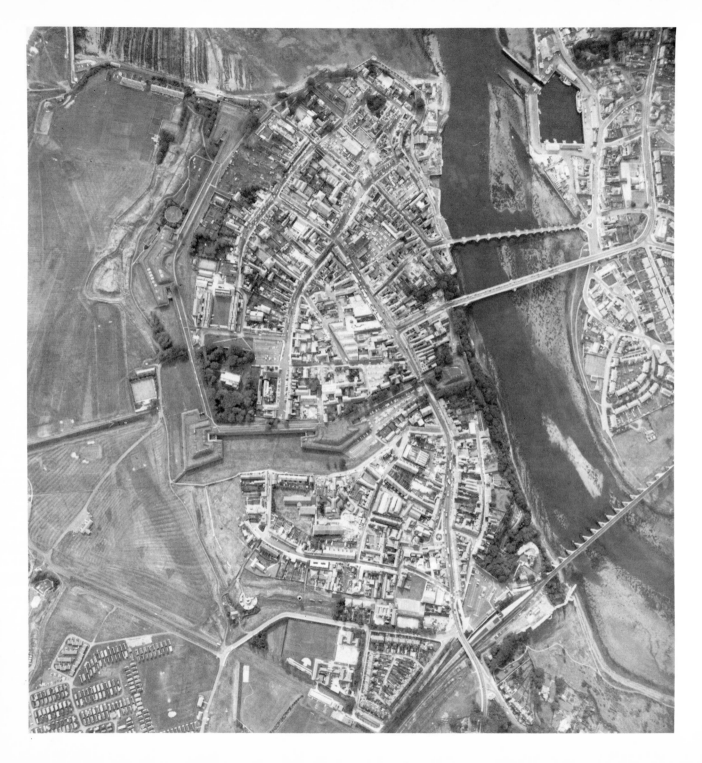

97 Berwick-upon-Tweed, Northumberland

So swiftly was military engineering advancing in the sixteenth century that a coastal fort like Camber would be outmoded within decades, while the much larger project at Berwick-upon-Tweed was damagingly exposed to frequent changes of plan. Berwick's vulnerability to the Scots ceased on the union of the crowns, under James VI and I, in 1603. But long before that, its refortification had been effectively abandoned with only the landward defences complete on the north and east quarters, and with the south and west still protected by medieval walls. Berwick was to

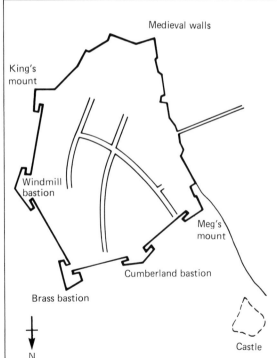

become the most expensive military work of its kind during Elizabeth's reign. And a good part of this expense resulted from disputes between the site engineers and their consultants on the project. What emerged was an urban fortification in the Italian manner, with fine arrow-head bastions (the Cumberland Bastion and the Windmill Bastion) at the centre of the north and east curtains (bottom and left), and with a particularly strong earthwork (the Brass Bastion) at the vulnerable northernmost angle between them. With changes principally in detail, artillery defences in this mode were to continue in construction right through until the development of large-scale trench warfare rendered them obsolete in their turn. They have nothing whatsoever to do with the Middle Ages. (1977)

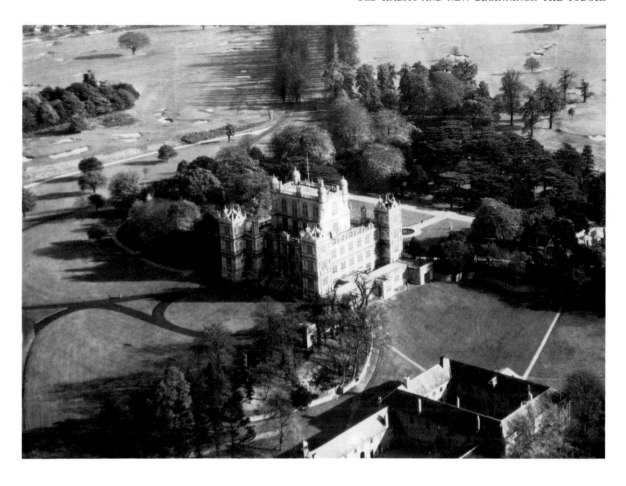

98 Wollaton, Nottinghamshire
Scarcely less innovative than Berwick, though to a different end, was a country-house like Wollaton, designed by Robert Smythson (architect of Longleat) for the wealthy coal-owner, Sir Francis Willoughby (d.1596). Wollaton retains the medieval great hall, but places it centrally where a court or cloister might have been, capped with the typically Elizabethan conceit of a 'Prospect Chamber', and turreted at the angles like a tower-house. At Wollaton, with the exception of the spacious and well-lit kitchen basement, utility is everywhere sacrificed to effect. The exterior ornament is eclectically Renaissance, borrowed from contemporary pattern books and drawing as freely on Netherlandish motifs as on the purer classicism of the South. The huge expense of a building like this was too much even for Willoughby's considerable fortune, leaving his estate sadly encumbered on his death. But his purpose was plain. 'Behold this house', an exterior inscription bids us, 'of Sir Francis Willoughby, built with rare art and bequeathed to Willoughbys. Begun 1580 and finished 1588.' (1950)

Inevitably there were those, among them William Paulet the rebuilder of Netley Abbey, who sought to preserve what they could from the past. As Lord Treasurer, it was Paulet who, soon after the beginning of Elizabeth's reign, sent off one of his auditors in 1561 to survey the royal castles, instructing him specifically that 'if any walles about the old castles decaied or any pile within that castle be standing, though the timber and lead be gone, yet let them stand till upon your report a further order be taken'. And it was on the Treasurer's later instructions that a number of the queen's fortresses, of small military potential, were nevertheless kept in service and in good repair.[16] But to designate one of these castles as an 'ancient monument', which is how Paulet and his colleagues described Tickhill, was just another way of drawing a final line across the past. Architecturally, the most adventurous innovators in court and county society might still borrow a motif or preserve a concept (a great hall or a gatehouse) from the Middle Ages. Yet in almost every other significant respect, the break with tradition was complete.

Three important houses of the final years of the sixteenth century may be taken to exemplify their many companion works in what has come to be labelled, certainly with some truth, as rural England's 'Great Rebuilding'.[17] Wollaton Hall (Fig. 98) and Longford Castle (Fig. 99) were both going up in the 1580s; Montacute House (Fig. 100) a decade later. Of the three, Montacute is the least 'fantastical', being the work of a parliament-based lawyer. Longford was built for Sir Thomas Gorges, interested in antiquity and the occult; Wollaton for Sir Francis Willoughby, coal-owner and entrepreneur. In each of these mansions, as was still common at that period, elements from the past were retained. Thus Longford – a deliberate sham – has Edwardian drum towers at the angles. At Wollaton, an ingenious but anachronistic great hall rises through the core of the building. Even Montacute, less eccentric than the others, retains the hall, with its traditional screens passage, on the ground floor to the right of the main entrance. Yet what, at the same time, unites the three is a rejection of the past's principal

99 Longford Castle, Wiltshire
Contemporary with Wollaton, but since much extended, was Sir Thomas Gorges's mansion at Longford. Triangular in plan, with drum towers at the angles, the original house can still be made out on the right of the present building, the base of the triangle constituting a formal show-front exceptional for its two-storeyed loggia (hidden by the tower on the bottom right). Gorges's geometrically planned house is called a 'castle' today, and the illusion was further developed in later times by Longford's nineteenth-century enlargers. But there is nothing truly military about a country-house of this kind, and what Sir Thomas seems to have intended was a reference, perhaps Anglo-Catholic, to the Trinity in his plan, finished off with antiquarian recollections. Such harking back to a romanticized past was not untypical of educated men of Gorges's or Willoughby's generation. They lived in a landscape of monastic ruins and of castles fast falling into disrepair, and could scarcely remain unmoved by what they saw. (1949)

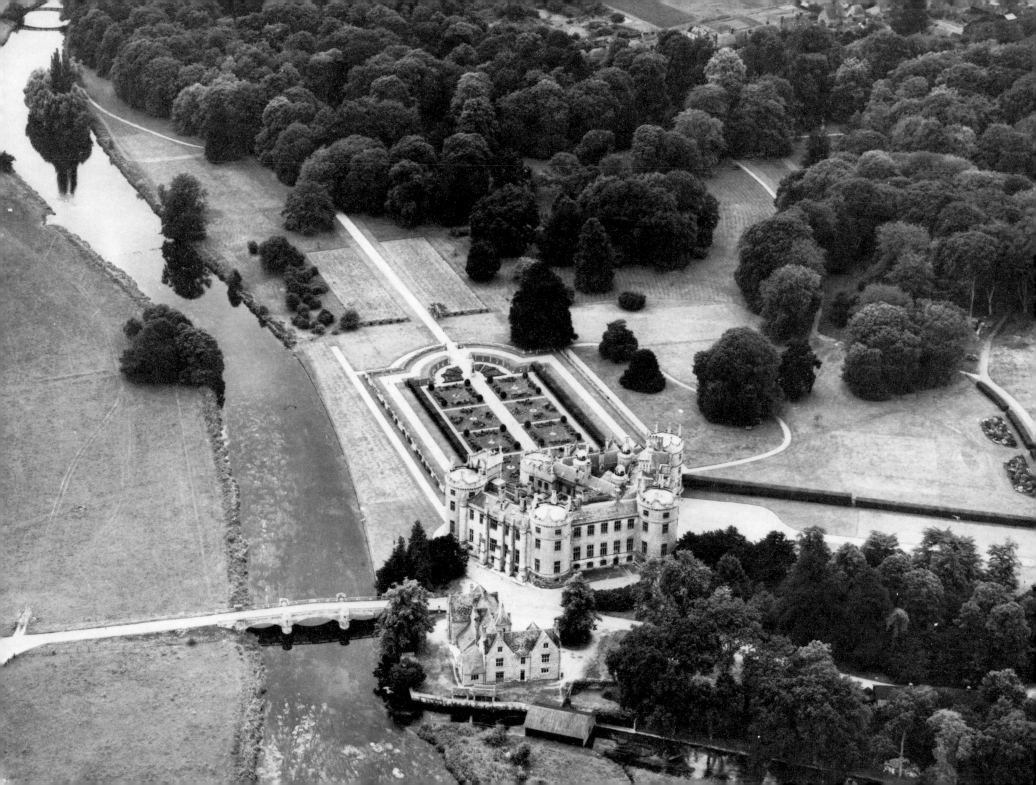

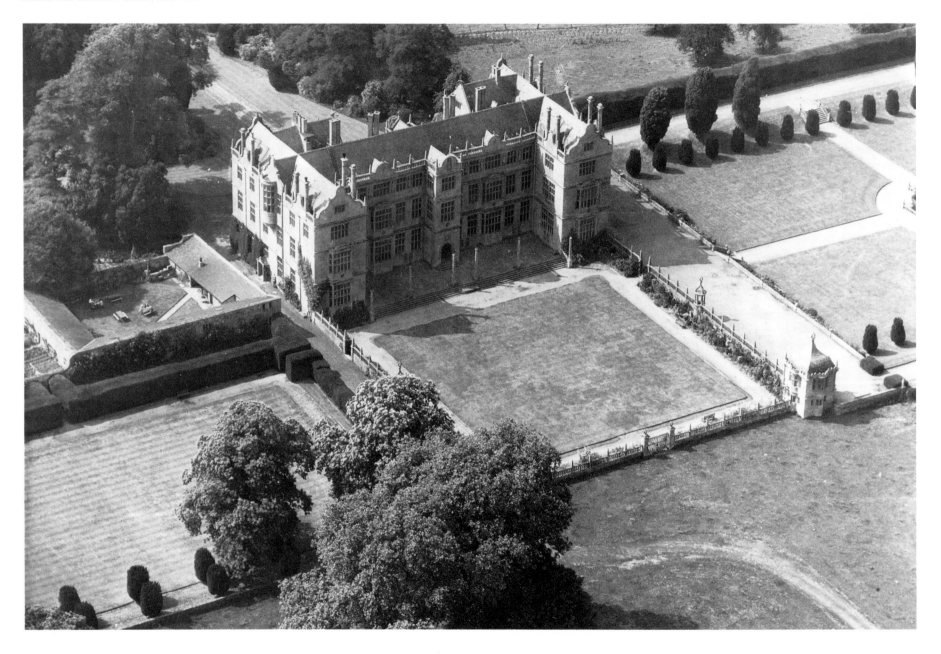

100 Montacute, Somerset
Only a decade later than Longford,
Montacute has already taken on the
appearance of a typical seventeenth-century
country-house. It has its throw-backs still,
most particularly in the great hall, to the right
of the central door and concealed by the
symmetry of the facade. But more important
than the common hall were the private
chambers of the Phelips family, and when
they came out from these to take the public
air, they would have done so more readily in
the spacious strolling gallery which, at top-
floor level under the gable, ran the entire
length (left to right) of the building.
Montacute, without the extravagance of either
Wollaton or Longford, is a house for gracious
living, designed and built for a local family
become wealthy in the late sixteenth century
on the profits of the law and on the
engrossment of former monastic lands. Before
the Civil War laid its finger on the Phelipses
and their kind, they must have viewed
themselves as the most fortunate of the
recipients of God's gifts. 'There are no other
men than themselves', as had been observed
much earlier of the English self-image, 'and no
other world but England.' (1955)

constraints. The conventional courtyard plan of Thornbury, Sissinghurst, or Knole has disappeared wholly at Montacute; at Wollaton and Longford, if recognizable at all, it has been transformed. Entrances are still important, being treated with bravado and panache at each of these houses, but the militaristic gate tower has now vanished. At all three again, symmetry has replaced the medieval emphasis on a more functional architecture, giving each element its due. At Montacute, for example, no visitor could have guessed, as he approached the east front, at the status of the hall it disguised. He could not have worked out, from external indications alone, where Sir Edward Phelips and his family had their lodgings. The contrast with a Tattershall (Fig. 81), or even a Thornbury (Fig. 91) could hardly be more complete. At neither had the harmony of the architect's master plan been allowed to override what contemporaries considered a proper emphasis on its parts.

There are other characteristics also of these three great houses which remove them effectively from the Middle Ages. In particular, there is an ingenuity and an allusiveness about them which, although entirely characteristic of their own generation, would have seemed fanciful and purposeless in their predecessors. Superficially, perhaps, the triangular plans of Longford and Caerlaverock (Fig. 44) may appear to bring the buildings together. However, Caerlaverock's triangle is military and functional, while Longford's is a play on the Trinity. A similar geometry, in which symmetry was dominant, informs the plans of Wollaton and Montacute. Less altered than Longford over the years, they each carry a whole battery of northern Renaissance motifs – busts of Roman worthies, balustrades and obelisks, pilasters, pediments and entablatures, shell-headed niches and those ubiquitous Flemish gables that would appear again in Thomas Sackville's remodelling of Knole (Fig. 94).[18]

Of course, there is much that could be said against such fripperies. Indeed, we are more likely today to find ourselves in general out of sympathy with them. Yet there is an overflowing exuberance in a little palace like Wollaton which, for all its

vulgarity, is also especially attractive. Promenading through the grounds or along the galleries of any of these houses, gentlemen and their ladies might sharpen their wits in those verbal exchanges in which we know them to have taken a particular delight. Surrounded by reminders of a classical past, they consciously looked back beyond the violence and superstition of more recent centuries to what they viewed as a superior civilization. In two generations – or in three, at most – cultivated society had shaken off the frame by which for too long it had been confined. If it now took some time to adjust to a new discipline, with some odd consequences in the meantime for architecture, the jolts and hiccups of transition were understandable. They had happened before, and they would undoubtedly happen again.

Glossary

Alien priory — a religious house, seldom of great size, owing obedience to an abbey outside Britain

Ambulatory — a covered walking-place or aisle, being the term usually applied to the aisle round the east end of a church, behind the altar

Apse (apsidal) — the semicircular termination of the eastern end of a chapel or church

Arrouaisian — the contemplative branch of the Augustinian 'family' of regular canons

Augustinian — communities of clerics (also known as Austin canons or 'black canons' from the colour of their habits) living by the Rule of St Augustine

Austin — an order of friars, modelled on the Dominicans and bound by the Rule of St Augustine; see also **Augustinian**

Bailey — the outer court or ward of a castle

Barbican — an outwork protecting a castle gate

Bastion — a projection, allowing flanking fire, from the line of a fortification; hence 'arrow-head' bastion

Bedehouse — almshouse; from 'bede' meaning prayer

Benedictine — monks observing the original Rule of St Benedict; also known as 'black monks'

Carmelite — an order of friars ('white friars') reorganized in the thirteenth century from the twelfth-century Order of Our Lady of Mount Carmel

Carthusian — contemplative monks, bound to silence, founded in 1084

Chancel — the eastern and most sacred arm of a church

Chantry — a commemorative endowment for masses to be sung for the soul of the founder; hence 'chantry chapel', 'collegiate chantry' etc.

Chapter-house — the chamber, usually in the east claustral range, set aside for daily meetings of a monastic community

Choir (quire) — the part of the church, between presbytery and nave, where the monks met to sing and pray

Cistercian — reformed Benedictines, established in 1098; also known as the 'white monks'

Clerestory — the line of windows above an arcade that helps light the body of a church

Cloister (claustral) — the open space, with surrounding roofed passage, in which monks took exercise and studied

Cluniac — an early reforming branch of the Benedictines, founded in 909 but especially important in the second half of the eleventh century

Colonization — the building-over of open markets with permanent shops or stalls; hence 'market colonization'

Corbel — a bracket or other projection, intended to support a cross beam

Corona — a crown of radiating chapels, usually apsidal

Crenellate — to supply with an embattled parapet, often taken to imply (as in a 'licence to crenellate') the entire fortifying process

Crossing — the point in a church where nave, transepts, and chancel meet

Cure of souls — the spiritual charge of parishioners

Curtain wall — the wall, pierced by gates and supported by towers, which encircles a castle

Demesne(s) — land kept in his own hands by the lord

Dormitory (dorter) — the common sleeping-chamber of the monks

Drum tower — a circular mural or angle tower

Entablature — the upper part of a classical order, over a column and its capital, with architrave, frieze and cornice

Forework(s) — earthworks or walls, including barbicans, protecting the approaches of a castle

Franciscan — friars, also known as the Friars Minor or 'grey friars', founded by Francis of Assisi in 1209 and vowed to corporate poverty

Frater — see **Refectory**

Friars Observant — purist Franciscans, advocating a return to the primitive Rule of their founder

Furlong — a measure of land in the common field, originally the length of the furrow

Garderobe — a privy or lavatory

Gilbertine	a double order of nuns and canons, founded by Gilbert of Sempringham in *c*.1131	**Postern**	a side gate
Grandmontine	Stephen of Muret's order, founded early in the twelfth century and dedicated to extreme austerity, initially giving unusually large responsibilities to the lay brethren	**Preferment**	promotion within the Church
		Premonstratensian	an order of canons ('white canons') founded by Norbert in 1120 and bound, with particular severity, by the Rule of St Augustine
Infirmary	a chamber or building for the care of the sick	**Presbytery**	the east end of a church, beyond the choir, holding the high altar
Interval tower	a mural tower, usually one of a number along the length of a curtain wall	**Putlog hole**	a hole designed to receive the end of a projecting timber
Justiciar	the king's chief officer in twelfth-century England	**Ravelin**	a triangular outwork projecting beyond the ditch and outer curtain, characteristic of artillery defences
Keep	the central strongpoint of a castle, usually in the form of a tower ('tower-keep') or a wall encircling the crown of a motte ('shell-keep')	**Refectory (frater)**	the common eating-place of the monks
		Reredorter	row of privies attached to a monastic dormitory
Lane	a walled and roofed passage; hence 'cloister lane'	**Ridge-and-furrow**	a method of ploughing, facilitating drainage, whereby ridges are ploughed up with a furrow between each pair
Lavatorium (laver)	the wash-place next to the refectory entrance in a monastic house		
Lay brother	an uneducated man, of lower status than a monk, accepting the Rule and employed in manual labour for the community	**Ringwork**	a defensive earthwork, usually circular or oval, surrounding a hall
		Rose window	a circular window with decorative internal tracery
Lay subsidy	a tax imposed on laymen by the Crown	**Savigniac**	an order of monks, founded originally in 1105 as a colony of hermits, merged with the Cistercians in 1147
Machicolation(s)	a projecting parapet or fighting gallery, usually with openings in the floor through which missiles could be directed at the attacker		
		Simony	the buying or selling of ecclesiastical offices
Mendicant(s)	friars vowed to poverty and living by begging	**Solar**	a private chamber, usually at the upper end of the hall
Motte	a castle mound, carrying the keep		
Murder-hole	a hole, usually one of several, in the vault of a castle's entrance passage, through which fire could be directed at an intruder	**Sub-vault**	a vault supporting an upper chamber
		Thegn	an Anglo-Saxon nobleman, of higher rank than a freeman (ceorl), but below an earl
Nave	the main body of a church, usually given over to the parishioners, west of the chancel arch	**Tironensian**	an order of monks, closely modelled on the Cistercians, founded early in the twelfth century by Bernard of Tiron
Obit	a memorial mass celebrated annually on the anniversary of the decease of the founder		
Oriel	a projecting window, supported on brackets and lighting an upper chamber	**Transept(s)**	the projecting arms of a cruciform church, meeting at the crossing
Plantation	the deliberate founding of a new community, as in 'town plantation'	**Wall-walk**	the fighting platform behind the parapet of a castle wall
Portcullis	a grating, sliding on vertical grooves, intended to seal off an entrance passage	**Ward**	the outer court or bailey of a castle

Chronological Table

987–1040	Fulk Nerra (count of Anjou): pioneer castle builder	STAMFORD: Anglo-Saxon borough			KIRKHAM: Augustinian house
1001–31	William of Dijon (abbot of Fécamp): founding father of the Norman monastic reform		1130s	St Bernard's Cistercians colonize the North of England	
1066	Battle of Hastings (14 October) Coronation of Duke William (25 December)	BURY ST EDMUNDS: planned borough extension	1135	Death of Henry I; accession of Stephen	MELROSE: first Scottish Cistercian house, founded by David I
1069	Harrying of the North		1147	Savigniac and Cistercian Orders unite	BYLAND: former Savigniac community becomes Cistercian
1070	Lanfranc becomes archbishop of Canterbury	WILMINGTON: alien priory			
1073–4	Prior Aldwin's mission to the North	TYNEMOUTH: Benedictine foundation	1153–65	Malcolm IV, king of Scotland	
1075–8	See transferred from Sherborne to Salisbury	OLD SARUM: cathedral and castle	1154	Death of Stephen; accession of Henry II	EASBY, LEISTON: Premonstratensian houses
1077	Paul of Caen becomes abbot of St Albans	ST ALBANS: rebuilt abbey church	1165–1214	William I (the Lion), king of Scotland	CRAIL: expanding port and borough on Scotland's prospering east coast
1078–81	First Cluniac foundation at Lewes Priory	WENLOCK, CASTLE ACRE: Cluniac houses			PLESHEY: refortified earthwork castle
		RICHMOND, CARISBROOKE, CASTLE ACRE, CLARE, LUDLOW: early castles	1189	Death of Henry II; accession of Richard I (Coeur de Lion)	
		ALDWINCLE: two-church village	1199	Death of Richard I; accession of John	CYMMER, EGGLESTONE: lesser Cistercian and Premonstratensian houses
1086	Domesday Survey		1204	John loses Normandy, Maine, Anjou, Touraine and Poitou; but continues to hold Gascony	FRAMLINGHAM, HELMSLEY: stone castles
1087	Death of William I; accession of William II (Rufus)				NEW ALRESFORD: new town plantation
1088	Rebellion of Odo of Bayeux	EYNSFORD: castle			
1090	See transferred from Thetford to Norwich	NORWICH: cathedral	1214–49	Alexander II, king of Scotland	ELGIN: cathedral
			1215	Fourth Lateran Council	
1100	Death of William II; accession of Henry I	THETFORD: Cluniac house	1216	Death of John; accession of Henry III	
		KILPECK: castle, church, priory cell	1217–28	Richard Poore, bishop of Salisbury	SALISBURY: cathedral and town on new site
1107–24	Alexander I, king of Scotland	STOW-ON-THE-WOLD, SWAFFHAM: market-towns			LINCOLN: rebuilding of cathedral
1124–53	David I, king of Scotland	ST ANDREWS: cathedral priory (Augustinian)			WEST WALTON: rebuilt parish church

1249–86	Alexander III, king of Scotland	BOTHWELL: Walter Moray's castle
1257	Richard, earl of Cornwall, elected King of the Romans	HAILES: Cistercian abbey founded by Richard of Cornwall (1246)
1264–5	Baronial revolt against Henry III	
1272	Death of Henry III; accession of Edward I	CAERPHILLY: Gilbert de Clare's castle, begun *c.* 1268
1276–83	Welsh wars	RHUDDLAN, CAERNARVON: royal castles in North Wales
		NEW WINCHELSEA: new town laid out in 1283
		ACTON BURNELL, STOKESAY: private castles licensed in 1284 and 1291 respectively
1290–92	Succession crisis in Scotland	MORTON: fortified manor-house
1297	William Wallace's rising against Edward I	CAERLAVEROCK: besieged and taken by Edward I in 1300, the same year he used SWEETHEART as his base
		TYNEMOUTH: licence to fortify priory (1296)
1306–29	Robert I (Bruce), king of Scotland	
1307	Death of Edward I; accession of Edward II	
1315–22	Period of agrarian crisis	
1327	Edward II resigns the throne; accession of Edward III; murder of Edward II	GLOUCESTER: rebuilding of abbey church following burial there of Edward II
1329–71	David II, king of Scotland	
1337	Edward III creates or revives the earldoms of Huntingdon, Salisbury, Suffolk and Northampton	MAXSTOKE: castle built by William de Clinton, earl of Huntingdon

1337	Philip VI's confiscation of English-held Gascony launches the Hundred Years War (to surrender of Bordeaux, 1453)	
1338	First of a succession of French coastal raids	
1346	French defeat at Crécy Scottish defeat and capture of David II at Neville's Cross	TEWKESBURY: rebuilding of east end of abbey church as Despenser mausoleum
1348	Edward III founds the Order of the Garter	WALSINGHAM: foundation of Franciscan friary under patronage of Elizabeth de Clare (1347)
1348–9	The Black Death ravages Britain	
1356	French defeat at Poitiers	WINDSOR: castle rebuilt on a grand scale by Edward III
1360	Peace of Brétigny	WINCHELSEA: sacked in French raid (again in 1380)
1361–2	Second visitation of the Black Death	HADLEIGH: castle refortified as a protection of the Thames against the French
1369	Anglo-French war resumed	LEISTON: abbey re-sited further from sea
1371–90	Robert II, first Stewart king of Scotland	TANTALLON: a Douglas castle refortified in the 1370s
1377	Death of Edward III; accession of Richard II	SCOTNEY, BODIAM (1380s), WARDOUR (1390s): private castles showing French influence
1381	Peasants' Revolt	BOLTON: Richard le Scrope's castle
1390–1406	Robert III, king of Scotland	BOTHWELL, HERMITAGE: other Douglas castles enlarged and refortified
		MELROSE: abbey rebuilt after English raids
		MOUNT GRACE: Carthusian house (founded 1398)

1399	Richard II deposed; accession of Henry IV	TYNEMOUTH, HULNE, MICHELHAM, ULVERSCROFT: priory fortifications	1469	Yorkist defeat at Edgecote	INGARSBY: enclosure of village site

1399 — Richard II deposed; accession of Henry IV — TYNEMOUTH, HULNE, MICHELHAM, ULVERSCROFT: priory fortifications — 1469 Yorkist defeat at Edgecote — INGARSBY: enclosure of village site

GLOUCESTER, CANTERBURY: major works under energetic and capable superiors

THAXTED: gildhall and church rebuilding

1454–86 Thomas Bourgchier, archbishop of Canterbury — KNOLE: building of country palace

1406–37 James I, king of Scotland (captive in England, 1406–24)

FOTHERINGHAY: Yorkist collegiate chantry (founded 1411)

1471 Restoration of Edward IV; murder of Henry VI — CASTLE ACRE: prior's lodgings

1475 Edward IV invades France; Hundred Years War ends at Peace of Picquigny — DITCHFORD: village enclosure

1413 Death of Henry IV; accession of Henry V

1483 Death of Edward IV; accession of Edward V; usurpation of Richard of Gloucester — ST OSYTH: abbey gatehouse

1414 Suppression of the alien priories

1415 French defeat at Agincourt

1485 Defeat and death of Richard III at Bosworth; accession of Henry VII — WHARRAM PERCY: village enclosure (1490s)

1422 Death of Henry V; accession of Henry VI — GARROW TOR: abandoned upland settlement

1488–1513 James IV, king of Scotland — LONG MELFORD, LAVENHAM: parish church rebuildings

1427–9 English defeats in France

1437–60 James II, king of Scotland — NEWARK: Scottish mid-fifteenth-century tower-house

MUCH WENLOCK: prior's lodgings

TATTERSHALL: Ralph Cromwell's castle and collegiate chantry

1509 Death of Henry VII; accession of Henry VIII — MUCHELNEY: abbot's lodgings

SUDELEY: Ralph Boteler's castle and chapel

1511 Anglo-French war begins — CAMBER: artillery tower

1513–42 James V, king of Scotland

1521 Execution of Edward Stafford, duke of Buckingham — THORNBURY: work on castle ends

1453 Bordeaux surrenders to the French

1455 Yorkist victory at St Albans begins the Wars of the Roses — NORTHLEACH, SWAFFHAM: parish church rebuildings

LAYER MARNEY: Sir Henry Marney's gatehouse

1534 Act of Supremacy

GLOUCESTER, CANTERBURY: crossing towers

1536 The lesser religious houses are dissolved
Lincolnshire Rising begins — NETLEY: Sir William Paulet's conversion

KIRKSTEAD: suppression and demolition (1537)

1460–88 James III, king of Scotland

1461 Edward of York defeats the Lancastrians at Mortimer's Cross and assumes the English Crown

1538–40 Surrender of the greater religious houses — MALMESBURY, CROWLAND: abbey churches retained in part for parochial use

1538	Henry VIII begins his programme of coastal defence	CAMBER: refortified with bastions
1542–67	Mary, queen of Scotland	TANTALLON: artillery defences
1547	Death of Henry VIII; accession of Edward VI	
1553	Death of Edward VI; accession of Mary I	
1558	Death of Mary I; accession of Elizabeth I	BERWICK-UPON-TWEED: arrow-head bastions SISSINGHURST: Sir Richard Baker's new country-house
1567–1625	James VI, king of Scotland	
1585	Open war with Spain	
1588	Defeat of the Spanish Armada	CARISBROOKE: refortified with bastions WOLLATON, LONGFORD, MONTACUTE: new country-houses
1603	Death of Elizabeth I; accession of James I	KNOLE: Thomas Sackville re-roofs and remodels the palace

Notes and References

Abbreviations

Agric.HR	*Agricultural History Review*
Ant.J.	*Antiquaries Journal*
Arch.J.	*Archaeological Journal*
Cal. Charter Rolls	*Calendar of the Charter Rolls preserved in the Public Record Office*
Cal. Close Rolls	*Calendar of the Close Rolls preserved in the Public Record Office*
CBA	Council for British Archaeology
EHR	*English Historical Review*
Ec.HR	*Economic History Review*
J.Brit.Arch.Assoc.	*Journal of the British Archaeological Association*
J.Eccl.H.	*Journal of Ecclesiastical History*
Med.Arch.	*Medieval Archaeology*
Medieval England. An Aerial Survey	M.W. Beresford and J.K.S. St Joseph, *Medieval England. An Aerial Survey*, Cambridge University Press, 1979 (2nd ed.)
Monastic Sites from the Air	David Knowles and J.K.S. St Joseph, *Monastic Sites from the Air*, Cambridge University Press, 1952
RCHM	Royal Commission on Historical Monuments
TRHS	*Transactions of the Royal Historical Society*
VCH	*Victoria History of the Counties of England*

Guides to individual monuments, published by Her Majesty's Stationery Office on behalf of the Department of the Environment, by the National Trust, and by other bodies, are cited below by author (where given), title and date, thus:

Charles Peers, *Richmond Castle*, 1953.
Scotney Castle, 1981.

1 Improvisation and Policy: the Anglo-Norman Settlement

1 H.M. Colvin (ed.), *The History of the King's Works. Vol.II The Middle Ages*, 1963, pp. 824–8.

2 Helen Clover and Margaret Gibson (eds), *The Letters of Lanfranc, Archbishop of Canterbury*, 1979, pp. 34–5.

3 Charles Peers, *Richmond Castle*, 1953.

4 S.E. Rigold, *Eynsford Castle*, 1964.

5 J.G. Coad and A.D.F. Streeten, 'Excavations at Castle Acre Castle, Norfolk, 1972–77. Country house and castle of the Norman earls of Surrey', *Arch.J.*, 139(1982), pp. 138–301.

6 For the reinterpretation, see R. Allen Brown, *Castle Rising*, 1978.

7 They are lovingly described by R. Allen Brown, *Dover Castle*, 1974.

8 *VCH Bedfordshire*, iii:176; *Medieval England. An Aerial Survey*, pp. 156–7; David Baker, 'Yielden Castle', *Arch.J.*, 139(1982), pp. 17–18.

9 *Medieval England. An Aerial Survey*, pp. 222–3. For the excavations at Pleshey, see the notes in successive volumes of *Medieval Archaeology*, starting with a record of Professor Rahtz's season there in 1959 (4(1960), pp. 145–6); the earlier seasons have now been reported more fully by Frances Williams, *Pleshey Castle, Essex (XII–XVI Century): Excavations in the Bailey, 1959–1963*, British Archaeological Reports 42, 1977.

10 For a study of Ludlow's planned development, as yet unchallenged except in points of detail by later work, see M.R.G. Conzen, 'The use of town plans in the study of urban history', in *The Study of Urban History* (ed. H.J. Dyos), 1968, pp. 113–30.

11 For the most complete description of the church and earthworks at Kilpeck, including a plan, see *RCHM Herefordshire I – South-West*, 1931, pp. 156–60.

12 Marjorie Morgan, *The English Lands of the Abbey of Bec*, 1968 (2nd ed.), p. 11.

13 The whole problem of these endowments is most usefully discussed by Donald Matthew, *The Norman Monasteries and their English Possessions*, 1962, pp. 32–65.

14 W.H. Godfrey and W. Budgen, 'Wilmington Priory', *Sussex Archaeological Collections*, 69(1928), pp. 1–52; *Monastic Sites from the Air*, pp. 50–51.

15 L.F. Salzman, *Building in England down to 1540*, 1967 (2nd ed.), p. 361.

16 *VCH Hertfordshire*, ii:484.

17 David C. Douglas and George W. Greenaway (eds), *English Historical Documents 1042–1189*, 1953, p. 634.

18 Quoted by B. Dodwell in her useful 'The foundation of Norwich Cathedral', *TRHS*, 5th series, 7(1957), p. 9.

19 L.F. Salzman, op.cit., p. 364.

20 For a recent re-dating of this well-known appeal, see Frank Barlow, 'William I's relations with Cluny', *J.Eccl.H.*, 32(1981), pp. 131–41.

21 R.N. Hadcock, *Tynemouth Priory and Castle*, 1952, pp. 4–5.

22 Brian Golding, 'The coming of the Cluniacs', in *Proceedings of the Battle Conference on Anglo-Norman Studies III. 1980* (ed. R. Allen Brown), 1981, pp. 65–77.

23 F.J.E. Raby and P.K. Baillie Reynolds, *Thetford Priory*, 1979.

2 Change and Growth: the Twelfth Century

1 For a useful short history of Stow, see *VCH Gloucester*, vi:142–65.

2 The rebuilding process is discussed by J.F. Williams, 'The Black Book of Swaffham', *Norfolk Archaeology*, 33(1962–5), pp. 243–53.

3 *Medieval England. An Aerial Survey*, pp. 51–2; for the background to these developments, see my own *The Parish Churches of Medieval England*, 1981, chapter 1.

4 Maurice Beresford, *New Towns of the Middle Ages, Town Plantation in England, Wales and Gascony*, 1967, pp. 442–3 and passim; and see also the same author's 'The six new towns of the bishops of Winchester, 1200–55', *Med.Arch.*, 3(1959), pp. 187–215; the 1260s reference to the main road to Alton relates to the improvement, not to the insertion, of this road (*Cal. Charter Rolls 1257–1300*, pp. 122–3).

5 For the story of Stratford, strikingly told, see E.M. Carus-Wilson, 'The first half-century of the borough of Stratford-upon-Avon', *Ec.HR*, 18(1965), pp. 46–63.

6 Planned villages are discussed by Brian K. Roberts in 'Village plans in County Durham: a preliminary statement', *Med.Arch.*, 16(1972), pp. 33–56; also in the same author's *Rural Settlement in Britain*, 1977, chapter 5 ('Village Forms'), and most recently in *Village Plans*, 1982, passim. See also June A. Sheppard, 'Metrological analysis of regular village plans in Yorkshire', *Agric.HR*, 22(1974), pp. 118–35. For Ogle, see *Medieval England. An Aerial Survey*, pp. 113–14, 116.

7 For Onley, see *Medieval England. An Aerial Survey*, pp. 38–9, with a fuller discussion of the

Northamptonshire desertions in K.J. Allison *et al.*, *The Deserted Villages of Northamptonshire*, 1966, passim.

8 For a sensible recent discussion of the medieval open field and for the nature and purposes of ridge-and-furrow, see Christopher Taylor's *Fields in the English Landscape*, 1975, chapter 4 ('Early medieval open fields'). The latest discussion of Laxton occurs in a cooperative piece, 'The open-field village of Laxton', *The East Midland Geographer*, 7(1980), pp. 217–48, also published as a separate booklet.

9 For this, see Bruce Campbell's three important papers: 'The regional uniqueness of English field systems? Some evidence from eastern Norfolk', *Agric.HR*, 29(1981), pp. 16–28; 'The extent and layout of commonfields in eastern Norfolk', *Norfolk Archaeology*, 38(1981), pp. 5–32; 'Agricultural progress in medieval England: some evidence from eastern Norfolk', *Ec.HR*, 36(1983), pp. 26–46.

10 Quoted by H.C. Darby, *The Medieval Fenland*, 1974 (2nd ed.), p. 52.

11 Ibid., pp. 131–6; and see also H.C. Darby, R. E. Glasscock, J. Sheail and G. R. Versey, 'The changing geographical distribution of wealth in England: 1086 – 1334 – 1525', *J. Historical Geography*, 5(1979), pp. 247–62.

12 R. Allen Brown, 'Framlingham Castle and Bigod 1154–1216', *Proc. Suffolk Institute of Archaeology*, 25(1949–52), pp. 127–48.

13 F.J.E. Raby and P.K. Baillie Reynolds, *Framlingham Castle*, 1959.

14 Charles Peers, *Helmsley Castle*, 1966; for the French parallels, see my own *The Castle in Medieval England and Wales*, 1982, especially pp. 33–40, 46–52.

15 G.W.S. Barrow, 'Scottish rulers and the religious orders 1070–1153', *TRHS*, 5th series, 3(1953), pp. 77–100; Archibald A. M. Duncan, *Scotland, The Making of the Kingdom*, 1975, pp. 142–51.

16 Charles Peers, *Byland Abbey*, 1952, pp. 3–4.

17 T. Jones Pierce, 'Strata Florida Abbey', *Ceredigion*, 1(1950), p. 21.

18 C.A. Ralegh Radford, *Cymmer Abbey*, 1946.

19 Rose Graham and P.K. Baillie Reynolds, *Egglestone Abbey*, 1958; A. Hamilton Thompson, *Easby Abbey*, 1948; for the Premonstratensians and their lay brethren, see H.M. Colvin, *The White Canons in England*, 1951, 360–62.

3 Affluence: the Thirteenth Century

1 A. Hamilton Thompson, *Easby Abbey*, 1948.

2 Charles Peers, *Kirkham Priory*, 1946.

3 James G. Mann, 'Butley Priory, Suffolk', *Country Life*, 25 March 1933, pp. 308–14.

4 J.G. Coad, *Hailes Abbey*, 1970; Elizabeth S. Eames, *Catalogue of Lead-Glazed Earthenware Tiles in the Department of Medieval and Later Antiquities, British Museum*, 1980, i:202–3.

5 The best single account of Muchelney is to be found in *VCH Somerset*, iii:38–49.

6 For excellent maps and an account of Salisbury's early development (before 1800), see K.H. Rogers, 'Salisbury', in *Historic Towns I* (ed. M.D. Lobel), 1969.

7 Archibald A.M. Duncan, *Scotland, The Making of the Kingdom*, 1975, chapter 11 ('The Church II: Reform').

8 Quoted here in L.F. Salzman's translation (*Building in England down to 1540*, 1967 (2nd ed.), p. 376).

9 C.N. Johns, *Caerphilly Castle*, 1978; also Douglas B. Hague's description of the castle in T.B. Pugh's *Glamorgan County History. Volume III. The Middle Ages*, 1971, pp. 423–6.

10 R. Allen Brown, *Dover Castle*, 1974, p. 13.

11 A. J. Taylor, *Rhuddlan Castle*, 1956.

12 For a discussion of these castles, with a location map and comparative plans, see my own *The Castle in Medieval England and Wales*, 1982, pp. 63–77; and for Caernarvon, both castle and town, see H. Carter, 'Caernarvon', in *Historic Towns I* (ed. M. D. Lobel), 1969.

13 W. Douglas Simpson, *Bothwell Castle*, 1958; Stewart Cruden, *The Scottish Castle*, 1960, pp. 17–18, 78–80.

14 The translation is from a contemporary French-language account of the siege, reproduced in B.H.St J. O'Neil's *Caerlaverock Castle*, 1952, pp. 5–6; for Caerlaverock's place in Scottish castle-building, and in particular for its association with the Edwardian engineers, see Stewart Cruden, op.cit., pp. 64–72.

15 George Smith Pryde, *The Burghs of Scotland. A Critical List*, 1965, p. 37.

16 Ibid., pp. 4, 8–9, 15.

17 Ronald G. Cant, *Historic Crail*, 1976 (3rd ed.); Anne Turner Simpson and Sylvia Stevenson, *Historic Crail: the archaeological implications of development*, 1982.

18 For a full discussion, with plans, of the development of Glasgow, see J.R. Kellet, 'Glasgow', in *Historic Towns I* (ed. M.D. Lobel), 1969.

19 William Mackay Mackenzie, *The Scottish Burghs*, 1949, chapter 5 ('Burgh Privileges'); the same author had earlier stressed the identity of royal and burgess interests (chapter 4).

20 Stewart Cruden, op.cit., pp. 95–6.

21 For the best recent description of Acton Burnell, see C.A. Ralegh Radford, 'Acton Burnell Castle', in *Studies in Building History, Essays in Recognition of the Work of B.H.St J. O'Neill* (ed. E.M. Jope), 1961, pp. 94–103.

22 Stokesay, being still in private hands, has not been studied very extensively. For the most complete description to date, see Margaret E. Wood, 'Thirteenth-century domestic architecture in England', *Arch.J.*, 105(1950:supplement), pp. 64–70 (and fold-out plan).

4 Hearth and Home in the Late Middle Ages

1 For a good systematic account of Winchelsea and its fortunes, see *VCH Sussex*, ix:62–75; and see also *Medieval England. An Aerial Survey*, pp. 238–41.

2 For a summary of the evidence, see my own *Medieval England*, 1978, especially p. 95.

3 Climate and its effect on Dartmoor settlement are discussed by Guy Beresford, 'Three deserted medieval settlements on Dartmoor: a report on the late E. Marie Minter's excavations', *Med.Arch.*, 23(1979), pp. 142–6.

4 *Medieval England. An Aerial Survey*, pp. 97–9; Dorothy Dudley and E. Marie Minter, 'The medieval village at Garrow Tor, Bodmin Moor, Cornwall', *Med.Arch.*, 6–7(1962–3), pp. 272–94.

5 Maurice Beresford's fine pioneering study, *The Lost Villages of England*, 1954, put great emphasis on deliberate depopulation in the fifteenth and sixteenth centuries, sparking off a long-lasting debate.

6 For the latest summary of the Wharram evidence, see J.G. Hurst (ed.), *Wharram. A Study of Settlement on the Yorkshire Wolds*, 1979, in particular Maurice Beresford's chapter on 'Documentary evidence for the history of Wharram Percy', pp. 5–25.

7 *Medieval England. An Aerial Survey*, pp. 16–17, and

Maurice Beresford and John G. Hurst (eds), *Deserted Medieval Villages*, 1971, plate 10. For the circumstances of the desertion, see Christopher Dyer's *Lords and Peasants in a Changing Society. The Estates of the Bishopric of Worcester, 680–1540*, 1980, especially pp. 251 and 260; for the descent of the manor of Ditchford, until recently counted as part of Worcestershire, see *VCH Worcestershire*, iii:268–9.

8 For Ingarsby's transformation, see my own *The Monastic Grange in Medieval England*, 1969, pp. 112–14, 211–12, and the references given there.

9 For the figures, see especially E.M. Carus-Wilson and Olive Coleman, *England's Export Trade 1275–1547*, 1963, passim; A.R. Bridbury's *Medieval English Clothmaking. An Economic Survey*, 1982, makes a characteristically stimulating contribution to the debate as to why English clothmaking took off in these years, emphasizing the importance of fashion.

10 Colin Platt, 'The evolution of towns: natural growth', in *The Plans and Topography of Medieval Towns in England and Wales* (ed. M.W. Barley), CBA Research Report 14, 1975, pp. 48–56.

11 Quoted by Michael Prestwich, *The Three Edwards. War and State in England 1272–1377*, 1980, p. 149.

12 For the most recent analysis of Maxstoke, see N.W. Alcock, P.A. Faulkner and S.R. Jones, 'Maxstoke Castle, Warwickshire', *Arch.J.*, 135(1978), pp. 195–233.

13 *The Chronicle of Jean de Venette*, in a passage reproduced by C.T. Allmand, *Society at War. The Experience of England and France during the Hundred Years War*, 1973, p. 173.

14 *VCH Sussex*, ix:67.

15 Some reconstruction of the accommodation at Hadleigh is attempted in P.L. Drewett's 'Excavations at Hadleigh Castle, Essex, 1971–1972', *J.Brit.Arch.Assoc.*, 38(1975), pp. 90–154; and see also H.M. Colvin (ed.), *The History of the King's Works. Vol.II The Middle Ages*, 1963, pp. 659–66.

16 R.B. Pugh and A.D. Saunders, *Old Wardour Castle*, 1968; and see also my own *The Castle in Medieval England and Wales*, 1982, pp. 124–5.

17 *Scotney Castle*, 1981

18 Catherine Morton, *Bodiam Castle*, 1975.

19 P.A. Faulkner, 'Castle planning in the fourteenth century', *Arch.J.*, 120(1963), pp. 225–30.

20 H.M. Colvin (ed.), op.cit., pp. 870–82.

21 Both are discussed and illustrated in my *The Castle in Medieval England and Wales*, 1982, pp. 140–2, 146–8.

22 W. Douglas Simpson, *Bothwell Castle*, 1958, p. 20.

23 J.S. Richardson, *Tantallon*, 1950.

24 W. Douglas Simpson, *Hermitage Castle*, 1957.

5 The Late-Medieval Church

1 J.S. Richardson and Marguerite Wood, *Melrose Abbey*, 1949.

2 J.S. Richardson, *Sweetheart Abbey*, 1951 (2nd ed.).

3 R.N. Hadcock, *Tynemouth Priory and Castle*, 1952, pp. 22–5.

4 W.H. St John Hope, 'On the Premonstratensian abbey of St Mary at Alnwick, Northumberland', *Arch.J.*, 44(1887), pp. 337–46; *Monastic Sites from the Air*, pp. 152–3.

5 W.H. St John Hope, 'On the Whitefriars or Carmelites of Hulne, Northumberland', *Arch.J.*, 47(1890), pp. 105–29; *Monastic Sites from the Air*, pp. 256–7.

6 *VCH Sussex*, ix:102.

7 Ibid., ii:77–9; *Michelham Priory*, 1980; *Monastic Sites from the Air*, pp. 228–9.

8 Gordon M. Hills, 'On the priories of Ulverscroft and Charley in Leicestershire', *J.Brit.Arch.Assoc.*, 19(1863), pp. 165–83; *Monastic Sites from the Air*, pp. 220–21.

9 *Cal. Close Rolls 1377–1381*, p. 486.

10 For a brief account of Leiston's history, see Richard Mortimer's introduction to his recent edition of the *Leiston Abbey Cartulary and Butley Priory Charters*, Suffolk Charters 1, 1979.

11 Both the roll and the book are now held at the Bodleian Library, Oxford (MS Lat. misc.b.2 and MS Top. Glouc.d.2).

12 J.S. Richardson and Marguerite Wood, *Melrose Abbey*, 1949.

13 Ibid., p. 22.

14 *VCH Gloucester*, ii:57.

15 For a good recent account of the buildings at Gloucester Abbey, now the cathedral, see David Verey, *Gloucestershire 2. The Vale and the Forest of Dean*, in Nikolaus Pevsner's *The Buildings of England* series, 1970, pp. 198–226.

16 R.A.L. Smith, *Canterbury Cathedral Priory. A Study in Monastic Administration*, 1943, pp. 190–94; and see also the character sketch in David Knowles, *The Religious Orders in England*, 1955, ii:189–90.

17 The Canterbury chronicler's description is reproduced in translation by L.F. Salzman, *Building in England down to 1540*, 1967, pp. 396–7. There is a useful recent account of the building works of Prior Chillenden and his successors in Francis Woodman's *The Architectural History of Canterbury Cathedral*, 1981, chapter 5 ('The Perpendicular Cathedral 1377–1485').

18 F.J.E. Raby and P.K. Baillie Reynolds, *Castle Acre Priory*, 1952, pp. 15–20.

19 D.H.S. Cranage, 'The monastery of St Milburge at Much Wenlock, Shropshire', *Archaeologia*, 72(1922), pp. 122–8; Rose Graham, *The History of the Alien Priory of Wenlock*, 1965, p. 21.

20 Gordon M. Hills, op.cit., p. 180.

21 Rose Graham, *English Ecclesiastical Studies*, 1929, pp. 132–6.

22 David Knowles, op.cit., ii:182–4; for the text of Henry V's Articles, see A.R. Myers (ed.), *English Historical Documents 1327–1485*, 1969, pp. 787–90.

23 David Knowles, op.cit., iii:159–60.

24 Mr Laurence Keen's excavations were reported in a lecture delivered at the Society for Medieval Archaeology's annual conference (April 1976).

25 Venables, 'The rules of the Carthusian Order, illustrated by the Priory of Mount Grace', *The Antiquary*, 10(1884), p. 4.

26 For the suppression of the alien priories and for Henry V's foundations, see David Knowles, op.cit., ii:161–6, 175–82.

27 James Lee-Warner, 'Petition of the prior and canons of Walsingham, Norfolk, to Elizabeth, Lady of Clare. Circa AD 1345', *Arch.J.*, 26 (1869), pp. 166–73.

28 E.F. Jacob, *Archbishop Henry Chichele*, 1967, p. 79.

29 For a useful summary of the statutes, see *VCH Northamptonshire*, ii:171–4.

30 L.F. Salzman, op.cit., pp. 544–5.

31 Rotha Mary Clay, *The Medieval Hospitals of England*, 1909, p. 120.

32 For illustrations of Grevel's brass and his house at Chipping Campden, see my own *The English Medieval Town*, 1976, figs 83–4.

33 For the text of the Long Melford inscriptions, see
Nikolaus Pevsner, *Suffolk*, 1974 (2nd ed.), pp. 344–5.

6 Old Habits and New Beginnings: the Tudors

1 *Monastic Sites from the Air*, pp. 226–7; Nikolaus
Pevsner, *Essex*, 1965 (2nd ed.), p. 340.
2 A. Hamilton Thompson, *History and Architectural
Description of the Priory of St Mary, Bolton-in-Wharfedale*,
Publications of the Thoresby Society 30 (for 1924),
1928, pp. 154–5.
3 For the text of John Freeman's letter to Thomas
Cromwell, see G.H. Cook, *Letters to Cromwell and
others on the Suppression of the Monasteries*, 1965, pp.
181–2.
4 A. Hamilton Thompson, *Netley Abbey*, 1953.
5 For a discussion (with plan) of Sopwell in the
context of other contemporary conversions, see my
own *Medieval England*, 1978, pp. 216–19.
6 Ibid., p. 219.
7 Datable to about 1587 and quoted by Claire Cross,
'Dens of loitering lubbers: Protestant protest against
cathedral foundations, 1540–1640', *Studies in Church
History*, 9(1972), pp. 231–2.
8 David Knowles, *The Religious Orders in England*, 1959,
iii:392.
9 The best recent discussion of the buildings at
Thornbury has been A.D.K. Hawkyard's
'Thornbury Castle', *Trans. Bristol and Gloucestershire
Archaeological Society*, 95(1977), pp. 51–8. See also my
own *The Castle in Medieval England and Wales*, 1982,
pp. 179–82; and for the Staffords, Carole Rawcliffe's
*The Staffords, Earls of Stafford and Dukes of Buckingham
1394–1521*, 1978, passim.
10 Nikolaus Pevsner, *Essex*, 1965 (2nd ed.), pp. 261–5.
11 Nigel Nicolson, *Sissinghurst Castle*, 1964.
12 For a good recent account of Knole, see John
Newman's *West Kent and the Weald*, 1969, pp. 342–9.
13 H.M. Colvin (ed.), *The History of the King's Works.
Vol.IV 1485–1660 (Part II)*, 1982, pp. 367–401,
415–47 (Camber).
14 J.S. Richardson, *Tantallon*, 1950.
15 Christopher Duffy usefully discusses the continental
material in *Siege Warfare. The Fortress in the Early
Modern World 1494–1660*, 1979, passim; and see also
Charles Peers, *Carisbrooke Castle*, 1948, and Ian

MacIvor's 'The Elizabethan fortifications at Berwick-
upon-Tweed', *Ant.J.*, 45(1965), pp. 64–96,
subsequently rewritten with additional illustrations in
the same author's *The Fortifications of Berwick-upon-
Tweed*, 1972 (2nd ed.); also H.M. Colvin (ed.),
op.cit., pp. 530–35 (Carisbrooke), 613–64 (Berwick-
upon-Tweed).
16 H.M. Colvin, 'Castles and government in Tudor
England', *EHR*, 83(1968), pp. 231–2.
17 While others have had their reservations about the
date range suggested, Professor Hoskins's label
remains substantially unchallenged (W.G. Hoskins,
'The rebuilding of rural England, 1570–1640', in
Provincial England. Essays in Social and Economic History,
1965, pp. 131–48, reprinting the paper first
published in *Past & Present* 1953).
18 For a valuable general discussion of the building
process in this period, see Malcolm Airs, *The Making
of the English Country House 1500–1640*, 1975.

Index